WHAT IF I HAD BEEN THE HERO?

WHAT IF I HAD BEEN THE HERO?
Investigating Women's Cinema

SUE THORNHAM

A BFI book published by Palgrave Macmillan

First published in 2012 by
PALGRAVE MACMILLAN

on behalf of the

BRITISH FILM INSTITUTE
21 Stephen Street, London W1T 1LN
www.bfi.org.uk

There's more to discover about film and television through the BFI. Our world-renowned archive, cinemas, festivals, films, publications and learning resources are here to inspire you.

Palgrave Macmillan in the UK is an imprint of Macmillan Publishers Limited, registered in England, company number 785998, of Houndmills, Basingstoke, Hampshire RG21 6XS. Palgrave Macmillan in the US is a division of St Martin's Press LLC, 175 Fifth Avenue, New York, NY 10010. Palgrave Macmillan is the global academic imprint of the above companies and has companies and representatives throughout the world. Palgrave® and Macmillan® are registered trademarks in the United States, the United Kingdom, Europe and other countries.

Designed by couch
Cover image: *Morvern Callar* (Lynne Ramsay, 2002), © Morvern Callar Productions Limited

Set by Cambrian Typesetters, Camberley, Surrey
Printed in China

This book is printed on paper suitable for recycling and made from fully managed and sustained forest sources. Logging, pulping and manufacturing processes are expected to conform to the environmental regulations of the country of origin.

British Library Cataloguing-in-Publication Data
A catalogue record for this book is available from the British Library
A catalog record for this book is available from the Library of Congress
10 9 8 7 6 5 4 3 2 1
21 20 19 18 17 16 15 14 13 12

ISBN 978–1–84457–363–9 (pb)
ISBN 978–1–84457–364–6 (hb)

Contents

Acknowledgments

I should like to thank the University of Sussex for granting me leave to begin writing this book. Thanks also go to colleagues, particularly to Kate Lacey, who took on additional burdens during my leave, to Thomas Austin, who allocated me a smaller teaching load in order that I could finish it, and to Elaine Saunders, who made sure that my research time wasn't invaded by meetings. I'd also like to thank Lee Gooding and Kevin Clarke of the University of Sussex, and Sophia Contento, of the BFI, who helped me find the images. Finally, thanks go to Mike, for his continued support, to Helen, from whom I continue to learn, and lastly to Anja, who inspired the postscript to this book.

Introduction

In childhood dream-play I was always
the knight or squire, not ·
the lady:
quester, petitioner, win or lose, not
she who was sought.

(Denise Levertov, *Relearning the Alphabet* (1970), p. 116)

In 1997 I published my critical history of feminist film theory, *Passionate Detachments*. In the introduction, I pointed uneasily to another history which was not charted there, that of feminist film-*making*: what Laura Mulvey had called the 'utopian other' of feminist film theory (Mulvey, 1989c, p. 77). And yet, as B. Ruby Rich stated so emphatically in her own history of the relationship between the two, written at the end of the 1970s, the 'films came first', with the first Festival of Women's Films held in 1971 and the early critical work following a year later. Many of the early festivals, she adds, took place in academic departments, and many of the early film-makers were 'led to film' through feminism (1978, p. 9). Both groups called themselves 'film feminists'. In the thirty years since Rich wrote this, the two histories, which had seemed so intertwined, have diverged, so that by the late 1980s Mulvey could argue that feminist film theory had 'lost touch with feminist filmmaking' (1989c, p. 77), and women's film-making can no longer be confidently labelled either 'utopian' or 'feminist'. And yet it remains important, it seems to me, to explore in terms of feminist theory these films which, to borrow Nancy Miller's words,[1] bear the signature of women, since by their very nature they must engage with those issues which have been of concern to feminist theorists: questions of subjectivity, of narrative and its relation to gender, of fantasy and desire, of the gendered ordering of space and time, and of regulation and agency. It is that exploration which is the concern of this book.

One reason for the divergence of these histories, of course, is that there are simply more women film-makers, and they are found all over the world, in commercial as well as subsidised or art cinema. Recent critical studies have focused on individual film-makers, on national or transnational contexts, on 'third

world', postcolonial or 'minority' women film-makers.[2] Yet, as Martha Lauzen's annual reports, *The Celluloid Ceiling*, show, the situation for women film-makers is bleaker than this would suggest. Lauzen's most recent study (2011) reports that in 2010 women comprised just 7 per cent of directors of the top 250 grossing films in the USA, a decline of two percentage points from 1998. Mostly, they worked in romantic comedy and romantic drama. Women who *have* been able to make films, like Jane Campion, have persistently drawn attention to the lack of opportunities for female directors and the absence in mainstream film of women's 'way of seeing the world' (Doland, 2007). Women, said Campion in 2009, are not 'being well served by the majority of movies that are being made' (Anderson, 2009). That Women Make Movies, the New York-based distributor of women's films founded in 1972, still sees its function as including 'helping women directors … worldwide … [and] giving a voice to women in places where women's voices are often silenced' (Zimmerman, 2011) indicates how far we should be from complacency.

'Women were most likely to work in the romantic comedy … and romantic drama genres,' reports Lauzen (2011, p. 2). A second and arguably key factor in this divergence is the advent of what Diane Negra has called the 'postfeminist era' (2009, p. 5) with which these genres have become increasingly identified. Commonly seen as beginning in the 1980s,[3] postfeminism and its themes became a dominant feature of western popular culture in the 1990s and 2000s. Postfeminism asserts women's empowerment, thus rendering the concerns of feminist theory at best marginal for contemporary women. Its 'new female icon', state the authors of *Introducing Postfeminism* (1999), is '[t]ough, sexy and irreverent'; she 'does not see herself as a victim, and she wants power'.[4] As Negra and others have argued, however,[5] while postfeminism 'fetishizes female power and desire', it also places them within firm limits: the limits of conventional codes of femininity (2009, p. 4). If feminist theory has critiqued femininity and the multiple sites and structures through which it is constructed, postfeminism celebrates its return. It is a femininity still naturalised as both destiny and ideal for women, to be achieved through constant self-surveillance, self-modification and consumption, but one which is now seen as productive of female power as well as pleasure. The difference comes through the operation of *choice*: this very traditional-looking femininity is presented as the outcome of individual choice for the contemporary young woman. As Charlotte insisted in *Sex and the City* in 2001, 'The women's movement [was] supposed to be about choice. And if I choose to give up work, that's my choice.'[6] Over and over again, writes Negra in her study of contemporary popular culture for women, 'the postfeminist subject is represented as having lost herself but then (re)achieving stability through romance, de-aging, a makeover, by giving up paid work, or by "coming home"' (ibid., p. 5). Forms of female agency and desire that are outside what Negra calls this 'romanticized emotional passivity', however, are subject to 'stern disapproval

WHAT IF I HAD BEEN THE HERO?

and judgement' (ibid., pp. 140, 152). In films like *Miss Congeniality* (Petrie, 2000), *Legally Blonde* (Luketic, 2001) and *The Devil Wears Prada* (Frankel, 2006) these negative traits are associated with a feminism that is now irrelevant and which must be rejected by the heroine in her search for successful female selfhood.

In these films, the quest narrative which Denise Levertov places at the centre of her 'childhood dream-play' is offered to women, but transformed by sleight of hand into the quest to be or become 'the lady'. She remains, in other words, the heroine. In other postfeminist films, however, the 'action chick' has become the hero: narratively central, active and dispensing an often graphic violence while simultaneously, in Linda Mizejewski's words, enjoying 'feminine consumerist choices, ... romance, career choices, and hair gels' (2005, p. 122). The emergence of such films seems to suggest, indeed, that the 'What if...?' in the title of this book is as outdated as the feminism depicted in *Legally Blonde*. Some critics have indeed argued in this way, seeing such often highly pleasurable postfeminist texts as straightforward evidence of women's increased power and status. Sherrie Inness, in the introduction to *Action Chicks: New Images of Tough Women in Popular Culture* (2004), for example, argues that,

> [w]ith changes in women's real lives came changes in popular imagery. No longer could women be represented in the same stereotypical ways as they had been in the past. Something had to change. The rise of the female action heroine[7] was a sign of the different roles available to women in real life. (p. 6)

Other writers have been less sanguine about such representations. Lisa Coulthard, for example, argues that 'the violent woman of contemporary popular action cinema does not upset but endorses the status quo' (2007, p. 173). Like the heroine of the 'chick flick', argues Coulthard, she subjects to display, irony and pastiche the gendering of narrative functions and outcomes that underpin our cultural myths and stories. But it is a spectacular display that is fundamentally 'apolitical, individualistic, and capitalistic', a 'celebration of the superficial markers of power' not transgression or critique (ibid.). As a consequence, argue both Negra and Angela McRobbie, such representations are often accompanied by a vague sense of 'melancholia' or loss. We might see this as the loss of all that lies outside the new mode of 'regulative gender power' (McRobbie, 2009, p. 115) that postfeminist femininity represents. We might identify it also with a (renewed) loss of access to desire, to transgression and to feminism – a loss that is the more bewildering because it is unrecognised. If, after all, we are promised the hero's quest only to find ourselves returned either to a normative femininity or a fantasy of individualised violence in which we are also the spectacular object of display, a certain sense of loss is inevitable.

'What if I had been the hero?' is taken from Sally Potter's experimental film, *Thriller* (1979), and is a conflation of two questions asked there: 'Would I have

preferred to be the hero?' and 'What if I had been the subject of this scenario instead of its object?' Potter's film, unlike its postfeminist successors, suggests that a simple gender reversal of hero/heroine, activity/passivity, subject/object produces outcomes that self-evidently don't work – indeed, are absurd. The narrative structures on which these oppositions are based are fundamental to our sense of identity, the fictions in which they are embedded forming the material on which we draw for our own identificatory fantasies. To seek to transform them therefore has implications – cultural, narrational, linguistic, subjective – which we also need to explore. Feminist theory has explored these implications, but so, I argue, has women's film-making, which *must* engage with all the implications of Potter's question if it is to put women at the centre of its narratives. If fantasy, as Judith Butler argues, 'is what allows us to imagine ourselves and others otherwise', establishing 'the possible in excess of the real', then the public fantasies of film provide the space of 'What if ...' of my title. But Butler also adds that when fantasy is *embodied*, 'it brings the elsewhere home' (2004, p. 29).

I am, of course, not alone in asking this question. The quotation from Denise Levertov which heads this Introduction was taken from Carolyn Heilbrun, who uses it in her own reflections on the kinds of stories women tell about their lives, on the *anger* these stories often repress, and on the fantasies women create in order to evade 'the narratives that have been controlling their lives' (1988, p. 60). Patricia Mellencamp's *A Fine Romance: Five Ages of Film Feminism* (1995), to which I shall return in the next chapter, begins with a story similar to that of Levertov and Heilbrun. 'When I was a young girl', she writes, 'I wanted to be a boy ... I was too restless and impatient for femininity, which was quiet, unobtrusive, dull ... Boys moved through space. Girls stayed in place. Boys never looked back. Girls waited' (1995, p. 1). In a footnote, she adds, 'I have always wanted to be the hero, never the princess who waits or is adored' (ibid., p. 292). Echoing Butler, she argues that feminist film-making can 'expand the contours of female subjectivity ... When the enunciation shifts into women's minds and into history (which includes our experience and memory), we cease thinking like victims and become empowered ... "Being the hero" is a state of being as well as action' (ibid., p. 257). Teresa de Lauretis has asked Potter's question more theoretically throughout her writing. My most constant companion in writing the book, however, has been Virginia Woolf, who asked the same questions eighty years ago. Her thoughts, struggles, anger, frustrations and evasions recur throughout.

The book is divided into two parts. The first, Questions, returns to the further questions that are implicit in Potter's enquiry, and to the ways in which they were debated and answered in the heady early days of what Jan Rosenberg (1979) called the 'Feminist Film Movement'. After teasing out in Chapter One the theoretical issues involved, I look in Chapter Two at the films over which the debates were fought, the documentaries and 'avant-garde' feminist films of the

1970s. Of the 120 films screened at the first International Festival of Women's Films of 1972, only thirteen were feature-length fiction films, and most of these had been made before the mid-1960s. The majority of the films screened were documentaries. Rosenberg's account of the 'Feminist Film Movement' concentrates on these documentaries: she is both excited and extremely wary at the prospect of the possible move 'into the mainstream' of the film-makers she interviews (1979, p. 75). Some feature films were being made in the 1970s, however, and the final chapter of this section focuses on these: on what happens when women move beyond the 'narrowly realistic or autobiographical modes' (Haskell, 1975, p. 72) that reviewers expected from women film-makers in the 1970s. The issues raised in this chapter provide the thematic headings for the second part of the book.

In the second part of the book, Explorations, I range much more widely, discussing films from India and Argentina as well as Europe, Canada, Australia and the USA, and produced between 1991 and 2009. I have contextualised them geographically and culturally only insofar as I felt it necessary; my interest is in how they have wrestled with the issues I explored in Part One. Chapter Four, Heroes and Writers, explores films whose protagonists operate to some degree as textual doubles for the female film-maker, by being in some ways *writers*. This is not always literally true. Some appropriate the words of others; some fail to write at all. Some write through oral storytelling; some through images. The films differ, too, in the nature of their exploration. Some seek to close the gap between the film's authorial voice, the textual writer and the (female) spectator; others leave a textual reality, in Patricia Ticineto Clough's words (1998, p. 116), 'criss-crossed with desire'.

In Chapter Five, Landscapes and Stories, I explore how landscapes might function for women film-makers. Heroes, after all, establish their wholeness as subjects through their penetration and conquest of space and landscape. Their journeys are always both literal and metaphorical. In them, as Manohla Dargis writes of the American road movie and its novelistic forerunners, 'the woman's body and the road are interchangeable' (1995, p. 87), sites the hero must travel on the journey to self-knowledge, maturity and, sometimes, self-destruction. Feminist *writers* have consistently employed spatial metaphors – describing 'situated knowledges' and 'a politics of location' – to envisage alternative modes of knowledge and social relations. But for women film-makers this vision must be concretised, and the gaze *at*, and exploration, penetration and ownership *of* landscape comes saturated in visual as well as literary traditions. In this chapter I explore the challenges of representing a different journey and a different relationship to place and landscape.

Chapter Six, Bodies and Passions, is concerned with how women film-makers have sought to represent female sexuality. As early as 1973, Claire Johnston insisted that in order 'to counter our objectification in the cinema, our

collective fantasies must be released: women's cinema must embody the working through of desire' (1973, p. 31). Yet confronted with a mainstream cinema in which, as Anneke Smelik writes, 'the mere appearance of a woman signifies sexuality; her body takes on the meaning of sex' (1998, p. 158), this is a hugely difficult task. This chapter explores some of the ways in which these difficulties have been addressed.

There are, of course, many more films that I could have written about. And many of the films that I have discussed could have been included in more than one of the chapters. Marleen Gorris's *Antonia's Line* (1995), for example, deals with female storytelling and women's sexuality as well as space and landscape, and the last film I write about, Kathryn Bigelow's *The Weight of Water* (2000), could similarly have been included in any of the last three chapters. In the work of some film-makers, like Jane Campion, Gillian Armstrong and Patricia Rozema, these themes can be seen intertwined in all of their films.

A final question for this introduction is whether, in light of the wealth of film-making I include and could have included here, my question should be posed less tentatively – should at least be asked in the present or future tense. I am not sure of the answer,[8] but I *am* sure that the 'What if ...' should remain. Fiction film is a medium of fantasy, and the fantasies constructed by women film-makers are constructed both against and through those more dominant stories that, in Carolyn Heilbrun's words, 'have formed us all' (1988, p. 37). Through the unfolding of these stories, both hero and subject are constructed and, through the gendered codes that underpin narrative, constructed as male. Against them, the embodied fantasies of women film-makers allow us to imagine otherwise, making 'the impossible a fictional possibility' (Clough, 1998, p. 13).

Part One Questions

Chapter One

'WHAT IF I HAD BEEN THE HERO?'

> We live our lives through texts. They may be read or chanted, or experienced electronically, or come to us, like the murmurings of our mothers, telling us what conventions demand. Whatever their form or medium, these stories have formed us all; they are what we must use to make new fictions, new narratives.
>
> (Carolyn Heilbrun, 1988, p. 37)

In *Thriller* (1979), Sally Potter's interrogation of Puccini's classic operatic melo-drama *La Bohème*, Mimi, the female victim-heroine become investigator, asks in voice-over: 'Would I have preferred to be the hero?' In the attic space, which is the film's *mise en scène*, the camera shows us Mimi, wearing jacket, tutu and pat-terned trousers, supporting the figure of Rudolpho, the opera's artist-hero, who is dressed only in ballet skirt. He is held by Mimi 'in arabesque', the classical ballet position which is, E. Ann Kaplan tells us, 'the most perfect form that the female form can take' (1983, p. 157), but one which works only if the woman is unable to move. Holding Rudolpho thus, she turns to camera, and the action is replayed, ending in a freeze-frame. Still in voice-over, Mimi rephrases her question: 'What if I had been the subject of this scenario instead of its object?' In Potter's film, the question does not produce the reversal of narrative sub-ject/object that the inverted arabesque suggests. The image is self-evidently absurd, and the response from the extra-diegetic Mimi is laughter. Instead, her voice begins to find answers to the questions she has posed throughout the film. In the romance narrative, her death was inevitable: 'Without my death ... I would have become a mother. I would have had to work even harder. ... I would have become an old woman.' Her function in the story was 'to be young, single and vulnerable, with a death that served their desire to be heroes'.

Mimi's doubled question, 'What if I had been the hero/subject?' is one which has haunted feminist film theory. For Patricia Mellencamp it takes the form, first, of a personal story, a 'Once upon a time'. 'When I was a young girl', she writes, 'I wanted to be a boy ... I was too restless and impatient for femininity, which was quiet, unobtrusive, dull ... Boys moved through space. Girls stayed in place. Boys never looked back. Girls waited' (1995, p. 1). In a footnote, she adds:

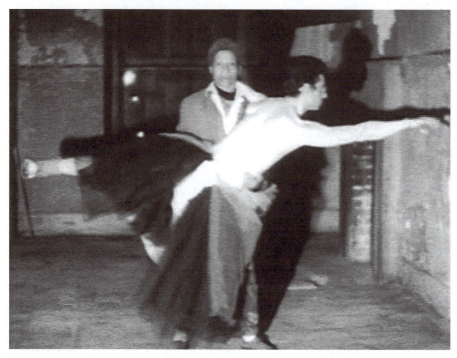

Thriller (1979): Rudolfo 'in arabesque'

When I was a girl, reading alone for weeks in the summer, surrounded by sacks of library books, was my greatest pleasure. First came fairy tales, ... then mysteries ... I still want to be a detective and have adventures – which might explain my fondness for movies; analyzing narrative ... is detection. I have always wanted to be the hero, never the princess who waits or is adored. (Ibid., p. 292)

Later in the book, Mellencamp applies the distinction to feminist film-making. Echoing Mimi's conclusions, she writes that such films,

expand the contours of female subjectivity ... when the enunciation shifts into women's minds and into history (which includes our experience and memory), we cease thinking like victims and become empowered, *no matter what happens*. 'Being the hero' is a state of being as well as action. Being the hero is, precisely, *not* being the victim. (Ibid., p. 257, original emphasis)

Elsewhere, in a curious though clearly overdetermined error, she amends the conclusion of Jane Campion's *The Piano* (1993), attributing its final lines to an imaginary poem by Thomas Hood called 'What If I Had Been the Hero?', instead of to their actual source, Hood's 'Silence'.

Other feminist theorists have posed the question in less autobiographical terms, though for all of them there is clearly something personal at stake. Laleen Jayamanne, who like Mellencamp calls herself 'a female academic investigator', notes, for example, that 'I prefer to use the phrase *female hero* because the structural connotations of the term *heroine* make the woman named by it a figure in need of rescue, while agency is synonymous with the hero function' (2001, pp. 207, 281, original emphasis). Finally, Teresa de Lauretis clarifies just what is at stake, structurally, in Mimi's question:

> Opposite pairs such as inside/outside, the raw/the cooked, or life/death appear to be merely derivatives of the fundamental opposition between boundary and passage; and ... all these terms are predicated on the *single* figure of the hero who crosses the boundary and penetrates the other space. In doing so the hero, the mythical subject, is constructed as human being and as male; he is the active principle of culture, the establisher of distinction, the creator of differences. Female is what is not susceptible to transformation, to life or death; she (it) is an element of plot-space, a topos, a resistance, matrix and matter. (1984, p. 119, original emphasis)

Mimi's question, then, is more than a matter of terminology, of will, or even of subjectivity. De Lauretis suggests that the identifications male-hero-human/ female-obstacle-boundary-space are built into the structures of narrative itself, so that when we do find ourselves within a 'female genre', we find that its narratives subordinate time to space, dealing, as Tania Modleski says, 'with people who are trapped in their world' (1999, p. 10). At the same time, it is a question that, however urgent for the feminist film theorist, *must* be tackled by the woman film-maker if she is to engage with narrative – and how can she not, even if what she produces is, as with Potter's *Thriller*, a form of anti-narrative.

This book, then, is about some of the answers that women film-makers have found to Mimi's question. In this opening chapter, however, I shall tease out in rather more detail the implications of the question itself: the conditions under which I, the female subject, might be the hero, and the further questions I might then encounter. These questions will concern narrative and subjectivity, gender and authorship, and fantasy and desire.

BEING THE HERO

For Teresa de Lauretis, as we have seen, 'being the hero' is also, as it was for Mimi, to be subject, the maker of meaning rather than its object. But such a 'mythical subject', she writes 'must be male'. His archetype is Oedipus, whose heroic quest is for self-knowledge, to be accomplished by means of the narrative's female figures. When finally achieved, such self-knowledge is also a

realisation of loss – of what de Lauretis calls 'an initial moment, a Paradise lost' (1984, p. 125), again associated with a female figure, the mother. In the hands of Freud, this narrative becomes the story of Everyman's passage into adulthood and culture.

It is little wonder, then, that feminist critics, like Mimi, have been suspicious of the role of hero, however attractive. Feminism, writes Meaghan Morris, 'is not easily adapted to heroic progress narratives' (1998, p. xv), and like Cora Kaplan, she calls for a 'different temporality' in the feminist narrative, and what Kaplan calls 'a more complicated, less finished and less heroic psychic schema' (Kaplan, 1986, p. 227). The female action hero in film has been viewed with ambivalence at best. Catherine Constable talks of 'the valorisation of masculinity which underpins the current ascendance of [this] ostensibly feminist prototype' (2005: 190), and Carol Clover famously analyses the 'final girl' of the slasher movie as a stand-in for the adolescent *male* viewer: 'We are, as an audience, in the end "masculinized" by and through the very figure by and through we were earlier "feminized." The same body does for both, and that body is female' (1992, p. 59).

We cannot, these writers insist, simply change the gender of the hero if narrative itself, or at least its dominant – its *heroic* – forms, is masculine, its function to produce the subject as male. Yet if I am to be the subject of the (my) narrative, I must also be the subject of its actions or events. If I am merely the subject of *narration* (the one the story is *about*), while not being the subject of its actions,[1] or if I begin as the subject of the story's actions but end as their object, I will have remained within Modleski's 'female genres', 'trapped within (my) world'. My subjectivity may have been produced as complex: my narration might have revealed a split subjectivity; in briefly becoming the subject of the story's actions I might have transgressed the codes of femininity; the story's closure, bringing my return to the status of object, may be uneasy, or tragic. But in all these cases I will have remained within what Nancy Miller calls *heroinism* (1988, p. 88). If I am to be the hero, then, I must transgress some dominant narrative codes, and the psychoanalytic structures that they reproduce. The story of which I am subject will be neither Freud's Oedipal journey nor its feminine equivalent, reproduced in 'female genres', in which the girl who is to become a woman must relinquish not only her desire for the mother but desire itself, so that her story, too, becomes a question of *his* desire.

A story, writes de Lauretis, 'is always a question of desire' (1984, p. 112). If narrative is a quest for meaning, as she suggests, then desire is written into its elements of process and temporality, and manifest in its plot. If I am to be the hero, then, I must be the one who *desires*. In Patricia Mellencamp's autobiographical narrative (1995), desire is identified with fantasy (wanting 'to be a boy/a hero'), with fairytale and film, and with investigation. This desire, then, is more complex than it looks. Initially, it seems to echo that described in Laura

Mulvey's account of the 'transvestite' identifications of the female viewer/reader of popular narratives. The story's 'grammar', writes Mulvey, means that the viewer's narrative identification must be placed with its desiring hero. For the female viewer, this produces a particular form of pleasure: the adult woman, now firmly fixed within the codes of femininity, finds in this identification a temporary release from these codes, through a fantasised regression to the pre-Oedipal 'active' phase of development which is shared by both sexes. Its very 'transvestite' nature, however, means that this is both a guilty and a temporary pleasure, realised only in fantasy: a 'fantasy of "action" that correct femininity demands should be repressed' (1989b, p. 37). But this pleasure is one which Mulvey locates in the viewer/reader. How, then, are we to also find it in the *film*, as Mellencamp suggests is possible? Mulvey's essay finds an answer in the figure of the tomboy-hero, the figure *in* the text who enacts Freud's journey to passivity: active and desiring at the narrative's outset, but either happily landed on the shores of femininity at its close, or the victim of a more brutal narrative closure when this proves impossible. Like Mellencamp, this figure is also often an investigator. We can find her in Clover's 'final girl' of the slasher movie, who is an active investigator precisely because she has not yet achieved full femininity. In Clarice Starling, protagonist of Jonathan Demme's 1991 film, *Silence of the Lambs*, we can find her more mainstream incarnation. Despite Clover's dismissal of the film – she calls it a 'slasher movie for yuppies' (1992, p. 232) – it is a film which Mellencamp wants to celebrate. It is 'epistemophilia' (the desire to know), not scopophilia (voyeurism) which drives Starling, she writes, and what she investigates is 'male subjectivity and sexual perversion'. She is, therefore, the hero:

> Starling uses her brains and sheer courage more than her body. Neither she nor the film exploits her appearance. Her body is strong, not agitated. From her opening and menacing jog, she is alone and becomes stronger. Surrounded by good and bad fathers, she uses her very smart mind; she is not dominated by fear or dependency or inadequacy. She is not rescued, she rescues, in the end. (Mellencamp, 1995, p. 142)

Despite her attractiveness, however, it seems to me that Starling remains Mulvey's tomboy-hero. The victim she rescues is the woman she refuses to/has not yet become: the fully feminine woman who has completed the Freudian journey and has thereby become the victim. The close of the film, like many such closures,[2] signals the *impossibility* of Starling's position. At the FBI graduation ceremony, with its virtually all-male congregation, Starling exchanges looks with her female class-mate, who is then drawn into posing for a photographed embrace with one of her male colleagues. Starling's active gaze shifts to her FBI 'father', Crawford. The camera holds for a long time on a close-up of their handshake: firmly clasped

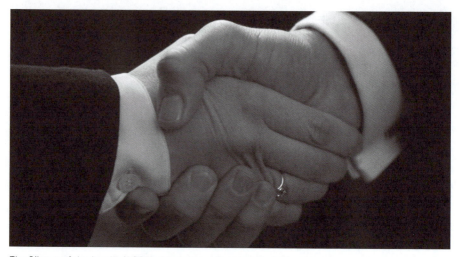

The Silence of the Lambs (1991): Starling and Crawford shake hands

hands are positioned centre frame, each edged by a white shirt cuff and the sleeve of a dark suit. 'Your father would have been proud today,' says Crawford, and Starling grins shyly. Then she steps outside the celebration to take a telephone call. It is from Lecter, and, framed against the white-painted brick wall of the corridor, she peers round the doorway as if to locate his voice, in a shot that echoes her earlier pursuit of Buffalo Bill in the dark cellar. The reverse shot, however, shows us not Lecter but Crawford, a darker and much more ambiguous figure now as, in the distance, he leaves the celebration. Our final shot of Starling is from a high angle with the camera zooming out, seeming to pin her against the corridor wall. Small, uncertain and anxious, she repeatedly whispers, 'Dr Lecter?' into the silence of the empty corridor. There is, the shot suggests, no place for her to occupy in the postgraduation world. She refuses to be claimed for femininity like her female colleague, but she is no longer a girl, and she cannot after all take up the masculine position (the position of the father) which the handshake suggested. Neither girl nor, in the terms of the film, mature woman, caught between masculinity and femininity, she *cannot* simply, as Mellencamp suggests she will, enter 'the arena of male subjectivity, law enforcement' and 'control' it (ibid.).

Mellencamp's investigative desire, however, does not end with maturity: 'I still want to be a detective', she says. For Potter's Mimi, too, becoming the investigator also means becoming the fully adult hero-subject. 'I am trying to remember', she says, looking back on her life-story: 'Did I die? Was I murdered? … What does it mean?' Yet as investigating subjects, both Mimi and Mellencamp are positioned *outside* the filmic narrative, asking, 'What does it *mean?*' In *The Woman at the Keyhole*, Judith Mayne argues that what characterises the narratives

WHAT IF I HAD BEEN THE HERO?

of the feminist films she discusses is that they 'share the desire to appropriate forms of narrative associated with the classical cinema to the representation of female desire' (1990, p. 85). It is a curious formulation which reflects the difficulty of the enterprise she is proposing. In it, desire is positioned outside the film, as the desire *for* a representation, and also, but far less certainly, inside the film, as the representation *of* female desire. Clearly, such narratives will not exhibit the easy fit between temporal movement and narrative resolution on the one hand, and the constitution of subjectivity and production of meaning on the other, that is evident in the Oedipal narrative and that Mellencamp wants to claim for Starling's story. They will be more uneasy, perhaps off-centre, since in speaking their desire they must, in Mayne's words, 'speak simultaneously of what the classical cinema represents and what it represses' (ibid.). They must, that is, articulate a female desire that is both investigative and the mark of an adult subjectivity.

THE HERO'S LOSS

For the male hero-subject, argues de Lauretis, narrative resolution brings both self-knowledge and a realisation of loss. With this statement, we are firmly in the territory of psychoanalysis, where the subject's entry into language and culture is founded on loss, the loss of a primary, pre-linguistic relationship with the mother. It is this – his separation and *distancing* from the mother – which grounds his ability to take up the position of subject within the 'symbolic order', the order of culture, in which meaning, and the ability to *make* meaning, has replaced being. As this sentence indicates, however, for psychoanalysis this subject is male. Women need to perform no such distancing, so that their separation from the object (the mother) is incomplete, and their subject-identity correspondingly weak. When they say 'I', they do so in a language which assumes the masculinity of the subject position, so that they are never wholly easy within it. They do not even, writes Mary Ann Doane, have access to the '*illusion* of a coherent and controlling identity' on which the man founds his subject identity (1987, p. 11, original emphasis). If, then, the hero's journey, driven by desire, is towards a 'sense of an ending' which brings simultaneously (self) knowledge and 'the memory of loss' (de Lauretis, 1984, p. 125), on what loss might the female hero's subject identity be founded? In this section I want to pursue this question, not just because it has constituted a problem for feminist film *theorists* – for after all women *do* speak and write and do make films, so that some answer must be presumed, if indeed one is needed – but also, and more importantly, because much of this film-making (and writing), it seems to me, *is* characterised by such a sense of loss.

For Mary Ann Doane, writing about the Hollywood 'woman's film' of the 1940s, it is the inability to inscribe such a founding loss into the positions of

female narrative subject and her imagined spectator that is typical in these films. They are characterised by 'overidentification' with the screen object rather than voyeuristic distance, by fantasies of persecution instead of desire, by a de-eroticised gaze, and by the narrative transformation of an active (and therefore transgressive) female subject into a mute and passive object (1987, p. 79). These, however, are films *for* women, whose narratives, however much they focus on women, are still, in the words of de Lauretis, stories which speak of *his* desire. Seeking to establish a theoretical foundation for an alternative form of women's cinema, a cinema *by* women, Kaja Silverman returns to the Oedipal story, to suggest a form of loss which might ground a female speaking and desiring subject. All human subjects enter culture by substituting language, or the 'symbolic order', for the real, she argues. The male subject's later identification of this loss with the loss of the mother, caused by his need to separate himself from her, is matched, she argues, by a similar process in the girl, for whom the mother is both the first love object and a figure of identification (1988, p. 150). Behind Freud's version of the feminine journey to maturity, then, in which the girl transfers her desire from mother to father and then must repress desire itself, stands another repression, that of the desire for the mother. Indeed, Freud recognised the 'circuitous' nature of the developmental path he described for women, and the correspondingly greater likelihood of its 'failure' (1977/1929, p. 376). For Silverman, however, this is not an earlier repression, pre-dating the turn to the father and the repression of active desire, but one consequent, like the boy's, on the entry into language and culture: on the need to create a separate 'I', or subjectivity. It is thus a desire which is both simultaneous with and fundamentally at odds with the 'normative and normalizing' desire for/of the father (1988, p. 123), and hence subject to a double repression.

In the visual structures of mainstream cinema, psychoanalytic film theory tells us, male subjectivity is reaffirmed through processes of identification, while the female other becomes the eroticised object of desire whose sexual difference generates both pleasure and anxiety.[3] It is male desire – for meaning and an 'imaginary plenitude' – which is thus spoken by the film. For the *female* subject, however, argues Silverman, identification and desire are not opposed but 'strung along a single thread' (1988, p. 150), and thus both interchangeable and reciprocal. This is a desire which might, perhaps, be characterised as the desire for the other woman *who is also myself* – myself as speaking subject. In it we can see Potter's Mimi, who searches for both an identity and a speaking position, and Mellencamp's desire to 'be the hero', which is a matter of 'enunciation' as well as action. The desire which might be spoken in such a narrative, then, will not be structured according to processes of objectification – through the separation of viewing/speaking subject and objectified/spoken object – but through more fluid and reciprocal structures of looking. It is a desire, however, which is doubly difficult to articulate, since it is at odds with not only normative structures

of desire but also the linguistic and narrative structures through which these find expression. It is in consequence, argues Silverman, often accompanied by the condition which Feud called 'melancholia'. Melancholia, the condition of uncompleted grief, is attributed by Freud to an unconscious and hence unnameable loss, and is characterised, in his view, by an internalised identification with the lost object and a simultaneous self-castigation for a sense of loss which is apparently motiveless (Freud, 2005/1917). For Silverman, this is the condition, and the loss, which grounds female subjectivity.

Silverman's account has been echoed more recently in the work of Judith Butler. Butler's argument, in *The Psychic Life of Power*, is that the foreclosure of same-sex attachment – what she calls 'the heterosexualization of desire' – produces the barred object as 'a melancholic identification' and an unavowable loss (1997, pp. 135–6). Melancholia thus becomes a form of containment, in which the foreclosed attachment cannot find discursive expression. In *Antigone's Claim* (2000), she goes further in identifying this foreclosed expression and consequent melancholia with a debarred *feminist* discourse. In the story by Sophocles, Antigone, the daughter of Oedipus (and also his sister), publicly defies the Theban king Creon by insisting on burying her dead brother Polyneices and is thereby imprisoned in a living tomb, where she kills herself. For Butler this figure, who is outside the conventional bounds of kinship and who insists on speaking within a public discourse which operates to exclude her, becomes the melancholic female subject, 'the one with no place who nevertheless seeks to claim one within speech, the unintelligible as it emerges within the intelligible, a position within kinship that is no position' (2000, p. 78). She therefore represents a kind of feminism, one which 'is not unimplicated in the very power that it opposes' (ibid., p. 2), since she seeks to appropriate its discourse, but one which also speaks of that which that discourse represses, and thereby exposes its limits and repressions.

For Butler, gender operates as a regulatory power, enforcing silencings and exclusions through our own repeated performances of its norms. Interestingly, in *The Psychic Life of Power* she frames her discussion of gender performance in terms of narrative. As subjects brought into being through the regulatory norms of language and culture which assign us our gender, we are, she writes, in some sense narrated. Even as we attempt to be the hero of our own story, the terms of that story, and our own genesis, are outside our capacity to narrate (1997, p. 11). Nevertheless for Butler, as we have seen, the 'melancholic' – that which is foreclosed but remains as an unavowed identificatory desire – can produce a critical and perhaps transformative relation to those norms. I cannot, she writes, 'remake the world' if I am to remain intelligible. If I have agency at all, 'it is opened up by the fact that I am constituted by a social world I never chose'. That 'my agency is riven by paradox' does not, however, make it impossible: 'It only means that paradox is the condition of its possibility' (2004, p. 3).

This idea, of a melancholic subject and an unavowable loss which is figured both in the narrative itself and in the desire which it traces, is one which is also expressed elsewhere by feminist critics, in discussions of female writing and film-making. It appears, for example, in the work of Nancy Miller, who writes of a female narrative which 'itself stages the difficulty of reading women's writing' through its staging of the 'desire for another logic of plot which by definition cannot be narrated'. This logic finds expression in the landscapes it creates, which pull against the temporal structures of the plot, creating the 'different temporality' which Meaghan Morris described (Miller, 1988, pp. 84, 87). For Miller, the loss which is inscribed in these stories is that of the female subject *as writer*. Of the poet Adrienne Rich, who writes of a similar sense of absence and loss, Miller says: 'To find "somebody to love," as the song goes, Rich ... would have to find someone *like her* in her desire for a place in the discourse of art and identity from which to imagine and image a writing self' (ibid., p. 109), and such a figure is impossible within the norms of femininity.

For Miller, then, Rich's illegitimate desire, a desire which is replicated in the work of other women writers, is both for the other woman who is also herself and for the position of writing subject which, for that self/other, is foreclosed. It is an analysis which is echoed in Laleen Jayamanne's discussion of Jane Campion's 1993 film, *The Piano*. Jayamanne writes of 'an unspeakable loss' of which Ada's abandonment of voice is 'an index, not a symptom' (2001, p. 31). Like Antigone, Campion's Ada has refused the norms of femininity, substituting what Butler, in her description of the melancholic subject, calls an internalised psychic state for the social world in which she lives (Butler, 1997, p. 179). This internalised world – the world of the maternal imaginary – is one she shares with her daughter Flora, her mimetic double, who translates her gestural signs into intelligible speech. Ada's playing of the piano, writes Jayamanne, is both 'a work of mourning for an unspeakable loss' (2001, p. 32) and an eroti-cisation of that loss, speaking in a musical register which is self-constitutive, unintelligible within a social world within which the piano is a traditional instru-ment of feminine accomplishment. Ada, however, seeks towards the end of the film to enter the public world of writing to express her desire. The sentence she inscribes on the piano key which she sends to Baines, 'Dear George, You have my heart, Ada McGrath', constitutes, writes Jayamanne, a decision 'to enter lin-guistic concatenation, with its clear separation between an "I" and a "you"' (ibid., p. 34). But we can also note the paradoxical – or impossible – nature of Ada's act. The sentence she writes seems to speak the passivity of conventional femininity, within the genre of romance. Yet her act is decisive, and constitutes a formal, public declaration – Baines is illiterate so would need it to be read to him – of an illegitimate desire and a refusal to be contained (she remains 'Ada McGrath' despite her marriage). Finally, Ada's choice of the severed piano key as tablet for her written text does not effect an erasure of the internalised and

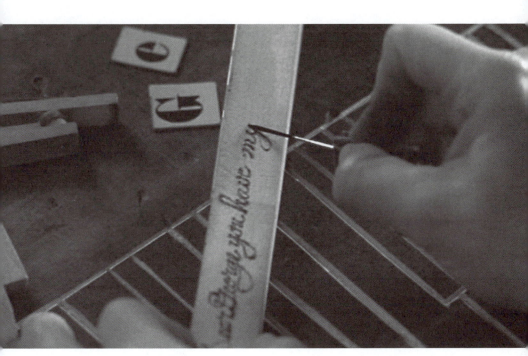

Ada's 'overwriting' in *The Piano* (1993)

self-constituting erotic language of the piano. Rather, it produces what Miller calls an 'overwriting', in which, as with the palimpsest,[4] the original remains a disturbing presence through the new text written upon it.

This idea of 'overwriting' is one we can also apply to other aspects of a film like *The Piano*. In a formulation which echoes de Lauretis's account of the gendered functions of narrative, Dorothea Olkowski writes that 'with respect to sexual difference, the masculine is *experienced* as time, the feminine is *experienced* as space' (1999, p. 77, original emphasis). To this Judith Butler adds, quoting Walter Benjamin, that 'melancholia spatializes', producing '"landscapes" as its signature effect' (1997, p. 174). Perhaps, then, we might argue, with Nancy Miller, that in women's narratives like these, 'the mapping and iconography of privileged places ... may be read as a desire for a revision of story, in particular of closure; a desire ... that falls outside the masculinist conventions of plausible narrative' (1988, pp. 253–4). The 'underwater' space of *The Piano*,[5] with what Campion called its 'vivid, subconscious imagery ... its dark inner world' (1993, p. 139), constitutes such a place. Just as the film's protagonist, Ada, presents us with a doubled, or impossible, writing, so Campion provides us with two closures to the film. The bright, conventional ending, in which Ada learns to speak and becomes a piano teacher in exchange for what Jayamanne calls an acceptance of 'intersubjective [heterosexual] erotics' (2001, p. 35), overwrites, but

does not erase, the alternative, impossible ending, in which Ada speaks, in voice-over, her own silence, over the image of her piano in its 'ocean grave', with herself floating above it.

NARRATING THE STORY

It is clear from the above discussion that if I am to be the hero of the story, I must also narrate it – it must, that is, be *my* story. The question of authorship in cinema, and female authorship in particular, is one which, from Claire Johnston's *Notes on Women's Cinema* (1973) onwards, has posed a particular problem for feminist theorists. Before turning to these debates, however, I want to return to an issue I raised earlier: that of the relation between a film's *narrative* and its mode of *narration*. The terminology comes from narrative theory, a branch of literary theory, and its application to the study of film has proved both useful and at times frustrating.

Adapting the work of literary critic Gérard Genette, Tom Gunning (2004) distinguishes three aspects of narrative. The *story* is the sequence of events which constitutes the narrative content, irrespective of the medium in which it is told; the *narrative discourse* is the specific discourse through which the story is told – the text itself; and the *narration*, or *act of narrating*, is the way in which the storyteller addresses a real or implied audience. Taken together, they constitute the process of 'narrativisation', the process through which, as Steven Cohan and Linda M. Shires write, 'all narratives organize a story so as to structure possibilities of cultural meaning' (1988, p. 82). The most obvious way in which this operates is through the manipulation of time: the narrative discourse may reorder the events of the story; tell them in flashback (or flash forward); compress or elongate them; subject certain events to ellipsis or recount them more than once; provide, or not provide, beginnings or endings. Most important, it will operate through a combination of *telling* (or *histoire*) and *showing* (or *discourse*). In the former, the processes of narration are effaced, so that the narrative seems to unfold as unmediated, or authorless; in the latter, time is slowed down and we are addressed more explicitly, through dialogue, or description, or point of view. Difficulties occur, however, in the transfer of these terms from literary criticism to the analysis of film. According to Seymour Chapman, description, which in the novel works against the forward movement of narrative, slowing it down, shifting our perspective and addressing us directly, is always subordinated to *histoire* in film. Establishing shots and descriptive details advance plot or characterisation and, most important, the camera, because of its photographic nature, always appears to be a neutral mode of narration (1981, p. 126). Thus *showing*, which in the novel would draw attention to itself as discourse – as *addressing* us as readers – in film appears to be neutral, a mark of film's realism. We might note here that it was precisely this quality of film to which Laura

Mulvey (1989a) drew attention in her argument that film elides the three gazes of film – those of the camera, of the spectator and of the male character whose point of view we share – and thus presents as neutral or natural what is in fact a highly constructed mode of discourse.

For Mulvey, the solution to this apparent seamlessness, and its inscription of masculine desire as natural, was the analysis and thus destruction of cinematic pleasure. Yet Gunning insists that 'the marks of enunciation in filmic discourse ... can only be camouflaged and not eradicated', so that 'we can establish a range of filmic narrators', stretching from the more to the less 'invisible' (2004, p. 478). If we return, then, to Campion's *The Piano*, we find landscape operating in precisely the way that Miller argues that it does in women's writing: disturbing narrative and itself made strange through colour, lighting and camera angle, with the camera now blending landscape and music in a shot that exceeds characterisation or plot, and now operating, in the words of the film's director of photography, as an intimate 'witness, ... go[ing] places where the camera can't really go' (Campion, 1993, p. 141). As spectators, then, we are very conscious of the film as *discourse*, addressing us in a very specific way.

In *Telling Stories*, Cohan and Shires offer a further analysis of the processes through which *narration* constructs its subject. In addition to the story's agent of telling or *narrating subject*, which may speak in the first person, as in an autobiographical narrative, or may present itself as neutral, as in the third-person novel or conventional feature film, we can also distinguish, they write, a *subject of narration* (1988, p. 108). The subject of narration, the character the story is *about*, is produced in the act of telling, but may be more or less aligned with the narrating subject. Thus, in the novel an 'I' may tell the story, as for example in Charlotte Brontë's *Jane Eyre*, but that 'I' may be very different from the 'I' who is narrated *in* the story. In Brontë's novel they are separated by time, and the mature woman who tells the story is not the child and young woman she describes. When we pay close attention to the mode of narration, however, we find that at times these two figures move together, so that the voice of the narrator merges with the consciousness of the child, and elsewhere move apart, as the narrator passes judgment on her younger self (ibid., pp. 109–10). Even in novels narrated in the third person, we can find sections focalised through the subject of narration, so that our point of identification shifts. The subject constructed through the narration, then, may be more or less unified or contradictory.

In film, of course, the narrating subject can never quite be an 'I'. Techniques like voice-over narration can appear to identify a character with the narrating subject, but the story told by the camera will always unfold from elsewhere. Thus we might want to argue that subjectivity in film narration is more subject to fragmentation than in the novel. Yet, as de Lauretis and others have pointed out, conventional film narrative functions to produce the sense of a

unified subjectivity – what she calls 'the mythical subject' – so that these marks of fragmentation are effaced. Insofar as film binds us as viewers into its processes of narration, too, it has been argued that it also constructs *our* subjectivity. Identifying with its protagonists, and caught up in its processes and scenarios of desire, we are no longer aware of the film as discourse – as speaking *to* us. Instead, as we identify with and through the narrational processes of the camera, it seems to be speaking *as* us.

Such analyses bring us closer to understanding just how de Lauretis's argument that the Oedipal story is 'paradigmatic of all narratives' (1984, p. 112) works within film. Rather than exposing subjectivity to fragmentation, the film text, as Lapsley and Westlake argue, *performs* the subject through its narrative processes (1988: 138). Thus narrative operates like gender in Judith Butler's formulation: it both produces and regulates the performance of subjectivity, containing it within the boundaries of the 'normal'. Going further, we can argue that film narrative is an *instance* of the processes of gender construction Butler describes. Like gender itself, it is 'a practice of improvisation within a scene of constraint' (Butler, 2004, p. 1), (re)producing gendered subjects through our identification with its processes. But the relatively smooth process outlined by Lapsley and Westlake, it can be argued, describes the production of the male subject. To understand its difficulties in relation to the female subject, we must return to the structure of the narrative as well as its narration. Cohan and Shires point out that the subject of a story's narration is not necessarily the subject of its actions or events (1988, p. 71). In female-centred narratives the two are in fact more often divorced, as in the romance where, although the focus of the narration is on *her*, it is *he* who is the subject of its actions, the one who rejects, rescues and, finally, proposes. In the narratives of persecution or suffering described by Doane in her account of the 'woman's film', indeed, the figure of identification offered by these films is debarred from action to such an extent that it becomes difficult for the film to sustain a sense of her subjectivity (1984, p. 74). In the female-centred novel, as Cohan and Shires discuss, this disjuncture can produce a subjectivity which is discursively produced across 'multiple and incompatible ideologies' (1988, p. 144): a figure of anger and revolt as well as domesticity and renunciation, held together by a precarious and shifting 'I'.[6] In the 'woman's film', argues Doane, a similar, though lesser sense of dislocation can be produced by forms of textual mimicry and doubling, in which we are conscious of femininity as performance, and by a divergence between voice and image, in which the disembodied nature of the voice draws attention to both the split nature of subjectivity and the constructed nature of the female image.

The Hollywood 'woman's film', however, is not cinema *by* women. Thus, while it would be a mistake to see a female-authored novel like *Jane Eyre* as a form of self-expression which stands outside dominant codes of femininity – indeed the analysis by Cohan and Shires demonstrates just how powerfully those

codes operate in the novel – it will nevertheless occupy a different and more contestatory position in relation to them than the 'woman's film', which is above all concerned to reinforce those codes. The forms of dislocation which Doane suggests are possible, if subordinate, within the 'woman's film', however, are techniques which Kaja Silverman proposes as important tools for the feminist film-maker. One of the means by which classic cinema imbues its male characters with 'enunciative authority', she writes, is through the disembodied voice-over, which serves to identify narrated with narrating subject and thus enable the male subject to transcend his positioning *within* the narrative. The female figure, on the other hand, is not only positioned in spaces within the narrative which come under the control and surveillance of the male figure (what Silverman calls 'safe' places); she is also either silenced or speaks with a voice always 'matched up' to her body. As silent woman she becomes 'enigma'; as speaker, she is 'held to' the limitations of her body as image. When, occasionally, she does speak in voice-over, her voice is autobiographical, functioning to evoke reminiscences which once more place her body centre screen. For Silverman, then, feminist film-making not only disrupts the 'safety' of 'female' places; it also frequently disembodies the female voice. Such a technique, she writes, 'disrupt[s] the specular regime upon which dominant cinema relies' and 'liberate[s] the female subject from the interrogation about her place, her time and her desires which constantly resecures her' (1988, p. 164).

AUTHORING THE FILM

With the idea of the feminist film-maker we have moved away from questions of narrative and into the very difficult terrain of film *authorship*. 'What films do we make and for whom?' asks Christine Gledhill in 1978,[7] in an essay which expresses exasperation with the failure of feminist film theory to find an answer. In Claire Johnston's pioneering work of the 1970s we find persistent attempts to answer this question – to establish, that is, the terms for a feminist film practice. In this work Johnston suggests many of the elements of such a practice which would be explored by later writers. Most famously, she argues at the end of 'Women's Cinema as Counter-Cinema' (1973) that, in order to 'counter our objectification in the cinema, our collective fantasies must be released: women's cinema must embody the working through of desire: such an objective demands the use of the entertainment film' (1973, p. 31). Mainstream film, she writes, masks its patriarchal origins by its mode of narration; as we have seen, it appears to unfold as 'a story from nowhere, told by nobody' (1976, p. 50),[8] thus concealing its status as discourse. Its 'fabric' must therefore be disrupted if new meanings are to be created. We cannot, therefore, think of women's cinema as simply a form of 'self-expression' – the spontaneous expression of a creativity hitherto repressed. Work that represents itself in this way simply masks its own

complicity with dominant structures. Instead, like *Jane Eyre*, or Antigone's speech in Butler's account, it will constitute the appropriation of a dominant discourse in an attempt to speak of that which that discourse represses. It must therefore use dominant cinema's codes and conventions – 'voyeuristic pleasure', for example, cannot be eliminated from the cinema' (ibid.) – even while disrupting them. The female subject who is 'spoken' in such cinema, too, is, in Judith Butler's words, 'not unimplicated in the very power that [she] opposes' (2000, p. 2) since she too is positioned within and by the 'symbolic order'. To seek to speak from outside that order is to be unintelligible; it is also to find oneself placed once more within the familiar nature/culture binary, in which the feminine is positioned as nature, not culture.

Johnston's work suggests a number of techniques through which this disruption might work. One, the dislocation of space and time – of 'the ordering of physical space' and 'the ordering of temporal space' (1976, p. 58) – has been discussed already. A second, to which I shall return, is the reappropriation of key icons, or figures of 'myth' (Barthes, 1973), through which the dominant ideology effects its own naturalisation. The figure of woman in dominant cinema, argues Johnston, is extracted from her historical context to become a signifier not of *women*, in their diversity and historical specificity, but of 'Woman': a figure of male fantasy or myth. Yet the very cinematic figures through which this works, argues Johnston, can be reappropriated: made to function within a different narrative, and reconnected to history and memory.

Reading this early work of Johnston, however, is often frustrating. On the one hand we find suggestions such as these as to how 'women's cinema as counter-cinema' might *work*. On the other, Johnston's explanation of how cinema itself functions seems to leave no room for such a 'counter-cinema' to emerge. The result is a sense of unresolved struggle in Johnston's essays.[9] Thus, for example, we find that 'Towards a Feminist Film Practice: Some Theses' (1976), despite its title, devotes eight of its nine pages to an account of the workings of dominant cinema and its construction of the cinematic spectator-subject. The essay's conclusion, that hope for an alternative mode of cinema lies in 'the possibility of a different Symbolic Order', one which is 'beyond the frame, the diegesis and our field of vision – but nevertheless present' (1976, p. 59), suggests a task of such magnitude that change seems only a fragile possibility.

One of the problems in Johnston's account lies in her concept of cinematic authorship. In his introduction to the edited collection *Theories of Authorship* (1981), John Caughie outlines the history of the concept within film studies. Beginning with the 1950s, Caughie traces the way in which the cinematic auteur came to mean the film's director, so that 'in the presence of a director who is genuinely an artist (an *auteur*) a film is more than likely to be the expression of his individual personality; and that this personality can be traced in a thematic and/or stylistic consistency over all (or almost all) the director's films' (1981,

p. 9, original emphasis). Such an approach – still evident though seldom explicit in today's film criticism – was, argues Caughie, 'simply the installation in the cinema of the figure who had dominated the other arts for over a century: the romantic artist, individual and self-expressive' (ibid, p. 10). This is the figure which Johnston so firmly rejects as 'idealist', even when it is gendered female. But if this approach was always problematic in the face of such a collaborative and industrialised cultural form as film, it was rendered more so by the intervention of semiotics and psychoanalysis into film theory. Such interventions, argues Caughie, shattered 'the unity of the author, scattering fragments over the whole terrain, calling into question the possibility of a theory of the author which is not also a theory of ideologies, of discourses, of commodities and, crucially, of the subject' (ibid., p. 200). In the famous pronouncement of Roland Barthes, the Author, as originating consciousness, was dead (Barthes, 1977), to be replaced by the workings of the text and its relation to ideology and to the subject.

What followed was a series of attempts to define what the task of the film theorist and critic had now become. For the editors of the journal *Cahiers du cinéma*, a film is a 'site of intersection' of structures, codes and languages, some specific to cinema and some belonging to the wider culture (1976, p. 496). It is the task of the critic, therefore, to read for gaps and contradictions rather than continuities and consistencies, so that the workings of ideology might be uncovered. Similarly, Stephen Heath, writing in 1973, argued that the author can no longer be regarded as a *source* of discourse, but should instead be seen as a fiction produced as an *effect* of that discourse (1981/1973, p. 220). The *text* must become our object of study, and from it we will produce a theory not of authorship but of subjectivity. For Heath, then, author and reader seem to merge into a single subjectivity: that inscribed within the text. Just occasionally he suggests that a group of films by a single director might betray a 'tracing ... of the insistence of the unconscious' (ibid., p. 219), although even here it is unclear to whom this unconscious belongs.

In the film theory of this period the film author disappears as originating consciousness, but makes partial reappearances as an unconscious structuring force. This is most apparent in Peter Wollen's attempt to incorporate a radically revised 'auteur theory' into a 'cine-structuralist' approach in the 1972 conclusion to his influential *Signs and Meaning in the Cinema*. For Wollen, the unconscious identified by Heath belongs both to the film and to its auteur. A film, he argues, 'is a network of different statements, crossing and contradicting each other, elaborated into a final "coherent" version'. It thus operates like the Freudian dream structure, presenting a series of more or less plausible representations behind which the analyst can discern 'a certain pattern of energy cathexis', or desire. It is this unconscious desire which organises the film's structuring of the multiple codes from which it is constructed, and it is in these unconscious patternings of desire that we can identify the auteur (1972: 167–8).

In all of these formulations, writes Caughie in his 1981 introduction, the author, 'rather than standing behind the text as a source, becomes a term in the process of reading or spectating' (1981, p. 200). Caughie's own account of the functioning of the author in the text returns us to questions of *narrative discourse*, discussed above. If film, as we saw, masks its operation as discourse under the illusion of its status as *histoire*, it is in the moments when, as spectators, we become aware of it as *authored* that we also become aware of it as discourse rather than *histoire*. When the film succeeds in effacing its point of address, argues Caughie, the spectator will be drawn into 'identifying with the fiction ... I seem to possess the film: it shows me what I want to see, it is my fantasy' (ibid., p. 204). When, however, we become 'aware of ourselves as spectators at a performance' – when, that is, the film draws attention to its own stylistic patternings as part of a directorial 'signature' – then a distance is opened up between me and the position the film has constructed for me. While such mobility of subject positioning may be part of the pleasures of the film, for example in our recognition of the film as a 'Scorsese film' or a 'Danny Boyle film', it can also open up a critical distance, allowing me to interrogate its enunciative position, and its positioning of me.

For Caughie, then, 'the author is a figure constructed out of his films' (1981, p. 205), one code among the many which structure the film. This, of course, disconnects the film text from the author as *social* subject, and in particular from the author as *gendered* subject. Caughie himself concludes his essay by affirming that the author 'as a sexual, social, historical subject, does indeed have a place within theory' and notes that feminist critics have questioned the author's removal from 'sexuality' and the 'sexual look' (ibid., p. 206). It is an uneasy conclusion, difficult to reconcile with the discussion which precedes it, and Caughie does not develop the argument. For Claire Johnston, however, for whom film theory *must* provide the basis for a feminist film-making practice (1973, p. 3), the problem it poses is urgent. If, as Peter Wollen suggests and Johnston accepts, the film director is an 'effect of the text', at best an 'unconscious catalyst', then the inevitable conclusion to be drawn is that the 'foundation of a revolutionary feminist cinema' must be laid via a rigorous *textual* analysis. It is a conclusion, however, that leaves Johnston uncomfortable. It is, first of all, very difficult to see how this could work. Second, such an exclusively textual approach is in 'real danger', she acknowledges, of ignoring both the specific power structures – social, economic and ideological – within which the film is produced *and* the political 'signature' to which the film itself lays claim (1975, pp. 122–4).

The difficulties in Johnston's approach can be seen in her analysis of the films of Dorothy Arzner. As one of the very few female directors to produce a substantial body of work in the Hollywood of the 1920s, 30s and 40s, Arzner becomes a test case for the kinds of textual dislocations which might be produced when the 'discourse of the woman' within the film text pulls against the

WHAT IF I HAD BEEN THE HERO?

ideological direction of its narrative. In Arzner's films, suggests Johnston, the dominant discourse of Hollywood cinema – 'that is, the discourse of the male' – is broken up, subverted and 'rewritten' from within. It is the 'discourse of the woman', she writes, 'or rather her attempt to locate it and make it heard, [which] gives the system of the text its structural coherence, while at the same time rendering the dominant discourse of the male fragmented and incoherent' (1988, p. 39). In Arzner's films, the discourse of the woman 'fails to triumph *over* the male discourse and the patriarchal ideology', but the male discourse is displaced from its position as the *framing* discourse within the film and rendered strange, open to scrutiny. The 'woman's discourse', and the desire it expresses, thus functions to dislocate and subvert; in its refusal to be 'expelled or erased' it also constitutes 'a triumph over non-existence' (ibid., p. 44, original emphasis).

Yet Johnston's argument that Arzner's work should be considered not in terms of 'revolutionary strategies' but rather of discursive disjunctures (ibid., p. 39) serves to gender Arzner as a director only to remove her agency. The *film* articulates a 'woman's discourse', but if this is not, as Johnston insists, to be identified with any specific character within it, neither does it quite seem to be identifiable with the director. Rather, it belongs to the 'subject' of the text. Perhaps in response to the difficulties this produces for a feminist analysis, Johnston's concluding comments display a shift of position. Arzner's films, she suggests, pose the question she herself raises in 'Towards a Feminist Film Practice' (1976) and repeats here: is it possible to found 'a new form of language' and to displace the centrality of the Oedipus myth? But they also supply an answer of sorts. Arzner's 'strategies' – now regarded as conscious – do not 'sweep away' existing forms of discourse, but they do constitute a process of 'rewriting': a reversal from within of the terms on which the dominant narrative text is constructed.

The essays by Claire Johnston which I have cited here were written in the 1970s and show the difficulties posed by contemporary theoretical developments for the feminist theorist who wished to articulate the grounds for a women's cinema. If the author was dead, how could a specifically feminist film practice be authored? If the 'discursive disjunctures' in Arzner's films are not a product of her specific positioning as a female director in Hollywood, then why should it matter whether there are female directors? The issue is wittily presented by Nancy Miller, in her discussion of literary authorship. Miller cites the conclusion to Michel Foucault's 'What Is an Author?' in which Foucault imagines a society 'without need for an author'. In such a society, in which the subject will be seen not as originator but as 'a variable and complex function of discourse', the identity of the author will become, writes Foucault, a matter of 'indifference: What difference does it make who is speaking?' (1984, pp. 118–20). Yet it does matter, argues Miller. 'Only those who have it can play with not having it', and Foucault, whose discourse certainly *has* the 'authorizing function', 'authorizes

"the end of woman" without consulting her' (Miller, 1988, p. 75). 'I like to know', writes Miller, 'that the Brontëan writing of female anger, desire, and, and selfhood issued from a female pen' (ibid., p. 72), because it matters whose desire is being figured in this text. When access to the signature, the 'authorising function', has been so lately granted to women it is important politically that it is not simply given up. But that signature is also important because it makes women, and their marginality, visible, and regenders male writing, so that it can no longer claim universality. After all, the subject who is dispersed through the 'unauthored' text is as universalised a subject as the author who is seen to transcend it. A female director, then, will be no less positioned within ideological and discursive structures and codes, but she will be positioned differently, and her films will derive from the difference of that relation.

FILM, FEMINISM AND THE AVANT-GARDE[10]

One answer to the difficulties in Johnston's attempt to include Arzner's films within the idea of a feminist counter-cinema was to turn to a different kind of film-making altogether for the feminist 'author'. In response to Gledhill's criticism that her work was too enmeshed in a self-enclosed theoretical framework to be able to envisage the feminist cinema she desired, Johnston herself sought to move outside that framework. We must, she argued 'move away from work on subjectivity which concentrates exclusively on the notion of subject production and the text ... and towards the more complex question of subjectivity seen in historical and social terms' (1980, p. 30). The feminist film-maker 'speaks' always from a specific historical and social position, and it is her assertion of a 'woman's discourse' about this position that challenges dominant conceptions of a fantasised 'Woman'. What matters, then, is not the nature of a film's textual structures – whether it is narrative fiction or art cinema – but the intervention it makes into the discursive and ideological field (the 'historical conjuncture') which it encounters. It is this which will constitute its radical status.

Such a shift reopens consideration of feminist 'art cinema' as oppositional practice, and with this comes what Kaja Silverman calls 'the re-emergence of the author' – or at least a specific *kind* of author – within feminist film theory (1988, p. 208). Pam Cook, for example, argued that a women's cinema could be best produced in a small-scale 'artisanal' mode of film production that would lie outside 'the dominant system' (1981/1977, pp. 272–3). Cook cites Maya Deren's films of the 1940s as examples of films which 'work against the linear flow of narrative and allow for an exploration of meaning in depth, rather than concentrating on the resolution of the narrative enigma' (ibid., p. 275). Such films were, she argued, both experimental – creating a dream-like effect – and profoundly personal, reinforcing that emphasis on the personal, the intimate and the domestic which is characteristic of both women's traditional creative work

and the Women's Movement, with its insistence on the *political* importance of the 'private sphere'. Against Johnston's earlier charge that such 'self-expression' played into an idealist concept of art, Cook argues, first, that it is a continuation of the kind of domestic craft-work (embroidery, diary or letter writing) that has historically constituted a 'submerged' women's discourse. Second, in a move that returns us to the importance – and difficulties – of semiotic and psycho-analytic theory, she argues that such personal expression can produce at best a 'fragmented' voice and 'partial autonomy' for the film-maker, allowing space for her 'unconscious and conscious concerns, without suppressing the personal, but without the privilege of the artist' (ibid., p. 279). At its best, such film-making constitutes a 'reworking' of filmic, non-filmic and theoretical material to produce what Sandy Flitterman[11] calls an avant-garde 'deconstruction cinema' (Flitterman, 1981, p. 244). Such film-making is exemplified in the films of Laura Mulvey, in particular *Riddles of the Sphinx* (1976).

Mulvey herself provides the most strongly argued case in support of the avant-garde 'deconstructive' film as the model for a feminist film practice. Answering Johnston's question about the possibilities for an entirely new language of film-making, Mulvey argues that any new forms can only grow out of a negation and deconstruction of existing forms. What is needed is therefore a 'feminist formalism', in which 'the means of meaning-making itself' will be subverted and made visible, and feminist content matched by an experimental form (1979, pp. 178–90). Writing in 1983, E. Ann Kaplan calls such films 'theory films', and attributes to them four characteristics. They focus on cinema as a 'signifying practice', drawing attention to its processes of construction; they use 'distanciation' techniques to prevent the spectator being drawn into the narrative discourse; they refuse the pleasures of identification with 'Oedipal' narratives, whether masculine or feminine, and seek to replace these with cognitive pleasures; and they mix documentary and fiction modes in order to unsettle the viewer (1983, p. 138). What results, argues Mulvey, is a focus on woman not as 'a visual image, but as a subject of inquiry', within a form which makes constant intellectual demands on the spectator (1979, p. 194).

If such work permits the (re-)emergence of the feminist film-maker as author, it also produces a number of problems. One, as Judith Mayne points out, is the fine line which these discussions tread between 'critique and celebration' (1985, p. 98). A concern to celebrate an 'authored' women's cinema sits uneasily alongside a theoretical framework which renders such authorship – and any notion of film-making as 'creative self-expression' – extremely problematic. But, argues Mayne, a similar ambivalence permeates the 'authored' films themselves. Mayne cites the conclusion of Potter's *Thriller* in which, following the film's deconstruction of both Puccini's opera and the theoretical structures on which its narrative relies, Mimi and her opposite, the 'bad girl' Musetta, embrace, while the men exit through the window. 'Perhaps we could

have loved each other,' says Mimi of Musetta. The film, writes Mayne, is thus ambivalently positioned between radical feminist affirmation – the position it would *like* to take – and an exploration of the difficulties – even impossibilities – in such an affirmation. Thus, while *Thriller* affirms the desire to *be* the hero/subject, as a deconstructive anti-narrative it cannot represent that desiring subject in action: the film ends with the suggestion of its possibility. Perhaps, then, the 're-emergence of the author' via the deconstructive 'theory' film is at the expense of the disappearance of both narrative and hero: both can be *undone*[12] within such a film, and, as possibility, both can be desired, but neither can be *enacted*.

Teresa de Lauretis's work on 'women's cinema' also takes non-mainstream or experimental films as its object, but seeks to shift the terms of its discussion beyond those of 'deconstructive cinema'. What distinguishes women's cinema, she argues, is not the problems it addresses or the authorial voice it presents but that it *'addresses the spectator as female'* (1987, p. 135, emphasis added). The address she envisages is fluid: it will invite processes of identification, but also a more flexible mode of engagement which she terms 'recognition'; it will inscribe *'subjective* space and duration within the frame' but will also construct women's 'discursive *social* spaces' (ibid., p. 145, emphases added); it will use but also disrupt narrative. De Lauretis is drawing here once more on the concept of film's dual modes of *histoire* and *discourse*. If a film is always a mode of discourse, however concealed, then its discursive address operates, she suggests, as a form of rhetoric. If narrative is a film's grammar, then rhetoric – its discursive address – constitutes its figurative patterns or tropes. The coherence of a 'women's cinema', therefore, will be found not in its narrative 'grammar' but in its discursive address – its figurative patterns. The woman film-maker, as a subject of discourse who tells her stories as a woman, will be inside and outside narrative, as she is inside and outside the ideologies of gender which narrative performs. Her 'remade' narratives will be 'founded on contradiction' (ibid., p. 114). They will find their coherence, however, in their address to a spectator gendered female – to what de Lauretis calls 'me, spectator, *as(-)woman*' (ibid., p. 124, original emphasis). The precise mode of such an address will vary: after all, as a female subject, and one who is constructed across race and class as well as sexual difference, I am myself a figure of contradiction. Nevertheless its 'narrative strategies, points of identification, and places of the look', however diverse, will all 'address, engage and construct the spectator as gendered subject' (ibid., p. 123).

FANTASY AND NARRATIVE

De Lauretis's account is suggestive but elusive. If a film's designation as 'women's cinema' is dependent on *my* recognition of its specific address, what

happens if I don't recognise that address? Or if I do but *you* don't? And what precisely happens to narrative, desire and fantasy in these films? How do they intersect within a narrative that is put into contradiction through its mode of address? Finally, (how) can the feminist film-maker 'remake' narrative so that it 'rewrite[s] our culture's master narratives' (de Lauretis, 1987, p. 113) and yet remains narrative? In the final section of this chapter I shall return to the issues of fantasy, desire and narrative and suggest some possible answers to these questions.

For de Lauretis, as we saw, a story 'is always a question of desire' (1984, p. 112). It is through narrative that fantasy, the individual expression of desire, is worked through in both the private stories of dream and daydream and the public narratives of literature and film. For Claire Johnston in 1973 a 'women's cinema' would therefore speak to women's fantasies and embody the 'working through' of female desire; it must, therefore, take the form of 'entertainment' or narrative cinema (1973, p. 31). Both writers draw on psychoanalytic theory, for which the origins of desire and of fantasy are indistinguishable, and fantasy is always narrativised (Laplanche and Pontalis, 1986). Fantasy, argues de Lauretis, grounds both subjectivity and public narratives through the ways in which it is structured within culturally dominant representations. As individuals, we construct our identities in relation to those representations. What is difficult, therefore, is to envisage how the story might be told differently. While de Lauretis's work on women's experimental cinema, as we have seen, suggests one possible answer to this question, I want to use her more theoretical work, and that of other theorists of narrative, to suggest alternatives.

Identity, argues de Lauretis in 1994, is a process of appropriation, interpretation and retelling. We appropriate public narratives and rework them through fantasy, returning them to the public world 'resignified, rearticulated discursively and/or performatively' (1994, p. 308). The suggestion here is that identity itself has a narrative structure, an idea which draws on Paul Ricoeur's concept of 'narrative identity'. For Ricoeur (1991), identity is best understood as neither a fixed essence nor a juxtaposition of fragmented, fractured and discordant elements, but as dynamic unity through time. It comes into being as a story which demands expression – which we *must* constantly tell and retell if we are to construct a concept of self through which to act in the world. And just as our narrative interpretations serve to make sense of our past actions, so they also provide the basis for future acts which will in turn be narrativised. *Public* narratives on the other hand, argue Somers and Gibson (1994) in their account of narrative and social identity, are constructed by and in social power structures. They constitute the culturally available repertoire of narratives within which we are invited to locate ourselves and through which we structure our own stories of identity. Beneath these public stories we can in turn identify *meta*-narratives, the master narratives of culture which, argue Somers and Gibson, provide the

underlying structure for, and authoritative reinforcement of, the public narratives which organise our cultural experience.

The meta-narrative of Oedipus, then, which is also the meta-narrative of progress, reason and the Enlightenment, underpins the public narratives told and retold through film. It is thus secured through a process of cultural sedimentation, but also through our own repeated investment in it as a fantasy which grounds our sense of identity. Yet fantasy and the desire that grounds it, as we saw through the work of Judith Butler, always exceed the narrative structures available for their expression. Fantasy, argues Butler, 'is what allows us to imagine ourselves and others otherwise; it establishes the possible in excess of the real; it points elsewhere, and when it is embodied, it brings the elsewhere home' (2004, p. 29). If the material on which we draw for our identificatory fantasies comprises normative fictions, it can be reworked by desire in relation to (embodied, gendered) experience, and provide the grounds for new discursive configurations.

Claire Johnston in 1973 offered another suggestion for the founding of a women's cinema which I should like to develop here. Myth – or ideology – she argues, operates through 'icons', figures whose historical specificity has been 'drained', to be replaced by another, ideological and 'naturalised' meaning. In cinema, the figure of woman operates in such a way: emptied of its function as signifier of *women*, in their diversity and historical specificity, it becomes the signifier of 'Woman', a universalised figure of male fantasy. Such fixed icons in turn ground mainstream narratives and genre definitions (Mellencamp, 1995, p. 160). But 'icons', writes Johnston, are also myth's weakest point: they can be reappropriated, made to function within a different narrative, and reconnected to history and memory.

Johnston's argument is developed by Catherine Constable (2005), using the work of feminist philosopher Michèle le Doeuff. Le Doeuff's concern is with the way in which images – by which she means *literary* images – function within the discourse of philosophy. As rational system, philosophy, she argues, secures its status *as* philosophy through its opposition to 'myth, fable, the poetic, the domain of the image' (2002, p. 1). What le Doeuff demonstrates, however, is philosophy's *dependence* on images; images, that is, perform the work that secures the philosophical argument. In particular, she points to the work that images of Woman do in securing the position of the rational male philosopher. Woman is constructed as the 'outside' or 'other' of philosophy, that against which its status is defined, but her image permeates it. Philosophy's 'imaginary portrait of "woman"' is, she writes, that of 'a power of disorder, a being of night, a twilight beauty, a dark continent, a sphinx of dissolution, an abyss of the unintelligible, a voice of underworld gods, an inner enemy who alters and perverts without visible sign of combat, a place where all forms dissolve' (ibid., p. 113). To the film theorist the portrait is familiar, as is its obverse: the passive, virtuous woman who is man's (and the philosopher's) willing subordinate.

Thus, if images sustain the philosophical system, they also undo it. They undo it both because they reveal its dependence on its opposite – image and fantasy – but also because they always exceed it. Shifting the argument to the *filmic* image, Catherine Constable suggests that what is important in le Doeuff's formulation is the idea that images *cannot* be fully contained by the system that deploys them: they always bear traces of the wider discourses in which they circulate; as products of fantasy they are always beyond rational argument; they can always be mobilised in other, potentially contradictory ways. Images, then, cannot fix desire or fantasy in the service of the discourse which reproduces and employs them, however much that discourse might seek to do this.

For Constable, it is 'the *conceptual* potential of filmic images' (2005, p. 190, emphasis added) which is released by their dislocation from their framing discourse, and the feminist theorist who will articulate this. If, however, we return these 'icons' to their functioning within narrative, as Johnston suggests, such dislocation will make them available for other narratives, other (re-)workings of desire. Most obviously, such a reworking occurs within the films of a director like Sally Potter (*The Gold Diggers*, 1983; *Orlando*, 1992), who has employed narrative, and the questioning female subject/hero, to investigate the spectacular images of her films' female figures and their functioning within the 'sexual economy' (Mellencamp, 1995, p. 162). Yet if all 'icons' are saturated with the history of their previous usages, then they can also be reworked in less overtly dislocating ways. For Meaghan Morris, in a formulation that has been more recently taken up by Alison Butler (2002),[13] such a women's cinema would constitute a 'minor' cinema in the sense in which Deleuze and Guattari define Kafka's novels as a 'minor literature'. A minor literature, writes Morris, 'is not "marginal": it is what a minority constructs *in a major language,* and so it is a model of action from a colonized, suppressed, or displaced position *within* a given society' (1998, p. xvii, original emphases).

Such a conclusion risks a certain utopianism, however, and I want to conclude this introduction rather differently, by returning to the difficulties as well as the possibilities for such reworking. In 'Professions for Women', Virginia Woolf famously writes of killing her own internalised 'phantom' of ideal femininity, the 'Angel in the House', in order to be able to write. 'Had I not killed her, she would have killed me', she comments (1993/1931, p. 358). It is a formulation that equates writing with survival and constructs the writer – sometimes 'I', sometimes 'she' – as hero. But Woolf adds that, having thus freed herself, she faced another problem which she could not solve. Letting her 'imagination sweep unchecked round every rock and cranny of the world that lies submerged in the depths of our unconscious being', she found her fantasy suddenly debarred; she could not articulate her own desires, could not speak the 'truth about [her] own experiences as a body' (ibid., pp. 359–60). Two points suggest themselves here. The first concerns the force of the regulatory power Woolf

encounters. We are, writes Judith Butler, 'passionately attached' to subjection; it is through the narratives that 'we never chose' that we construct our identities (1997, pp. 105, 2). Second, it is clear from Woolf's story that if fantasy is to, in Butler's words, 'establish the possible in excess of the real' it must reconnect to the body, its desires and its experiences. Put slightly differently, fantasy must connect to history, embodied experience and memory if it is to transform the sedimented narratives with which it must work.

CONCLUSION

'I think that the question of an effective feminist practice is *insoluble*', writes Nancy Miller in her discussion of women and writing. But the question is insoluble, she adds, only for the *theorist*, for whom it throws up difficulties and contradictions. Effective *practices* exist, practices bearing 'the signature of women' which 'move, persuade, even transform' (1988, pp. 68, 73, original emphasis). The narratives which are thus produced are not foreseeable, but they are different, 'since the story of the woman who writes is *always* another story' (ibid., p. 72, original emphasis). It seems to me that the process of producing these *other* stories – a process which is essential since, as Carolyn Heilbrun adds, the narratives provided *for* women are 'insufficient for [our] needs' (1988, p. 120) – is the process of engaging with Mimi's question, and with all the further questions that follow from it. It is this process that I shall seek to track in the chapters which follow.

Chapter Two

WOMEN'S LIBERATION CINEMA?

The films came first.

(B. Ruby Rich, 1978, p. 9)

The home is out of history; cinematic heroes go out into the public sphere to do whatever it is that makes them the hero. ... feminist documentary films, like consciousness-raising groups, strive to find a new way of speaking about what we have collectively known to be really there in the domestic sphere and to wrest back our identity there in women's terms.

(Julia Lesage 1990/1978, pp. 231–2)

The 1970s was a time of oppositions, of dualities ...

(Patricia Mellencamp 1995, p. 133)

The early 1970s, as B. Ruby Rich points out in her 1978 survey article, saw a huge surge in women's film-making activity, in women's film festivals and in feminist film criticism. The three, as Rich suggests, begin together, the product of an 'initial crossfertilization between the energies of the women's movement and cinema', but if all three emerge from the cultural shift marked by the publication in 1970 of feminist works such as Kate Millett's *Sexual Politics*, Shulamith Firestone's *The Dialectic of Sex* and Robin Morgan's edited collection *Sisterhood is Powerful*,[1] it is in the area of film-making practice that the influence was most immediately felt (Rich, 1978, p. 9). The first International Festival of Women's Films, held in New York in June 1972, screened 120 films in all, of which only fifteen had been made before 1966.[2] But it is also significant that only seventeen of these were feature length (defined as 70 minutes or over), and that of the thirteen feature-length fiction films screened, over half had been made before the mid-1960s. All except twenty films were documentaries and, outside the themed section on 'Women in Arabia and Africa', the vast majority of these came from the USA. All but ten of the documentaries were 30 minutes or less, and a third were shorter than 10 minutes. The festival's fifteen thematic groupings included 'The Feminine Mystique', 'Social Protest', 'Maternal Images' and 'Woman: Myth and Reality'. These, then, were films made possible

by the increased availability of 16mm film in the late 1960s and directly tied to the emerging US women's movement.[3] Yet by 1978, when Rich's account was published, the 'unity, discovery, energy, and general we're-here-to-stay spirit' (ibid.) of this moment had already receded; the journal *Women & Film*, also founded in 1972, had folded following editorial disagreements; and the 'period of normalisation' which followed had also produced theoretical and critical splits and uncertainties. In this chapter, then, I shall trace these arguments in relation to some of the films over which they were fought before examining, in the following chapter, some of the fiction films directed by women which did emerge, rather more problematically, during the 1970s.

NAMING AND MAPPING: THE DEBATES

Rich's 1978 article is called 'The Crisis of Naming in Feminist Film Criticism', and the desire to name, to map and, in many cases, to prescribe the contours of a new and authentically feminist form of film-making is one of the most evident characteristics of 1970s feminist film criticism.[4] Writers like Jeanne Betancourt (*Women in Focus*, 1974), Bonnie Dawson (*Women's Films in Print*, 1975) and Sharon Smith (*Women Who Make Movies*, 1975) sought to catalogue films by women: Dawson lists 800 16mm films by women and Smith provides a directory of 725 contemporary women film-makers in the USA. While all three pay some attention to earlier and non-US film-makers, the emphasis in all is on 'the new film-makers', a 'different breed of women film-makers' (Smith, 1975, p. 145) who are 'united ... by [a] shared [feminist] consciousness' (Betancourt, 1974, p. vii). All provide distribution details and biographical and/or critical contextualisation, and the emphasis is on *using* these films, either with women's groups or in an explicitly educational context. Betancourt states:

> By reading about and seeing films that present real women, those who have been oblivious to the stereotypes of women in film may begin to recognize them by the contrast offered in the films I suggest. Filmmakers, present and future, can be inspired. Librarians have here a guide for new purchases – where and how to use them. College and high school personnel have a manual that helps them determine how to use their audiovisual funds without spending the hours to search out films as I have. (Ibid., p. vi)

By 1978, however, when Rich's article appears, the arguments about what might constitute a truly feminist film-making – and how that film-making should be named – have become far more troubling. Claire Johnston's 'Women's Cinema as Counter-Cinema' (1973) and articles by Johnston, Laura Mulvey and Pam Cook in *Screen* had argued that cinematic form as well as content must be disrupted if a feminist (counter-) cinema was to emerge, and the argument had

been taken up by the American journal *Camera Obscura*, established in 1976 in the wake of disagreements within the editorial collective of *Women & Film*. Rich's own inclusive taxonomy divides feminist films into three categories: 'validative' films (documentary or cinema vérité in form), films 'of correspondence' (self-consciously experimental and 'writerly') and 'Medusan'[5] films (those employing humour), and contrasts all three with the new male-directed 'woman's film' of the 1970s, which Rich prefers to call 'projectile' ('fantasy projections of the male directors') (1978, p. 11). But her conclusion, that '[i]t is tempting to be prescriptive, to say that feminist films should be anti-illusionist, or be made collectively, or offer positive role models, a good story or no story. Yet no prescription quite works …' (ibid., p. 12), finds itself at odds with precisely such prescriptiveness in her contemporaries.

The first issue of *Camera Obscura* opens with a statement very similar to that of the first issue of its predecessor, *Women & Film*: that 'women are oppressed not only economically and politically, but also in the very forms of reasoning, signifying and symbolical exchange of our culture' (1976a, p. 3).[6] The films championed here, however, are much less eclectic. They are films which 'contribute to the development of a feminist counter-cinema' not only by 'having as their central concern a feminist problematic', but also, and more importantly, by 'operating specific challenges to cinematic codes and narrative conventions of illusionist cinema' (ibid., p. 4). As the editors write in a retrospective of 1981, they saw the feminist documentary as having only a limited usefulness, as part of a 'consciousness-raising' exercise, arguing that although these documentaries 'presented themselves as unmediated and transparent, … as having a privileged access to truth because of their documentary form', in fact they 'lacked even a minimal analysis of the political and ideological determinants of women's oppression'. Their governing idea, that 'we could change people's attitudes fundamentally by showing them positive images with which to identify', was fundamentally mistaken (1981, p. 8). What were needed were experimental, deconstructive films by women, films which challenged the conventions of film construction and cinematic viewing which remained unquestioned in the feminist documentary, and it was in these terms that the films of Yvonne Rainer, Jackie Raynal and Chantal Akerman were discussed.[7]

Annette Kuhn, in a review of Claire Johnston's work written in 1975, similarly suggests that 'a feminist counter-cinema' might consist, at its extremes, of either 'films portraying a female cultural heroine via the conventional entertainment film' (she cites Nelly Kaplan's 1969 *La Fiancée du Pirate* as an example) or of 'films questioning at the level of cinematic codes myths and stereotypes of women and images of women within texts which themselves constitute a foregrounding of the dominant means of signification' (her example is Mulvey and Wollen's 1974 *Penthesilea*) (1975, pp. 111–12). Yet if the *Camera Obscura* collective dismisses all films apart from the experimental and avant-garde, and

Kuhn makes no mention of the documentary in her alternatives for a feminist counter-cinema, a very different account of feminist film-making was constructed by Jan Rosenberg in her history of *Women's Reflections: The Feminist Film Movement*, published in 1979. For Rosenberg, feminist film-making is a direct political outcome of the 1970s women's movement, its twofold aims to 'mediate between the movement and the public and ... recruit new members', and to 'promote intra-movement solidarity and *esprit*' (1979, p. 3). What is crucial in its definition is that the film-maker, whether working as an individual or collectively, 'conceives the film and also *directs* the production of it'. Since narrative feature films are industrial products and thus inevitably complicit with dominant values, her account 'refers almost exclusively to documentary and avant-garde films',[8] films which will be shown not in movie theatres but 'in schools, museums, and similar non-theatrical settings' (ibid., pp. 2, 4, original emphasis).

Rosenberg's typology of feminist films has three categories: the 'social issue' documentary, the 'personal portrait' documentary and the 'women's avant-garde film' (ibid., p. 47). Of these, it is the first category with which she is most comfortable, since it aligns most closely with the women's movement. These films, she writes,

> resemble consciousness raising in structure as well as intention. Women speak in their own words about various problematic aspects of their lives. Their dawning feminist awareness is simulated on screen; a woman is typically shown talking first to herself, and then to a small group of other women who are, or represent, a consciousness-raising group. (Ibid., p. 56)

The films follow a common structure: interviews with 'a number of rather diverse women whose experiences are strikingly similar' are intercut, so that, as the women 'talk to the camera and to each other, their parallel narratives' are seen to 'lead to similar conclusions'. Each woman's story thus 'lends credibility and legitimacy to the others', and a feminist 'totality' emerges within which audience members can in their turn produce a politicised reading of their own stories (ibid.).

Rosenberg is less certain about the 'personal portrait' documentary. While these films, she writes, 'reflect feminists' mounting concerns with private life', they are nevertheless open to the charge of narcissism, focusing on individuals and tending to express 'inward-looking yearnings within the dominant culture' (ibid., p. 62). Her strongest reservations, however, concern experimental, avant-garde films, which have 'their roots in subjectivism and continue to be preoccupied with the exploration of the self' (ibid., p. 26). If the 'social issue' film focuses on the 'heightened consciousness' of the present in contrast to the 'blindness' of the past, and the often less radical 'personal portrait' film is more

likely to find continuities between past and present, the avant-garde film, in contrast to both, loses sight of a political present altogether, presenting 'an ahistorical, transcendent view of human experience', and thus 'implicitly deny[ing] the importance of past, present, and future' (ibid., pp. 60–71). The arguments of the *Camera Obscura* collective, while acknowledged, are given only eight lines in Rosenberg's book, and the films championed by that journal are absent altogether from her account.[9]

Rosenberg's account, however, often reads like a last-ditch defence of the issue-based documentaries she champions. Reflecting on her interviews with their makers, she comments that most of them want to make feature films: 'If the majority of feminist film-makers have their way, the feminist film movement will function to provide them with the training which ultimately will allow them to become feature film-makers ... in Hollywood'. She is, unsurprisingly, pessimistic about such an outcome, fearing that, once absorbed into the mainstream, 'film-makers may increasingly focus on the personal and neglect the political dimension in women's lives' (ibid., pp. 24, 114). At the same time, however, she both sees the shift as inevitable and, however briefly, seems to recognise possible limitations in her own approach. Perhaps, she reflects, the 'dominance of the documentary aesthetic' and its defenders has 'impeded the development of a serious, theoretical feminist film criticism' (ibid., p. 107).

Rosenberg's doubts, as well as her fears, indicate something of what is at stake in these early arguments. Both the advocates of the feminist documentary film and those who, like Pam Cook, support an avant-garde, deconstructive feminist film-making insist on the importance of an independent sphere of feminist film-making, distribution and exhibition. 'The organisation of small-scale independent production and distribution/exhibition facilities', writes Cook, 'is of vital importance if women are to make any significant intervention into "patriarchal" culture' (1981/1977–8, p. 280). It is this independence, and the feminist context within which the films will be presented, shown and discussed, that will be lost with any move towards the mainstream. Yet, as Annette Kuhn observes in her 1977 review of the early issues of *Camera Obscura*, such a context necessarily marginalises the films, making them unavailable to a mass audience. This inaccessibility – in the sense of unavailability – is, she argues, compounded in the case of avant-garde films, which are also inaccessible in the second sense of the term – unintelligible to most actual audiences.

All of these arguments, and their contradictions and limitations, are rehearsed most directly in 'Women and Film: A Discussion of Feminist Aesthetics', with participants Michelle Citron, Julia Lesage, Judith Mayne, B. Ruby Rich and Anna Marie Taylor, published in 1978. For Citron and Lesage, it is film's accessibility which makes it an ideal political and educational tool. Feminists, argues Lesage, must 'be involved in mass culture because that's a way of shaping consciousness' (ibid., p. 85), and Rich adds that feminism's 'validation of subjective response,

personal experience' must be reconciled with, not simply opposed to, the dominant 'voice of history' (ibid., p. 90). What, then, will constitute the difference of a *feminist* film aesthetics? Mayne's answer emphasises the participatory quality of feminist film-making and film viewing: 'The strategic interest of film collectives is, I think, a different relationship with what's being filmed and who's being filmed, which I hope would necessitate a different relationship between who's watching the film and who's made the film' (ibid., p. 96). Yet this categorisation by *process* is clearly unsatisfactory. Rich responds that the highly figurative, autobiographical work that can result is often 'root-bound', Taylor adds that 'participation' need not be literal – it can occur when the film demands a new mode of reading through the transgression of cinematic codes, and Mayne counters that such a 'breaking of the codes' is itself no guarantee of radical film-making – it too, can become 'just another style, another technique' (ibid., pp. 96–100).

This discussion between feminist critics and film-makers, then, rehearses the arguments which had characterised the 1970s in the USA and Britain. But it also raises two issues which had been repressed in these debates: the question of women's visual *pleasure* in film, and that of the difficulties of constructing woman as desiring subject and 'author' within a *dominant* film-making practice. The first is posed in a difficult discussion of the pleasures women viewers experience in the female image, and the questions this raises about ideological complicity. Acknowledging that female spectators too find 'intense visual enjoyment' in screen images of women, Taylor must also recognise the difficulties this produces for a feminist analysis. '[H]ave we', she asks, 'as female viewers also been taken in by the way women have been filmed so that our own sexuality and therefore our very intense visual enjoyment regarding female stars is determined in advance elsewhere?' (ibid., p. 88). These questions – of pleasure, fantasy, desire and their relationship to representation and ideology – are absent both from Rosenberg's account of the documentary film (they surface briefly in her uncomfortable dismissal of filmic expressions of 'narcissistic, inward-looking yearnings') and from *Camera Obscura*'s advocacy of films which 'provoke reflection on the signifying process, on representation, and on the figure and function of the woman image' (1976a, p. 5). Taylor's own response to the question she raises suggests that an engagement with these issues in women's film-making practice will require more subtle dislocations of cinematic conventions than are allowed for in any of the discussions so far.

The second question extends these concerns to a consideration of women's voice and writing. This is the problem posed by Virginia Woolf in 1931 when she writes that, having 'killed' that internalised self-censor, 'the Angel in the House' – the idealised image of a passive and domestic femininity – she nevertheless finds herself still unable to articulate her own desires, to write the 'truth about [her] own experiences as a body' (1993/1931, p. 360). This melancholic sense

of loss and foreclosure, which has to do with both embodied desire and writing, and which persistently produces a narrative which 'itself stages the difficulty of reading women's writing' (Miller, 1988, p. 84), is termed by Anne Callahan (2001) *vagabondage*. *Vagabondage*, she writes, is the constantly shifting subject position of the woman for whom *writing female desire* produces impossible contradictions. To write of desire, within a form beyond the private and autobiographical, is to assume the masculine position and produce the woman as object. When a woman writes of her own desire, therefore, she 'gives voice to the unrepresentable' (Callahan, 2001, p. 58), stepping, like Butler's Antigone, outside the bounds of public intelligibility, to 'occupy a position … that is no position' (Butler, 2000, p. 78).[10] Simultaneously, she exposes as a 'male masquerade of femininity' the figure of woman that we see elsewhere (Callahan, 2001, p. 58). Thus, her stories are always doubled: stories of desire which are simultaneously stories of (the difficulties of) writing. Returning to the arguments of the 1970s, then, we can think of the advocates of both the feminist documentaries and the experimental films of the 1970s as again and again affirming the death of 'the Angel in the House'. Both sets of claims affirm the fact of writing and the authority of the feminist voice. Moving beyond this to an exploration of (difficulties of) the writing of desire, however, proved far more difficult.

In the 1978 discussion, it is Rich who raises this issue. Seeking to articulate the difference of a woman's film-making within a male-dominated tradition, she uses the image of the mirror to represent the relationship of the film-maker to their subject. 'Like the man watching his wife through his own reflection,' she writes,

> all filmmakers, male and female, superimpose their own image on top of their subject. When that subject is a woman, the male filmmaker effects a cancellation, a warping or erasure of that subject. However, if the filmmaker is a woman and a feminist, then there is instead the possibility for a reinforcement, a doubling or enlarging of the subject, by virtue of her superimposition of her own *like* image. (Ibid., p. 100, original emphasis)

Rich's account recalls Woolf's famous comment that '[w]omen have served all these centuries as looking-glasses possessing the magic and delicious power of reflecting the figure of man at twice its natural size' (1993/1929, p. 32). It also recalls Christian Metz's characterisation of the cinema screen as 'that *other mirror*', in which the spectator's apparent absence from the screen enables a more powerful identification: with himself as 'all-perceiving' subject – powerful, ubiquitous, transcendent (1982/1975, pp. 4, 49, original emphasis). For man, argues Woolf, representation is always self-representation, the image always shows him himself, while woman's access to representation is blocked: she is invisible as herself. For Metz too – though this is never stated explicitly – it is

the male spectator for whom the film acts as an enlarging mirror. Rich's formulation suggests the possibility of another scenario of desire, in which the 'doubling or enlarging' function of cinema's 'other mirror' can work to enable women's self-enunciation. In her account, the film-maker and her subject do not merge, as is suggested in accounts of the feminist documentary, but nor are they divorced, dislocated or fragmented. Instead, the image of the mirror functions to insist on a framing distance, on the film as *text* not simply as process or self-expression. At the same time, however, its doubling effect produces a different kind of vision and desire, and perhaps also suggests, in the traces of the film-maker herself still visible in the text's construction, that doubled story, of both desire and writing, to which Callahan draws attention. For Rich, then, the independent but marginalised space of a separate women's film production, whether of documentary or experimental films, is not enough. There is 'real possibility for doing feminist work' within mainstream film production (1978, p. 100).

THE FILMS: THE FEMINIST DOCUMENTARY

Rosenberg's account of the feminist documentary films sees them as a direct expression of the women's movement, with a common structure, that of consciousness-raising, and common aims. Critics countered with the problems of 'realism', beginning with Claire Johnston's critique of the limitations of this 'emerging women's cinema'. These documentary films, she writes, 'largely depict images of women talking to camera about their experiences, with little or no intervention by the film-maker'. But 'the idea of non-intervention is pure mystification ... the "truth" of our oppression cannot be "captured" on celluloid with the "innocence" of the camera ... New meanings have to be created by disrupting the fabric of the male bourgeois cinema within the text of the film' (1973, pp. 28–9). Six years later, Laura Mulvey goes even further in identifying feminist documentaries with cinéma vérité techniques, and these techniques with a cinematic realism which is incapable of serving an oppositional politics. These are films, she writes, with 'good intentions', but they are naive in their belief that the 'magical instrument' of the camera, 'by registering shared experiences can create political unity through the process of identification'. A politics thus 'restricted to emotion' and reliant on identification, she argues, can never be effective (1979, p. 185).

These arguments, as Janet Walker and Diane Waldman write (1999, p. 8), were hugely influential. They structure both E. Ann Kaplan's account of 'the realist debates' in 1970s feminist film-making, in her *Women and Film* (1983), and the similar chapter on 'real women' in Annette Kuhn's *Women's Pictures* (1982). Both writers have reservations about the blanket critique implied in this rejection of realism. Kaplan notes 'the danger of a theory that ignores the need for emotional identification with people suffering oppression' (1983, p. 217),

and Kuhn argues that 'the kinds of identification made possible' in these films 'centre on the necessity of naming women's experience, of making the personal political', so that what is affirmed in them is not a notion of 'absolute truth derived from "neutral" observation', but *situated* truths which validate an oppositional politics based on women's experiences (1982, p. 152). Yet both argue that the myth of transparency which underpins their claims to present the 'real world' and 'real women' mystifies the processes of cinematic representation and positions the spectator as passive recipient of 'truths' about the world 'out there'.

Other writers countered these criticisms by insisting on both the function and the effectiveness of feminist documentaries in producing 'a critique and antidote to past cinematic depictions of women's lives and women's space' (Lesage, 1990/1978, p. 233). These are films, argues Julia Lesage, which make visible a so far unrepresented women's experience and name a previously unarticulated knowledge. In so doing, they identify that knowledge as political and thus challenge dominant 'truths' and the social structure that supports them: the separation of a politicised public sphere – what Lesage calls the sphere of history – from a privatised domestic sphere: a space 'out of history'. What 'woman' might *mean*, both socially and on screen, is redefined, and women are reconstituted as subjects: of discourse, of action, of knowledge, of politics and of history (Michel, 1990/1981, p. 241).

These defences, however, are *political* defences; like criticisms of the films for their naive realism, they assume a commonality of structure and a 'transparency' of form. More recent commentators, however, have suggested, first, that the films display '*multiple* film styles and theoretical assumptions' (Juhasz, 1999, p. 194, original emphasis) and, second, that it is more productive to view documentary's claims to 'transparency' not as naiveté but as rhetoric. Thus Alexandra Juhasz insists on the variety of realist forms that can be found in any documentary film, arguing that these are used not to imply that 'the "reality" portrayed is fixed, stable, complete, or unbiased' but rather to make arguments *about* that reality and its interpretation. Similarly, she argues, identification, both conscious and unconscious, is solicited strategically, as a means of moving us 'to anger and action' (ibid., pp. 195–6). In a similar way, Jane Gaines argues that the political documentary depends on a form of 'political mimesis' which 'begins with the body'. Films, she argues, 'make their appeal through the senses to the senses', and film-makers 'use images of bodies in struggle *because they want audiences to carry on that same struggle*' (1999, pp. 90–2, original emphasis). Both writers draw on Bill Nichols' arguments about documentary *rhetoric*. Documentary, he argues,

is a proposition about how the world is – what exists within it, what our relations to these things are, what alternatives there might be – that invites consent. … Documentary reference to the world around us is not innocent.

... What it includes and excludes, what it proposes and suppresses, remain
issues of significance. (1991, p. 140)

Nichols also argues that narrative and exposition in documentary function like narrative in the fiction film: to organise meaning, to contain the real (and the unconscious) and to secure ideological consent. No less than fiction films, therefore, documentaries are also characterised by *excess*: by that which 'stands outside the web of significance spun to capture it' (ibid., p. 142). That which stands outside, which cannot be contained or made to mean within the terms of the argument set by the documentary, is identified by Nichols with 'history ... the referent of documentary' (ibid.). Yet in the feminist documentary it seems to me that it can also have other identifications. Excess may take the form of a femininity which refuses to be aligned with feminism, of the personal as an embodied experience which exceeds its designation as political, or of differences – of class or race, for example – which exceed arguments for a unity between women. It can be found in evidence of a rupture between past and present where the argument is for continuity, or in moments of continuity where the argument is for a radical break. It can also be found in suggestions of an unnameable, unrecoverable loss, where the argument is for political gain, or in elements that remain unarticulated, where the argument is for a new or recovered voice. In the following analysis, therefore, I consider some of these 1970s documentaries in terms not of their commonalities of structure but of their differences, disjunctures and moments of uncomfortable excess.

Betty Tells Her Story (Brandon, 1972) is, in Rosenberg's terms, a 'portrait film'. In it, Betty, a plump, middle-aged woman, formally dressed in a dark dress with a silver brooch, with discreet makeup and formal hairstyle, sits, legs crossed, facing the camera in a high-backed chair flanked by a coffee table bearing flowers and a dark sofa. She tells her story twice, the tellings separated by an intertitle: 'Later that day, the film-maker asked Betty to tell her story again'. In each telling, the camera gradually moves closer, ending in close-up of her face. Her story is of being invited as a young teacher to the Governor's ball, of buying an expensive dress for the occasion, of trying it on before the mirror and for friends, of feeling for a moment, and for the only time in her life, both beautiful and special, and of losing the dress that same evening. Contemporary commentator Jeanne Betancourt explains its significance: 'Betty, whose whole life must be haunted by size-five models in perfect dress, bearing, and setting, unwittingly gets to some rather ugly realities of our "beauty culture"' (1974, p. 23). This, then, should be a consciousness-raising story, and indeed Betty's second telling offers rather more judgments on the event than the first. There was, she says, something 'uncomfortably plush and posh' about the 'very expensive' dress shop, she 'felt suddenly luxurious' in trying on the dress – it 'was like being on stage and being the centre of everybody's concern' – and she was

Betty telling her story in *Betty Tells Her Story* (1972)

'embarrassed' by the experience. But, as Betancourt's use of the term 'unwitting' reveals, the interpretation that Betancourt wants her to produce isn't quite the story that Betty tells. In neither telling does Betty resolve the meaning of the event, despite her closing comment in the first that 'there's something there that I really haven't fully understood – yet'. 'It just seems very strange somehow' she murmurs, almost inaudibly, after the second telling.

Betty's story seems best understood in terms of some rather different theoretical frameworks, neither of which function to resolve ambiguities. The first is Annette Kuhn's account of 'memory texts'. 'The language of memory', argues Kuhn, seems 'to be above all a language of images', sharing 'the imagistic quality of unconscious productions like dreams and fantasies'. Remembered events are 'somehow pulled out of a linear time-frame, or refuse to be anchored in real historical time' (2000, pp. 188, 190). In telling and retelling them, we perform a kind of 'secondary revision',[11] pulling their events into a narrative structure that gives them meaning within a shared social framework. At the same time, in telling our story and thus 'welding together' the narrating 'I' and the narrated 'I', we affirm ourselves to be a unified individual (ibid., p. 180). Betty, then, struggles to fix her memory within time: she tells us precisely when and where the events happened. But it is the image that she remembers, an image

of herself as beautiful, an image which is both persistently present and yet, she says, 'just a memory, like something that never happened'. In making sense of this moment, a moment which is repeated three times in the story, as she tries on the dress for herself and for friends, she offers two contradictory frameworks. One I have already mentioned: it is the critique of the constructedness of the image, based in a class and gender politics, towards which she edges in the second telling. The second, however, is more persistent and far more grounded in affect, and is based in romance. 'I felt suddenly transformed', she says. 'It was like some fairy story … I watched while they wrapped [the dress] up in pink tissue paper and put it in a pink box. … I felt like a princess when I walked down the stairs.' Her sense of loss in the disappearance of the dress was, and remains, overwhelming. Betty knows it is disproportionate, but cannot resolve it.

Unlike the memory texts of which Kuhn writes, however, Betty tells her story to camera. We are thus acutely aware both of her struggle to capture the image of her own impossible beauty and convey her overwhelming feelings of pleasure and loss, and of her efforts to pin these feelings down, to fix their meaning, through narrative. We are also very aware of her *body*. The Betty we see is disciplined and formal, her body contained. She epitomises what Jane Gallop, in *Thinking Through the Body*, calls 'the drive for order', the 'drive to subordinate the disorderly body' (1988, p. 54) to narrative and meaning. Yet both the *jouissance* and the loss of which she speaks are disorderly, uncontained, and of the body. Betty, then, reminds us visually of the difficulties women have in speaking both from the body and of the body. She does not succeed in affirming herself as a unified individual, for whom past memories lead to and can be explained by the present. She cannot present herself as a fully political subject. Instead, two competing narrative frameworks – those of femininity and of feminism – struggle for dominance, and neither can contain the excess which is her embodied fantasy and its loss. Deborah Rose, in a contemporary review of the film,[12] commented that 'I could see a reservoir of deep, deep pain which startled and frightened me' (Betancourt, 1974, p. 24), reminding us that, in Gallop's words 'if we think the mind–body split *through the body*, it becomes an image of shocking violence' (1988, p. 1, original emphasis).

Joyce at 34 (Chopra and Weill, 1972) was, according to Rosenberg, 'the earliest documentary portrait to explore intergenerational relationships' (1979, p. 65). It follows film-maker Joyce Chopra over a fifteen-month period, beginning just before the birth of her daughter Sarah, viewing her at work, visiting her mother, with friends and with her husband and growing daughter. Her voice-over reflects on her responses to these events, looks back, with the aid of photographs and home movie footage, at her mother's and grandmother's history and those of her schoolfriends, and contemplates the future. Praised by Rosenberg, for E. Ann Kaplan it exemplifies the problems of realism. She has four related criticisms. First, the film establishes 'an unwelcome imbalance

Joyce at 34 (1972)

between the author and spectator', positioning the author as source of knowledge and the spectator as passive recipient of its message that 'marriage, family, and career can all function harmoniously'. Second, it denies its processes of construction, setting up 'Joyce' as a 'real woman' and failing to draw attention to itself as film. Third, and extending this, it presents Joyce as a unified individual, beyond the social, economic, psychic and symbolic structures in which she is embedded. Finally, then, it 'perpetuates the bourgeois illusion', suppressing mention of class and economic relations (1983, pp. 127–9).

Kaplan's criticisms are familiar, but oddly inappropriate. *Joyce at 34* is highly self-reflexive, its linear narrative broken by frequent reminders both of its own status as film and of the power of visual representation, by disjuncture between voice and image, and by the eruption of counter-voices, competing cyclic temporal structures and visual oppositions between public and private spheres and identities. The film begins with a visual image: of Joyce looking into a full-length mirror so that we share her self-reflection. It is the stuff of advertising images, except that Joyce is heavily pregnant. Her voice-over sees the imminent but overdue birth as like 'some film job' that suffers persistent delays – which, of course, it is. Joyce, then, is female body, reflective and angry consciousness ('I'm really angry at ... being biologically this way') and film-maker. At intervals throughout

the film, including in the filmed birth sequence, we see Chopra's co-director, Claudia Weill, and hear her questions.

The film's linear narrative is similarly disrupted. Against the chronicle of temporal progress are set a number of competing cyclic structures. One concerns Joyce as film-maker. In this role she is found in outside spaces and, filmed in long shot, as constantly mobile: at airports, crossing city streets to use a public telephone, carrying film equipment to and from work, filming in public buildings. Here she is confident, a separate individual, and the sequences contrast with the cramped inside sequences of motherhood and family, where she is never alone. An early sequence sees Joyce walking confidently to work as an older woman says in voice-over, 'You're truly liberated if you can carry on a career and feel that you're doing the right thing for yourself and your children', suggesting, as Rosenberg comments, 'that Joyce (and women of her generation, whose lives she typifies) are resolving feelings of guilt which former generations of working mothers experienced' (1979, p. 67). Yet later sequences evidence no such success. Joyce must now leave her daughter behind when she films and her voice-over reflects on the conflicts this causes: 'I've just got to take this job seriously and as long as she's with me all I think about is her.' In the final sequences, work – editing – has moved inside, constantly impeded by the attentions of the small child, and mothering has moved outside, as Joyce, no longer mobile, sits in the street with another young mother, the children playing at their feet.

A second source of disruption are the mirrored group and family sequences, in which other voices compete with Joyce's for authority, and contrast with each other. The first is the chaotic meeting round her mother's family table of a group of her mother's friends, who reflect on and argue over the meanings of their lives as teachers. They became teachers, one says, because they had 'something to give', but another counters that teaching was 'the only feasible position for a girl of my time, my religion (Jewish) and my background'. What they agree on is that they were 'torn with conflict' between work and motherhood: 'Whatever we do is wrong, that's how I … spent my whole time teaching.' Her own mother, says Joyce in voice-over, 'dreamt of being a concert pianist. … Now she only plays once in a while, to accompany my brother David, who *did* become a musician.' Joyce herself, it is implied, will achieve what her mother and grandmother did not. Yet a later group sequence, with Joyce's childless friends (her 'consciousness-raising group' according to Rosenberg), presents a very different picture of such achievement. One young woman, whose mother *did* become a concert pianist, finds herself not liberated but paralysed by her mother's success: 'I just can't do it because she did it, you know.' The third group sequence is of Joyce's Jewish family at a festival celebration, the men saying prayers and the women preparing and serving food. This is 'the first time in years', reflects Joyce, that she has wanted to return home for this festival. The subordination of

WHAT IF I HAD BEEN THE HERO?

women that such traditions involve is made clear in the sequence, but the family celebration occurs between two montage sequences of Joyce in her domestic maternal role, so that her relationship to this traditional world is left uncertain.

This, then, is far from a straightforward demonstration that 'marriage, family, and career can all function harmoniously'. Neither Joyce nor the other figures we see are unified and non-contradictory individuals. Joyce's view of her mother's thwarted ambitions is countered by her mother's own insistence on maternal priorities, Joyce's husband's assertion that parenting conflicts have been resolved is contradicted by his accusation, on Joyce's return from filming, that Sarah has 'forgotten' her mother ('That's your mother, Sarah') and Joyce's own voice-over is frequently contradicted by the montage of events that we see. The conclusion of the film sees Joyce speak direct to camera. 'I don't want to have another baby,' she says, and then, 'in theory I want to have another baby'. Having only one child, she says, will be regarded as 'selfish', but a second child will be 'the end'. 'The end of what?' we hear Weill ask, off screen. It is a moment that makes us aware of the film as (fractured) discourse. With one child, says Joyce, 'I can *just* about work everything out. But if I have two children, it's curtains.' The screen shows her smiling at us, but we realise that what we are seeing is a freeze-frame. Her voice and image do not coincide, and her final laughter is uncertain.

Union Maids (Reichert/Klein/Mogulescu, 1976) is classified by Rosenberg as a portrait film which 'simultaneously develops political themes which transcend personal issues' (1979, p. 88). Of the films discussed here, therefore, it approaches most closely her ideal of the consciousness-raising film in which interviews with 'a number of rather diverse women whose experiences are strikingly similar' are intercut, so that a political analysis is reached which will in turn be taken up by audience members. Indeed, such a function was explicitly envisaged by film-maker Reichert, who co-founded feminist cooperative distribution group, New Day Films, in order to ensure access to, and interaction with, potential audiences. In a 1975 interview, Reichert describes the impact of screenings of films like *Union Maids*:

> [A woman] came up to me afterwards with this beautiful look on her face, like she'd just realized something. And she said, 'I never realized that the women's movement was about change and politics.' She was a working woman and had never seen any connection between herself and the women's movement. It was very clear she'd seen herself in the films. ... Consciousness raising groups, women's centers, and all kinds of activities around the country started with films being a catalyzing force. (Lesage, Martineau and Kleinhans, 1975, p. 22)

It was in terms of its claims to realism and transparency, then, that *Union Maids* was both praised and attacked. For Linda Gordon, writing in *Jump Cut*,

the film chooses 'not to comment', 'limit[ing] us to seeing the story through three individual narratives'. It belongs to the three women who are its subjects: 'Ultimately the film is theirs, and they are its strength. The film lets us see them, and the view is clear due to the filmmakers' craft' (1977, p. 35). For Noel King, however, writing four years later, this apparent transparency is precisely what is wrong with the film. Its politics are based on the individual, 'articulated by textual mechanisms which fix the individual subject as responsible', and 'suppress[ing] any notion of ... the social and linguistic formation of subjects' (1981, p. 11). Whereas Gordon feels that the film contains insufficient narrative intervention, for King there is too much of what is simply a static and teleological 'familiar narrative system'. Like Laura Mulvey, he argues that such a film's 'good intentions' are inevitably undermined by its realist techniques.

Union Maids is a collective portrait of three women union organisers active in the labour struggles of the 1930s, who had initially been interviewed for Alice and Staughton Lynd's book, *Rank and File* (1973). Interview material, in which we see the women being interviewed by Reichert and Klein, is intercut with contemporary news photographs and newsreel footage. The women's personal narratives serve as voice-over for this material, and they also speak the bridging commentary that fills in historical detail. Across both images and speech we also hear the songs of the labour movement, from one of which the film takes its title. The structure is chronological, recounting the women's first employment, introduction to activism and participation in union struggles. The final sections move us from the effects of McCarthyism on union activities in the 1950s to summative self-reflections and comments on contemporary political movements.

These, then, are women active in the public sphere. For Gordon they are heroes: it is, she writes, 'a film about heroics ... It reasserts the potential of leadership by people who are at once exceptional and ordinary' (1977, p. 34). Similarly for Sonya Michel, writing in 1981, the women, in telling their own stories, 'constitute themselves not only as subjects – as actors in their own lives – but simultaneously as actors in history and in feminist politics, *and* as subject/actors in cinema'. In so doing, they 'set up an interrogation of the public by the private – often of the male perspective by the female' (1990/1981, pp. 241–2, original emphasis). Here, then, are women *as* heroes, in all the terms outlined earlier in this book (see Chapter One). In being subjects of their own stories they are also, if not writers, then *speakers*: oral historians who are also constituted as experts who can produce *histoire* as well as *discourse*.[13] All the women are photographed at some point standing in front of microphones, and one of the women, Sylvia, recounts a childhood story in which this identity was established. Taken to a Garveyite rally by her father, she was told to pay attention to a young woman speaker, and instructed, 'I want you to be like her. When you grow up you have to be a *speaker.*'

Kate in *Union Maids* (1976)

In its use of archival material to *validate* the women's accounts, *Union Maids* fuses autobiography, oral history and documentary evidence to make an intervention into what Rich calls the dominant 'voice of history'. Unlike the slightly later *Life and Times of Rosie the Riveter* (Fields, 1980), which it resembles in structure, its women are not ordinary but exceptional, and its archival footage supports rather than being undermined by their voices. Two elements from the later film are therefore absent. The first is the complex nature of the relationship between dominant media constructions and individual testimony, in which wartime newsreels construct representations of a passive femininity even as they urge women into the workforce, and the interviewed women, in contrast, recount an active *working* identity which is nevertheless caught up in a complex relationship to femininity.[14] The second is *Rosie*'s exposure of the highly constructed and ideologically contradictory nature of the newsreel form,[15] and thus implicitly of documentary itself.

Union Maids is, therefore, best viewed in terms of its rhetorical strategies.[16] King points to its use of music and song, whose effect, he writes, is 'always to hold a reading at the level of the visceral, the affective, the nostalgic' (1981, p. 15). This is what Gaines terms 'political mimesis', in which 'elements ... that make a visceral impact' are employed to produce a 'powerful mirroring effect'

in audience communities who, as a result, 'want to kick and yell, … want to *do* something' (1999, pp. 98–9, 90, my emphasis). We do not, however, have to attack the film as King does to be able to unpick the elements of excess which cannot be contained by the strategies and structures it adopts. Indeed, sympathetic critics like Gordon and Michel also point to some of these. The most commented upon is the suppression of the three women's membership of the Communist Party, which provided the supporting structure for their activism, and whose omission produces a more individualistic focus. Excess in Nichols' definition, as that which 'stands outside the web of significance spun to capture it' (1991, p. 142), also appears in other forms, however. It is perhaps most evident in the moments when divisions between women are apparent, most notably in terms of race, despite the narrative of unity which the film presents. It is there, curiously, in the very archival material which is used to validate their stories. If the autobiographical stories are of heroic, exceptional individuals, the photographs suggest communities of ordinary women. That these heroic stories mask internal conflicts and narrative repressions is also suggested in those moments when the incompatibilities between political activism and femininity are revealed. 'The Union was a man's job, this was the way it was looked upon,' says Stella. 'There were very few women who were actually married and had children that were active in the Union.' None of the women discusses a personal life; all celebrate their fathers and omit mention of their mothers. In the only story of a female family influence, Kate's account of her paternal grandmother's refusal to 'be a servant' in her husband's family is couched simply as an either/or. 'I'll go out to work with the men', Kate reports her as saying, 'and I challenge any male member of this household to outdo me when it comes to work.' Stella, too, 'became a dedicated radical … because I wasn't about to do housework'. The internal conflicts suggested here are quickly repressed, but they provide moments which disturb the film's heroic narrative.

Annette Kuhn, in an account of the autobiographical narrative which echoes King's arguments about this film, writes that autobiography's processes of 'secondary revision' construct 'a powerful central organising ego for its own story', producing a linear narrative which asserts the continuity of the individual self through time: 'A kind of causal logic is taken for granted: the adult who is writing "now" is contained within the child [she] writes about' (2000, p. 180). The heroic narrative here, however, is frequently interrupted by moments of mimesis. These women frequently *perform* their stories for the camera, re-enacting moments of heroic conflict with an energy that simultaneously constructs for us a powerful image of that moment and draws attention to its status *as* performative excess. These elderly women, after all, are *not* the young activists they perform; there is a fracturing between the younger self of that lost but reimagined moment and the older woman whose performance seeks to recreate it.

WHAT IF I HAD BEEN THE HERO?

A final instance of an excess which 'stands outside the web of significance spun to capture it' concerns the film's diachronic progression. For King, *Union Maids'* teleological narrative is one in which the past leads inevitably to the present. The film, he writes, 'attributes a common origin to working class and feminist movements', rewriting 'the history of unionism as if it had been female' (1981, p. 17). Yet only one of the women, Stella, sees a continuity between their activist history and the 1970s women's movement, and even she expresses 'an impatience with certain young women who I feel can't relate to working women. When you ... have choices, you can't relate to people who don't have, you know. And women who went to *work* for a living have a whole different concept of life.' The others insist that 'there was purpose in my life', but against a dominant sense, which Kate says has been repeatedly expressed by her family, 'especially in the recent years', that their activism was futile and Kate herself worth 'nothing'. If the film, then, seeks to *imagine* 'the history of unionism as if it had been female' and feminist, it cannot produce a closure which would affirm it.

THE 'AVANT-GARDE' FILM

For the *Camera Obscura* collective films like those discussed above rely on processes of emotional identification, allied to a notion of cinematic transparency, which together fail to produce the 'distanciation' which would provide space for critical analysis (1976b, p. 58). At a time when realist narrative forms dominate cinema, functioning to 'reunif[y] and rephall[ize] a spectator posed by the film as coherent and all-powerful' (Penley, 1977, p. 25), what is needed, they argue, is not *more* realism but rather a modernist film-making practice whose 'self-reflexiveness and formal rigor' will make 'a decisive break with illusionist practice, and at the same time explore 'problems of feminism' (*Camera Obscura*, 1976b, p. 58). But identifying such a practice was a difficult enterprise. It would need to be quite different, for instance, from the films of male avant-garde film-makers whose preoccupation with cinematic form failed to investigate the ideological and unconscious processes of cinema. Inheritors of a romantic idealism, argued Constance Penley, their supposedly materialist cinema in fact produced a narcissistic *re*centring of the unitary (male) subject, gratifying 'an infantile wish to shape the real to the measure of the subject's own boundless desire' (1977, p. 19).

This criticism is very like Rosenberg's critique of *women's* avant-garde films, which she sees as 'celebrat[ing] stylistic innovation' but, rooted in 'subjectivism', as a-historical and hence a-political. Important as 'highly individualized expressions' of 'women's consciousness', they are nevertheless, she writes, only 'tenuously connected to feminism' (1979, pp. 69–71). The solution to this impasse of a formalist avant-garde which was insufficiently feminist and a feminist film-making which was insufficiently formally self-reflexive lay partly in the

appearance of a small number of what Kuhn termed 'deconstructive' feminist films and Kaplan 'avant-garde theory films', and partly in claiming *for* a feminist politics films whose self-designation was rather different. Both groups are problematic in terms of the claims made for them, though for somewhat different reasons.

Yvonne Rainer's *Film about a woman who …* (1974) falls into the latter category. For the *Camera Obscura* collective, it 'contribute[d] to the development of a feminist counter-cinema both by having as [its] central concern a feminist problematic, and by operating specific challenges to cinematic codes and narrative conventions of illusionist cinema' (1976a: 4). It thus occupied a central place in the first issue of *Camera Obscura*, with forty of the issue's 140 pages devoted to an analysis of the film accompanied by an interview with Rainer. The film, Rainer's second feature-length film following her shift from dance and choreography to film-making, continues the concern of her dance performances to break with codes of illusionism and foreground performance. Sound and image are dislocated; a female voice-over cannot be precisely matched to a female character; characters are identified only as 'she' and 'he' and seem interchangeable; 'he' can speak 'her' thoughts; still and moving images alternate; frequent intertitles can be held silently for long periods then merge into voice-over; sound and/or image can reference other films, particularly melodrama and, in a sequence of forty stills from its 'murder-in-the-shower' sequence, Hitchcock's *Psycho*; acting is expressionless; the unanchored discourse is frequently expressed in clichés; there is almost no synchronised dialogue; in some sequences the four 'characters' provide an internal audience for slides projected on the screen. In one sequence titled 'Emotional Accretion in 48 Steps', a man and woman are seen lying in bed together, while their thoughts are presented chiefly through intertitles and occasionally via a male voice. In each case these most intimate of thoughts are presented in the third person.

The techniques constitute what Kaja Silverman calls a 'jamming of the semic code' (1988, p. 166), and produce a distancing of the spectator which the film's frequent references to performance – particularly female performance elicited by the male gaze – accentuate. For the *Camera Obscura* collective, these techniques function 'both as a distancing device to maintain audience awareness of the constructed nature of film, and as a device which structures in audience participation in the construction of meaning.' Rainer's strategies thus 'serve not only to prevent identification with fictional characters, but also help to work against conventional narrative development and illusionism' (1976b, p. 67). Yet there are a number of difficulties with their position, difficulties highlighted in the interview with Rainer which accompanies the article. Rainer not only denies a political intent to her anti-illusionism, but also states that she has moved towards both narrative and a concern to elicit audience empathy. Modernist techniques, she argues, do not preclude illusionism, and her own concerns are

Film about a woman who ... (1974)

personal and autobiographical: 'the most I can ask of myself is that I create work that retains a powerful connection to my own experience, whatever distance from literal autobiography it traverses' (Rainer, 1976, p. 95). Clearly Rainer's comments do not invalidate the *Camera Obscura* reading, but they do raise some important issues. The first echoes a point made by Judith Mayne in the 1978 discussion quoted earlier, that modernist or avant-garde techniques do not themselves guarantee political critique. It is a point recognised in the *Camera Obscura* collective's 'Chronology', published three years later, when they comment on 'the dangers in conflating Modernism and Brechtian practice; we realized that we would have to be more careful about making formal concerns "speak" a political message' (1981, p. 11).

The second, related point concerns the collective's tendency to conflate the 'spectator-in-the-text' (Kuhn, 1977, p. 127) with the film's social audience. For the collective, films which 'are reflexive in terms of the processes of signification

and the production of meaning' (Rainer, 1976, p. 79) *necessarily* produce a critical distance in the spectator which can be harnessed for political ends. Rainer, however, counters with accounts of the actual audiences for her films. These, she argues, are small and self-selected; they are not *outside* ideological structures, simply differently positioned, since they are part of the circuit of art films made possible by public subsidy. Thus, the audience's *social* positioning will produce their reading of any given film and its techniques. 'How can we say which kind of film will make "people" think, or make them active, and which will not?' she asks (ibid., p. 84). It is a point which, as Ann Kaplan points out (1983, p. 115), is oddly confirmed by the collective's own account of viewing *Film about a woman who ...* . Whereas it was impossible for them to identify with the women featured in feminist documentaries, they write, they *could* imagine themselves within the semi-autobiographical situations Rainer constructed for her female characters (ibid., p. 59). Clearly there *is* a kind of identification going on here: not with a depicted character, whether historical or fictional, but with an imagined film-maker, in whose constructed world, emotional conflicts, textual references and intellectual structures the collective can find a mirroring of their own ideas and concerns.

'I was determined to rise above my working-class family by proving I was an intellectual,' writes Michelle Citron of her own attraction to avant-garde film-making (1988, p. 48). Certainly it is possible to read the attraction of these early films by Rainer[17] as lying just as squarely in their 'validative' qualities as did the attraction of contemporary documentaries; they simply address a different audience. In its focus on internalised emotional dilemmas, *Film about a woman who ...* represses questions of differences between women – of class, race, or generation – at least as firmly as do the documentaries to which the *Camera Obscura* collective contrasts it. Its references outside the text, whether to *Psycho* or to the letters of Angela Davis to the imprisoned George Jackson, serve not to locate conflicts historically or politically but rather to universalise them in the internalised struggles of 'A woman' who is, in fact, far from universal. The extracts from Davis's letters come after the slow disrobing of one of the white women on screen by one of the male figures, and they are presented partly through patches of printed text stuck to the face of another of the women (Rainer herself), and partly as spoken by Rainer's voice-over. All specificity – historical, racial, political, cultural – of the Davis–Jackson situation[18] is thus removed.

Michelle Citron's *Daughter Rite* (1978) begins from a very different starting point. Citron describes her attempts to move away from what she saw as the emotional flatness and inaccessibility of avant-garde films while still retaining their self-reflexive quality. 'I tried to solve the problem of accessibility', she writes, 'through the device of mixing modes (documentary, narrative and avant-garde) and genres (*cinéma vérité* and melodrama), in order both to critique film language and also to open it up to non-avant-garde audiences' (1988, p. 52).

WHAT IF I HAD BEEN THE HERO?

Scripted scene in *Daughter Rite* (1978)

The film, then, has its roots in feminist documentaries and their audiences, interweaving scripted and acted scenes shot in the manner of the portrait documentary – as interviews direct to camera – and based on interview material, with optically printed, slowed and repeated home movie footage over which a narrator, who identifies herself also as the film-maker, reads entries from her journal. Each of its two strands – scripted scenes and home movie/journal sequences – features a mother and two daughters, and both strands juxtapose the adult relationships between mother and daughter(s) with the daughters' memories of childhood and adolescence. In both we find powerful but ambivalent feelings towards the mother, and between the sisters. The mother's complicity with patriarchal norms – most evident in the home movie footage in which the daughters are seen being repeatedly groomed for femininity and the vérité sequence in which the younger daughter recounts her rape by a step-father and her mother's refusal to recognise it – results in anger and rejection by the daughters, but this alternates with an identification with her which is both acknowledged and feared.

This is, as B. Ruby Rich and Linda Williams write (1998/1979, p. 218), a daughter's film, explicitly concerned with the identificatory desire for, and rejection of, the other woman who is both mother and sister. It is at the same time a film whose desire is to find a speaking voice which will be bound neither by

the feminine images of the home movie footage nor by the maternal family drama which is repeatedly recounted and re-enacted. Like Betty, its daughters tell their stories, mixing remembered events and dream, but far more explicitly than in *Betty Tells Her Story* the film's own status as constructed discourse is acknowledged and revealed. Memory and dream are self-reflexively presented, as the 'daughters' recount remembered events from childhood and the narrator describes dreams in which her mother is both powerful and destructive. Both contrast with the home movie footage, in which mother and daughters repeatedly smile for the camera but in a manner, as Ann Kaplan writes, rendered 'uncanny' because of the jerky, repeated movements which undercut the apparent harmony of the images. The images function, she argues, 'like the superego to the id that is escaping through the voice-over narrations' (1983, p. 186).

Writing about home movies, Vivian Sobchack argues that their function is not that of exposition or narrative but rather of evocation. We do not look *at* their highly specific images so much as *through* them in an attempt to reconstitute 'the real event or person or our real selves "elsewhere" and in other times' (1999, p. 248). The inevitable failure of these attempts produces the sense of an 'irrevocable loss' which underlies the nostalgia or 'empty sympathy' which such images evoke in us. In slowing, manipulating and repeating such footage, Citron generalises its images, turning both home movie and its affective functioning into object of investigation. Made aware of the constructedness of its images, we focus also on the constructedness of the femininity and maternal relationships that they depict. It is clear that the sense of loss which it is the function of such images to evoke is always the loss of an *imagined* identity and relationship, the identifications solicited always identifications with an imaginary self. For all the apparent presence of the documented footage and the sisters interviewed in vérité style, then, *Daughter Rite*'s primary concern is with absences.

One such absence is of the paternal figure. In neither strand of the film do we find such a figure: the mothers bring up their daughters alone. Yet, as Janice Winship commented in the same year in relation to the cover images of women's magazines, what 'appears to be *central*' in the images, 'the relation of women to women – is simultaneously defined in relation to absent men/masculinity' (1978, p. 134, original emphasis). The absent photographer of the home movie images is, we presume, the father; it is for his gaze that mother and daughters pose in party dresses or performing domestic tasks. In the vérité sequences the paternal figure appears only in the younger daughter's account of her violation, which simultaneously destroys any intimacy between mother and daughter. If the father's absence is also an uneasy presence, however, the more notable absence is that of the mother herself, who is pictured only in the fragmented images of the home movie footage. In a later version of her article on 'naming' in feminist film criticism, B. Ruby Rich contrasts feminist film-making with both a 'Cinema of the Fathers' (Hollywood or 'dominant' cinema) and a 'Cinema of the Sons'

(avant-garde art cinema) (1985, p. 342). *Daughter Rite* is a film which, like Winship's work on women's magazines, seeks to apply a feminist analysis to constructions of a femininity which is also inhabited by the feminist investigator, who thus analyses a shared experience. But it represents a Cinema of the Daughters, its collective understanding constructed through separation from and rejection of the mother. As Rich and Williams write, 'The girl ... in the home movies has grown up and taken over from Dad: now it is she who gets to peer through the lens, this time with X-ray eyes, to visualize the family' (1998/1979, p. 218). We never hear the mother speak; the nearest we come is in the film's closing lines where the narrator *imagines* her mother's voice, which speaks only to question her daughter's own finding of a voice. 'Why do you have to say all this?' she is imagined asking of the film we have just seen.

For E. Ann Kaplan, the film offers two possible viewing positions: those of daughter and of 'spectator-therapist', critical witness to the daughters' construction of the maternal figure (1983, p. 184). It is the latter position which Kaplan prefers as 'the most appropriate critical stance', distanced from the negation of the mother enacted within the film. For other critics, however, the shared position into which the film invites them is that of daughter. Jane Feuer, for example, in an early review of the film, describes herself as 'speak[ing] ... with the voice of the film critic' but watching 'as a daughter' (1980, p. 12). She adds that 'every woman who has a mother' ought to see it (ibid., p. 13). The film cannot imagine the mother as subject, despite the fact that one of the daughters in the vérité sequences is herself a mother. Unlike in *Joyce at 34*, which presents us with another film-maker daughter who is also a mother, we do not see the mother as active subject of history, with her own internal conflicts and her own counter-voice. This is the mythical Oedipal mother, alternately masochistic victim and powerful and phallic.[19] The space of the film is the maternal space, whether this is the mother's house which is uneasily occupied by the sisters in the vérité sequences or the space of memory and dreams constructed by the home movie/journal sequences, and it therefore risks becoming a universally entrapping space in which the daughter(s), too, become disembodied. The daughter remains caught in her relationship of love/hate, likeness/unlikeness with the mother, unable to establish a relationship of difference.[20] For critics like Feuer, the film 'avoids the easy Utopian solution that the *vérité* approach implies', making us see 'that "documentaries," in purporting to be "truer" than fiction, may have been deceiving us all along' (1980, pp. 5–6). It can also be argued, however, that, in moving away from the historical specificity of the documentary subject, its daughters lose their capacity for action and identity in the world and its mother(s) their status as subjects.

In B. Ruby Rich's 1980 categorisation of feminist films, *Daughter Rite* is placed in the category of 'Reconstructive' films, alongside Sally Potter's *Thriller* (1979). Both, argues Rich, seek to 'reconstruct some basic cinematic styles

(psychodrama, documentary) to create new feminist forms' (1985, p. 353). For Annette Kuhn (1982) *Thriller* is an example of 'feminine writing', and for Ann Kaplan (1983) of the 'avant-garde theory film'. It is possibly the most written about of the avant-garde feminist films of the 1970s, because it most closely fulfils the criteria for a politicised avant-garde cinema which was seen by writers like Claire Johnston and Pam Cook as the way forward for feminist film-making.

If *Daughter Rite* depends for its framework on the portrait documentary, *Thriller* draws in a similar way on the narrative structures of popular melodrama and its underpinning romance narrative. Since its underlying text is Puccini's *La Bohème*, it also demonstrates the continuities between 'high art' and popular culture. As E. Ann Kaplan argues, the narrative structure of Puccini's opera is one constantly replayed in the romance stories of the 'woman's film' and elsewhere (1983, p. 36). For Mary Ann Doane, writing about the 'woman's film' of the 1940s, the love story or romance is the generic sub-group which most attempts to represent female desire. Such desire, however, is problematic and dangerous for ideological structures which position the woman as passive *object* of desire, so that the films adopt a number of strategies to contain it. They position it outside social structures, so that it becomes 'an imaginary desire' (1987, p. 114). They produce it as narcissistic, so that the woman is constantly depicted as captivated by her own mirror image – though always 'the image of herself held in the gaze of a man' (ibid., p. 117). They identify it with instability, so that the female protagonist shifts from active subject to passive object of (male) investigation (ibid., p. 36). Finally, to the extent that the woman's desire remains excessive, the films identify it with death: they 'often end badly, frequently with the death of the female protagonist, [their] melodrama verging on tragedy' (ibid., p. 118). For Hilary Radner, the romance thus has at its heart a 'masochistic scenario'; to be 'singled out as heroine', its female protagonist must also be 'positioned as silent'. The romance genre, she writes, is 'built upon the silencing of the feminine voice … [Its] principal object … might be best summarized as the transformation of this loss of "voice" into a dream of love and happiness' (1995, pp. 69, 67).

Potter's film addresses all these issues. Like the other avant-garde films discussed here, it mixes still and moving images, manipulating the speed of the latter, and separates image from voice. Like them it presents us with multiple versions of its female protagonist and a cinematic space – in this case Mimi's attic room – which is an internal rather than a material space. The film begins with a black screen and the voice of *La Bohème*'s hero, Rodolfo, mourning the death of Mimi. As the orchestral chords signalling Mimi's death fade, they are replaced by a woman's laughter, and the black screen dissolves into an attic scene of black actress Colette Laffont seated to the right of the screen, book in hand. As her laughter continues, the scene dissolves into a still of the empty stage set of the opera. Suddenly we hear the shrieking strings which accompany the

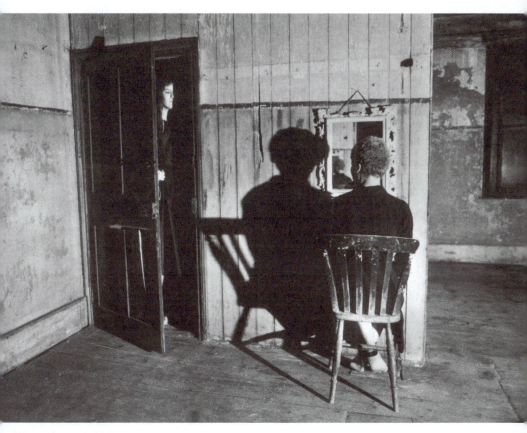

Mimi in *Thriller* (1979)

shower murder of Hitchcock's *Psycho* and the screen shows a second, white woman, only half in the frame. She too is seated on the wooden chair, and we see the legs of two other figures, heavily shadowed, lying on the floor. In the final shot of this pre-title sequence we see the first woman, now seated facing us in front of a mirror, her hand over her mouth, looking off screen into heavy shadow. Behind her the mirror shows us not the reflection of her back but the screen image of her that we see, endlessly repeated in receding mirrors. As the image dissolves into a second shot of her with the mirror, now looking into it and with her image reflected, but at a distorted angle, we hear the sound of a heartbeat, and Laffont's French-accented voice say, 'I'm trying to remember. To understand. There were some bodies on the floor. One of them is mine. Did I die? Was I murdered? If so, who killed me and why? What does it mean?'

Potter's film, then, represents the investigation by Laffont/Mimi of the meaning of the romance narrative of which Mimi is heroine.[21] Just as the screen splits her image into two figures and frequently bisects it with shadows, so the

voice-over investigation shifts between the first and third person: 'When she first looked, she recognised herself as the other. ... And then, as my image turned away, I saw the other side. Was it me?' But the cyclic structure of the film in fact presents a progression: we begin with Mimi/Laffont's recounting of *La Bohème*'s story; we then retrace the story as an investigation of Mimi as split subject/object; finally a speaking 'I' emerges ('Suddenly I understand'), with an analysis which answers her initial questions. As heroine she was, says this now confident Mimi/Laffont, fixed and silenced within the male narrative: 'There was me in the opera and there was me in the attic.' In their stories her material history as classed and gendered (and raced) subject is effaced: 'They produce stories to disguise how I must produce their goods.' Her death was necessary for the romance narrative to function, since 'Without my death ... I would have become a mother. ... I would have become an old woman. ... an old seamstress ... I had to be young, single and vulnerable.' Her death, which 'served their desire to be heroes', was indeed murder.

Like *Daughter Rite*, *Thriller* is concerned with a search for female subjectivity conducted within and against cultural, linguistic and representational structures which position woman as silenced and to-be-looked-at object. As with Citron's film, too, its search for a female subject and speaking/writing voice also involves the search for a relationship with the 'other woman' who is also herself. Here, however, this relationship is prevented not by the absence of separation between mother and daughter, but by the cultural construction of Woman, a single figure with two aspects: Madonna/whore, good woman/bad woman, Mimi/Musetta. Finding a space from which to speak, becoming an 'I', involves, in Teresa de Lauretis's words (1988, pp. 183–4), recognising both the differences between women and the differences *within* women, and distinguishing both from the construction Woman. As construction, then, Mimi is both interchangeable with and opposite to Musetta, the narrative's 'bad girl', who does *not* die since her death can never be a tragedy. 'We were set up as opposite and complementary characters', concludes Mimi/Laffont at the end of the film. 'We never got to know each other. Perhaps we could have loved each other.' As she says this the two women embrace at the attic's doorway, while the male figures exit through the window.

For Judith Mayne, the film's concluding desire to affirm a female bonding which it has suggested is repressed in a text like *La Bohème* is at odds with its investigation of the difficulties of establishing a female identity and female desire (1985, p. 98). Yet *Thriller*, no less than the documentary films considered earlier, relies on rhetorical strategies, leading us, through Mimi/Laffont's self-investigations, to the unambiguous conclusions of a consciousness-raising journey. The space in which the film operates, however, is not the historical space of the documentary but the narrative space of *La Bohème* and the internalised space of Mimi's split subjectivity. It is thus doubly distanced from the material reality of

WHAT IF I HAD BEEN THE HERO?

the working-class woman which the opera is seen to repress in the construction of its heroine, and which it is the concern of *Thriller* itself to render visible. In pointing towards its conclusions, therefore, it must gesture beyond the film, with problematic consequences. One form in which this operates is through the photographs of nineteenth-century seamstresses which are screened as Mimi speaks of her own labour and material existence. The effect of these images, however, is to offer as *truth* the very documentary images that the film is usually seen as undermining, and to position *Thriller* as curiously dependent on the feminist documentary which it is often seen as superceding. For all the film's exposure of the constructedness of both narrative and identity, there is, it seems, a truth outside of narrative which can be captured in these documentary photographs. If the film's structure means that it cannot quite access this truth – these are generalised images of anonymous women – neither can it, as Mayne suggests, construct the alternative *woman's* story repressed within the opera. The *absence* of this story is registered acutely, but, like the embrace between Mimi and Musetta which ends it, the film remains within its internalised attic space, gesturing towards the possibilities of an alternative, woman's story: '*Perhaps* we could have loved each other ...' (my emphasis).

CONCLUSION

'Women's independent/political films,' writes Michelle Citron (1988, p. 54), 'whether documentary or avant-garde', were products of a 'larger social/political context' which made possible their funding, production and distribution to audiences of women who saw themselves as part of the women's movement. Despite the fierce theoretical battles which were fought over their relative merits as a counter-cinema to mainstream narrative film, when we look at them now it is their similarities as much as their differences which seem striking. Both employ rhetorical strategies in their attempts to construct a female protagonist who is both subject – of speech/writing, history, cinema and desire – and embodied, sustained by her relationships with other women. Both are concerned with cinematic language, with the relationships of women to the figure of Woman, and of lived experience to fantasy and desire, with the weight of patriarchal expectations, and with the problems of the maternal relationship. The rhetorical strategies of both groups produce significant repressions. In the case of the documentaries, historical ruptures, discontinuities and differences are repressed, as are internal conflicts and the complexities of desire. Rosenberg notes that in her sample of both groups of films, 'sexuality and sensuality are central themes in 13 sample avant-garde films but not in any documentaries' (1979, p. 72). In the avant-garde film, material historical differences of race, class and generation are repressed, as is the specificity of lived experience. A final repressed desire which they share, I would argue, is for their other: the narrative fiction film in all its

ambiguities. Rosenberg notes with some despair that 'Most documentary film-makers I spoke to wanted to make feature films' (ibid., p. 23), and both Citron and Potter[22] have confessed their attraction to narrative. 'The next expansion of feminist films will go beyond the confines of independent (documentary and avant-garde) film-making, into the mainstream,' concluded Rosenberg (ibid., p. 75). It is a curious formulation with which to close her account of the films, suggesting the constraints and limitations of the films she has been concerned to celebrate. For Michelle Citron, writing in 1988, the move would entail considerable restrictions of independence and control, but she too writes of the limitations of both documentary and avant-garde films. 'Narrative film', she writes, 'is more ambiguous. It allows for contradictions, paradoxes, uncertainties. ... To make narrative films is to take risks. However, these are risks we need now to take' (1988, p. 62).

WHAT IF I HAD BEEN THE HERO?

Chapter Three

UNEXPLORED TERRITORIES

> [T]he itinerary of the female's journey, mapped from the very start on the territory of her own body ... is guided by a compass pointing ... to the fulfilment of his desire.
>
> (de Lauretis, 1984, p. 133)

> Being a woman is unexplored territory, and we're pioneers of a sort ...
>
> (Loden, 1974, p. 69)

Writing in 1979, Jan Rosenberg was cautionary about the desire of women film-makers to move into fiction films. Noting the 'dream' of making feature films harboured by many of the film-makers she interviewed, she comments: 'If women succeed ... in making it in the theatrical movie market (writing and/or directing feature, fictionalized movies which are shown in regular movie theatres), the connection between feminism and film may strain or die out' (1979, p. 114). She lists only two 'exceptions' to her dismissal of feature films, Joan Micklin Silver's *Hester Street* (1974) and Claudia Weill's *Girlfriends* (1978), and, in a book devoted to feminist films and film-makers, discusses neither.[1] A similar absence characterises the very different position of the early *Camera Obscura* collective, whose 'Women Working' section is focused exclusively on experimental and avant-garde film-makers. Finally, Marjorie Rosen, Joan Mellen and Molly Haskell, whose more populist studies of women and cinema were all published in the early 1970s,[2] are equally dismissive. Mellen, who provides the longest discussion of films made by women – at fourteen pages – concludes that 'Films made or written by women have ... failed to offer images of women possessing resiliency, forcefulness, imagination or talent' (1974, p. 30). A slightly later article by Haskell for *Village Voice*,[3] 'Are Women Directors Different?', suggests something of the difficulties posed by these films. Discussing Lina Wertmüller's *The Seduction of Mimi* (1972) and Liliana Cavani's *The Night Porter* (1974), both products of 'that rarest of birds, the woman director ... of commercial, or narrative films', Haskell comments that both pose problems for the reviewer because 'neither woman works within the narrowly realistic or autobiographical modes that we might have expected from women directors' (1975,

p. 72). The Viennese hotel which is the setting of Cavani's film, she adds, 'is more hallucinatory than real'. Fiction film, that is, is more ambiguous, more concerned with the settings and scenarios of fantasy and desire, with narrative and myth, with a discourse that presents itself as *histoire*, with images and identifications. It is, writes Elizabeth Cowie, in 'our public, published forms of fantasy' like cinema that we play out difficult and ambiguous relations 'of self and other, of desire and its repression, as well as the impossibilities of desire'. The dilemma of feminism, she continues, is that it is 'caught between the politics and pleasures of positive, women-centred stories, and the difficulties of fantasy' (1997, pp. 6–7). For Rosenberg, as also, I think, for both the American critics of cinematic 'images of women' and the advocates of the 'avant-garde theory film',[4] those difficulties represented a lure – dangerous for feminism as a political movement. Nevertheless, as Haskell's review indicates,[5] such films were being made, if in small numbers, and I shall discuss some of them in this chapter.

The four films I shall discuss span the decade of the 1970s. Barbara Loden's *Wanda* (1970) was one of the few contemporary feature films to be shown in the first International Festival of Women's Films of 1972,[6] and is mentioned briefly by both Rosen and Haskell. Filmed on grainy 16mm film stock, and with Loden herself playing the central character, it tells of an abandoned and drifting miner's wife from Pennsylvania and her involvement with a petty crook, 'Mr Dennis', and his dream of pulling off a major bank robbery. Released in only one New York cinema and never shown elsewhere in the USA, it received positive but rather uneasy reviews in the New York papers, where Loden's failure to 'come up with a bold new breed of screen woman' was lamented,[7] but it was also screened in a number of European film festivals, winning the 1970 Critics Prize in Venice. More recently, Loden's status as an actress and the second wife of Elia Kazan, Kazan's judgment of her as lacking 'the equipment to be an independent filmmaker' (Kazan, 1988, p. 794), her inability to raise the finance for a second film and her death from cancer in 1980 have combined to intensify the identification of Loden as director with her protagonist, which was a feature of the early US reviews, producing a dominant reading of the film in terms of the pathologised body of Loden herself. In these readings, the film as text disappears, while the body of Loden/Wanda is read symptomatically, for signs of the 'suppressed anger' (Reynaud, 2004/2002, p. 227) beneath the beautiful exterior, an anger that, erupting as liver cancer, would later kill her.[8]

Liliana Cavani's *The Night Porter* (*Il Portiere di Notte*) appeared four years later, although her earlier *I Cannibali* (1970) had also been screened (as *The Year of the Cannibals*) at the first International Festival of Women's Films. Set in 1957, the film concerns the post-war encounter in a Viennese hotel of Max, a former Nazi officer, and Lucia, a young woman now married to an American orchestra conductor, who was his concentration camp victim. Moving between past and present, the film sees the couple replay their earlier sado-masochistic relationship

until both are killed by the group of former Nazis of which Max is a member. Reviews in New York, where the film opened in October 1974, were on the whole savage,[9] with Vincent Canby in the *New York Times* condemning it as 'romantic pornography', and Pauline Kael in the *New Yorker* as 'porno-profundity [which] is humanly and aesthetically offensive' – although in the same issue that Canby's review appeared, Grace Lichtenstein reported that the film, which had been 'both a critical and box-office smash in Europe', 'racked up record receipts on the opening day of its American premiere' in New York.[10] Like *Wanda*, the film won a number of prizes in European film festivals, and critical responses in Europe were both more positive and more academic than US reviews (Marrone, 2000, pp. 225–6). This critical acknowledgment, however, came at the expense of a focus – as in the New York reviews – on the film as specifically the work of a woman director.[11]

Chantal Akerman's *Les Rendez-Vous d'Anna* (*Meetings with Anna*) was released in 1978, three years after Akerman's *Jeanne Dielman*, the film described by *Le Monde* as 'Certainement le premier chef-d'oeuvre au féminin de l'histoire du cinéma.'[12] Its episodic narrative depicts the journeys, and meetings, of a young film-maker, Anna, as she travels from Paris to Essen and back again in order to promote her film. She will return to Paris only briefly, it seems, before preparing to leave for further promotional screenings. Her journey, via Cologne and Brussels, echoes the earlier migrations of her Polish-Jewish family, now settled in Belgium, and the stories of all the characters she meets mirror this sense of displacement. With a larger budget than Akerman's earlier films, an international cast and more commercial distribution – by Gaumont – *Meetings with Anna*, unlike the other films discussed here, nevertheless remained firmly in the 'art cinema' category, receiving its first American screening not in a cinema but as part of the 1979 New Directors/New Films series at the New York Museum of Modern Art. It was, however, felt to be something of an 'aesthetic compromise' (Margulies, 2003, p. 60), reviewed in the *Village Voice*, for example, as 'neither as radical nor as challenging' as Akerman's previous films, 'synthesiz[ing] aspects of its precursors for more popular consumption' (quoted in ibid., p. 74). In the more commercially minded *New York Times*, however, Janet Maslin, reading the film's protagonist as a direct reflection of its director, described it as 'unduly self-indulgent' and 'arid', despite its at times 'mysteriously playful' tone.[13]

Of the four films to be discussed here, Gillian Armstrong's *My Brilliant Career* (1979) comes closest to offering Cowie's 'politics and pleasures of positive, women-centred stories'. An adaptation of the 1901 novel by 'first wave' feminist writer Miles Franklin, it recounts the story of Sybylla Melvyn, a young woman living in the Australian outback and dreaming of a career in the arts. Moving first to stay with her wealthy grandmother, and then to act as governess to a poor outback family, Sybylla finally rejects her rich suitor, Harry, in order

to become the writer of 'My Brilliant Career'. The first Australian feature film directed by a woman since the 1930s, and also having a female producer, scriptwriter and art director, *My Brilliant Career* was the 1979 Australian entry at Cannes and the New York Film Festival, and the winner of seven Australian Film Institute Awards. Financially successful, the film was also critically well received. Critics, however, were uneasy about Sybylla's final rejection of Harry and the 'trumpeting' of feminism which this implied.[14] Janet Maslin's review in the *New York Times* both expresses this unease and once again reads the film and its director in terms of the body of its protagonist. Armstrong, in Maslin's account, becomes the 'daring, assured, high-spirited' young director of a film whose protagonist – having seemingly 'wandered from the pages of a Louisa May Alcott novel into the Australian outback' – similarly 'defies convention, with her flashing eyes and her wicked smile'. Thus the film's disturbing feminist outcome becomes a product of the 'buoyant sense of mischief' which is attributed to both of these youthful – girlish – figures.

In some ways these four films constitute two pairings. The two European films deal with the aftermath of the physical and psychological displacements produced by World War II, their settings the transient spaces of hotels, rented city apartments and railway stations. Lucia's loss of place and identity is echoed in the stories of Anna's mother and her friend Ida, both of whom are living out – though in less extreme fashion than Lucia – fantasies of identity, power and romance which are not their own. In the two 'new world' films, on the other hand, it is the vast landscape that signals the displacement of their protagonists, placing them in a critical relationship to the nostalgic fantasies of the central male characters, whose dreams of home are rooted in the myth of place. In each of the pairings, the later film gives its protagonist access to forms of independence, mobility and self-expression denied the trapped figures of the earlier films, though all stage the difficulty of uniting body, voice and writing. Most important for my purposes, all four films deal with issues which are central to a feminist problematic and which will recur throughout this book: with the question of (heterosexual) romance and its functioning as controlling narrative structure in women's stories; with the importance of masculine myth and fantasy as a structuring force in women's own fantasies and narratives; and with the difficulties in establishing a female authorial 'voice' and subjectivity in the face of such structuring myths and fantasies. These are all, then, attempts to chart another journey, and to trace what happens to space, time and narrative (especially the narratives of heroism and romance) when that occurs. Finally, all four are highly concerned with the processes of cinema itself and its implication in such structures, both drawing attention to elements of cinematic staging and performance within the narrative and using dislocations of time and space to find expression for what Nancy Miller has called the 'desire for a revision of story, ... a desire ... that falls outside the masculinist conventions of plausible

WHAT IF I HAD BEEN THE HERO?

narrative' (1988, pp. 253–4). In the dislocated landscapes of these films, what Teresa de Lauretis (1984, p. 27) has called 'the achieved coherence of a "narrative space" which holds, binds, entertains the spectator ... as the subject of vision' is disturbed, revealing the difficulties entailed in female authorship and what Miller calls its 'revision' of dominant narratives.

'A TERRITORY STAKED OUT BY HEROES AND MONSTERS'

A central question in all four films, then, concerns the romance narrative. In her chapter 'Desire in Narrative', Teresa de Lauretis traces Freud's 'story of femininity', the story of 'the journey of the female child across the dangerous terrain of the Oedipus complex'. It is a story, she writes, which leaves the girl 'forever scarred by a narcissistic wound, forever bleeding'. But the girl 'goes on, and the worst is still to come. No longer a "little man," bereft of weapon or magical gift, the female child enters the liminal stage in which her transformation into woman will take place; but only if she successfully negotiates the crossing, haunted by the Scylla and Carybdis of object change and erotogenic zone change, into passivity. If she survives, her reward is motherhood.' With motherhood comes 'the ambiguous and negative' power to 'refuse, to withdraw', and also to 'undergo separation and loss'. In this transformative process, however, her 'body ... has become her battlefield and paradoxically, her only weapon and possession. Yet it is not her own, for she too has come to see it as a territory staked out by heroes and monsters ... a landscape mapped by desire, and a wilderness' (ibid., pp. 131–2).

This second stage of the female narrative journey, which takes place in a liminal space and time, a space and time belonging at once to fantasy and fairytale and to the body, and where the normal rules of space, time and action are suspended, is the territory of romance. The romance myth, in which 'she' is 'presumed to be the subject' is, in fact, writes de Lauretis, a matter of *her* passivity and *his* desire, and it is in essence a story of sadism. Sleeping Beauty must always be *overcome* by Prince Charming, and the cost of desirability, as the sea witch explains to the Little Mermaid, is a pain so great that 'it will feel as though a sword were going through your body'.[15] Yet this essentially contained and circular narrative space, which begins with puberty and ends with the resumption of normal relations of gendered power in marriage, has become *the* space – perhaps the only culturally sanctioned space – in which female subjectivity cannot only be explored but can dominate. It is a space which must in some way, then, be negotiated by the female film-maker.

The reappropriation of the romance narrative, however, is complicated also by the 'silencing of the feminine voice' that Hilary Radner has identified as one of its primary characteristics. The romance narrative, she writes, 'as a feminine genre, almost inevitably seeks to define the feminine and feminine pleasure in

terms of silence' (1995, pp. 67–8). The melodramatic articulation of female subjectivity and desire through music, costume, bodily and vocal symptom and *mise en scène*, rather than speech, is familiar to us through the 'woman's film'. If, as Kaja Silverman writes, it is a characteristic of mainstream cinema as a whole that it 'holds the female voice to the female body' (1988, p. 162), while the male voice is permitted to transcend this limitation in assuming the authoritative form of disembodied and extra-diegetic voice-over, then the romance narrative performs such 'holding' as containment, repeatedly returning the female voice to the silence of the displayed body. We might remember that the Mermaid's 'beautiful body' and 'lovely eyes' were purchased at the cost of her voice ('Now she was mute, she could neither speak nor sing'), and the *Taming of the Shrew*, which Radner identifies as the true 'ur-narrative' of romance (1995, p. 13), has at the heart of its story of sadism a silencing. This story of silencing is also one which the female film-maker, herself by definition a 'shrewish' woman whose 'voice' transcends the film's diegesis, must negotiate.

The four films discussed here tackle the question of the romance narrative and its accompanying silencing in two distinct ways. In the earlier films, *Wanda* and *The Night Porter*, we find ourselves within this liminal space, with the contours of the myth and its entanglement in more dominant masculine myths of nation and identity exposed through a female protagonist who remains damaged and silenced. In the later *Meetings with Anna* and *My Brilliant Career*, however, not only do we find a female subject of speech/authorship *within* the film, but the extra-diegetic presence of the film-maker-writer is foregrounded, setting up a critical distance from the narrations and silencings enacted within the text, and posing more explicitly questions of separation and loss.

Wanda begins in the bleak aftermath of the moment of romance. The first shots of the film place us in the industrial landscape of the Pennsylvania coalfields. Beginning with an extreme long shot, we shift to the repetitive motions of dump trucks moving coal from slag heaps, and then into a cheap house on the edge of the coalfield. An old woman sits knitting, looking out of the window; behind her is a small religious cross and a photograph of a man in naval uniform. As the camera pulls out, we see a US flag in the pane of an internal glass door. A toddler crosses the room to sit beside the woman, and we see an exchange between its mother and her husband as he leaves the house, accompanied by the crying of the baby she picks up and begins to feed. In this very precisely positioned scene, Wanda is out of place. Lying on the couch, with hair curlers and empty beer cans beside her, she comments, 'He hates it 'cause I'm here.' She begins to get dressed. In one of the ellipses that characterises the film's editing, the next shot positions us outside, as the camera moves left to right across the grey waste of the coalfield, in a tracking shot which lasts almost two minutes and begins with Wanda as a tiny sharp white figure in the vast grey industrial landscape, then slowly zooms in to follow her as she asks an old man

Wanda (1970): Wanda in the empty shopping mall

picking coal to lend her money. For Reynaud (2004/2002, p. 235), the shot is 'quasi-magical', an impression heightened by the absence of sound: we hear only the low drone of machinery and the occasional muffled barking of a dog. From this point we do not see Wanda in a domestic setting again.

In the remaining opening sequences of the film, we see Wanda further cut adrift, first from motherhood, then from employment, and finally from any remaining self-image. Outside the local courthouse she pauses before a huge war memorial which lists the names of American fallen heroes; inside, when the judge in her divorce hearing demands, '*Did* you desert [your children]?' she can respond only with 'They'd be better off with him' (her husband). Refused employment in a clothes factory because she is 'just too slow', she thanks the manager who rejects her. Finally, after a brief sequence in which she is picked up and then abandoned by a travelling salesman, we see her in the no-place of an almost empty shopping mall. She lingers in front of shop windows whose blonde mannequins, shot from behind and seeming to dwarf and entrap her between them, offer idealised versions of herself. In a rare point-of-view shot, we see her look up at one, its face and hair a mocking mirror of her own, before averting her eyes and walking away.

When, then, she meets Mr Dennis, the petty thief into whose attempted bank robbery she will be drawn, and the narrative assumes a shape, it is clear that *her* dream of romance ('Mr Dennis, don't you want to know what *my* name is?'; 'Are you married?') is both bounded by and dependent on *his* fantasy of outlaw

heroism. Her body, in de Lauretis's terms, is 'staked out' by him. He dresses her ('Why don't you do something with your hair?'; 'I thought I told you to get a dress'; 'No hair curlers. Makes you look cheap') and rehearses her for the robbery with a handwritten script. It is a fantasy scenario in which he is not only writer and director but also star, and she is supporting actress and audience. When, as they stand in front of the hotel mirror, he urges her to agency ('Maybe you never did anything before. … But you're going to do this'), the mirror reflection shows her looking down, shrinking away as he grasps her shoulders. It is he who gazes into the mirror, his identity and agency which are at stake in her failure to play her role.

Wanda's passivity is broken only by three brief moments of agency, all of which are marked by a finding of her voice, in a film in which she is otherwise almost silent. The first serves to undermine his fantasy. With Wanda in silent and puzzled attendance, Dennis performs the elaborate process of stealing and starting up a car, only for her to reach up to the sun visor and take down the keys, asking 'Why don't you use these?' The second, however, is fully bounded by that fantasy as, during the overpowering of the bank manager and his family, Dennis loses control and it is Wanda who seizes back the gun and briefly takes control, before relapsing once more into silence and passivity. In the final instance, after Dennis's death, Wanda breaks away from the soldier who has driven her onto waste ground for sex. She escapes, screaming and crying, and the camera gives us a brief glimpse of the blue sky above the treetops. In the final freeze-frame of the film, however, we find her once more being bought drinks and food, a silent member of the audience for a country band, isolated, alienated and displaced.

In *Wanda*, then, the feminine dream of romance functions in relation to a far more powerful masculine fantasy of outlaw heroism. It is this which drives the narrative after Wanda's early aimless wanderings, and whose demands are behind those brief moments of apparent tenderness which might fuel *her* fantasy. Just as Wanda's desire for food – the only desire she expresses directly in the film – is fulfilled only in the service of Mr Dennis's own plans, so her fantasies of relationship subsist only through those gestures which, in fact, serve his goals. Yet if Loden's protagonist remains firmly pinned within this masculine fantasy, her film, with its temporal and spatial dislocations and recurrent imagery of a tarnished American dream which is synonymous with that fantasy, invites critical reflection on it.

Dennis's journey is circular, 'not going anywhere' as actor Michael Higgins (Mr Dennis) commented (Reynaud, 2004/2002, p. 237), trapped within an industrial wasteland which is largely featureless. The film's diegetic space, as Reynaud points out, is structured without a vanishing point, and Loden herself commented that she always saw her characters '*in* something, surrounded by something' (Carney, 1985, p. 130, original emphasis). There are two exceptions

to this entrapment within landscape, both of which offer critical commentary on masculine myths of escape and transcendence. In the first, Wanda and Mr Dennis have stopped at the roadside. Dennis, his movements unsteady after his consumption of whisky, beer and pills, places his jacket round her shoulders and suggests she cover her hair, ambiguous gestures which can be read both as a nascent tenderness and as the beginnings of the plan to involve her in his bank robbery. 'If you don't have anything you're nothing,' he says. 'You're not even a citizen of the United States.' As the noise of what proves to be a remote controlled toy plane invades the filmic space, Dennis gazes upwards, searching for the plane. Losing control, he climbs on top of the car and reaches skywards, shouting and gesturing after the disappearing plane. The camera follows him in this Quixotic gesture, soaring above the landscape and framing him against the sky, an absurd and tiny figure.

The second instance of fantasised transcendence comes as Dennis visits his father before undertaking the bank robbery. The scene is shot in Holy Land USA, a 17 acre site standing above Waterbury, Connecticut, which contains a miniature Bethlehem, catacombs and a Garden of Eden. Already crumbling and tawdry, in 1970 it was still the site of pilgrimage bus tours. Against the sound of recorded hymn singing, Dennis and Wanda approach an empty clearing above the city, dominated by a monument labelled the 'Tower of God' which an old man, Dennis's father, is tending. Cutting between the uncomfortable encounter between Dennis and his father in a decaying chapel and Wanda's participation in a guided tour of the 'catacombs', complete with Christ on the cross and figures of bloodied martyrs represented by shop mannequins, the episode brings together a number of the film's recurring images. The scene of Dennis's humiliating failure to fulfil his father's dreams of success and his own Oedipal fantasy, it also suggests the destructiveness of this fantasy, dependent as it is on sentimentalised images of heroic martyrdom, and its entanglement with a self-righteous but commercialised and fake vision of America as God's promised land.

Space in *Wanda*, then, has a doubled quality, at once observed with documentary precision and having the distanced quality of a surreal fantasy. Similarly, we have a doubled sense of time. Raymond Carney has commented that the film's frequent editorial ellipses cause it to 'jump rapidly and unpredictably between scenes to create a feeling of extreme rush and haste' (1985, p. 152). At the same time, however, time often seems frozen. From the silent chorus of old women and men on whom the camera frequently lingers, for whom time seems to have stopped, to Wanda herself, whose speech and small actions are performed with a painful hesitation, this frozen quality serves to distance us from the frantic actions which characterise Mr Dennis and his outlaw narrative. In Wanda's almost slow-motion actions, too, and the long moments when she simply holds a facial expression or bodily position, as if absorbing a

Pain and loss in *Wanda* (1970)

pain – and at times a realisation – which cannot find expression, we can trace the contours of an unnameable melancholy and sense of loss.

Critics have wanted to see *Wanda* as a narrative of doomed romance. Even Reynaud, who insists that '*Wanda* is not a love story' (2004/2002, p. 241),[16] nevertheless describes Mr Dennis as 'a drowning man uttering a word of love'. Reviewers noted its parallels with *Bonnie and Clyde* (Penn, 1967), released three years earlier,[17] and, more recently, Brian Pera has commented on its referencing of Hitchcock's *Marnie* (1964). While the reviews noted parallels, however, for Pera it is the contrasts that are important. Whereas in *Marnie*, he writes, 'Connery's attempts to make over Hedren are depicted as heroism, as a man saving a woman from herself', in Loden's film Mr Dennis's attempted transformation of Wanda reveals 'his own issues of insecurity and instability, the fact

WHAT IF I HAD BEEN THE HERO?

he needs to make her over not to rescue her but to define himself' (Pera, 2008).[18] What Estelle Changas, in an early review, calls Wanda's 'road adventures' (1971, p. 50), undercut 'all the optimism' implicit both in the road movie's transformation narrative and, as a highly critical early interview suggests, in the American dream that underpins it.[19] Yet far from being 'limited' by its 'subjective vision', as Changas concludes, *Wanda* offers a commentary on those narratives and their underlying myths. Wanda herself remains trapped within her world, the final freeze-frame showing her once again trading her silence and passivity for food, but the film positions *us* as critical outsiders.

HEROISM AND FASCISM

> Subjectivity is installed not only through an identification with external images, but through the 'click' of an imaginary camera.
>
> (Silverman, 1988, p. 161)

In *The Night Porter* heroism and romance are present most apparently at one remove, in the performance of Mozart's *The Magic Flute* which Lucia and Max attend and Lucia's American husband conducts. The opera's narrative and Mozart's music provide, as we shall see, a persistent counterpoint to the first half of the film. In one early flashback-fantasy scene, however, we find these themes more directly addressed. The earliest flashbacks we see, after Max and Lucia first encounter each other in the lobby of the Hotel zur Oper, alternate their memories of their first meeting. Lucia, a child[20] in a pink dress, brooch and matching pink hair ribbon, is picked out of the line of concentration camp victims by Max's film camera and its blinding light. Her face is bleached and frightened, and she turns her head away. The memory is intercut with Max's reverie in the present, framed against a poster of *The Magic Flute* and a newspaper page showing a bridal photograph. A few moments later, Lucia looks into the mirror of her hotel bathroom and we see there (through the looking-glass) the reverse image of Max's view: Max's camera and the light approaching her/us, threatening and blinding. The flashback which follows, however, beginning as Lucia cowers in the bathroom having heard Max in the next room talking to her husband, is quite differently constructed. We see Lucia on a merry-go-round, again in the pink dress, brooch and hair ribbon, with her outfit completed by white buckled shoes and knee socks, and a white cardigan carefully tied over her shoulders. She is one of a group of girls on the merry-go-round, all similarly dressed, and now her face wears lipstick and makeup, and her look is expectant and knowing. The girls seem alternately suspended in mid-air by ribbons and fixed in seats secured firmly by chains. Lucia, that is, is ready for her prince: a child on the edge of adulthood, at once innocent and knowing, vulnerable and alluring. She is Gigi and Cinderella, a 'little girl'[21] whose desire is, to quote

Valerie Walkerdine, 'without an object, a desire that must float in space' (1997, p. 173). Such desire, writes Walkerdine, will be 'colonized by masculine fantasies, which create female desire in its own image'. But, she adds, the girl/daughter will in turn take 'those fantasies to [her] heart and [her] unconscious, making them [her] own' (ibid., p. 181). The merry-go-round sequence is broken by what seems to be a reverse shot. The sequence is shot from below and we cut to a close-up of Max with his camera pointing upwards, so that it is his cinematic construction we are watching, even though the reverse shot is strictly impossible, since he remains in the camp, filming amid the line of prisoners. What Lucia's memory sequence shows us, then, is her internalised self-image as it is constructed for her by Max's cinematic fantasy. Finally in the sequence, the brutal nature of the relationship thus constructed is revealed when the whirr of the camera which accompanies the scene gives way to the sound of gunshots and screams, the sounds continuing as the flashback returns us to Lucia in line, being filmed by Max.

This identification of Lucia as 'little girl'/princess to be imprisoned and 'rescued' is continued in the first half of the film by the constant references to the narrative of *The Magic Flute*. Critics[22] have noted that, as Lucia attends the opera and becomes aware of Max staring intensely at her from a few rows behind, the duet between Pamina and Papageno which celebrates the joys of marriage accompanies, in perfect time ('Man and wife, and wife and man. Man and wife …'), her flashback of a guard raping a male inmate while watched by a silent audience of ragged prisoners. As the opera continues, however, there are further mirrorings. As Max, dressed in a doctor's white coat, removes Lucia from the silent audience of prisoners and we see her chained to a bed, arms above her head, while Max's fingers rhythmically penetrate her mouth, we hear Tamino, the rescuing hero, sing of his love for the absent Pamina ('Perhaps Papageno has found her and is bringing her to me'). And later, as Lucia walks through the streets of Vienna, passing the 'Mozart Erinnerungs-Räume' (Mozart commemorative – or memory – rooms), we see a flashback of Max, in a parody of the romantic hero's decisive act of tenderness,[23] first swab and then kiss the bleeding wound[24] on her arm which is the mark of her identity as concentration-camp inmate, accompanied by the duet of Tamino and Pamina as they find one another in Zarastro's educative prison.[25] In this act, which is once again watched by a spectral group of prisoners, Max performs as both father (Zarastro) and hero (Tamino). Lucia remains passive and withdrawn, but her face registers an increasing fascination.

Like *Wanda*, then, *The Night Porter* features a male fantasist-storyteller who constructs himself as hero and seeks to position his captive child-woman within a fantasy narrative which has powerful social and cultural endorsement. In his own narrative, Max is actor ('He had fun passing himself off as a doctor,' says Klaus), photographer, film-maker and father-hero. Like Mr Dennis, he is also

The Night Porter (1974): Max kisses Lucia's wound

Pygmalion, dressing his 'little girl' – who remains a child, frozen in time – to play her part in his narrative. Far more overtly in this film, however, this is a profoundly sadistic narrative, revealing the links between voyeurism and sadism, victimhood and absorption, and it is endorsed by a far darker social power structure than the American Dream which underpins Mr Dennis's outlaw fantasy. Cavani's use of the Nazi concentration camp as her scenario was condemned by early reviewers who saw it as 'horror décor' (Kael, 1974) for the film's 'pornographic' exploitation, and has been viewed with unease by later critics,[26] but it is precise and purposeful. It is the patriarchal and, as Marguerite Waller (1995, p. 212) terms it, 'hyper-masculinist' power structure of Nazi Germany, with whose uniform Max is constantly associated[27] and for which, it is made clear,

WHAT IF I HAD BEEN THE HERO?

he acted as both photographer and executioner, that gives his fantasy narrative both its power and its legitimacy. But this is a structure replayed also within the high culture of post-war Vienna, as well as within the much older fairytale narrative whose sadism is masked by music and play in the eighteenth-century opera watched by the Viennese audience. At the heart of the fairytale is the 'little girl's' imprisonment and erotic relationship to the father. Like the fairytale princess, Lucia must be frozen in time; like Pamina or Beauty or Bluebeard's young wife she must be imprisoned. As the father/hero, Max 'saves' her by raping her,[28] and at the end of the film he forces her feet once more into the 'slippers' that she wore as a child/princess as he leads her to her death.

Two elements, however, complicate this narrative further. The first, emphasised by Kaja Silverman in her reading of the film (1980), is the ambivalence of Max's own positioning within the later playing out of his fantasy. His insistence that Lucia is still his 'little girl' cuts him off not only from the social world of post-war Vienna, from which he is already alienated in his preference for the dark, self-reflecting spaces of the hotel at night, but also from the group of former Nazis who seek to wipe out all witnesses to their past. Divorced from the legitimating structures which endowed his role as father/doctor/cinematographer/voyeur with power, his own weakness is revealed. His uniform as night porter, without the crucial swastika insignia, persistently renders him as servant not master, and we begin to see the ease with which, as Freud suggested,[29] the masculine sadistic fantasy slides into its reverse, a masochistic fantasy which enacts both desire for and identification with the position of victim. Locked in his apartment with Lucia, he begins by replaying his role as father/torturer/saviour, but increasingly he and Lucia move between roles, so that he is positioned not simply as parody of the nurturing hero,[30] carefully slicing bread into strips and lifting the weakened and childlike Lucia from the toilet, but as himself on the side of the feminine: cut, confined, sexually passive, investigated, the object of both the gaze and the gunshot. If *his* identity as powerful and sadistic father/hero is dependent on *her* positioning as passive daughter/victim, it is even more dependent on the sanction of an external structure whose cultural myths and systems of social power habitually reinforce it.

The second element which complicates *The Night Porter*'s narrative is Lucia's own complicity in Max's fantasy. The flashback scenes show her move from repulsion to passivity to complicit performance, and her re-encounter with Max repeats this process with a startling rapidity. The scene in which her complicity is sealed is the flashback scene of her performance of Dietrich's cabaret song, 'Wenn ich mir was wünschen dürfte', a song about the difficulties and ambiguities of (female) desire, to an audience of masked musicians, Nazi officers and

The Night Porter (1974): Max leads Lucia to her death

prostitutes. It is a scene which begins in Max's narration to the Countess: not, he insists a 'romantic' story despite his rediscovery of his lost 'little girl', but a 'biblical' one. In it, Lucia, a sexualised androgynous figure dressed in 'oversize trousers with suspenders that could hardly hold them up, bare chested and an SS hat on her head' (Cavani, quoted in Marrone, 2000, p. 111), performs to an expressionless audience amid Nazi regalia and sexual symbols. The viewpoint is chiefly that of Max, positioned, gazing intently, at the edge of most of the frames, but the spectacle is distorted by camera angles and tilts. Lucia is at once child, androgyne, sexual object and fetish, but her performance, controlling space and the look, gives her a kind of power. The illusory nature of this power is revealed, however, when she is presented with Max's gift, the head of fellow-prisoner Johann who 'used to taunt her', and her expression turns from pleasurable expectation to horror and revulsion. Her performance, she is now compelled to see, has been that of Salome, daughter, seductress and symbolic murderer, her brief moment of power revealed as both illusory and complicit. Two final points further emphasise this absence of structural power. First, this is a *licensed* moment of carnival, as the watching SS officers make clear. Second, as with the earlier image of Lucia as princess, it is clear that it is *Max's* fantasy we are inhabiting here.

When Lucia is drawn back to reinhabit the fantasy, then, it is not, as with Bert, the homosexual dancer, an attempt to recapture his/her own fantasised moment of power – in Bert's case the performance of the ideal (eroticised) male body for the same audience of Nazi guards. Bert, seeking to recreate that moment of imagined transfiguration, is compelled to repetitively restage the performance, but now as cinema, with lights and mirrors/screens replacing audience and physical space, and with Max as director and sole audience. For Lucia, though, however she may tease, reverse roles and commit her own small sadistic acts within its boundaries, it is the space of Max's fantasy to which she must return. The chains which were implicit in the merry-go-round scene are now literal, and her regression to the position of child – the position in which she was loved/beaten and had a fragile power because of this[31] – is extreme. At the end of the film, when Max once again puts on his Nazi uniform and dresses Lucia in a/the pink dress, white knee socks and child's shoes, she is completely passive and broken.

Like Wanda, then, Lucia can find no alternative narrative to the masculine fantasy that absorbs her. For Molly Haskell and Teresa de Lauretis, two feminist critics of the 1970s who did like the film, this is precisely the point. Haskell's argument that Lucia's surrender to 'the "unspeakable" requirements of her enemy-guardian' plays out 'what is traditionally a woman's way of surviving', but in extreme and hallucinatory form (1975, p. 72), is developed further by de Lauretis. 'The way in which Lucia is victimized,' she writes, 'the truth she discovers in herself and lives out, the imagery of her bondage to the Father ... are a

WHAT IF I HAD BEEN THE HERO?

true metaphor, however magnified, of the female condition' (1976–7, p. 37). As in *Wanda*, the power of this 'bondage' is underwritten by the all-pervasive power of a dominant cultural myth. If Mr Dennis's fantasy has the Holy City and the American Dream on its side, then the darker version of Max[32] is underwritten not only by the 'hyper-masculinist' myth of Nazi Germany but by a far longer tradition of European culture. Like *Wanda*, too, while the film shows us this myth, and its power, it shows us in distanced form. This is not the oppressive vast landscape of Wanda's world, but an equally oppressive world of reflected and refracted interiors: mirrors, hotel rooms, apartments, doorways, corridors and staircases, tiny shops crammed with memorabilia. Andrea Slane has commented that the film 'eliminates any point of origin, making both the "original" interactions in the flashback concentration camp and the "re-created" sexual scenarios in the present equally theatrical' (2001, p. 262). It places us, in other words, in the world of cinema and theatre, myth and fantasy, but its shifting and mirrored points of view, its counterpointed narratives, unexpected edits, angles and lighting, its disturbing discontinuities of sound and image, all make us aware of its constructedness. Its camera, as Marguerite Waller suggests, 'seems to want us never to mistake for mimetic representations its "signifying" plays on the images it gives us' (1995, p. 216). Like Wanda it suggests no escape, and only small rebellions, for its central female character. In an ending which is even more bleak than that of the earlier film, Max and Lucia finally step outside and move forwards, away from us, across a wide and modern bridge in the dawn light. But they are still performing their roles as 'little girl'/princess and father/hero, and they walk to their deaths.

AUTHORIAL JOURNEYS

> I would like to carve out a … space from which it might be possible to hear the female voice speaking once again from the filmic 'interior,' but now at the point at which an authorial subject is constructed rather than as the site at which male lack is disavowed.
>
> (Silverman, 1988, p. 188)

Silverman's distinction between the author 'in' the text and the author 'outside' it, though not used in quite the way I shall employ it here,[33] nevertheless provides an important way of distinguishing between the two pairs of films I discuss in this chapter. While both *Wanda* and *The Night Porter* very clearly draw attention to male 'lack' and expose the process of its displacement onto the female figure, neither can offer a female subject of speech/authorship *within* the film. Put differently, the feminism of both films is 'outside' the text: what is examined within it is the construction of femininity, so that its female character struggles, and fails, to find a voice and a story. In *Anna* and *My Brilliant Career*, however, feminism is also inside the text, embodied in the figure of the female film-maker/writer.

HI/STORIES: *LES RENDEZ-VOUS D'ANNA*

> [T]he methods and approaches of traditional histories have proved problematic for feminists, not least of all because so many documents preserved from the past offer only limited traces of women's presence, while presenting massive evidence of their marginality and repression.
>
> (Petro, 1994, p. 66)

Twenty years after Lucia's return to a Vienna saturated with Holocaust memories, Chantal Akerman's film-maker protagonist, Anna, makes a similar journey. This, too, is a journey into memory which is both personal and heavy with the weight of a brutal history, and its protagonist, like Lucia, is a displaced, homeless woman whose journey is traced through the transient spaces of hotel rooms and city apartments. There are crucial differences, however. If *Les Rendez-Vous d'Anna* is, like *The Night Porter*, a 'war film', as Lynn Higgins (1999, p. 59) has termed it, in this case it is Anna's mother and her generation who lived through and then escaped the Holocaust, so that Anna becomes the investigator of these memories rather than, as with Lucia, becoming reabsorbed by them. One generation on, Anna's return is as a film-maker, not a wife, and it is made alone. She is mobile, a figure of *vagabondage*:[34] passing through, throwing open the windows of each hotel room or train carriage she enters, she performs a role that has traditionally been seen as male, as we are reminded by the silk tie she finds in her hotel room and the difficulty that the desk clerk has with her status as *female* film director: 'C'est vous la réalisatrice – on dit comme cela, n'est pas?'[35] Finally, and most obviously, the film's – and our – gaze at this journey is very different. We are not, as we were in *The Night Porter, inside* this world of mirrored interiors, where everything – every look, every movement – leads back into an inescapable past. The camera is static, the long takes framed symmetrically and in long or medium shot, often from a low angle, with an absence of close-ups or point-of-view shots and with clear edit breaks between shots. As spectators we are pushed away, forced to search, as Meg Morley suggested in an early review, 'for a reading' (1979, p. 213), scrutinising the frame and looking beyond it as characters walk away or move out of shot.

The effect is one of dislocation and unease. Film-maker Anna is a precise observer of detail – as we see in her description of the tie she finds – and an attentive listener to the monologues of others, in each case moving closer to touch the speaker at a key point in their narrative. But for the most part she herself speaks very little and her speech is often awkward, 'out of step with the situations', as Morley noted (ibid., p. 214). There is no sign of her *as* film-maker, and her journey is not of her own construction: its itinerary is planned for her, and her 'meetings' are either chance encounters or responses to the desires of others. Critics have noted Akerman's 'self-inscription' (Foster, 2003, p. 3) within

WHAT IF I HAD BEEN THE HERO?

the film: like Akerman, Anna is Belgian, lives in Paris and has a Polish (Jewish) family who fled Nazi Germany. But if Ivone Margulies can argue that *Les Rendez-Vous d'Anna* is therefore both Akerman's 'film on Europe' and her 'most Jewish film' (2003, p. 61), her protagonist is also, like Barbara Loden's Wanda, a 'Hitchcockian' blonde – chosen for her *unlikeness* to Akerman herself and for the lack of facial 'transparency'.[36] The film-maker is, then, at once an authorial presence within the film and abstracted from it. Unlike Barbara Loden, she cannot be pathologised as the body of/inside the film, but nor can she be seen straightforwardly as a hero-protagonist, self-consciously retracing her mother's journey in order to tell her story.

What Anna encounters are the narratives of others, each recounted in a transitional space – a station, a train, a footpath, a hotel room – and spoken in a monologue during which Anna remains silent. The characters she meets before her return to Paris form two pairs: the two men are youngish and German; the two women are older – Anna's mother and the mother of her former fiancé – and are displaced Polish-Jewish survivors of Nazi Germany. Margulies has noted the way in which both male characters merge their own story with 'platitudinous' (ibid., p. 67) and generalised historical accounts. Put another way, both construct romanticised accounts in which the idea of nation as 'home' is irretrievably mixed with the notion of family and a beloved woman who 'belongs' there. Heinrich, the German teacher who remains in the house of his father and grandfather, constructs a version of German history composed of classical music, flowers, an unchanging small town – he is unable to see that it is now a suburb, surrounded by roads and railways – and male friendship. It is a history which draws no distinctions between the communists and the Nazis: in his account both brought hope, both were later killed or imprisoned. Post-war, the country was invaded, he says, by 'Russians, Americans, British, French and Belgians', and divided in two. Finally, his friend Hans, a 'truly good man', lost his job through 'unpatriotic activities' – whether right or left wing we do not know, since Heinrich seems to draw no distinctions between the two. 'What have they done to my country?' he asks finally. Heinrich's narrative, then, is of a lost masculine identity, in which national 'wholeness' and the music of Handel and Mozart are identified with the performance of male friendship ('We'd sing [Don Giovanni] together, acting out all the parts'). The betrayal of this national ideal by 'others' merges in his narrative with the betrayal of his wife who despite his love eloped with 'un Turc, un homme très brun' – the casual racism serving to remind us of that which is missing from Heinrich's narrative of a betrayed German greatness. It is a narrative in which he also seeks to place Anna – 'I feel as if I've known you forever'; 'The whole family loves you already' – as the new object of his romantic fantasy and the replacement mother for his daughter.

The second German, with whom Anna shares a cigarette on her journey to Brussels, appears to be a mirror opposite of Heinrich. He cannot bear to stay in

Les Rendez-Vous d'Anna (1978): Anna with Heinrich

Germany, and recounts his travels through Belgium ('the land of plenty'), South America ('a strange climate, hot and humid') and the rest of Europe. But his, too, is a hero narrative, a narrative of 'the road' which forms another ironic counterpoint to Anna's own travels. It is a journey through 'gunfire, footsteps, noises, smells' and women, in which the ideal country will contain both 'justice, a grand and glorious thing' and romantic love – 'a woman whom I'll love and who will love me'. And he, too, seeks to place Anna within his story, both in the past, in Belgium, and in the future, in Paris. Both men, then, tell grand stories of melancholic loss, but in both cases the grandeur is undercut by the banality of the account, and the narrative is stripped of its authority by being bound to the embodied experience, and desire, of its author. If, as Kaja Silverman writes, classic cinema persistently locates the female voice within the (to-be-looked at) female body, so that it is always diegetically contained (1988, p. 45), while the male voice more often 'speaks from an anonymous and transcendental vantage point, "over" the narrative' (ibid., p. 163), then this strategy is reversed here. Authority rests with the female film-maker, who can neither be contained within the male narrative nor, since she is not identical with her 'Hitchcockian' alter ego, be placed with any certainty within the text itself.

WHAT IF I HAD BEEN THE HERO?

The second pairing is of mothers. In Ida's story, the grand is replaced by the mundane, and melancholy by an everyday loss of hope,[37] in a monologue which echoes Juliana Schiesari's account of the 'gendering of melancholia'. While male melancholia is traditionally seen as a privileged state, argues Schiesari, giving rise to a heightened representational power, women's 'lower-valued' form – depression – is seen as an 'everyday' condition which is unable to represent/articulate itself. 'And not only is the male form empowering and the female one disempowering,' she writes, 'but melancholia is romantically garbed in the past while depression is given only the banality of the present' (1992, p. 16). Thus, while Ida's story refers obliquely to the war – 'all those terrible things that happened' – these are events which had effects on *her husband*; she does not, as the male characters do, appropriate them for a personalised history with herself at its centre. Her own depression is caused by the everyday cruelties of her husband: 'my husband's become irritable and fussy ... he yells over nothing at all'. The thwarting of her own early desire to be an artist is mentioned only in passing; what frames her narrative is the loss of romance: 'I remember when I fell in love with my husband. I was thirteen. ... I was so proud to walk down the street with him.' Like Heinrich, it seems, her husband projects his own loss onto her ('he ... seems to blame me for all that's happened'), but she remains imprisoned within his story, seeking, like the men, to position Anna within it, and alternately accepting and rejecting Anna's own very different status: 'Why write if you don't love each other? Let writers write.'

Anna's mother, whom she meets on the station in Brussels before returning to Paris, tells another version of Ida's story. She too is displaced, continuing to struggle with a second language (the women in the film have had to learn to speak in a language not their own; the men must do it when they encounter Anna, who speaks only in French), and preoccupied with her husband's decline: 'He sighs and becomes withdrawn. I try to boost his confidence. ... His gaze is turned inward.' As with Ida, Anna refuses to return 'home' with her, instead seeking a hotel room for the night. Here, however, as the two women lie in bed, in the darkened room that invokes both memory and dream (and, psychoanalytic film theory tells us,[38] cinema itself), Anna herself tells a story. It is a story of desire for an Italian woman, unexpected and, unlike the heterosexual narratives, founded on mutuality of desire and storytelling: 'She told me about herself, and I told her about myself. ... We kept on kissing, and then it all became very easy.' It is a relationship patterned on that with the mother ('for some strange reason I thought of you'), not the father. Recounting it, Anna first asks her mother, 'Have you ever loved a woman?', and then moves from this narrative of desire to a memory of a shared childhood moment with her mother in which we see what Kaja Silverman calls 'the endless reversibility of their relative positions' (1988, p. 153),[39] ending with an embrace which closes the scene. This, then, is a very different story from the melancholic hero narratives that

Ida's monologue in *Les Rendez-Vous d'Anna* (1978)

the male characters have told, or the loss of, and imprisonment within, the dream of romance which has structured the mothers' stories. It is suggestive of Silverman's account of a (usually repressed) desire which is at odds with the 'normative and normalizing' desire for/of the father (1988, p. 123), one in which identification and desire are both interchangeable and reciprocal, and which might, she suggests, form the basis for a female speaking and desiring subject.[40] As recounted here, however, it is a story told in absence. Anna's journey is punctuated with failed attempts to telephone her lover in Italy (the line is always too busy or subject to time delays), and though the storytelling is made possible by the return to her mother, it is clear that this is a fleeting and partial return. If, then, the story suggests the basis for an alternative female/feminist desire and narrative, it is a narrative squeezed between alternatives which invoke the weight of history as well as tradition, and one characterised, like the film itself, by the split between storytelling and embodied desire in the present.

Anna's final meeting in the film is with her lover Daniel in Paris. As with the other men, Daniel's monologue mixes grand themes ('I think I should try to fix things … a better life … food for everyone') – though this time set in the

present not the past – with a fantasised image of home and children ('I'm going to get a bigger place. That way if I have children …'). Like them, too, he seeks to fold Anna into this fantasy. 'What is lovelier than … a woman's voice,' he says, and then, 'Will you sing for me?'. Anna resists, but then, standing next to a blank and flickering television set, complies, performing an Edith Piaf song, 'Les Amants d'un Jour'. The song forms an ironic counterpoint to the scene we are viewing, telling the story of two young lovers – 'chérubins portant le soleil' – who commit suicide in a cheap hotel room. In the person of its barmaid narrator, however, it also tells of a life 'banal à pleurer', and in its referencing of Piaf it returns us once more to a wartime history of transient spaces and failed dreams which recurs throughout the film. For Margulies, 'the film's emotional and intellectual core lies in Anna's singing' (2003, p. 71), but this is an enactment of *Daniel's* fantasy of romantic loss from which Anna remains doubly distant, first through the figure of the song's narrator and second through its status as performance. It is a fantasy Daniel prefers to the relationship itself: he speaks of his desire for Anna in her absence ('and then you'll leave … and I'll be left wanting you more than ever'), but he rejects her attempts to arouse him.

The end of the film sees Anna return to her apartment, a space as empty and transient as the hotel rooms she has so far occupied. After her brief attempt to unite voice and embodied desire in the scene with Daniel, it also returns us to the separation of sound and image, body and voice, as Anna lies on the bed, expressionless, playing back the messages on her answer machine. With one exception, they are records of other people's desires and plans for her. The exception is the voice, we assume, of Anna's Italian lover, who asks, first in Italian and then in English, 'Anna where are you?' The lover, that is, speaks of her own desire in her own language, but she also draws attention to Anna's *absence*.[41] In the film Anna's identity has been as both 'Anna' and 'Anne', her journey seems doubly not her own – both chosen for her by her agent and replaying that of her mother's forced migration – and though she speaks French throughout she suggests to the stranger in the train that it is not her native language: 'I don't speak it that well.' Her desire – measured, like Wanda's, in her relationship to food[42] – has also been absent: refused, recalled as memory, or seen as distant and unreachable. If Anna's is a body that will not be drawn into a male fantasy or narrative, and if she insists on controlling language, space and time, still her own narrative is spoken only briefly and overshadowed by more dominant hi/stories, and her desire can be spoken only in its absence, as memory. Akerman's strategy of separating female body and 'voice', while it gives authority, as Silverman suggests, to that voice, nevertheless continues to pose the problem of the difficult relation between the female body and language, between cinema and a narrative of *female* desire.

DISCURSIVE AUTHORITY: *MY BRILLIANT CAREER*

If *Les Rendez-Vous d'Anna* can be seen to reframe Lucia's story of Holocaust survival and displacement, of transitory spaces and journeys which lead always into the past, then Gillian Armstrong's *My Brilliant Career* is, like *Wanda*, above all a journey through landscape. Here, too, we find the flimsy houses of the immigrant poor squatting on a vast, inhospitable landscape, and more populous, respectable places making claims to territory, history and traditions blessed by God. Like Wanda's, too, Sybylla's journey ends where it began, with Sybylla back home in Possum Gully, the place from which she longed to escape.

There are crucial differences, however. Like that of *Anna*, this narrative is framed in a number of ways. It is framed temporally: in *Anna* we *know* from the film's opening sequence that the protagonist is a film-maker, so that, although we see no traces of the film-making process in the film, this knowledge organises our sense of Anna's journey, her responses to others, and her future – as well as, self-reflexively, our sense of the film we see. Even more so in *My Brilliant Career*, we *know* that Sybylla will escape and become a writer: the film's opening sentences, spoken by the teenage Sybylla, are the introductory words of the autobiographical novel which we know to have been published in 1901.[43] Just as *Anna*, too, investigated an earlier narrative journey – that of the mother – so too does Armstrong's film become an investigation of Sybylla's journey, a journey which is paralleled with Armstrong's own.[44] And just as *Anna* creates a framing distance between film-maker and her diegetic stand-in, so too is the writer-protagonist of *My Brilliant Career* persistently framed within its shot compositions. Rather than the static camera and symmetrical framing of *Anna*, however, here we find a no less self-conscious 'painterly' framing (Robson and Zalcock, 1997, p. 17) which functions, as Felicity Collins argues, to open up a space between 'Sybylla's voice in the novel' and the film's own vision (1999, p. 23).

Most obviously, this is a narrative framed in relation to romance. Far more than the other films discussed in this chapter, it draws on the story, characters and iconography of the archetypal feminine journey to be found in the fairytale, the English 'woman's' novel and the costume melodrama. Here we have the poor but spirited heroine, rejected by her mother, who is transplanted into a world of gentility and country house balls, 'made over' and then humbled, in readiness for her rescue by the hero on a white horse. Robson and Zalcock suggest the narrative's debt to *Jane Eyre* and to the Hollywood 'women's films' of the 1930s and 40s, which also featured fearsome matriarchs and female struggles for independence, and we could equally well cite the popular historical romance and its forerunners in the novels of Jane Austen: the confrontation of Sybylla and Harry in Harry's office recalls not only that between Elizabeth and D'Arcy but its countless successors whose sado-masochism is less disguised. Tania Modleski quotes a typical example:

'You need a thrashing,' he said, his face inches from hers. 'A real thrashing, the kind that will teach you some sense.'

'Let me go,' she ground out angrily, pushing against the steel wall of his chest.

'Then you need a protector,' he said more levelly. 'Face it, Grace, you need me.'

'You are the most arrogant, conceited man I've ever had the misfortune to meet.'

'You are the most unreasonable, lunatic woman ...' he growled, then leaned forward, pinning her with his body ...' (Modleski, 1999, pp. 57–8)[45]

But if Sybylla is Cinderella and her successors, she is also the shrew who must, says her grandmother, be 'tamed', and the film draws attention to aspects of the romance narrative usually concealed. Here, as in Jane Austen's world, marrying without love is unacceptable and marrying *for* love can be folly ('Your mother married for love and – I, too, married for love,' deserted Aunt Helen reminds Sybylla). But here the social bargains masked by the romance – that fairytale endings function to secure social order and that 'clothes, shoes, makeup' can take a woman 'across the river and to the other side' of class divisions, as Carolyn Steedman (1986, pp. 15–16) puts it – are rejected. *Any* marriage, for Sybylla, involves 'los[ing] myself in somebody else's life'.

We see, too, the problematic nature of the bargain offered. While the women are fixed within the domestic, social and geographic spaces determined by their social standing upon marriage, the physical, sexual and social mobility of the men is emphasised in key scenes: the casual coming and going of Uncle J. J.; Aunt Helen's warning to Sybylla that Harry 'has quite a reputation with the ladies in Melbourne'; and Harry's sexual advances to Sybylla when he thinks her a servant, contrasted immediately with his shyness when meeting her as a 'lady'. The most marked of these scenes is Harry's first proposal, noted above, when he drags Sybylla away from the servant dance in the open air outside the official ballroom and into his office, a room we have not seen before. As the camera pans around the walls, we see racks of guns and mounted trophies, ledgers, maps and riding whips. Here, at the heart of the workings of the social structure which Harry embodies, is a room built upon a masculine power and activity which stretches beyond the desires of the individual. Rejected, Harry leaves, and the camera pulls back to frame Sybylla alone within the room, in a shot whose composition mirrors the earlier shot of her mother, offered to us as Sybylla's memory, equally alone within the squalid kitchen of the house to which her marriage has assigned her. If Aunt Gussie tells her that 'Loneliness is a terrible price to pay for independence,' and the film suggests that, since Gussie is a spinster and a painter, this is a price she has herself paid, these shots remind us of a profound loneliness *within* marriage. Outside, Harry and Sybylla resume their

My Brilliant Career (1979): the confrontation between Sybylla and Harry

pre-adult relationship of equals, but it is a relationship which cannot exist within the fixed spaces of the house itself. Finally, this scene draws attention to another aspect of the romance which we see in the exchange quoted by Modleski above: the evidence of women's *anger*, quickly suppressed in the conventional romance, and diverted inwards to become masochism, self-control or melancholy. Sybylla strikes Harry with his riding whip; later she will also strike the McSwat child who refuses to accept her authority; she would, she says at the end of the film 'destroy' Harry if she married him.

Armstrong's film persistently disrupts the romance narrative in its use of space, time and performance, all of which return us, by way of contrast, to *Wanda*. As in *Wanda*, the film offers us tiny figures and run-down houses within an overwhelming landscape. But there are crucial differences here. Self-consciously 'painterly', Armstrong's landscape compositions are nevertheless constantly disrupted, by sudden shifts of focus, by glimpses of that which lies beyond the frame, and by movement. A key example comes when Sybylla, on the way to being 'tamed' via a regime of skin care, face masks and hair brushing, is seen, first of all in close-up, decorously reading, wearing gloves and sun hat, with a red parasol behind her. The camera pulls back to reveal her seated under a tree by a lake, the pastoral scene completed by European trees and grazing cattle. The image could be one of Monet's *Woman with Parasol* paintings or that of his imitators among the Australian impressionists. The visual quotation is immediately rendered parodic, however, by the entry into the shot's foreground of the foolish Frank Hawden, whose gift of daffodils is greeted with an affected, 'Oh, thank you, Mr Hawden!' As he leaves, we see Sybylla throw the

WHAT IF I HAD BEEN THE HERO?

flowers into the water, and suddenly the rains arrive. Sybylla discards hat, gloves and novel, circling in the rain, arms held wide and reaching skywards. This is not, we are reminded, rural England or France, and Sybylla is not tamed. From the framed shots of lawns, box hedges, boating lakes and colonial houses the camera constantly shifts to show us the vast expanse of Australian bush beyond them and, at the edges of the frames, the figures of itinerant labourers travelling through it. The film is full of framed photographs and paintings as well as its own deliberate framings, but Sybylla herself is constantly in motion, not trapped within the landscape as Wanda is, but rather in constant movement *through* the film's interior and exterior spaces, moving out, as Patricia Mellencamp writes, of 'the confinement, the entrapment, represented by domesticity (and codes of femininity)' (1995, p. 48). Running, dancing, seizing the reins and driving, her refusal of physical confinement is also a refusal to be fixed by boundaries of class and 'respectable' femininity.

On two occasions, as Felicity Collins reminds us (1999, p. 22), we look with Sybylla into the far distance: the first time when she first speaks of her ambitions and the second at the end of the film with her manuscript completed. As she stands, arms outstretched once again, in the dawn light, Sybylla looks beyond the temporal as well as the spatial confines of the film. Reviewers commented on the contemporary nature of Sybylla's journey, and indeed its narrative arc has striking similarities not only to other feature films by women of the 1970s, such as Claudia Weill's *Girlfriends* ('plain' young woman struggles to reconcile the demands of relationships and the 'selfishness' needed to be an independent and creative woman), but also to Hollywood's 'New Women's Cinema' of the late 1970s.[46] Sybylla's journey, then, is one which gestures to the future, as Collins writes,[47] and what we see is *not* precisely the visualisation of Sybylla's words: writing, when we see it, is framed for us by the camera; it is interrupted, incomplete, naive and on occasion patronising. For most of the film it is far more an absent object of Sybylla's desire than an achieved self-expression. But if the camera seems to show us more than the words – the limits of Sybylla's worlds and of her vision, her repeated containment within and seduction by the social worlds of her grandmother and Aunt Gussie, what she does not as well as what she does see – this is a framing which is itself constantly disrupted by Sybylla's own movement and voice. The film, that is, offers us a split authorial focus: if Sybylla writes herself a future unanchored in her present, Armstrong's film, with its shifts of focus and its compositional and generic quotations, also asks questions about authorship and its origins which it does not resolve.

One of the ways in which it does this is through an emphasis on performance. Sybylla's own performances are of two kinds. The first, which serve to track the complex relationship between her ambitions, femininity and social class, are her performances on the piano. Discordant, narcissistic and out of tune in Possum

Gully, her performance marks both her ambition and her refusal to contribute to the family domestic labour. Refined at her grandmother's house, the limitations of this form of performance as an outlet for her artistic ambition are revealed when she finally performs competently, as accompaniment to the decorous dancing of others at Harry's ball. What in Possum Gully had served as a resistance to domestic hand labour (sewing, ironing), is here revealed to be merely its extension, serving, like Aunt Gussie's elaborate 'paintings in feathers', to confine her artistic ambition within the accepted limits of respectable femininity.

If these scenes focus on Sybylla's – and her mother's and Aunt Gussie's – *hands*, then the scenes in which she impersonates an Irish servant identity, and above all the scenes in which she dances, involve her whole body and are both far more transgressive and far more dangerous. From the scene in which Sybylla dances with the servants to a 'bush band', to her 'Bacchanalian' dancing with Frank and her solitary dance in the rain, these are performances which refuse containment. But they are a dangerous form of self-expression, pushing her closer to the boundary between 'respectable' and 'fallen' femininity from which there could be no return, as we see from her grandmother's horror when Uncle J. J. suggests that, based on her talent as a dancer, Sybylla should become an actress.

In the other films discussed in this chapter, I have focused on a masculine performance of a fantasised hero narrative sustained by social and cultural power. Harry, in *My Brilliant Career*, offers no such narrative: he embodies rather than articulates the figure of the mythical hero. Another performance by a male character does, however, articulate the position of which the film is a critique. This, Frank Hawden's performance of 'The Holy City', is noted by Felicity Collins as a scene which 'momentarily shifts ... attention away from Sybylla, although it has no apparent 'narrative significance or consequence' (1999, p. 17). Like Collins, I find the scene important, but I want to read it rather differently. In it, Frank, dressed in dinner suit and 'the image of an English gentleman', gives a flawless and complete performance of the hymn, with the camera focusing on his rapturous face as he does so. The hymn, however, is not Blake's 'Jerusalem', as Collins writes, but the Victorian version by Maybrick and Weatherly, whose authors were best known for their sentimental music-hall songs, with Maybrick himself a music-hall performer whose career ended in scandal with his sister-in-law's trial for murder. Like *Wanda*'s Holy Land USA, then, this is a ritualised performance which makes a claim: its 'New Jerusalem' is Victorian England, and Frank's performance makes confident claim to the transcendent nature of its values. It is powerful, but it is also absurd. Rural Australia is not England, and beneath the claims to blessedness for the absent homeland lie the tacky sentimentality, inequalities and brutality of Victorian society. But Frank's rendition is also perfect. Unlike Sybylla's performances, in this masculine performance there is no split between body, voice

My Brilliant Career (1979): Sybylla at the end of the film

and composition, and no uncertainty: unlike Sybylla, Frank can confidently claim to embody the transcendent values that he expresses, and into which he seeks to absorb Sybylla.

At the end of the film we follow Sybylla's gaze beyond the temporal and spatial limits of her story. As she stands with her arms outstretched, as she did in the rain, and taps her fingers along the gate top, Armstrong's film, with its female director, scriptwriter and producer, supplies the swelling extra-diegetic music that converts Sybylla's limited and contained performances of Schumann's 'Scenes from a Childhood' into triumph. Like the other films discussed in this chapter, *My Brilliant Career* reverses the dominant structure described by Silverman, confining the male voice diegetically to the male body, however socially and culturally powerful its narratives may be. More than the others, it not only grants discursive authority to a collective female voice outside the text but also goes further towards an alignment of this voice with a female figure within the text. There remains an unresolved split, however, between the voice and embodied desire, and it is in the film's focus on moments of performance, and on spatial and temporal dislocations, rather than in its attempts to heal that split by gesturing towards the future, that its feminist critique is most acute.

Part Two Explorations

Chapter Four

HEROES AND WRITERS

> I doubt that a writer can be a hero. I doubt that a hero can be a writer.
>
> (Virginia Woolf, 1978/1931, p. xxxix)

In 1931 Virginia Woolf gave a speech to the London/National Society for Women's Service which was later to become the essay 'Professions for Women'. Her speech followed one by composer and suffragette Ethel Smyth and her task was to speak about her professional experiences as a writer. There are two key passages in the typescript, both marked by numerous alterations and excisions,[1] and both considerably shortened in the final essay. The first and most famous is her description of the Angel in the House, 'the woman that men wished women to be'. The Angel, she writes,

> was intensely sympathetic. She was immensely charming. She was utterly unselfish. She excelled in the difficult arts of family life. She soothed, conciliated, sacrificed herself ... and in short was so constituted that she never had a mind of her own but preferred to sympathise with the wishes and minds of others. Above all – I hope I need not say it – she was pure ... Almost every respectable Victorian house had its angel. (1978/1931, pp. xxix–xxx)

Woolf had to kill this internalised phantom, she says, if she was to be a writer: 'I turned upon that Angel and caught her by the throat.' Simultaneously, she 'tried ... to resuscitate, encourage and revive the imagination within', an imagination, writes Woolf, which will 'rage ... when she is not ...' – the sentence is unfinished (ibid., p. xl).

In the second passage, which clearly caused her considerable difficulty, Woolf describes the process of writing that, having killed the Angel, she can now undertake. Again she constructs for herself a split subjectivity. The 'I' figure – the one who would write – is described as a 'fisherwoman', holding on by means of 'a thin ... thread of reason' as her imagination 'sweep[s] unchecked round every rock and cranny of the world that lies submerged in our unconscious being' (ibid., p. xxxviii). It is an exploration which is, however, checked. Woolf cannot, she says, make use of what her imagination tells her 'about women's bodies ...

their passions', because 'the conventions are still very strong'. She cannot, that is, 'be a hero', because 'the moment I become heroic ... I become so conscious of my own heroism, and of opposition, that I wake up; and then I cannot write' (ibid., p. xxxix). Ethel Smyth, however, *is* a hero – and a composer. She is – and here the metaphor shifts again – an 'ironclad' (an armoured warship), while Woolf herself, following in her wake, is 'a little sailing boat' or alternatively 'an idle and frivolous pleasure boat' (ibid., pp. 165, xxvii).

Two things seem to me to be important about these passages. The first concerns their contradictions and ambiguities. It is, says Woolf, the voice of 'reason', 'I', her waking self, that cuts short her imaginative exploration of 'women's bodies ... their passions', yet the words this voice speaks seem altogether reminiscent of those of the Angel she now says she '*tried* to murder' (my emphasis). 'My dear,' says the voice, 'you were going altogether too far. Men would be shocked' (ibid., p. xxxviii). Elsewhere in the manuscript notes, however, she is clear that men *should* be shocked. '[L]iterature which is always pulling down blinds is not literature', she writes. 'All that we have ought to be expressed – mind and body – a process of incredible difficulty and danger' (ibid., p. 164). Here it seems that women writers *should* be heroes, indeed that it is heroism that will *produce* women's literature. On the other hand, the terms which define Smyth – who, we are told, *is* a hero – are both military and decidedly masculine (in addition to being an ironclad she is a 'blaster of rocks' and 'maker of bridges'), evoking a wartime enterprise which Woolf describes later in the notes as 'stupid and violent ... I detest the masculine point of view. I am bored by his heroism, virtue and honour' (ibid.). The metaphors she chooses for herself, moreover, are feminine and passive, but ambiguous in tone: she is 'a *little* sailing boat', or in the alternative version, 'an *idle and frivolous pleasure* boat' (my emphases). It would seem, then, that Woolf's famous advocacy of the androgyny of the writer (in the finished version of 'Professions for Women' the fisherwoman persona becomes a fisher*man*) should be read, as Mary Jacobus has suggested, not as utopianism but as a desired resolution of an impossible and unresolved conflict – what Jacobus calls 'a simultaneous enactment of desire and repression' (1979, p. 20). Certainly, in this 1931 manuscript the images of writer and hero, waking self and subject of fantasy, reason and rage, the disembodied writer and the passionately embodied woman struggle to come together and persistently pull apart. The hero and the writer *should* be one, it seems, but for Woolf at least they cannot be.

The second point that I want to pick out of these much amended passages is the image that Woolf chooses to describe the process of writing: what holds together the writing 'I' and the 'unchecked' imagination, she writes, is a 'thin' but strong 'thread'. Two years earlier, in 'A Room of One's Own', she had used a similar image. There the 'thread' became a 'spider's web' which is the writer's work, spun into the air but still 'attached to life at all four corners' and, as we discover, 'the web is pulled askew, hooked up at the edge, torn in the middle',

very much the product of a 'corporeal' creature despite its apparent immateriality (1993/1929, p. 38). The violence of this last image reminds us of the images of violence in the 1931 lecture: both the implicit violence of the repressions to which the woman writer is subject, and the resulting violence of her response ('If I had not killed [the Angel] she would have killed me'; 'an imagination which will *rage*', my emphasis).

In her comments on Woolf's description of the tearing of the web, Nancy Miller suggests the following reading: 'When we tear the web of women's texts we discover in the representations of writing itself the marks of the grossly material, the sometimes brutal traces of the culture of gender; the inscriptions of its political structures' (1988, pp. 83–4). To this we might add Woolf's own discovery of the body and of female rage. This chapter, then, will be concerned with this process as it is enacted in – and can be performed on – the work of women film-makers, where the difficult relationship of woman to narrative subjectivity is often imaged through the textual figure of the writer. Before turning to this figure and the ways in which she might be represented and embodied, however, I want to trace a little further the image of the web and its woven threads which Woolf uses and Miller interprets.

Seventy years after Woolf, novelist Antonia Byatt returns to this image via Ovid's story of Arachne. Arachne is an ordinary village girl whose extraordinary skill as a spinner and weaver causes her to challenge the goddess Athene, insisting that she is the better weaver. In the contest that follows, Athene's tapestry depicts the glory of the gods, in which she includes herself, and, at the corners of the tapestry/web, where Woolf would see it as 'attached to life', scenes of punishment of rebellious humans. The stories depicted in Arachne's tapestry are equally, in Byatt's words, tales of 'shape-shifting and metamorphosis', but they are very different, portraying the deceptions and sexual brutalities of the gods towards women. Although Athene can find no flaw in Arachne's work, she is enraged. 'She tore up the beautiful web,' writes Byatt. 'She pulled apart the briefly visible image of divine deceits, rapes and violation' (2001, p. 142). In despair, Arachne tries to hang herself, but is instead turned by Athene into a spider. She becomes an eternal weaver of webs, as Miller writes, but no longer of stories. She is now all body: 'restricted to spinning outside representation, to a reproduction that turns back on itself. Cut off from the work of art, she spins like a woman' (1988, p. 82).

This doubleness of the image of the woven web – at once transcendent and grossly material, spinning stories and tablecloths, able to 'map ... the visibility of light' and object of mundane 'women's work' – is what Byatt plays on in her reworking of Ovid's tale. She sees herself, as both woman of 'ordinary origins' and writer, in Arachne: 'the movement, the intricate knotting and joining and change in tension and direction of a thread, became the image I had in my own mind of the things I wrote', and she traces the origins of this 'bright work' to the

needlework created by the earlier women of her family (2001, p. 138).[2] But Byatt also has her own version of Woolf's Angel, in the figure of her headmistress, 'a sweet-spoken, silver-haired woman' who had, she claimed, both 'written books and made tablecloths' but who insisted to the rebellious girl that tablecloths were 'more honest, and better, and gave more pleasure'. This figure, writes Byatt, 'haunts my dreams still, the nay-sayer, the antagonist, the fairy godmother who turned gold threads back into dull straw' (ibid., p. 139). In Byatt's story it is this sense of magic, evoked here in its reversal, the sense of 'an original shifting brilliance', that transforms the narrative threads into gold and makes it possible for the woman writer – as Arachne – to be both writer *and* hero. But, although the obstacles she encounters are less fully internalised than in Woolf, she too is conscious that the agents of magic – spinning wheel and needle – are both tools of transformation and instruments of regulation, repression and control.

For Byatt, it is not only narrative – Ovid's story – but also visual image which provides this link between herself and Arachne. Arachne's tapestry is a 'mapping of the visibility of light' (ibid., p. 147), but it is also a matter of movement and stories, 'constantly coming into shape and constantly undone and reforming' (ibid., p. 141). It is, in other words, a form of cinema. To provide the bridge between herself and Arachne, Byatt appropriates not only Ovid's tale but also Velásquez's painting, *Las Hilanderas* (The Spinners), which has been read as a depiction of Arachne's story. In the painting we see five women spinning in the foreground, with the light falling across the back and shoulders of one of them. Behind and above them and splitting the group of women, hung in a brightly lit alcove, is Arachne's tapestry, which depicts the rape of Europa. In front of it in the alcove are three expensively dressed women and two further female figures which seem to fade into the tapestry itself: apparently Athene, with helmet and shield, and Arachne herself, who seems to be showing the tapestry to her well-dressed female audience, one of whom is gazing out towards the women workers in the foreground. Here again, then, is the doubleness of women's weaving: both luminously visible as art and materially present as women's work.

Reading Byatt's account, it is clear that there are problems in her appropriation of Arachne as the figure of the writer *in* the text, problems which prevent a linear flow in her retelling of the tale. Arachne is doubly removed – doubly mediated – for Byatt: first by Ovid and then by Velásquez. Her tapestry is yet further mediated, since it seems, in Velásquez's painting, to be a copy of Titian's painting of the rape of Europa. As authors, both Athene and Arachne seem, then, to fade into the fabric of the work itself, and the most vividly present women in the painting are not the two competing authors but the women workers, who are purely the objects of Velásquez's, and our, gaze. The tapestry/screen into which we are drawn is not, after all, Arachne's work but that of the male artist, who repeats – indeed intensifies – the obliteration of Arachne as *writer* that

Velásquez's *Las Hilanderas* (c. 1657)

Ovid's tale recounts. Finally, in trying to reclaim her through the painting, Byatt is faced with the obstacle of the woman's body, in all its materiality as object, which sits in the foreground, dominating our gaze. Like Woolf, she deals with these twin problems – the problem of the *body* of the represented woman writer and that of the over-writing of her work – by splitting her voice/persona. Unlike most of the other retellings of Ovid's tales in the edited collection to which she contributes, hers is not a linear narrative but a series of interwoven fragments – autobiography, story, critique and science. If she is more confident than Woolf in adopting the position of narrative subject, the figure of 'I' still dissolves repeatedly into the fabric of the essay, even as the essay itself (different typefaces as well as different styles) echoes the variety of woven patterns that she describes in Arachne's text.

One final analogy suggests itself in considering Byatt's use of Velásquez's painting. For if the central lighted space of Arachne's hung tapestry evokes the cinema screen, with the angle of the light (coming from somewhere over the spectator's left shoulder to light up the tapestry/screen) suggesting the cinematic projector, then this in turn evokes the image of Plato's cave with which cine-psychoanalysis[3] has compared it. Yet the processes of identification so often evoked by this comparison can't be made to work in the same way when *women* play

the parts of both creator and spectator. Despite its subject matter, Velásquez's painting is concerned at heart with the question of *male* authorship: both the figure of Arachne and her tapestry disappear, to be replaced with the competitive relationship between Velásquez himself and Titian, whose painting he reproduces (as Arachne's) but outdoes. Similarly, as spectators our identification is not with Arachne or the spinners but with the transcendent gaze of Velásquez himself[4] which finds its ultimate object, via the relay of the women, in the painting which mirrors back that gaze. Women, it seems, are permitted here the *illusion* of authorship/vision/the gaze while in fact serving, to borrow a phrase from Mary Jacobus (1986, p. 85), 'as mirrors for acts of narcissistic self-completion' on the part of male artist and spectator.

If, then, the figure of Arachne, as rebellious hero and author, weaver of stories and creator of images of 'an original shifting brilliance' (Byatt, 2001, p. 137), seems an irresistible double within the text for the female writer outside it, Byatt's essay also reminds us of the difficulties in this appropriation. In neither Ovid's tale nor Velásquez's painting do we *see* Arachne's tapestry; in her rereadings, Byatt must also produce a (re-)writing, creating both Arachne's text and her own identity as writer as she writes. 'It is with rereadings that women textualize their fierce struggle with authorship', writes Patricia Ticineto Clough (1998, p. 77), in her discussion of the problems of female authorship. In these 'rereadings', she argues, it is particularly tempting for the female author to use the figure of the investigating hero/writer as a textual double, so that through her relationships with other women (the mother, the 'other' woman, the mirrored self) this character comes to a self-understanding which is authorised by the text. Clough argues, however, that if she uses this device the woman writer is in danger of simply replacing the male Oedipal subject by his female equivalent, in a 'fantasmatic construction of a unified subject-identity' (ibid., p. 116) which disavows sexual difference. Instead, she writes, what we should look to are texts in which 'the authority of realist narrativity' is disturbed, 'sporadically ripped open with arresting descriptions of the body' (ibid., p. 125). Clough's metaphor echoes Woolf's description of the textual web which is 'pulled askew, … torn in the middle'. For Clough, however, this does not signify, as it did for Woolf, a failure in the text; instead, what she calls a 'ghosted or haunted realism', or a 'perforated history' (ibid., pp. 114, 125), signals a 'haunting of the unified identity of realist narrativity with sexual difference and self-division' (ibid., p. 129). Realist narrative in these texts is both used and disrupted; 'androgyny' is refused.

There is one final thread that I want to draw out in this opening section. The theorist on whom Clough draws in her account of the 'haunted realism' which might characterise women's writing is Fredric Jameson, and Jameson is describing not the novel, but cinema. In film, writes Jameson, the 'unified subject, readily generated by verbal texts, can … be seen to be in question', since 'the camera, the apparatus, the machine' always tells the story from somewhere else, displacing the

WHAT IF I HAD BEEN THE HERO?

author as subject of enunciation, and so threatening the illusion of unity which the realist narrative seeks to construct (1992, p. 132). Whereas in most films, however, this potential disruption is covered over through the unified gaze of author/camera/spectator, in the 'magic realist' films which he describes it is intensified, so that the narrative thread 'remains disjointed from the lived experience of the film itself' (ibid., p. 133). But while the intensity of experience described by Jameson is most often an experience of violence, it is a very different sensory encounter which Clough identifies in the female writers she discusses. In what could be read as a response to Woolf, for whom such writing, in puncturing the surface of realism, would be a failure,[5] her discussion of the later novels of Toni Morrison celebrates a 'struggle with authorial desire [which] does not end in a fantasmatic construction of a unified subject-identity'. Instead, the eruptions of the sexed body into narrative produce the sense of a realist narrativity which is 'haunted' by 'sexual difference and self-division' (1998, pp. 116, 129).

HEROISM AND REREADING

This chapter, then, picks up one of the themes introduced in Chapter Three, that of the difficulties in establishing a female authorial 'voice' and subjectivity in cinema. In it I shall explore films whose protagonists are in some ways *writers*. This is not always literally true. Some appropriate the words of others; some fail to write at all. Some write through oral storytelling; some through images. The films differ, too, in the nature of their exploration. Some seek to close the gap between the film's authorial voice, the textual writer and the (female) spectator; others leave a textual reality, in Clough's words, 'criss-crossed with desire' (ibid., p. 116). Many position their protagonist in the past: in some this permits the promise of a unified female subjectivity in the text's future, the spectator's present; others offer no such promise.

I want to start in what seems an unlikely place, with a film produced by the American Girl organisation, responsible for American Girl novels (123 million sales), dolls (14 million sold; you can construct your own doll – 'the friend U create'), magazines and, its website tells us, clothing, furniture and accessories. Although *Kit Kittredge: An American Girl* (2008) was the first filmed version of the novels to be released in cinemas, it was also part of a series: preceded by three made-for-television movies, *Samantha: An American Girl Holiday* (2004), *Felicity: An American Girl Adventure* (2005) and *Molly: An American Girl on the Home Front* (2006). On the other hand, *Kit Kittredge* was directed by Patricia Rozema, whose films are preoccupied by the questions which are the subject of this book, and in particular by the issue explored in this chapter: (how) can the female *writer* be hero?

In *The Acoustic Mirror* Kaja Silverman writes that one of the means by which classic cinema imbues its male characters with 'enunciative authority' is through

Kit Kittredge (2008): Kit, Will and Countee

the disembodied voice-over, which serves to identify narrated with narrating subject and thus enable the male subject to transcend his positioning within the narrative. The female figure, on the other hand, she argues, is not only positioned in spaces *within* the narrative which come under the control and surveillance of the male figure; she is also either silenced or speaks with a voice always 'matched up' to her body (1988, p. 164). *Kit Kittredge* reverses this. The film opens with Kit's voice-over, the voice of a writer: 'It was May 2, 1934 and … I wanted to be a reporter,' she says, and the first image we see is that of a typewriter. Although the narrating voice clearly speaks from a point when this has been achieved, we cannot locate it precisely: we don't know from where or when this voice speaks, although it is still recognisably the voice of the young Kit. It establishes an identity, however, which is subject both of the narration – the voice-over reappears throughout the film – and of the narrative: Kit is protagonist and hero. She will guide us to 'truth' – both the resolution of the crime mystery which unfolds and the larger social truths which this confirms: that the hobo community is generous and honourable and that 'we're all just a few strokes of bad luck away from being in that exact same spot ourselves'. Kit, then, becomes a published writer – a 'reporter' – in the process of solving the mystery of the spate of local and national thefts which have been preoccupying news reports. They were committed not by homeless hobos, and certainly not by Will and Countee, the two young hobos who come to work for Kit's mother in exchange for food, but by two travelling magicians, lodgers in Kit's house and 'respectable members of the community'. Kit's judgment is confirmed by the newspaper reports exonerating the hobos that close the story.

WHAT IF I HAD BEEN THE HERO?

This, then, is a film which, at least at first sight, sets out to close the gap between the film's authorial voice, the writer in the text and the (female) spectator. It is, after all, as Rozema commented, 'a kids' movie', though she added that it was also 'definitely a feminist enterprise from the get go' (Merin, 2008). It is a narrative in which *writing* is the object of desire of the narrative subject (the nine year-old Kit) and the demonstrated achievement of the narrating subject.[6] It is also one in which being a writer is also being a hero: Kit investigates, reporter's notebook in hand; she learns to see the truth of the hobos' lives in order to report it accurately – to tell a story which is also truth. She becomes a subject both through her own writing and, as hero, in that of others, which now echoes her own. Kit is also a maker, recorder and interpreter of images. The 'member-o-belia' on the walls of her tree-house record her own heroes (most notably Amelia Earhart and Eleanor Roosevelt), and are succeeded by shots of bellows camera and binoculars – both vital parts of her investigative armoury – in the slow pan around the room which begins the film. Most important, she is able to read the visual evidence of guilt which in this story is written, in the form of a tattoo, on the *male* body, and she learns to discount, as trickery, the 'magic' woven by the film's villains, a magic which includes the 'levitation' of a passive and apparently unconscious woman for a rapt audience of women and children. At the end of the film, society is remade in the image of Kit's own desire (which is also her mother's): as a benevolent matriarchy which is inclusive of racial, class and, within limits, gender differences.

And yet ... the film constantly reminds us that stories, including news reports and the stories we tell to others in the letters we write, are not to be trusted. We invest them and their heroes with desire but their utopian resolutions are illusory, as the film's references to *Grimm's Fairy Tales* (in which, 'no matter how scary it gets, everybody lives happily ever after'), the story of Robin Hood, the popular 'novelette' and even the nursery rhyme remind us. Language – or at least the dominant language – is similarly untrustworthy. Against its myths and moral panics is set 'hobo language': a language of signs which belongs to the dispossessed and which comes to Kit's rescue, though it too can be manipulated by the unscrupulous. As the child Countee finds upon learning to read, to move out of the closed world of hobo and enter literacy/the symbolic order is also to enter the slippery world of stories and desire: '"The cow jumped over the moon." What's a cow doin' jumpin' over the moon? All this time in learnin' to read and *this* is what they say!'

The film's most important point, however, concerns the instability of all signifiers, and especially of those most crucial of signifiers: those of gender. In this it references another, much-analysed detective story, Poe's 'The Purloined Letter'. Poe's story centres on a letter, whose contents we never discover, which is received by the Queen who seeks to conceal it from her husband, the King. The letter is stolen twice, first from the Queen by the King's Minister and then

from the Minister by the detective Dupin, each time after first being effectively hidden simply by being placed in plain view. The letter 'escape[s] observation', as Poe's detective, Dupin, comments, 'by dint of being excessively obvious', and this is the central point of the story. Dupin himself is able to 'purloin' the letter because he understands this and so can *see* the letter. For Jacques Lacan the story illustrates 'the supremacy of the signifier' (1972, p. 50) in constructing meaning and identity, and Dupin, the analyst, stands in, of course, for Lacan himself. It is not the *content* of the letter which determines its meaning and its power, but its position within the shifting relationships of the story's protagonists. Similarly, the letter is gendered not by its content but by the nature of the 'script' (masculine or 'delicately feminine') in which it is written. Extending this analysis to take in the more general comments on the signifier in 'The Agency of the Letter in the Unconscious', Lacan's argument is that while linguistic signifiers, including most crucially those of gender, may be arbitrary, and culturally constructed, they are no less fixed and determining. Thus, each of us as subjects must, as Jane Gallup puts it, 'function in relation to an arbitrary and thus absolute' gender boundary, 'a boundary installed irrevocably ... through the advent of the signifier' (1982, p. 10). It is perhaps also worth noting that when Lacan wants to find an analogy for the letter's openness to Dupin's discovery in Poe's story, it is the image of the female body that he chooses. The purloined letter, he writes, 'like an immense female body, stretch[es] out across the Minister's office when Dupin enters. But just so does he already expect to find it, and has only ... to undress that huge body' (1972, p. 66).[7] The detective/analyst, then, may be arbitrarily positioned by the signifier, but he undoubtedly possesses the phallus, through whose agency he can investigate the passive body of the woman.

Towards its close, Rozema's film echoes the device which is central to Poe's story. Wrongly accused of the spate of robberies, Will and Countee have taken refuge in the hobo camp, but whereas Will, the older teenage boy, is found there by Kit and her friends, Countee has disappeared. The true culprits finally unmasked, Kit asks where Countee is. 'You know how they say', replies Will, 'you wanna hide somethin', you do it in plain sight.' Countee has been there all along, but dressed as a girl, the girl she has always in fact been. Like everyone else, Kit has been deceived, first by Countee's appearance as a boy, and then by its reversal. 'You may be a girl,' responds Kit's friend Stirling to this new revelation, 'but you'll always be a boy to me.' Signifiers of gender, then, which have seemed to be unquestionable in the film, are in fact slippery, and gender itself, which in Lacan's analysis is culturally fixed, is revealed to be fluid.

At the close of the film Kit's father, absent through most of the film, returns and is accepted back into the household, which is nevertheless very different from the one he left. Neighbours, lodgers, family and the mixed-race group of

Kit Kittredge (2008): White feminist utopian resolution?

hobos are all inside, at Kit's mother's insistence, all contributing to the feast. In the garden, Kit's own tree-house replicates this structure. Kit is once again in charge, but her gang now includes one (feminised) boy, Stirling, and the black Countee. It is a white feminist utopian fantasy resolution, revising and rewriting the history of the 1930s in which the film is set, but also addressing the contemporary economic recession of the period of the film's production. Yet if, as I suggested, it thereby seems to offer to close the gap between authorial voice, textual writer-hero and (female) spectator, its story is not the Oedipal narrative and its magical resolution is not an Oedipal magic, which relies on the figure of the passive, floating woman 'levitated' by the film's villain and Lacan's imagination alike. Through the figure of Countee, too, the 'realist' resolution is 'perforated' in the manner Clough describes. The troubling body of Countee disturbs the film's smooth diegetic surface, pushing us outside, to a confrontation with bodies which can not be contained, issues which are not resolved, within the narrative. It is Kit who is the 'American girl' of the film's title, but her far more polysemic double, the black Countee, who straddles genders, languages and cultures, functions to undo the apparent certainties (themselves self-conscious in their utopianism) of the film's resolution.

EXITING THE BLOODY CHAMBER

> *Everything here is yours, my dear*, [Bluebeard] said to her. *Just don't open the small door. I will give you the key; however I expect you not to use it.*
>
> (Atwood, 1993, pp. 82–3, original emphasis)

In her essay on Howard Becker's *Writing for Social Scientists*, Patricia Ticineto Clough discusses a chapter by Pamela Richards which is included in the book, written in the form of a letter to Becker. In it, Richards discusses her difficulties with authorship, describing a dream in which 'I knew absolutely and with complete certainty that I was a fraud.' It is a knowledge that 'wasn't constructed through some explicit argument; it didn't develop out of anything I recognized; it was just there' (Clough, 1998, p. 75). For Clough the statement 'fractures Richards' chapter in two'. As a social scientist, Richards can 'fake authority' only via a mode of writing that disavows sexual difference, but when writing autobiographically, as a woman, she feels herself to be spectator rather than author: 'wrapped in the image' of her dream, 'lost to it' (ibid., p. 76). Enclosed within Becker's text, moreover, Richards' self-analysis renders her, argues Clough, 'more a character than an author, more a figure of the text's enunciation' (ibid., p. 74). It is a figure which is useful to the male author/teacher, as Arachne's was to Velásquez, since it enables him to both speak through and at the same time distance himself from the figure of the woman.

Lynne Ramsay's *Morvern Callar* (2002) gives us a protagonist who as writer *is* a fraud, usurping the position of author through inscribing her own name on the manuscript of her dead boyfriend's novel, and deleting his own. This act of appropriation reverses and undoes the process Clough describes, reabsorbing the male writer within a female-authored dream (that Morvern is 'dreaming' is emphasised several times in the film). It is an undoing, moreover, that mirrors that which operates in the film itself, since *Morvern Callar* is itself a 'rereading' of a male-authored novel (by Alan Warner) which speaks through the voice of its female narrator. Morvern Callar, then, is a twenty-one-year-old supermarket worker living on the west coast of Scotland, whose writer-boyfriend has committed suicide at Christmas, leaving her with presents to unwrap – a leather jacket, a cigarette lighter, a Walkman and a compilation tape of 'Music For You' – and the text of a novel on the computer. The novel is 'for you' and is accompanied by precise instructions on how to get it published. Morvern leaves the body in the flat and parties with her friend Lanna, then returns, posts the novel to a publisher, cuts up the body and buries it in remote woodland, cleans the flat and uses the money her boyfriend has left (for his funeral) to buy a package holiday for herself and Lanna in Spain. She leaves the holiday resort, the novel is accepted and Morvern is paid £100,000. She returns to Scotland to pack up the remaining music in the flat and then departs once more, Lanna having declined to accompany her this time.

Ramsay (2002) described the film as 'a black fairytale', and the description draws attention not only to the elements of desire and wish-fulfilment central to its narrative (several critics pointed to 'implausibilities' in Ramsay's revised plot[8]), but also to the distanced and surreal quality of many of the sequences, a surrealism which, as Linda Ruth Williams has commented, 'can be uncovered

WHAT IF I HAD BEEN THE HERO?

The opening of *Morvern Callar* (2002)

at the heart of [its] realist storytelling' (2002, p. 25). Williams compares Morvern to Cinderella, but the primary reference is surely to a far darker tale. The film begins, after all, in a 'bloody chamber', but unlike the chamber in Bluebeard's castle which the phrase evokes, the body which lies here and will be dismembered is not hers but his. It is a space of magical reversals: like Bluebeard, Morvern's boyfriend leaves instructions for her behaviour in his absence; like Bluebeard's young wife, she disobeys, appropriating the keys – here those of the computer keyboard – which should have ensured her obedience. But the curiosity and agency which are the wife's undoing are here liberating, and are liberated through this death. The film's opening sequence sets the scene for these reversals. We see close-ups of Morvern's face – the continuity constantly interrupted by a black screen – as it rests against her lover's neck and hair. His naked back is to her, her hand is on his shoulder, and as we watch she dreamily brushes his hair with her lips and caresses his unresponsive shoulder and arm. It seems to be a bedroom scene, with his power in the relationship marked by her entreaty and his unresponsiveness. It is only when her hand moves over his wrist that we

see the cut and the blood there. As the camera pulls back we are given a diegetic cause for the cuts to black, as the coloured Christmas tree lights blink on and off, but this cutting between dark and light, like the frequent splitting of Morvern's body in the frame and shots of her actions through doorways, will be characteristic of the film. The one constant light in the scene is that of the computer screen, whose instruction 'READ ME' seems to be offering an explanation, *his* explanation. He is a writer, his words tell us as Morvern scrolls down the screen, but as a writer he does not need to explain to her: 'Don't try to understand, it just felt like the right thing to do.' Later, in the bar, a man will refer to him as 'Dostoevsky'.

If the 'bloody chamber' of the film's opening reverses that of Bluebeard, it recalls too that of Sally Potter's *Thriller*, which also opened with a body, that of seamstress Mimi, and posed questions about the relationship between masculine writing and female labour. Does the male artist, asks Mimi, 'really suffer to create in the way I must suffer to produce? ... Was the truth of my death written in their text?' Speaking about her film, Ramsay said that she saw Morvern's boyfriend as Alan Warner, the author of the novel *Morvern Callar*, and as 'the tortured artist looking for posthumous fame' (Andrew, 2002). Like Mimi's artist lover Rudolpho, he has used the working-class girl as his muse, perhaps, like Warner, choosing her as his novel's speaking voice. Later in the film, in response to her publisher's comment that 'What I really loved [about the novel] was hearing such a distinctive female voice,' Morvern describes, in the longest speech she makes in the film, the life of a writer as she has observed it. It is a description which answers in stark terms Mimi's question. 'It's got a lot to offer me,' she says. 'I mean, it's much better than waking up on cold mornings knowing it's thirty-nine years to go till pension. I mean, when you're writing you just knock off when you want, look out the window, smoke a cigarette, make a cup of coffee, take a shower.' As with Poe's 'purloined letter', described in the previous section of this chapter, we never discover the content of the novel, or indeed its title. It is its power to confer *authorship* that is important; in claiming that, Morvern claims the status of subject and also of hero.[9]

If her boyfriend's novel, and the money it brings with it, liberates Morvern, however, the vision she will explore has its origins elsewhere. Early in the film, after Morvern has returned to the flat after the party and begun the process of listening to the music on the compilation tape which will distance her, and us, from her surroundings, there are two sequences which draw attention to what Morvern *sees*. In the first, as she works in the supermarket, we see a point-of-view close-up of a grub in a carrot, which Morvern both gazes at and touches, curiously. It is the first of a number of disorientating sequences in which she looks intensely at details of the natural world, often insects, and reaches out to touch them, and we seem to share both vision and touch. In the second sequence, which follows immediately, she returns through the snow to visit

Morvern Callar (2002): Morvern in the supermarket

Lanna's grandmother. Although the details of the old woman's poverty are realistically drawn, and we see Morvern's compassion as she prepares soup for her, it is also a fairytale journey, in which the old woman serves a magical function. As the two women sit opposite each other on either side of the window, the old woman eating and Morvern watching her eat, we see on the window-ledge, haloed against the window's white light, a pink orchid. The old woman slowly raises her arm and points to it – or more precisely to the light beyond which touches it – and as Morvern leans forward and turns her head in response to this silent gesture, we follow her gaze. Both of these modes of seeing – the intense gaze at details of life below the smooth surface of the ordered everyday, and the look beyond, at light or sky – are repeated in the film, until they come together in the sequence in which Morvern, finger to lips, leads the two publishers into a Spanish graveyard, where we see both flower and light, and Morvern herself seems to be doubled, looking both back – at the publishers framed in the distance – and forwards, finally walking out of the frame. If Morvern's 'purloining of a man's cultural capital' (Williams, 2002, p. 24) liberates her, then, and his gift of the walkman acts to sever her connection with the everyday while preserving a dialogue with him (Ramsay described the tape as 'like a letter to her'), what it liberates is her own power to see, to touch and to journey.

Morvern's journey is towards subjectivity. At the start of the film she has no identity: she is a foster child whose foster mother is dead, her flat Nottingham

accent makes her out of place in Scotland, and her name, which she must constantly spell out since no-one recognises it, combines a Scottish place name (Morvern) with a Spanish verb (Callar, to keep silent). She is happy to substitute other names, from the Helga or Olga she claims to be in Spain to 'Jackie', the name on the identity necklace she wears and says she has found. She is also a figure of melancholy. For Freud, melancholy is what Laleen Jayamanne calls 'the unperformability of sadness' (2001, p. 256) and the melancholy subject one who, unable to name her loss, and so mourn, instead internalises it, identifying with the lost object. For Jayamanne, this figure can also be identified with the gothic woman of romance, exemplified in the 'impassioned, archaic cry' of 'I am Heathcliff' uttered by Cathy in *Wuthering Heights* (ibid., p. 38). At the beginning of the film, then, Morvern cannot name her loss – her boyfriend is 'at home', 'lost', 'gone … to another country', she says – and the walkman tape, obliterating external sounds for Morvern and at times for the viewer too, suggests a merging of identities which is accentuated by some of the lyrics we hear: 'I'm sticking with you/Cos I'm made out of glue … Saw you hanging from a tree/And I made believe it was me'. But this music accompanies her cutting up of the body, which we see – or rather don't see – through a doorway, as Morvern busies herself with the dismemberment wearing only pants, dark glasses and the walkman strapped (stuck?) to her side with tape. What develops then is less a romantic merging than an appropriation or mimicry. In the end, Morvern simply cleans him away, the removal marked by a thorough house-cleaning exercise and her possession of the flat by another burst of housewifely activity: the anarchic baking scene with Lanna. Lanna replaces him in the flat and accompanies Morvern to Spain, so that Morvern's journey to subjectivity is traced not only through the film's vivid and disturbing sensory sequences but also through this relationship, which is finally also left behind. Unlike, Morvern, Lanna has not wanted to venture beyond the resort, and she sees only sameness. 'It's the same crap everywhere,' she says. 'So stop dreaming.' Leaving the Spanish graveyard towards the end of the film, it seems as though Morvern has now replaced melancholy by a due mourning. In this process, the lost object has first been externalised, in the music, and then gradually afforded its appropriate recognition. In finally packing *all* the flat's records, tapes and CDs for her return to Spain, Morvern is providing herself with the means to make her own (musical) choices. The final sequence of the film finds her once again in a disco and, as in the opening sequences, our access to her face is intermittent, as the coloured lights flash on and off. Plugged into the walkman, she is distanced from the disco sounds which in the film's early party scene overwhelmed her. The track we hear is 'Dedicated to the One I Love', but we do not know whether this is his choice or hers, since *she* seems now to control *his* voice. Her face, however, is still and purposeful, and she looks at everything she encounters.

Critics commented that while we often seem to be inside Morvern's head, we are at the same time baffled by her. Frequently the film removes natural sound, giving us as soundtrack the music into which she is plugged, then withdraws our identification, leaving only the tinny sound of the walkman as heard by an outsider. Similarly, while we share her intense scrutiny of natural objects, she is often presented as a split figure on the screen, divided by door frames or shadow, at the edge of the frame or seen coming and going behind doorways. We cannot put these sequences together into a *motivated* narrative. Intensely tactile and surreal sequences punctuate, to use Clough's terms, realist narrativity. If Morvern, then, stands in for the female film-maker, neither the relationship between them, nor those with the spectator and with masculine authority is easy. Like Morvern, the film-maker has 'purloined' authorship[10] and with it access not only to its symbolic and cultural capital but also to the economic capital that underpins it. She has substituted for the words of the novel, which themselves appropriate the figure of the woman as their speaking voice, a world of intensely realised but 'unfathomable' (Williams, 2002, p. 23) images and sounds which, though often blackly surreal, nevertheless clearly represent both the materialities of the lives of working-class women and a 'realist' narrative of escape. Interestingly, in trying to describe their effect, Linda Ruth Williams (ibid., p. 25) attributes to them a violence – they 'stick inside you like shrapnel, like repressed thoughts' she says – that is not to do with their content but with their function and effect. Like Woolf's text, Ramsay's is a web suffused with light but also 'pulled askew, hooked up at the edge, torn in the middle' (1993/1929, p. 38), and thus reminding us of the 'corporeality' of difference.

SWEET LIES AND TRICKERY

> She found his previous women quite easily. They were in the linen closet, neatly cut up and ironed flat and folded, stored in mothballs and lavender. … The women didn't make much of an impression on her, except the one who looked like his mother. That one she took out with rubber gloves on and slipped into the incinerator in the garden.
>
> (Atwood, 1993, pp. 84–5)

Gillian Armstrong is a director who has often used the figure of the female writer in her films: the aspirant young writer of the past whose completed book closes the film, in *My Brilliant Career* (1979) and *Little Women* (1994), and the maternal writer, for whom the domestic space figures as both maternal and creative space, in *The Last Days of Chez Nous* (1992). Her female figures, however, are also performers, from Sybylla in *My Brilliant Career* to the self-reinventing Florence Broadhurst, subject of her 2006 documentary *Unfolding Florence*, which mixes archival material, interviews, re-enactment and animation to construct a

figure whose identity – simultaneously female artist and glamorous imposter – simply eludes capture. The relationship between the female artist in the text and the director and spectator is therefore never straightforward, and the narrative's realism never without its framing counterpoint.

Death Defying Acts (2007) deals with storytelling and dreams, magic and money, Oedipus and performance, music hall and cinema, fairytale and modernity, masculine narcissism and female relationships. Set in the early 1920s, it juxtaposes the documented story of Harry Houdini's final performances, and his ambivalent pursuit of the 'truth' of psychic vision through invitations to reward any successful revelation of his mother's dying words, with the fictional relationship between two figures familiar from Armstrong's films: the storytelling daughter (Benji) and the abandoned but self-reinventing mother (Mary McGarvie).[11] As with *Kit Kittredge*, the film's voice-over is provided by the child protagonist, but we cannot place its origins. It is a fairytale – what Armstrong called a 'what if' story. Benji and her mother live in a picture-book cottage in an overgrown graveyard, always framed through mist and trees, and reached by crossing a green, wooded space which separates it from the city. Beyond it we can see a gypsy encampment (though we can also see the discordant structure of an abandoned gasworks). Benji's narrative is influenced by both the comicbooks, which present Houdini as 'a god', and the materialities of her own life and desires: 'If you were Houdini you wouldn't be living in a place with a leaking roof, worrying how to pay the coalman. ... No, you'd be inside somewhere warm and cosy, eating cake.' Thus, though she offers to give us 'truth', her vision is contradictory: she disavows then (ambiguously) accepts her own psychic 'gift'; she echoes her mother's judgments then contradicts them; she romanticises both Houdini and his relationship with her mother in a way that neither Mary nor Houdini's manager and father-figure Mr Sugarman do, then aligns herself with Sugarman: 'It was up to me and Mr Sugarman to keep things on the right path.' She is an observer of adult sexuality: as she presses her nose to the glass dividing wall in the pub to which her mother takes Houdini, the scene recalls the parallel ones in Armstrong's earlier film, *High Tide* (1987), in which another daughter watches from behind a glass wall as her mother performs sexually for a male audience.[12] But she is also herself a performer, always in disguise – as a boy, as her mother's 'dusky disciple' in her act as 'Princess Kali', or as the dutiful daughter – and always in movement: a trickster not a victim. The vision in which she fulfils Houdini's wishes, and foretells his death, is both trickery and truth.

Benji's mother, Mary McGarvie, is also a performer – and a 'public woman'. Writing of Armstrong's films, Felicity Collins argues that they are 'centrally preoccupied with the cinematic articulation of female experience in the modern era', and thus with a reworking of the 'recurring figures' through which cinema has rendered such experience: 'the public woman, the street-walker, the window shopper, the flaneur/flaneuse, and the prostitute' (1999, p. 78). It is a description which

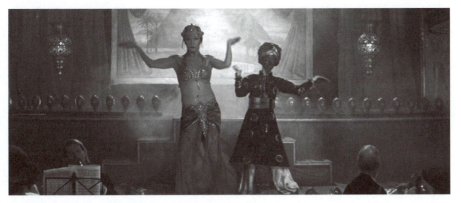

Death Defying Acts (2007): Mary and Benji's music-hall act

draws on feminist accounts of the emergence of the 'public woman' as a focus of male fears of femininity at the end of the nineteenth and beginning of the twentieth century. Newly visible in the 'fantasy palaces' of the theatre, the exhibition centre and the department store, with their 'open staircases and galleries, ornate iron work, huge areas of glass in domed roofs and display windows, mirrored and marble walls' (Nava, 1997, p. 66), the modern woman brought with her the fear, Elizabeth Wilson suggests, that 'every woman in the new, disordered world of the city … [might be] a public woman and thus a prostitute' (1992, p. 93). Nava's description captures a number of the spaces of Armstrong's film: the vast hotel, with its ironwork and mirrored walls, the grand public library, the city squares and the music hall. When we first see Mary McGarvie, then, she is being called a 'gypsy strumpet' and a 'tarted-up hussy' by the wife of the man who flirts with her in the streets. If her home is a fairytale cottage in the woods, her place of work is the city: its streets, its library and its music hall. In all of these she is a performer, most notably as the glamorous and psychic 'Princess Kali', who performs exotic dances and claims the possession of psychic powers.[13] She is a mobile and self-transforming figure, 'a mistress of disguise' according to Benji, and her act, which is performed as a means of economic survival, tops the bill at the local music hall. She is positioned, then, at the moment in the twentieth century at which music hall has not yet quite given way to cinema: when women can top the bill and can reverse the voyeuristic male gaze, through a smart piece of trickery which targets the man in the audience as its victim. Like Bubbles in Dorothy Arzner's *Dance, Girl, Dance* (1940), Mary answers back to her largely male audience, but the music-hall world of female double acts and surreal comedy that she inhabits will shortly give way to the economic and technological power of cinema, with its temporal and spatial separations, and its repositioning of women as spectators.

Harry Houdini straddles both these worlds. Like Mary, he performs magic tricks via a body that is offered for public display. But he is also a cinema star

– Armstrong saw him as 'a huge, huge superstar … like a rock star' – for whom power and technology can produce a reality in the image of his desire: 'I'm the great Houdini. I make things the way I want them. … Oh I can, believe me.' His self display – for audiences, reporters, cameras and himself – is a narcissistic blocking of self-knowledge. Like *Kit Kittredge* and *Morvern Callar*, the film plays on that which is hidden/in plain view. It presents us with two chests. The first is the transparent water tank in which Harry performs his 'death defying' escapes, regurgitating the small key which unlocks the handcuffs on his wrists. The second, also opened with 'a tiny wee key', as Mary calls it, is the locked trunk which he keeps in his hotel room, and which Mary and Benji investigate in the hope of finding the answer to the question of his mother's dying words. Both spaces are haunted by the figure of Houdini's mother, the first through his fantasy image of her swimming towards but unable to reach him, the second through the wedding dress and photograph that Mary and Benji find in the trunk when Sugarman gives them the key. Although Harry sees the trunk as 'Pandora's box' – the 'shameful' nature of femininity that Pandora both discovers and unleashes when her curiosity for that which is forbidden overwhelms masculine prohibition – what is, in fact, discovered is the secret of Oedipus, so that the myth that is invoked is not that of Pandora but, once again, that of Bluebeard. As in Margaret Atwood's version of the tale that opens this section, 'neatly cut up and ironed flat and folded, stored in mothballs and lavender' is the empty image of Houdini's mother, which Mary is invited both to inhabit and to invest with speech. The secret, however, is that this ideal image is silent – Harry's mother spoke no 'final words' to him, despite his repeated attempts to produce them. In finally refusing to perform as his mother, despite the starring nature of her role in the filmed performance, and the $10,000 reward, Mary refuses the Oedipal script. In a last twist, Benji subverts the whole Oedipal scenario by herself speaking, with due theatricality, as the mother.

In Felicity Collins's study of Armstrong's films, she writes of the importance of spatial composition in disturbing narrative identification, and of the motif of water as 'mark[ing] the fluid space of a second, … insistently female social imaginary' (1999, p. 80). In *Death Defying Acts* the key spaces are juxtaposed and frequently intercut: the fairytale cottage and the public–private, masculine space of the hotel; the stage and the cinema; the gothic heights of Scott's monument where Houdini imagines himself as Icarus; and the underwater sequences. Characters are seen through mirrors or screens, paired through mirroring gestures or positioned at the edges of a frame which is split by a pillar or wall. Despite the film's *narrative* logic, then, which sees fairytale replaced with technology, music hall with cinema (which really does defy death) and active female performers with the passive and tearful female audience identified by Mary Ann Doane (1987) as cinema's construction of female spectatorship, the film's use of space disturbs this logic. These spaces, and their different temporalities, seem to

Death Defying Acts (2007): Mary and Benji at the end of the film

exist in parallel, so that at the end of the film Benji's voice continues to compete with the cinema newsreel captions for interpretive authority. Throughout the film, the spotlight and the light of the cinema projector have been juxtaposed. The second uncritically records Houdini's exploits, and allows him to smile, wink and gesture to the audience – to Mary and Benji but also to us, in the film's opening sequence – even after death. The first, the spotlight, is far more ambiguous. The film opens under water, with a spotlight's beam diffused by – or dissolved in – the blue water. Benji's voice speaks of her 'gift' of seeing 'things other folk didnae see', which is 'like looking into deep water and seeing things on the other side'. As Houdini emerges from the water and winks at us/the camera, however, Benji reports that 'the four winds and the sea bowed down before [him]'. Houdini will seek to tame the water, to replace the spotlight with the cinema projector and the opacity of water with the 'transparency' of the screen. But the film's final shot of the two women shows them no longer looking at the screen but embracing, and on Benji's closing words, 'me and mam, we had the here and now, and we had each other', we are returned to the film's opening image, so that the projector beam becomes once again dissolved in blue water.

These last images, of course, have an unavoidable psychoanalytic ring, reminding us of the common origins of cinema and psychoanalysis in the 'frenzy of the visible' (Comolli, 1980) of modernity, of Freud's use of the camera and the spotlight as analogies for consciousness (Freud, 1976/1900, 1984/1923) and, finally, of Virginia Woolf's account of her 'submerged' and inaccessible 'passions'. Indeed, at one point in the film Houdini refers to his triumphant emergence from the 'sea of the unconscious'. Yet if the film plays on the gendered associations of this imagery, in the end it reminds us that all forms of storytelling are both trickery and truth, and sets its own extravagant fairytale of mother–daughter relations – another form of storytelling and cinema – against cinema's own claims to speak for modernity.

ARACHNE'S THREAD

> [T]he woman who tries to write ... goes to poetry or fiction looking for her
> way of being in the world, since she too has been putting words and images
> together; she is looking eagerly for guides, maps, possibilities; and over and
> over ... she comes up against something that negates everything she is about:
> she meets the image of Woman in books written by men. She finds a terror
> and a dream. ... she finds La Belle Dame Sans Merci ...
>
> (Adrienne Rich, 1979, p. 39)

> Jane's female heroines have never been conventionally heroic.
>
> (Chapman, 2002, p. 105)

Like those of Gillian Armstrong and Patricia Rozema, Jane Campion's films
have been preoccupied with the relationship between women and writing. From
An Angel at My Table (1990), Campion's film about novelist Janet Frame, to *In
the Cut* (2003), whose protagonist, Frannie, describes herself as a writer for
whom writing is a 'passion', Campion's films have explored the difficulties, and
the possibilities, of female authorship. Frannie, however, is less a writer than an
investigator of the writing of others, and in particular of masculine possession
of the twin poles of high culture – specifically poetry – and the language of the
street,[14] and her simultaneous fascination with, sense of exclusion from, and
resistance to this arcane form of masculine high culture are feelings Campion
(Garcia, 2009) has claimed to share. Like Frannie, then, Fanny Brawne in *Bright
Star* (2009) begins as an investigator, trying to 'work out' Keats's poetry. But
she is also a seamstress – a maker, like Byatt's grandmother and like Mimi in
Potter's *Thriller*, of 'her own bright work': an 'intricate knotting and joining and
change in tension and direction of a thread' produced, like all 'women's art', in
'snatched time' (Byatt, 2001, p. 139). It is her work that we share in the film's
opening close-ups, in which thread passing through a needle's eye is shot as a
beam of light against the black of the screen, its brightness touching the white
of the film's title, which seems to be both written and sewn. We follow the
needle, as it struggles to pierce the coarse texture of linen, and then – in an
image that recalls Woolf's description of her own writing process – the thread
as it is pulled to the cloth's surface, before these unsettling images are replaced
by a far more conventional shot, of Fanny sewing, like one of Vermeer's seam-
stresses, against a window. Later, there will be a more explicit echo of Woolf, as
Keats tells Fanny towards the close of the film, 'We have woven a web, you and
I, attached to the world but a new world of our own invention. We must cut the
threads.' Keats is referring here to both poetry and romance. The two are insep-
arable in this film, and unlike Woolf Keats has no desire to recognise the
corporeality that anchors them. Both romance and its articulation in poetry

WHAT IF I HAD BEEN THE HERO?

Bright Star (2009): Fanny sewing

exist better in the absence of their object, as Keats demonstrates, and Fanny resists, throughout the film.

In *Writing the Voice of Pleasure*, her study of the relationship between the western romance tradition and women's writing, Anne Callahan argues that the ideal woman found in the writings of this tradition is in fact a feminised man: the mirror image of the male writer, for whom *writing*, not the woman, is the object of desire. Language, or the text, is 'both the quest and its object' (2001, p. 21), she argues, and the ideal femininity thus constructed is, for women, uninhabitable (and unspeakable) because chimerical, a fantasy both addressed to and *about* the male self. The fantasised fusion with this constructed being which characterises romance is therefore both a surrender to and a disavowal of a femininity which is both desired and – in its corporeal aspects – feared. It seems to me that it is this which we see – and see being *constructed* – in *Bright Star*. The film's opening images, described above, are accompanied on the soundtrack by a Mozart duet in which two voices, a soprano and a high tenor, overlap and seem to merge, suggesting the fusion of identities in romance. Later, however, the

music is reprised in a drawing room performance, and we see that the soprano voices in fact belong to two boys; it is an all-male performance (the tenor voice belongs to Keats), in which women are relegated to the silent background. This is a move which the film repeats a number of times. A second instance begins with the sequence that leads to the first kiss between Keats and Fanny. In it Keats describes his dream – 'I was floating above the trees, with my lips connected to those of a beautiful figure ... Flowery treetops sprang up beneath us and we rested upon them' – and Fanny tries to occupy the position of the dream lover: 'Whose lips? Were they my lips?' We then see Keats, alone, enacting the scene of his fantasy as he lies, eyes closed, supported by the blossoms of a tree-top.[15] When, in the following scene, we seem to see the sequence captured in Keats's poetry, however, as his friend Brown quotes from 'The Eve of St Agnes', it is a *female* figure that is described in Keats's lines: 'trembling in her soft and chilly nest,/In sort of wakeful swoon, perplex'd she lay'. Most of all, it is 'Bright Star' itself which shows this slippage between masculine and feminine identities. The film tells us that the image refers to Fanny: 'You dazzled me – there is nothing in the world so bright or delicate,' Keats writes to her. Yet, as the poem itself makes clear, the star is an imagined double for the poet himself, and it is Keats who is the 'bright star' of the film.

We can also see in Keats the male melancholic described by Julia Schiesari, for whom the 'higher' form of melancholia provides inspiration for a heightened artistic expression which 'engender[s] the male subject in terms of a loss that he can represent – and that represents him – as a legitimate, if not privileged, participant in the Western tradition' (1992, p. 74). Keats is depicted as poor and struggling, but for the film's audience his voice carries the authority of the western Romantic tradition. For him love and death – or absence/loss – are inseparable even before his illness, and before Fanny. His letters to Fanny fantasise a merging of 'your loveliness and the hour of my death' and conjure a Fanny that dissolves into words and air – 'I want a brighter word than bright, a fairer word than fair ... I almost wish we were butterflies and lived but three summer days.' Their final farewell spins a fantasy of an impossible future existing only in words, and in the closing sequences of the film Keats is wholly absent, wholly represented by his words. If Fanny, in contrast, is wholly present in the film, *her* voice is lost and her craft devalued in the poeticisation of romance which the film is concerned both to construct and to make visible. The film begins with her insisting that she is Keats's equal. 'My stitching has more merit and admirers than your two scribblings put together,' she says to Keats and Brown. 'And,' she adds, 'I can make money at it.' She is a designer as well as a seamstress, and she thinks of poetry as a craft, like stitching: the poets she admires are those who are clever with words as she is with design. In a society in which 'almost all women sewed – they sewed and they waited' (Wilson, 2009), however, her craft is seen as part of the 'women's world' of

household tasks and decorous occupations. Her designs, worn only by herself, mark her with the kind of feminine excess that characterises the transgressive heroine of the 'woman's film' of the 1930s and 40s. Like Stella Dallas of King Vidor's 1937 film, she designs and sews ruffles and pleats, in a desire for 'something else' that is recognised only as excess.[16] In the course of the film, her clothes become plainer and her sewing more conventional and serviceable to others – we see her begin to design again, fleetingly, only when it seems that Keats has left her – until her final act of needlework is to produce the black clothes of mourning.

Fanny, then, embodies and literalises desire. She has dreamed of being the 'fairy princess' that Keats constructs in his poems; indeed she has drawn such a figure 'with pinholes' on her bedroom wall, the bedroom that Keats now occupies. But it is he that now constructs the fantasy that animates it. 'She wears a butterfly frock,' he says to Fanny when he finds the figure, and later this image – of Fanny and himself as (doubled) summer butterflies – becomes one of the many in his letters and poems that merge love and death. Fanny, however, literalises the image. She constructs a 'butterfly farm' in her room, complete with caterpillars, and confines herself to it. 'There is no air,' says her mother, entering the room, and we can see that the butterflies, though beautiful, are dying. Fanny, however, rejects her mother's explanation: it is when she is without Keats's letters, she says, that she feels 'as if the air is sucked out of my lungs', and she will later repeat the sensation of being unable to breathe when she hears of Keats's death.

But if *Bright Star* shows us the seductiveness of the web woven by romance and Romantic poetry, for both Fanny and the viewer (and reviewers seemed wholly seduced by the film's beauty), it also shows us what it denies and represses. If the ideal feminine of Keats's imagery denies the body,[17] the film shows us the abject and bleeding body which it represses, not in the corporeal woman but in the poet himself. It is Keats who bleeds uncontrollably, who must be carried upstairs by women, who is trapped inside looking out at Fanny, who must be protected and nurtured. If Fanny is seduced by the image of idealised femininity that Keats offers her, she cannot embody it. He does, however, and this renders her both powerless and displaced (trying to *embody* Keats's vision) and, at the same time, potentially empowered. In this play of gender inversions, Brown, the wealthier 'scribbler' who is Keats's financial support, is both her 'enemy' (Fanny uses this term) and rival for Keats's love, and Keats's own inverted double, occupying the masculine position which Keats claims in his poetry but does not really understand.[18] Thus, in Brown's loveless seduction of the maid Abigail and treatment of Fanny – he is not sure, he says, whether she should have a kiss or 'a whipping' – we see the casual brutality which is the underside of Romantic masculinity. We also see the importance of Keats himself to the homosocial cultural circle which surrounds and protects him, valuing

Keats and Fanny: gender inversions in *Bright Star* (2009)

his words but not his presence. To it he offers not only an idealised image of a disembodied femininity but also a flattering – and necessary – mirror-image of a romanticised and heroic masculinity.

Reviewers suggested that *Bright Star*, with its 'delicate, headily romantic, poetry-infused love story' (Stables, 2009, p. 46), was a surprising departure from Campion's more usual probing of 'the dangers of desire and the lives of resilient, occasionally mad heroines chafing at their constrained circumstances' (Solway, 2010). Instead, it offers the seductive and fragile beauty of romance. Identified with spring and summer, blossoms and butterflies, romance in the film is brief, beautiful, death-bound, incapable of preservation. But it is also – like consumption – ultimately airless and devouring. For the male writer, it is clear, it confers a symbolic power – the 'heightened artistic expression' which Schiesari suggests produces him as a subject whose ability to *represent* loss renders him a 'privileged participant in the Western tradition'. This is, adds Schiesari, a 'fantasmatic capacity', a 'privileging of absence in order for the desiring fantasy' – of a 'de-corporealized (idealized) woman' – to 'take hold' (1992, p. 111). Women, she argues, have been no less the subjects of loss, but, in seeking to represent it, have characteristically had access only to a language that enacts 'a mourning for their barred or devalued status within the symbolic' (ibid., p. 75). This is a form of representation, as psychoanalysis has insisted,[19] that belongs

WHAT IF I HAD BEEN THE HERO?

both to the body and to the everyday – the world of Fanny in *Bright Star*. In the quotation that heads this section, it is a poem by Keats that Adrienne Rich chooses to exemplify her own description of this 'de-corporealized (idealized) woman'; Fanny, of course, recalls the Arachne of Byatt's narrative, wearing her 'bright work' on her body.

Yet this is Fanny's film. It is her steady gaze that we follow as she observes the male world of culture, idleness and physical dominance, and her world that we occupy – from the bedroom, parlour and kitchen to the landscape covered with washing lines and billowing sheets that we first see when she walks across Hampstead Heath with her family at the start of the film, and which later becomes the background for Keats's quarrel with her over Brown's valentine card. If Keats is inspired by absence, her world is one of vivid colour. It is *Fanny's* clothes that match the colours of the film's art direction, from the bright blue of the field of bluebells to the soft whites of her room, so that it is her world in which we are immersed. Fanny works not through words but through touch: having her sister Margaret bring her a copy of 'Endymion', she takes the book from her and caresses its surface, and her response to Tom Keats's death is to embroider a pillowslip on which his head will rest.[20] We are constantly made aware of her hands – at work sewing, caressing the cat or a book – and it is through the touch – or not-quite-touch – of hands that she draws Keats, at least temporarily, into her world. As the two approximate the touch of hands through the thin wall that divides their rooms, the mirroring that results effects a 'feminisation' of Keats that is no longer abstract but a matter of embodied desire. In the scene in which Brown warns of the 'trap' that Fanny's 'slippery blisses' represent and confesses his own love for Keats, Brown too takes and caresses Keats's hand. But whereas for Brown touch can be justified only through praise of the hand as writing instrument, Fanny persistently turns words into a form of touch.

In Woolf's analogy, with which I began this chapter, it is only when the web of writing is torn that we can see the corporeality that underpins it, and the story of Arachne, who challenged such myths of incorporeality and insisted on her own equality with the gods, ends with her restriction *to* the body. In Campion's reworking of Arachne's story, however, we find a different outcome. At the end of the film, Fanny cuts her hair and sews herself mourning clothes. As the camera follows her onto the heath and closes in on her face, she recites 'Bright Star'; like Ada in *The Piano* (1993), she ends by speaking male language. In doing so, however, she reappropriates the poem, so that its object becomes not herself but Keats, its speaking subject herself. If the film itself has often been seen as analogous to poetry[21] – inviting, like Keats's description of poetry in the film, an immersion into its world – then it also has a very different heritage. A bright tapestry, stitched together from its high Romantic source material, it remains attached, via Fanny, to the body. In the film's opening sequence, it is

Fanny's thread which is the beam of light that pierces the black of the screen, not simply competing with the handwritten title for our attention but touching it with light and supplying its words with texture. The film, then, contextualises Keats's poetry within a very different tradition from that of Romantic 'high art'. Here, the 'vision of light' which is the woven web is firmly anchored in the body, and the 'bright work' of film-making takes poetry as its object and anchors itself in a tradition of 'women's work'.

Chapter Five

LANDSCAPES AND STORIES

Women are the earth that is to be discovered, entered, named, inseminated and, above all, owned. Symbolically reduced, in male eyes, to the space on which male contests are waged, women experience particular difficulties laying claim to alternative genealogies and alternative narratives of origin and naming.

(McClintock, 1995, p. 31)

[I]s there any place that no man has ever occupied?

(Le Doeuff, 1991, p. 103)

When, at the end of the 1920s, Virginia Woolf sought to express the difficulties of female authorship (and subjectivity), it was in terms of *space* that she expressed both her difficulties and the (more or less successful) process of writing itself. She could not, she thought, be a hero, as we saw in Chapter Four, because heroes – her example is Ethel Smyth, composer and suffragette – were 'armoured tanks' or 'ice-breakers', 'blast[ing] rocks and mak[ing] bridges' in order to carve out pathways across a 'rough' terrain of land or sea (1978/1931, pp. xxvii–xxviii), while she could envisage no such relationship of conquest for herself. In a similar way, 'A Room of One's Own' (1993/1929) constructs its argument about the difficulties of women's writing through narratives of spatial exclusion. The most famous is Woolf's account of her expulsion from the spaces of knowledge in Cambridge. Flushed with the excitement of 'a wash and tumult of ideas', she writes, she found herself 'trespassing' on male preserves, an experience which the essay renders literally:

It was thus that I found myself walking with extreme rapidity across a grass plot. Instantly a man's figure rose to intercept me. ... His face expressed horror and indignation. Instinct rather than reason came to my help; he was a Beadle; I was a woman. This was the turf; there was the path. Only the Fellows and Scholars are allowed here; the gravel is the place for me. (1993/1929, p. 5)

Later in the essay, the story of Shakespeare's imaginary and equally gifted sister repeats this account of unauthorised mobility and reprisal, with more tragic

consequences. Rebelling against her confinement within house and marriage, 'Judith Shakespeare' 'made up a small parcel of her belongings, let herself down by a rope one summer's night and took the road to London' (ibid., pp. 43–4). Ridiculed, pregnant and rejected, she kills herself and now lies 'buried at some cross-roads', absorbed into the landscape over which she sought to travel.

If the impossibility of crossing and occupying space as a woman is how Woolf figures the difficulties in establishing authorship and subjectivity, however, the process of writing itself is also registered through spatial metaphor. In the essays and speeches of 1928–31 the same image recurs, of Woolf 'sitting on the banks of a river ... lost in thought', and fishing:

> To the right and left bushes of some sort, golden and crimson, glowed with the colour, even it seemed burnt with the heat, of fire. ... The river reflected whatever it chose of sky and bridge and burning tree ... Thought ... had let its line down into the stream. It swayed, minute after minute, hither and thither among the reflections and the weeds, letting the water lift it and sink it ... (1993/1929, p. 5)

Indeed, it is this process – the occupation of a personal landscape in which land, sky and water are blurred and from which female writing can, however tentatively, be drawn – that, in 'A Room of One's Own', inspires the 'trespass' which provokes the wrath of the beadle quoted above. Despite the essay's title, then, it is women's relationship to landscape, not their occupation of the contained space of 'a room', that most frequently expresses for Woolf the difficult processes of female authorship and subjectivity. Commenting on such evocations of personal landscape, Nancy Miller suggests that they represent 'the iconography of a desire for a revision of story', for 'another logic of plot' outside male-centred narrative structures (1988, p. 87). At the same time, it is women's exclusion from 'landscapes of [male] fulfilment' (Gilbert and Gubar, 2000/1979, p. 188), and/or their reduction *to* landscape, that again and again in Woolf's writing describes their repression and alienation.

In this chapter, then, I want to pick up a second theme introduced in Chapter Three, to explore further how landscapes might function for women filmmakers, for whom the gaze *at*, and exploration, penetration and ownership *of* landscape comes saturated in visual as well as literary traditions, and literal as well as metaphorical images. Before doing this, however, I want to explore a little further the relationship of gender to landscape.

GENDERING LANDSCAPE

The forest, place of the hero's education, is a female domain.

(De Lauretis, 1984, p. 115)

Anne McClintock, in her study of the poetics and politics of British imperialism, offers a powerful analysis of this relationship. She also offers an analytic method – what she calls a 'situated psychoanalysis' – that insists on both the psychic origins and the material effects of the imperial fantasies she describes. In these narratives, she writes, 'knowledge of the unknown world was mapped as a metaphysics of gender violence … In these fantasies, the world is feminized and spatially spread for male exploration' (1995, p. 23). Thus western cartographers mapped 'virgin territory', Enlightenment philosophers 'veiled "Truth" as female, then fantasised about drawing back the veil' (ibid., p. 24) and nineteenth-century novelists and poets like Haggard and Kipling imagined an Africa or India whose landscape could be mapped as a woman's body. In the 'excess of gender hierarchy' evident in such representations, McClintock traces both a complex eroticism and narcissistic anxiety. Their narratives of exploration, naming and control, and depictions of 'ritualistically feminized borders and boundaries', she writes, evince both a 'profound, if not pathological, sense of male anxiety and boundary loss' and an eroticised dread of 'engulfment' (ibid.).

It is not surprising that these metaphors also appear in the writings of Freud, for whom the 'complicated topography of the female genital parts makes one understand how it is that they are often represented as *landscapes*, with rocks, woods and water' (1973/1915, p. 190, emphasis added), while the work of the (male) analyst is likened to a process of exploration, excavation and archaeological translation (1976/1900, p. 457). For Freud, Haggard's *She* (1887), one of the imperial adventures analysed by McClintock, is 'a *strange* book', representing 'an adventurous road that had scarcely ever been trodden before, leading into an undiscovered region'; its 'hidden meaning', he tells a female admirer, is the secret of 'the eternal feminine' (ibid., pp. 586–8, original emphasis). Following McClintock's argument, however, we can also note the context of Freud's description here. For the dream that evokes this self-identification with Haggard's imperial adventure – a dream of 'a journey through a changing landscape' whose 'boggy' ground is occupied by a variety of 'primitive' peoples – in fact begins with the dissection of Freud's *own* body and concludes with a terrifying loss of masculine power.

In the imperial adventure, the male hero, as McClintock describes, is rendered whole, 'erect and magisterial' by the conquest of a feminised land (1995, p. 26). 'Standing aloft on Sheba's Breasts' (ibid., p. 243), he converts landscape into map, in a process which orders, contains and overwrites, attributing to his masculine narrative both the authority of history and the universality of desire, while the feminised landscape and its colonised people remain as, at best, history's objects, displayed within space for the penetration of time. Feminist geographer Gillian Rose echoes this analysis, describing 'masculinist claims to know which are experienced as a claim to space and territory' (1993, p. 147). While *place* within geographical discourse, she writes, is conceived 'in terms of maternal Woman',

opaque and unknowable (Freud's *'vessels* and *bottles, … receptacles, boxes, trunks,* … room-symbolism [and] house-symbolism' (1976/1900, p. 189, emphasis added)), *space,* in contrast, is seen as transparent and knowable. Both underpinning imaginaries, however, 'depend in their different ways on a feminized Other to establish their own quest for knowledge' (Rose, 1993, p. 62). Thus, she writes, 'the image of landscape as a perspectival space centred on the hero … is a necessary part of the grandeur and authority of masculinity' (ibid., p. 107). Heroes, then, are one with their actions: they establish their wholeness as subjects through their penetration and conquest of space and landscape. Their journeys are always both literal and metaphorical. As Manohla Dargis writes of the American road movie and its novelistic forerunners, 'the woman's body and the road are interchangeable' (1995, p. 87): sites the hero must travel on the journey to self-knowledge, maturity and sometimes (since this is an Oedipal journey) self-destruction.

In Mary Ann Doane's account of the 'woman's film' of the 1940s, we find mapped again and again the difficulties of rendering a *female* protagonist's journey to self-discovery in spatial terms. Women are for the most part, she writes, confined to the home, looking out: within 'women's films', she notes, 'images of women looking through windows or waiting at windows abound' (1984, p. 72). When women do become active investigators in these films, it is the dark, hidden spaces of the home that they investigate, as we see in films like *Rebecca* (1940) and *Gaslight* (1944). The home or house, writes Doane, borrowing from Freud, 'connotes not only the familiar but also what is secret, concealed, hidden from sight' (ibid., p. 73). Thus mapped onto the iconography of the female body, this investigation of the *place* of 'home' is invested with horror: the woman investigates *herself* and finds, in *Bluebeard* fashion, the bloody horror of an abject victimhood. When, however, it is *space* that she crosses, in narratives of female desire, such spaces are 'yoked to the register of the imaginary' (Doane, 1987, p. 115). She may encounter desire in hazily depicted foreign lands, like Charlotte Vale in *Now, Voyager* (1942), or in the fantasised historical past of the Gainsborough melodramas (1943–7). She may, like Laura in *Brief Encounter* (1945), simply imagine romantic fulfilment in exotic places, in fantasy scenes projected onto the carriage windows of her commuter train. Female desire is foreign, and dangerous – 'I didn't think such violent things could happen to ordinary people,' says Laura. Its spaces are the stuff of 'fiction' or 'daydream' (Cook, 1983, p. 16), contained by a circular narrative structure which returns us to the 'ordinary' or 'real'.

Complicating attempts to reverse the gendered identification of male subject/hero as conqueror of space (and bearer of time), and female as territory to be mapped and explored, is the sedimented nature of this narrative. The hero who 'crosses the boundary and penetrates the other space', writes Teresa de Lauretis in her account of desire in narrative, thereby creates culture, history, difference. The female is 'what is not susceptible to transformation … she (it) is an element of plot-space, a topos, a resistance, matrix and matter' (1984, p. 119).

All narrative, she concludes, 'is overlaid with what has been called an Oedipal logic' (ibid., p. 125) – and we can add that this includes the broader cultural narratives, of progress, reason and the Enlightenment that have structured our sense of western modernity.[1] Such narratives are not only expected; they are *realistic*. To seek to reverse their gendered identifications invites not only disquiet but also charges of implausibility. In perhaps the most well-known mainstream example of such attempted reversals, Ridley Scott's *Thelma and Louise* (1991), we see some of these difficulties. As Thelma and Louise take on the status of heroes, the landscape they cross is in turn 'masculinised': studded with buttes and mesas, telegraph poles and cattle fences, oil derricks and crop dusters. For the most part, though, this is a landscape masculinised by being *already occupied*; trucks, motorcycles, herded cattle and patrol cars all block the women's progress, and even the landscape's physical features, its buttes and mesas, register an intertextual masculine occupation. These, writes Manohla Dargis in her account of the film, are 'a visual cue for *Ford's* Monument Valley' (1995, p. 92, emphasis added). Equally important is the fantasised nature of this journey: both space and time are rendered fantasmatic in a journey in expanded time through a landscape saturated 'with unreal colour', where what are encountered are cinematic archetypes and 'a vast image repertoire' (Willis, 1993, p. 123). The film's ending resolves its questions of female identity and desire, as its male-centred predecessors do their crises of masculine identity, through the freeze-frame. But the action which is suspended is the reabsorption of the protagonists into the female landscape of the 'goddamn Grand Canyon', not the Oedipal shoot-out of *Butch Cassidy and the Sundance Kid* (1969); and the still image to which they are returned is not the public photograph of historical record that memorialises the heroes of the earlier film.[2] Thelma and Louise cannot enter *history*. They may perhaps enter myth, but our final image of them is that of the glamorous *snapshot*, with its over-bright colours and masquerade of (eternal) femininity.

Another way of thinking about this gendering of space and time is in terms of the opposition between narration and description. To say, as Laura Mulvey does, that woman's 'visual presence tends to work against the development of a story-line, to freeze the flow of action in moments of erotic contemplation' (1989a, p. 19)[3] is to fix women on the side of description. It is also to say that this description is *motivated* by the gaze of the male protagonist. For Seymour Chapman, as we have seen (Chapter One), *all* description is subordinated to narrative in film, since the camera's apparent neutrality means that its evocations of space or place serve chiefly to authenticate the film's realism. This identification of the feminine with a freezing of time, however, means that it is difficult to envisage the *woman's* journey across space, or to see her as a figure *in* landscape rather than a property of landscape itself. Thus, in de Lauretis's account of Freud's paradigmatic 'journey of femininity' – which is also the underpinning narrative of the 'woman's film' – the female protagonist is trapped

within space, her task that of finally *being* in 'the place (the space) where a modern Oedipus will find her and fulfil the promise of *his* (off-screen) journey' (1984, pp. 139–40, emphasis added).

And yet, as we saw in the writing of Virginia Woolf, landscape has also figured centrally in the work of women writers as a space of female freedom and self-assertion. Ellen Moers, in her account of some of these 'personal landscapes', describes them as landscapes 'independent of administrative boundaries … not a country at all, but the material out of which countries are made' (1986, p. 263).[4] Many of these spaces, of course, are imaginary, abstracted from 'real' historical time. This notion of an atemporal space as the space of *another* story is identified by Paul Ricoeur (1991) as the space of dreams, and by Judith Butler (1997), following Walter Benjamin, as that of melancholia.[5] More recently, Liedeke Plate has seen it as the space of memory, a form of spatial 'haunting' that refuses to recede into the past of 'historical time' but is instead insistently *present* in the 'here-and-now of consciousness' (2011, p. 122). It features prominently, she writes, in postcolonial narratives, as a form of 'writing back' against the dominant narratives of conquest and occupation. Finally, we find a similar notion of a narrative inscribed in space rather than time in Adriana Cavarero's (2000) reworking of Karen Blixen's African story of the man who, searching in the dark to find the source of a 'terrible noise' outside his house, finds in the morning that his stumbling and apparently incoherent movements have traced the figure of a stork on the ground. It is an involuntary and fleeting design, but it captures in space the 'design of [his] life' (Blixen, 1954, p. 215). In narrating his story, Blixen herself returns space to time but nevertheless insists that *meaning* is to be found not in the 'causal logic' (Kuhn, 2000, p. 180) of the conventional life story, but in the accidental figure traced in landscape.

'Metaphor is inherently spatial,' writes Alison Blunt (1994, p. 64). Put differently, description, which is a 'lapse in time' whose content 'unfolds in space' (Bal, 1991, p. 112), is (almost) always metaphorical.[6] Feminist writers have consistently employed spatial metaphors – describing 'situated knowledges' and 'a politics of location' – to envisage alternative modes of knowledge and spatial relations which can position the female subject as *present in* and *travelling though* space without laying claim to 'truth' or the possession of territory (Woolf's 'blast[ing] rocks and mak[ing] bridges'). The difficulty is in concretising these alternative landscapes and spatial relationships: it is notable, for example, that in Gillian Rose's feminist critique of geography (1993), the spaces which are so concrete in her early chapters become wholly metaphorical when she seeks to imagine an alternative feminist spatiality. For women film-makers the challenge is particularly exacting: the stork must be represented and not simply described; the country which is 'not a country at all, but the material out of which countries are made' must be made visible; the landscape must be seen differently. Above all, this essentially time-based medium must be made to foreground place.

SPACE AND MEMORY

Away From Her (2006), Sarah Polley's Oscar-nominated directorial debut,[7] adapts Alice Munro's (1999) Canadian short story *The Bear Came Over the Mountain* to tell the story of Fiona and Grant Anderson, married for forty-five years, as Fiona develops Alzheimer's disease and moves into a residential home, Meadowlake. Grant must watch first her apparent loss of memory of their marriage, as she develops an intense relationship with fellow resident Aubrey, and then her grief as Aubrey is withdrawn from Meadowlake by his wife Marian, whose financial situation means that she cannot keep him there. Aubrey's return to Meadowlake is finally effected by Grant through his decision to embark on a relationship with Marian.

I want to begin with a recurrent point of reference in the film, only glancingly mentioned in Munro's story, W. H. Auden's (1937) *Letters from Iceland*.[8] A sprawling collage of poems, facts, myths, quotations and letters – real and imaginary – and in turn serious and parodic, the volume seems to enact a conflict between form and formlessness. Narrative, aesthetics and the discipline of poetry represent the former, while the latter is not only embodied in the seemingly haphazard structure of the book, but is also figured repeatedly through the twin images of landscape and the body, which represent for the artist/traveller both the point of constant return ('home') and the spaces/places of recurrent wandering or escape. Thus, one of its poems, 'Detective Story', begins by asking, apparently as a continuation of an earlier thought: 'For who is ever quite without his landscape …?' It continues:

Who cannot draw the map of his life, shade in
The little station where he meets his loves
And says good-bye continually, and mark the spot
Where the body of his happiness was first discovered?

An unknown tramp? A rich man? An enigma always
And with a buried past – but when the truth,
The truth about our happiness comes out
How much it owed to blackmail and philandering.

The rest's traditional. All goes to plan:
The feud between the local common sense
And that exasperating brilliant intuition
That's always on the spot by chance before us;
All goes to plan, both lying and confession,
Down to the thrilling final chase, the kill.

Yet on the last page just a lingering doubt:
That verdict, was it just? The judge's nerves,
That clue, that protestation from the gallows,
And our own smile ... why yes ...

But time is always killed. Someone must pay for
Our loss of happiness, our happiness itself. (1967/1937, p. 120)[9]

Like Auden's essay 'The Guilty Vicarage', published a year later (1963/1938), the poem's subject concerns 'why people read detective stories' (1967/1937, p. 119). The detective story, it tells us, imposes narrative order (temporal 'maps') on landscape and life, uncovers a buried 'truth' about a past whose happiness – now lost – is found to have depended on 'blackmail and philandering', follows a predictable structure ('All goes to plan'), and passes judgment. Like his own journey to Iceland, the detective story is for Auden a 'phantasy of escape' (1963/1938) which circles obsessively around home. It is a masculine story, and in the film it is Grant's story. Grant is, like Auden, an interpreter of Icelandic myth: a former university teacher, 'I teach – I taught – ... Norse mythology,' he says. Narrating the 'map of his life' for nurse Kristy, he describes it, as Auden does that of his protagonist, in spatial terms, as a recurrent movement of return to the 'body of his happiness'. 'I never wanted to be away from her,' he says of Fiona. Like Auden's protagonist, too, Grant has been a 'philanderer' (Munro, 2002, p. 286), and the aftermath of his guilt is also described in spatial terms. He did not leave Fiona, she remembers, but instead both transplanted her and returned her home, as in fairytale, to 'a cottage on a lake' which had belonged to her grandparents. 'You promised me a new life,' she says. 'We moved out here and that is exactly what you gave me.' If, then, the murderer of Grant's happiness seems to be 'time', as in Auden's poem, the narrative he provides betrays the 'lingering doubt' of another possible verdict.

Munro's story is focalised through Grant, whose betrayals and self-justifications are weighed through the distancing irony in the narrative voice. The flashback structure of Polley's film seems to echo this focus. We begin with Grant as active protagonist, driving through a snowy urban landscape with the aim, we later learn, of persuading Marion to return Aubrey to Meadowlake. Through flashbacks we discover what led to this event, before the film returns us finally to the present. It is Grant's voice-over which also establishes the film's theme. As the initial shot dissolves into an image of a young Fiona posed for the/Grant's camera against a lakeside background, we hear him say, 'She said, "Do you think it'd be fun if we got married?" ... I took her up on it. I never wanted to be away from her. She had the spark of life.'

What I want to suggest, however, is that the film both significantly shifts the narrative balance of Munro's tale and, through its use of space and landscape,

Away From Her (2006): Grant and Fiona by the 'cottage on a lake'

tells a different story. The most obvious shift is its use of Fiona's voice, which in the film is imbued with the distancing irony of Munro's narration. It is thus not Grant, as in the story, but Fiona who tells the tale of the wartime German soldiers who, when asked why they labelled their dogs 'Hund', responded, 'Because that is a Hund.' As Fiona tells the tale, she attributes it in turn to 'that Czech student of yours, Veronica', who, the film suggests, committed suicide after Grant's affair with her.[10] In Fiona's hands the tale becomes, not a reference to her own memory loss and need for labels, as in Munro's story, but an oblique and pointed reminder of that which cannot be named in the relationship between herself and Grant. It is also Fiona rather than Grant, as in Munro's story, who comments that he 'never left' her. 'You still made love to me, despite disturbing demands elsewhere,' she says, the words of Munro's narrator giving to her comment an odd formality and ironising authority. Fiona, then, persistently wrong-foots Grant, playing on the distance which her memory loss has created between them.

It is, however, the film's use of space and landscape that most significantly undercuts Grant's careful mapping of memory, landscape and life. Fiona's family, Grant reminds her, comes from Iceland, the 'youngest country in the world', volcanic and unstable, 'always shaking itself off'. But for her the Icelandic landscape is not to be mapped but imagined, and we share for a moment her vision of a landscape marked by blue and white craters, water, ice and white volcanic eruption – not so much a country, perhaps, as 'the material out of which countries are made'. It is a place of fantasy and desire, not exploration: a place, she says, that she 'knew about and … thought about and maybe even longed for,

but ... never did get to see'. Annette Kuhn has commented that the 'linear narrative of conventional autobiography, its production of the narrator as a unitary ego, is the outcome of a considerable reworking of the rough raw materials of an identity and a life story'. It is a reworking, she adds, that can be called in psychoanalytic terms 'secondary revision' (2000, p. 180). If Munro's story offers us a narrative whose 'secondary revision' is apparent, Polley's film goes further, offering a counter-perspective in which the 'rough, raw materials' of identity, life story and history persist, like those of Iceland's landscapes, in erupting into visibility. It is Fiona who, seeing television news footage of the Iraq war, comments, 'How could they forget Vietnam?', just as she persistently unsettles Grant's smooth account of their married life. But these are memories not organised around a central structuring ego or narrative: Fiona comments on her own sense of self that 'I think I may be beginning to disappear.' In the end, then, Grant's 'map of his life' is not the story that is told.

The story that contests it – Fiona's story – emerges rather differently. Like Blixen's, this is a story told through landscape – its design, as Cavarero comments in relation to Blixen's story, 'seen only [momentarily] from the perspective of whoever looks at the ground from above without treading on it' (2000, p. 2). Most obviously, the snow that covers over signs of life and obliterates the distinctions of landscape, including that between land and frozen lake, seems to represent the erasure of memory that comes with Alzheimer's disease. Yet it is increasingly clear that such erasure has taken place *before* the start of the story, and is Grant's rather than Fiona's. Annette Kuhn writes that 'memory does not simply *involve* forgetting, misremembering, repression ... memory actually *is* these processes' (2000, p. 186, original emphasis). Like Aubrey's,[11] Grant's memories – the story that he tells Kristy, or the brief remembered images that we see of a young Fiona or Veronica, at once grainy and over-bright – are romanticised constructions that fix Fiona in place and mask the repression of more disturbing events. Fiona's Alzheimer's disease, in contrast, produces memory as unbidden eruption *into* place. When Grant, reading to her from *Letters from Iceland*, suggests a 'letting go' which is also the imposition of order, she counters that she *cannot* 'let go' of memory and grief because 'If I let it go, it'll only hit me harder when I bump into it again.'

What Fiona retains is a form of embodied memory that resists such narrative revisions. Kuhn writes of 'the insistence on *place* in memory', and of memory's 'less tangible pre-texts ... (places, sights, sounds, smells)' (ibid., p. 188, original emphasis). Fiona's memories are bound up with place, season and the body. Her encounter with the yellow skunk lilies which are a first sign of spring is presented in terms of a sexuality which echoes that evoked at the start of the film, where Grant's reading of Ondaatje's 'The Cinnamon Peeler', a poem which evokes the physical imprint of desire on the body, is heard over the wordless touching of the couple in bed. It is a sexuality which is bound up

with both memory and forgetting, and is at once embodied and fantasised. 'When I look away, I forget what yellow means,' says Fiona, 'but I can look again.' As she inserts her fingers into the flower, she comments, 'I think you're supposed to be able to put your fingers inside the curled petal and feel the heat' – but, she adds, she cannot be sure whether 'what I can feel is the heat or my imagination'.

Grant's developing relationship with Marian is marked by a series of ironic counterpoints to these embodied memories: cut daffodils for the lilies; a formal dance for the informal embrace to music, Fiona's feet on Grant's; the embarrassed aftermath of sex for familiar touch and smell. But it is the institution and its explanatory discourses that deaden memory and embodied identity. If Grant and Fiona's relationship is marked by the rhythms of touch, smell and familiar movement, in Meadowlake this is replaced by institutional routine and, in the case of Fiona and Aubrey, a parody of domestic marital ritual. In Meadowlake Fiona loses her own clothing and the identity choices it signified (she begins to dress rather like Marian), her memory of marriage to Grant and, increasingly, her sense of embodiment. 'So as you can see we get a *lot* of natural light,' says Meadowlake's supervisor repeatedly, as she welcomes guests and new residents. As Fiona loses her sense of identity and her appetite for life, a recurrent shot shows a light-filled institutional corridor down which she walks, moving away from us – and from Grant – with increasing slowness, her body seeming to disappear into the light.

Reversing the more obvious connotations, then, we can argue that the film's space of embodied memory is the snow. Like the man in Blixen's story, at the beginning of the film Fiona and Grant trace the narrative of their lives in the tracks they leave on the landscape: now parallel, now diverging and constantly remade. Viewed from above, they form 'the fleeting mark of a unity that is only glimpsed' (Cavarero, 2000, p. 3). Once without Fiona, Grant moves aimlessly across the snow, a small figure framed in a long shot which employs a series of fades that seem to lose him in the snow. For Fiona, however, the landscape is identified with both the familiarity and the pain of embodied memory. We not only see her register the spring lilies as a brightness and warmth that evoke sensual memory; we also follow her when, lost in the white landscape, she abandons her skis and lies down, arms and legs outstretched to touch the snow, gazing upwards at the darkening sky. As the camera zooms slowly down on her through a circular hollow between the trees, we see her smile as she sighs and looks skywards, before the shot dissolves into one which shares her gaze as she looks absorbedly at trees and sky. Later, when Grant takes her back to the cottage and the landscape they have shared, the expanse of snow now empty of tracks is too painful for her, stirring uncontrollable memories ('Everything. Everything just reminds me of him,' she says), and she asks to return 'home'.

Away From Her (2006): Fiona in the snow

The early sequences, with their rhythmic movements over a surface that smoothes and buries but also traces and reveals, contrast with the busy purposelessness of Meadowlake, where the moving eye-level camera captures a restlessness that is both ordered and without meaning – like the unending imaginary ice hockey match to which one of the residents provides a ceaseless commentary. Here, movements do not trace patterns; instead, the use of repeated dissolves together with a seeping white light serve to leave only the institutional structure intact as its residents lose both identity and substance. With Fiona now in Meadowlake, Grant looks back from the snow-covered fields at the cottage they shared, to see its lights go out in sequence as his voice-over quotes from the textbook on Alzheimer's disease: 'It is like a series of circuit breakers in a large house, flipping off one by one.' This equation of Fiona with home – with place – is, however, one refused by the film. The succeeding montage of shots shows us Grant's own dismantling of the cottage's Christmas lights, before returning us to the vast landscape of snow beyond him, and the line of tracks across it. While Grant turns back to the house, the camera continues to follow the tracks.

Highly reflexive, *Away From Her* constantly points up, only to question, the gendered connotations of landscape and movement. The bitter response by nurse Kristy, when Grant finally thinks to ask her about herself, reminds him – and us – that in heterosexual relationships it is men who leave and women who stay, and that in this unequal structure, 'in my experience, at the end of things, it's almost always the men that think that not too much went wrong'. The film reverses this structure, so that it is now Grant who is confined to place, waiting

WHAT IF I HAD BEEN THE HERO?

and watching helplessly, framed by windows, first as Fiona sets out from their cottage and fails to return, leaving only tracks in the snow, and then in Meadowlake, as she pursues her relationship with Aubrey. It is she who is now leaving him, as the dialogue repeatedly underscores, and Grant's obscure sense that this is a consciously inflicted punishment for his earlier infidelities is reinforced not only by Fiona's oblique and ironic references to the past but also by her growing elusiveness. When a rhyming shot reveals Fiona observing Grant and Kristy's conversation through an upstairs window, it is as a shadowy figure in motion, not – as with Grant – as helpless voyeur. The effect is to render her mobile and elusive, beyond Grant's attempted mapping.

The close of the film sees Fiona wrong-foot Grant yet again. After, as in Auden's poem, 'All [has gone] to plan', and Aubrey has been returned to Meadowlake, Fiona's embodied memory and sense of identity suddenly return. It is Grant, not Aubrey, whom she remembers and embraces, so that the film's constantly shifting movement of departure and return is halted, at least temporarily, as the camera circles round the embracing couple. The film's final two shots, however, return us to the beginning and its alternative modes of representing the relationship of memory to place and narrative. We follow again the tracks seen from above, though this time we reverse their progress. Finally, we return to Grant's remembered image of the young Fiona; this time, however, she turns away, to look at the landscape beyond.

THE IDEA OF BORDERS

It is the snowy landscape that also dominates Courtney Hunt's *Frozen River* (2008). Hunt's first feature film, winner of the Grand Jury Prize at the 2008 Sundance Film Festival and nominated for two Oscars, focuses on two women living in poverty near the Canadian border in New York State. Ray Eddy is a part-time worker in the local Yankee One Dollar store, who lives with her two sons, Troy Junior (TJ), aged fifteen, and five-year-old Ricky, in a trailer home described by TJ as a 'tin crapper'. When her gambler husband Troy runs off with the money for the 'double-wide' trailer they've been saving to buy, her search for him leads her to the Mohawk reservation which straddles the US–Canadian border marked by the St Lawrence river. There she confronts Lila, an equally marginal figure in the Mohawk community, who is attempting to steal the car Troy has abandoned. Lila is a smuggler, driving illegal immigrants across the border for $1,200 per person. A partnership between the two women results, driven by Ray's need for cash and Lila's need for a car. After several successful trips across the ice of the frozen river carrying their human cargo in the boot, the two are caught when the breaking ice causes them to abandon the car.

The film's opening, with its twanging guitar music and framed landscape shot, recalls that other female outlaw film, *Thelma and Louise* (1991). Indeed,

Frozen River (2008): the river

director Hunt has said that 'the idea of the Old West', with its journeys, its boundary setting and its lawlessness, was 'the chief genre guiding me' (2009a, p. 49). The film's slow pan up and across the snowy landscape that fills the screen is, however, very different from the earlier film. This landscape, with its dirty ice, cracks and lumps of snow, has no features, no road leading through it into the distance and, until the very end of the slow tilt, no horizon. A shot of an equally grey sky is followed by a montage of shots of barriers, checkpoints and trucks, with foregrounds dominated by a series of counterpointed signs: 'US Customs and Border Protection, Massena, NY'; 'Stop'; 'Be prepared to show identification'; and, in the background, 'Welcome to the United States'. In the next few minutes, more signs track the contested history of this featureless landscape. 'Welcome to Massena, Gateway to the Fourth Coast' (Masséna was one of Napoleon's field marshals) is followed by 'Land of the Mohawk' and, finally, as Ray stops in pursuit of her missing husband, 'Wolfmart Gas-Restaurant' and 'Territorial High Stakes Bingo'. In the landscape of roads and borders, it is the articulated truck or 'semi', rather than the railroad of the Western film, that establishes legitimate boundaries. In *Frozen River* they bring, and take away, the television set, the rented furniture and the trailer home; the stability of the river ice is measured by whether it can bear the weight of a 'semi'. Patrolling the boundaries are the state troopers: ever-present on the boundary roads, watching and waiting.

If *Frozen River* is concerned with the 'myth of the frontier' (Shohat and Stam, 1994, p. 115) and its centrality in the American imaginary, however, it is the absurdity as well as the regulatory power of this myth on which it focuses. Shohat and Stam have written of this variant of the imperial adventure that in it, a

WHAT IF I HAD BEEN THE HERO?

'binary division pits sinister wilderness against beautiful garden, with the former "inevitably" giving way before the latter' in the establishment of new names, new boundaries, new possession of the land (ibid., p. 116). Here, this dream of mobility and occupation finds its worn echo in Ray's poor white family: in the television fantasies that tempt Ricky, and in the invitation to 'Live the Dream' in the flyer for 'Versailles homes' which Ray keeps by her bed, stroking the image of the 'double-wide' trailer with her thumb as she gazes at it. Its absurdity is registered not only by the poverty of this dream, however, but also by the presence of the 'Land of the Mohawk' which, as Lila tells Ray, is 'on both sides of the river' which divides the USA and Canada, so that 'there is no border'.

This, then, is what Anne McClintock (1995) has called 'anachronistic space', the space occupied by a people who are seen by colonial discourse as somehow outside historical time. But the equation of native peoples and women with landscape that McClintock sees this discourse as performing is one critiqued by the film. Its opening suggests such an equivalence, only to radically disturb it. After the initial sequence of shots, the film cuts to an image of Ray's trailer. We see a car outside, its passenger door open and Ray seated there, smoking. The camera tracks slowly across her fleece dressing gown, filling the screen with a texture which echoes that of the snow in the opening shot. As it reaches her face, however, and she brushes away a tear, she becomes active, and it is her activity that drives the narrative. Both Ray and Lila are at once mobile – active survivors – and marginal in these landscapes. Both live in trailers: within barely domestic spaces which are cramped, fragile, temporary and vulnerable to the elements. We see both filling cracks and covering windows to maintain warmth. Both are outsiders, temporary part-time workers as they are squatters on a hostile landscape.

Frozen River (2008): Lila and Ray

For both, the structures on whose margins they live are at once object of their dreams and powerfully regulatory. For Lila, the pressures are overtly and traditionally patriarchal. She has been marginalised by the Mohawk community for causing the death of a 'Mohawk son', her husband, and for the same reason has been forced to relinquish her baby son to her husband's mother. We see her watch from the darkness through the lighted window of her mother-in-law's home in order to catch a glimpse of her son.

For Ray, the dream of money, romance and home functions as regulatory fantasy despite the reality of an absconding gambler husband, the squalor of her surroundings and the stark evidence of men's exploitation of women in the pole dancing club and the young Chinese women whom its owner ships into the USA. In the shelves of unopened toiletries – which include 'Romance bath salts' – in her bathroom, and in her repeated, conflicted attempts to leave a message on her mobile phone which will draw back her absent husband, we see the lingering traces of the kind of fantasy which Barbara Loden depicted forty years before in *Wanda* (1970).[12] Yet it is not helplessness or the power of a masculine fantasy that drives Ray into action, as it did Wanda. 'I was looking for a story that was *literally* active,' commented director Hunt, one in which the female protagonists 'were taking a risk and doing something that would normally be done by men' (2009b). Ray and Lila drive, use a gun, make money and take risks for survival. They use the boundary markers that define their worlds – Lila's Mohawk identity, Ray's whiteness – in order to escape detection. Above all, they learn to manoeuvre within the no-space, the undefined space between boundary lines which is the frozen St Lawrence river.

Frozen River makes references, then, to conventional mythic narratives. In addition to Ray's dreams, we see a forest whose depths are rendered magical by the misty light and where a temporary comfort is found as the women flee from the troopers. Most startling, in its glancing treatment and marginality to the main story – it acts as motivation for Lila to reclaim her son – it is an ironic reworking of the Christian story. One of the pairs of human cargo is a Pakistani couple, their new-born infant smuggled in a duffle bag which is cast adrift in the snow by Ray, who fears its contents might be explosives. The infant is rescued by the women, who return across the ice to find it and restore to its parents in the inn/motel; the women subsequently leave. This, then, is a story which is *not* told, though the political comment in its recasting of territorial occupiers and poor migrants is clear. Instead the focus is on the women's circumvention of boundary markers – of nation, race and, above all, gender – in which the frozen river becomes the space between. Bounded by temporal as well as territorial limits – the journeys must be completed before daybreak, and before the ice melts – it is a space where the women are active and where they forge a relationship of interdependency. The importance of this space, and its fluctuating meaning, is marked by a series of echoing images of the river which

punctuate the film. One of these repeated images sees the frozen river stretch to the horizon, symmetrically framed between two groups of trees and with tracks drawing our eyes forward into the distance and the dawn sky. If, however, this image seems to echo those shots of the onward trail which characterise the Western (and the opening of *Thelma and Louise*), in the second group of shots – with which the film both begins and ends – there is no horizon, no trail and no dawn sky. The frozen river fills the screen, not as route to somewhere else and some future time, but as itself – a space which is unbounded and unmarked by the signs of occupation but also dangerous and difficult. This, then, is not a journey of escape but a narrative of survival. As Carolyn Steedman writes of her own story of female lives 'lived out on the borderlands', '[w]omen are the final outsiders', figures within not heroes of 'conventional narratives of escape' and the 'working class landscapes' that these narratives construct. Their stories exist 'in tension with other more central ones' – the myths and romances that are 'central to a dominant culture'; to tell them is to make it possible for women to 'step into the landscape, and see ourselves' (1986, pp. 5, 143, 14–15, 20–1, 24).

Ray and Lila's capture comes when they threaten to exceed the boundaries of the no-space of the St Lawrence river, in seeking to actively rescue the two Chinese girls. The film ends in compromise. Fleeing through the misty, ethereal forest, Ray reaches the edge of the river – now bleak and unknowable – and pauses, then turns back to hand herself in. Being white, she will receive a lesser sentence than Lila. Sharing the money with Lila, who has been expelled from the Mohawk community but has regained her son, she settles for a 'single-wide', and the film closes on the fragile rebuilding of the now hybrid family that this represents.

THRESHOLD ZONES

Women are ... without class, because the cut and fall of a skirt and good leather shoes can take you across the river and to the other side: the fairy-tales tell you that goose-girls can marry kings.

(Steedman, 1986, pp. 15–16)

At the opening of Rudyard Kipling's *Kim*, the protagonist, a white orphan who has grown up in the streets of India, sits 'astride the gun Zam Zammah ... opposite the old Ajaib-Gher – the Wonder House, as the natives call the Lahore Museum'. He has, with 'some justification', kicked off the Indian boy who was there before him – his justification being that 'the English held the Punjab and Kim was English' (2000/1901, p. 6). The story of travel, 'passing' and adventure that follows is both a kind of imperial map-making (we are told of Kim's proficiency with maps) and a search for an identity that can reconcile the comfort of the maternal (India) with Kim's paternal inheritance as colonial ruler. Reflecting

on the novel, Anne McClintock comments that in it women 'serve as boundary markers and threshold figures; they facilitate the male plot and the male trans- formations, but they are not the agents of change' (1995: 70). At the same time as India is embraced as 'Mother Earth' (Kipling, 2000: 178), women themselves are banished to 'the impossible edges of modernity: the slum, the ghetto, the garret, the brothel, the convent ...' (McClintock, 1995: 72). These are spaces that McClintock labels 'threshold zones': 'abject zones' that are both necessary to and rejected by 'industrial imperialism', and as such 'are policed with vigor' (ibid.).

Deepa Mehta's *Water* (2005), set in the India of 1938, has been most often discussed in relation not to colonialism but to Hinduism, subjected as it was – during Mehta's initial attempt to film in India – to attacks by Hindu extremists because of its supposed anti-Hindu subject matter (Chaudhuri, 2009; Saltzman, 2005). Though its context is India's anti-colonial resistance movement led by Mahatma Gandhi, there are no white characters in it. An early scene, however, suggests both a wider reach and a greater complexity than this focus indicates. In it the eight-year-old Chuyia is exploring the rooms of the ashram to which, as a new widow, she has been brought by her father and mother-in-law. As she enters a room, she comes face to face with a large framed portrait of a Victorian child of about her own age, dressed in sailor suit and red hat, sitting cross legged and holding an apple. Typical of Victorian idealised images of children, the most famous of which, *Bubbles* (1886) by Millais, served as an advertising poster for Pears soap,[13] the image functions as an ironic mirror for Chuyia. The child's black curls and pale skin mock her own dark shaved head, his opulent clothing con- trasts with her white sari and the apple – symbol of childhood innocence – points up her own 'polluted' state. Chuyia pauses and reaches out to touch the image.

It is a scene that points to the complexity of the context within which the ashram and its inhabitants are placed. First, like a number of other scenes (Narayan and Kalyani's drive round the colonial square; the western opulence of Rabindra's father's house and Rabindra's own westernisation; the references to Gandhi's imprisonment) it reminds us of the wider context of colonialism within which the stratified Indian society that we see is positioned. Second, it reminds us that structures of class and gender power permeate both societies. And, finally, it is a marker of the complexity of the networks of power by which those structures are held in place. The space of the widows' ashram is, in McClintock's words, 'policed with vigour', but its inhabitants also police them- selves. It is from the tyrannical 'keeper of the house', Madhumati, that we hear the strongest advocacy of the religious edicts that have caused her own incar- ceration, and the loudest abuse of the liberator Gandhi. The house that she runs, invisible to the city outside, is nevertheless enmeshed in its economic and social structures. The image at which Chuyia pauses would seem to belong to Madhumati.

Water (2005): Chuyia in the ashram

Water, then, tells the story of child bride Chuyia, who is deposited in the ashram on the death of her much older husband. Among the fourteen widows who live there, she meets Kalyani, whose story dominates the middle section of the film, and Shakuntala, who is the central figure in the final section. The youngest and most beautiful of the other widows, Kalyani is used by Madhumati as a source of income: the eunuch Gulabi ferries her across the river at night to be a prostitute in the houses of the rich. Meeting Brahmin law graduate Narayan, a follower of Gandhi, Kalyani and he fall in love. As he takes her across the river to meet his parents, however, she realises that his father is one of her clients and returns, to drown herself in the Ganges. Madhumati decides to replace Kalyani with Chuyia, and she is taken across the river by Gulabi. Realising this, Shakuntala is too late to prevent the rape of Chuyia, but on the return of the boat picks up the collapsed child. She takes her to the train station where the released Gandhi is due to pause on his journey across India, and hands her to Narayan, who has joined Gandhi and his followers on the train.

From its opening, the film juxtaposes stillness and movement. It begins with a wide shot of a stretch of water covered with water lilies, a line of trees in the background touched by the setting sun's rays. The colours are a saturated green

and red/orange. It evokes, suggests Shohini Chaudhuri, 'a sense of timelessness, of a landscape and way of life that has remained unchanged for centuries' (2009: 13). In it, however, are two points of movement. The first is sudden and brief: a close up of a leaf shows a frog jump suddenly out of frame – a freedom of movement that points up the constraints that will follow. The second is slower: we become aware of a cart drawn by bullocks crossing the frame. It is this on which we next focus, and we see the young Chuyia, still dressed in bright sari and with silver anklets and long hair, being driven with her dying husband, but rebellious – poking the dying man's feet, pouting and wriggling. As the group cross the river on a boat – the film's first river crossing – we become aware of the gendered nature of this idyllic scene. The agents of movement are men, its passengers women. As the film develops, we see its male figures move around the city, cross the river, wander along its banks. They can move between classes and between East and West: Narayan wears a combination of Indian dhoti and western shirt and coat and carries a black umbrella; he and his friend Rabindra quote Byron, Shakespeare and Sanskrit poetry; his father's home mixes Indian and western furnishings; he speaks in Hindi, English and Sanskrit. In the joyful scene of rain that marks the mutual attraction of Kalyani and Narayan, where the celebratory actions of the two are intercut, she celebrates in childlike movement and play with Chuyia within her room, while he runs through the streets, Gene Kelly-like, before setting his umbrella afloat on the river. When at the end of the film Gandhi's train arrives to offer Chuyia an escape route, it too is filled with men.

Against the fluidity of these movements are set the constrictions of the women's space. Here the dominant colour is a faded blue-white, and the camera is close in, capturing the details of the shaving of Chuyia's head, the women's bodies as they lie huddled together on their sleeping mats, or the old widow Patiraji's face as she sucks on the forbidden sweet laddoo that Chuyia has brought her. Here the water is laboriously drawn from the well, or brought in small containers from the holy river. The ashram is one of McClintock's 'abject zones', invisible to the outside world, on the margins of the city's life as it is on the edge of the river. A closed space of the kind traditionally identified with the feminine (de Lauretis, 1984, p. 118), it is a space which is most decidedly not the maternal space of home. It is not only Chuyia who dreams constantly of 'home'; so too does the old Patiraji, who fantasises constantly about the sights and tastes of her childhood. This is an enforced private sphere, marked by deprivations of food, hair, clothing (the widows can wear only a single cloth sari without blouse), and personal space. Its internal as well as external segregations are marked by the frequent boundary shots, where scenes are filmed through barred windows or doorways, or around obstacles. But in the brief glimpses of the lives of other women that we see, they are no more mobile, constricted by their positions as wife, mother or daughter: Narayan's

mother may seek to guard her own privileges, but she can only complain that her husband is 'never home'.

The film, however, insists on movement and colour – and eventually agency – *within* these cramped, monochrome spaces. Chuyia's furious movements at the start of the film, as she evades the clutches of Madhumati by racing round the ashram's courtyard or chases the puppy Kaalu through the streets, are filmed with a hand-held camera which captures their whirling fluidity. Chuyia jumps on Madhumati's back, dances and plays pat-a-cake with Kalyani; celebrating the festival of Holi, all the widows throw coloured powder and the camera is positioned among them as they twirl and dance in the ashram's courtyard. Garlanded and dressed as Krishna, Chuyia dances with his flute at their centre, disrupting boundaries of gender and decorum and the hierarchies of the house.

At the same time, the structural limits on this female movement are evident in the gendered meanings attached to some of its key terms. In the quotation from Carolyn Steedman that heads this section, Steedman talks of the 'fairytales' in which the trappings of femininity can 'take you across the river and to the other side'. Here, however, it is men who can freely cross the river which marks the boundaries of class and wealth; for Kalyani and Chuyia, to be 'sent across the river' is to be sold into prostitution. In a similar way, the word 'play' is first used by Narayan, in response to Kalyani's question as to whether he is married. 'My father says, childhood is a time for play, not for marriage,' he replies. Later the sentence finds a chilling echo as Gulabi ferries Chuyia across the river with the promise: 'This is Kalyani's friend's house. Play here for a while, then I'll take you home.' We see Chuyia enter the room, with its red light and opulent curtains, in which a middle-aged man – Rabindra's father – lies on a four poster bed with a drink in his hand. As we follow her admiring gaze, she says, 'I've come to play.'

The film offers two other 'women's stories', both also patterned on popular narratives of femininity. The first is that of Kalyani, which references both Indian and western myths of romance. Narayan, with his flute and love of water, is Krishna[14] – for Kalyani, who prays to a small statue of Krishna in her room, he seems the literal embodiment of the god. He is also Romeo, as Kalyani's appearance on her balcony and Rabindra's mocking references ('Stand beneath her balcony, but don't quote Shakespeare') make clear. In this story Kalyani's dream of escape is dependent on Narayan's own fantasy of being, as his father puts it, 'a hero in an epic play'. Her mobility is entirely dependent on him – his carriage, his boat, his proposed journey to Calcutta; her childlike innocence is without agency.

Shakuntala's story – the story that closes the film – also echoes both Indian and western archetypes. In Hindu mythology, Shakuntala is a figure of abandonment:[15] a maternal figure who, abandoned by her husband, brings up her

Water (2005): Shakuntala at the close of the film

son, the future emperor Bharata, alone in the forest. Mehta's narrative also echoes the Hollywood maternal melodrama, however. As Shakuntala runs alongside the departing train at the close of the film, calling out to the child she has relinquished in order to save her, the corner of her sari held to her mouth, we find an echo of the similar scene in Vidor's *Stella Dallas* (1937) in which Stella – also an abandoned maternal figure rooted to *place* – waves goodbye to the daughter she is relinquishing into the care of her upper-class father and his new wife. Whereas Stella's is a journey to a transcendent acceptance of absence and maternal sacrifice, however (Kaplan, 2000/1983; Williams, 2000/1985), Shakuntala's is towards an independent and *present* subjectivity within the spaces in which she finds herself.

On the one hand, then, the film's ending suggests that only by becoming mobile in space can women enter time and history, and that the child Chuyia will achieve this. Countering such a conclusion, however, the textual message on which the film closes reminds us that in 2001 over 34 million widows in India still 'live in conditions of social, economic and cultural deprivation'. The new historical era which the close of the film ushers in did not, in fact, transform a patriarchal society.[16] Shohini Chaudhuri has argued that the film's closing reliance on the structures of melodrama is 'ultimately limiting' (2009, p. 19). I would suggest, however, that this is only the case if we assume that these structures have to bear the weight of a narrative in which place, and women's identification with it, gives way to their entry into historical time, and that the ending is, in fact, more ambivalent. The final focus is not on Chuyia, but on Shakuntala's calm and increasingly determined face as she looks, not towards

WHAT IF I HAD BEEN THE HERO?

the disappearing train, but back towards the ashram and town. As with Steedman's maternal figure, hers is a story lived outside both history and 'the romances of the family and the fairy-tales that lie behind [the] closed doors' of the middle-class household (1986, p. 139). Unlike in Steedman's narrative, however, when Shakuntala re-enters this space of marginality and exclusion it will be as a subject who will contest the religious and social structures which render it both circumscribed and abject.

UTOPIAN SPACE

[W]hen evoking the name and destiny of women, one thinks more of the space generating and forming the human species than of time, becoming or history.

(Kristeva, 1986, p. 190, original emphasis)

Antonia's Line (1995) is the fourth film by Dutch writer and director Marleen Gorris, and winner of the 1996 Oscar for Best Foreign Language Film as well as other international awards. Opening with the impending death in old age of Antonia,[17] it then takes us back fifty years to the end of World War II and her return, with daughter Danielle, to the village where she grew up and where her mother is about to die. As she settles on the farm that she inherits, the film traces her 'line' across three further generations: her daughter Danielle, grand-daughter Thérèse and great grand-daughter Sarah. Around this generational line is accumulated a much larger community of lovers and their families, friends and refugees from the world beyond. The film closes with the return to Antonia's death in the present, and the revelation that the voice-over narration which we have heard throughout the film is that of Sarah.

In Geetha Ramanathan's discussion of the film, she comments that its framing of Antonia within *landscape*, a framing which is 'so infrequent in mainstream film for women that it appears mythical', gives *Antonia's Line* a 'heroic scope'. Despite this framing, however, the narrative itself is 'at odds with male mythical texts'; Antonia, that is, 'does not act in any obvious heroic way' (2006, p. 183). Her comments draw attention to the characteristics of the film on which I want to focus here: while *Antonia's Line* has been seen as epic, mythic, or fairy-tale narrative,[18] this is not a narrative in which space or 'landscape' functions as the setting for heroic adventure, whether by this we mean Oedipal conquest, journey to self-realisation, or ultimate return to, or exile from, the space of home. Nor is it a 'feminine' story in which woman learns to relinquish her identification with narrative and temporal mobility and to accept her identification with space or place. Rather, the film removes the markers of historical time to another place, on the periphery of its narrative space, in order to reimagine the relationship of its female subjects to both space and time.

Most obviously, the film's concern is with two issues discussed in Chapter One: the question of female authorship and of how this might rework women's relationship to time and history. *Antonia's Line* begins with a female voice-over and a female subject. That the two cannot simply be equated, however, is signalled by the opening words of the voice-over: 'Even before the sun had risen, Antonia knew her days were numbered. She knew more than that, she knew this would be her last day.' The voice-over, then, distances us from Antonia, as does the evident framing of the single two-minute take which follows Antonia from her bed as she puts on her dressing gown, sits before her mirror and then leaves the room. Yet if in these opening minutes we constantly see Antonia within frames – those of her mirror, and of the doors and windows through which we look out and then in at her – the final focus on her gaze, as she looks out of her window, identifies us with her point of view. A dissolve from her pensive face takes us back in time, as a red bus moves past the camera to reveal a much younger Antonia and Danielle standing in a village, suitcases in hand. What the film gives us, then, is a doubled point of origin and authority for the narrative: Antonia's memories and a third-person narrator. At the end of the film, this narrator too is given an identity: 'And I, Sarah, her great grand-daughter, would not leave the deathbed of my beloved great grandmother.' Neither of these figures, however, constitutes the 'unified subject-identity' that, according to Patricia Ticineto Clough (1992, p. 116), usually authorises the realist narrative. The Sarah we see is a child, so that we do not know the relationship of this figure to the apparently omniscient narrative voice. Instead, the narrative is multiply authored, through a form of what Ramanathan calls 'generational storytelling' (2006, p. 182), whose authority derives from its composite nature, at once multiple and dis-embodied.[19]

In such a narrative our sense of time is altered. Historical time is not absent. We know that Antonia and Danielle arrive in the village at the end of World War II: that the village has been occupied and recently liberated is evident from the British flag and the unevenly painted sign – 'Welkom to our Liberaters' – which we see on the wall of the village bar as the two walk past. Later, Antonia tells her daughter of the villagers' wartime record of both resistance and collaboration. Thereafter, however, historical change is registered largely *somewhere else*: in the visits to the city made first by Antonia and Danielle, in the search for a father for Danielle's child, and then by Thérèse as student and then lecturer. Time within Antonia's own world has been described as 'monumental' or 'mythic' (Ramanathan, 2006; Sellery, 2001). It is marked by seasons and generations, the rhythms of the body (Danielle's desire for a child; Antonia's renewed sexual desire 'after all these chaste years') and of community; it may be fecund ('Time gave birth again and again') or brutal (time 'tore through life like a vulture in search of prey'). It is a use of time that has invited two comparisons: with Julia Kristeva's concept of 'women's time', and with the use of time within 'magical realism'.

Distinguishing between 'men's time' (linear, teleological, 'in other words, the time of history') and 'women's time' (cyclical and/or monumental), Kristeva sees the latter as identified with myths of a maternal utopia: 'the belief in the omnipotence of an archaic, full, total englobing mother' (1986, pp. 192, 205). It is a concept that, as Kaja Silverman has pointed out, is both alluring – Silverman (1988, p. 125) calls it 'one of the governing fantasies of feminism' – and limiting, for it places women, and the feminist utopias they might imagine, outside culture, history, the symbolic. Such a concept is one that at times *Antonia's Line* seems to endorse. Discussing time with the reclusive philosopher Crooked Finger, for instance, Thérèse suggests that different creatures might live in their own time, prompting the idea that such temporal separateness might also characterise 'Antonia's line'. Yet the exchange that follows dispels this. Hugging the old man, Thérèse exclaims, 'Finger, you stink!' and he replies, 'That's the smell of time past.' Finger's concept of time, that is, is as much a product of his embodied experience, as much a construction, as is Antonia's. Both constitute ways of living with and within time, not separate temporalities.

The expansion and contraction of time in *Antonia's Line*, and its incorporation of elements of the fantastic into its narrative, have also prompted its identification with the genre of magic(al) realism. Tracing its roots back to the interweaving of magical and real in myth and epic, magical realism (or metaphoric or mythic realism) disrupts realist conventions through its co-location of the real and the magical, to produce 'dual' or 'plural worldhood', and an interweaving of history, memory and fantasy that serves a critical or recuperative function (Zamora and Faris, 1995; Wilson, 1995; Foreman, 1995). It is this that J'Nan Morse Sellery sees *Antonia's Line* as doing, using its device of a 'youthful narrator empowered by magic realism' for feminist purposes, in order to 'contest … the hegemonic gender values of culture, family, and religion' in post-war Holland (2001, p. 115). Thus, Danielle's imagination rewrites the Christian story of death and resurrection through her vision of her grandmother's resurrection, in which she – and we – see the old woman sit up in her coffin, singing 'My Blue Heaven' to the accompaniment of priest and choirboys, and blessed by a smiling plaster Christ. And at the close of the film the child Sarah's gaze calls up the presence of the dead villagers in celebration of Antonia's final supper.

Yet if the film echoes the critical reflexiveness of magical realism in its references to Christian mythology (in addition to Danielle's visions, Antonia is the 'prodigal daughter' and the film's five-generation female lineage ironically echoes that of Genesis), to witchcraft (in Antonia's powerful cursing of the rapist Pitte) and even to popular film genres (in the confrontation of Antonia with Pitte at gunpoint in the village square or 'the knight on the white charger'[20] who makes Danielle pregnant), it also has a different heritage. We can also link it to the 'personal landscapes' of women writers of which Ellen Moers writes, landscapes

which carry 'the fullest tally of spiritual, historical, national, and artistic associations' (1986: 258). It is a heritage punningly noted by one reviewer who commented that Antonia 'carve[s] out a realm of freedom in a farm of her own' (Jaehne, 1996, p. 28). The film's disruption of realist conventions of time, then, can also be seen as the construction of a different relationship to space and place.

The village and its surrounding landscape are inscribed with male occupation. All of the village spaces are gendered, with the bar (all-male except for Olga who serves at the bar) and the church as the most notable instances. Repeated shots emphasise the division in the church: men on one side of the aisle, women on the other, and the male priest in his pulpit towering over the congregation in his celebration of men and denunciation of women. Outside the village, paths and fences mark the boundaries between male and female spaces, and it is men who drive the tractors along the borders. Within Farmer Dann's walled farmyard – the dark farm to Antonia's light farm – 'the men's loud voices [ride] roughshod over the women's silence', and women are abused and raped. This is a space of Freudian 'family secrets', but the incest that takes place is a matter of power, not desire. At the beginning of the film, it is this family that dominates the village ('The farmers here only breed sons,' says Antonia to Danielle), occupying the outside spaces (a public wall becomes 'the Saturday night urinal') and confining women within walls and silence. Antonia's mother, too, has been subject to such treatment, and is consumed by rage and bitterness as a result.

In contrast, 'Antonia's line' is characterised by mobility and fluidity, and the space of her farm by openness. As Antonia and Danielle leave the village for the farm at the beginning of the film, they walk out of the static frame that seemed to confine them; when they return, Antonia guides Danielle and the viewer around and past the various spaces – Crooked Finger's house, Chiel the blacksmith's smithy, the rooms of Mad Madonna and the Protestant – which house the villagers. Antonia's farm is marked by a fluidity of movement between inside and outside: the most frequent scene is that of the outside table at which Antonia's extended family eats, talks, quarrels and dances. The wrought iron gates which mark the boundary of this space are open. Beyond these scenes, we see the family in the fields, haymaking and mending fences, as well as in the kitchen and bedroom. The women, says the narrator, 'had so little to do with the village that the villagers accepted them'. What the film effects, however, is a reversal of this relationship between margin and centre: the villagers gradually congregate around the table, so that in Sarah's final vision all of them – dead and living, friend and enemy – are gathered there. The village, too, reverses its allegiance: when Antonia enters the village centre to confront the rapist Pitte, it is the young men who silently exact physical punishment on her behalf while she pronounces judgment, in a curse that echoes those of her mother at the beginning of the film but now carries a power previously denied.

Antonia's Line (1995): Antonia's family table

Antonia's is, then, a utopian matriarchal space. It can admit men provided that they do not assert dominance, as we see from the progress of her relationship with Farmer Bas. From his initial marriage proposal, which occurs – uncomfortably – in the doorway which marks the boundary of her space, to her initiation of a sexual relationship which must take place in a neutral space – 'not in my house or yours' – to their final dance around the communal table, we are presented with the spatial terms on which a successful heterosexual relationship may be negotiated. This, however, is not straightforwardly 'women's space' any more than it is 'women's time'. Karen Jaehne (1996) has noted the references throughout the film to Dutch landscape painting. Like *Frozen River*, the film employs a series of echoing landscape images which punctuate the film – rendering time in spatial terms. These images, however, in their framing, deep focus and detail, quote others. As Antonia the sower strides across the field scattering seeds, we see a gendered reversal of Millet's *The Sower* of 1850 and the 1888 version by Van Gogh which it inspired. Elsewhere, the haymaking scene and the framed landscapes recall those of seventeenth-century Dutch painters such as van Ruisdael (Jaehne, 1996, pp. 27–8). For Jaehne, this signals continuity with the vision of these earlier artists. The fact that these are self-evidently quotations, however, seems to point to a rather different significance. First, it creates a continuum between the film's vision and the ironic, playful reversals of painter Danielle, whose visions encompass a lesbian reworking of Botticelli's *Birth of Venus* as well as a matriarchal resurrection. Once again, this is a vision multiply

Antonia's Line (1995): Antonia the sower

authored and authorised. Second, such evident authorial intervention insists on the mediated nature of these landscape images. This is not a celebration of the land – though its insistence on joy includes that element – so much as a questioning of the terms on which landscape has been celebrated. Millet's social realist *Sower* has been seen as a plea for social justice, but objectifies its object nonetheless. Gorris's film uses and reverses the symbolic features of such landscape painting (its Manichean images pit Antonia's sunlit farm against the dark menace of Farmer Dann's), while at the same time pointing to both the labour and the tradition involved in painting (in the glimpse we see of Danielle at art school she has to draw a version of Rodin's *The Thinker*). In situating its own authorial vision both inside and outside the narrative – Antonia farms, Danielle paints and the film's vision extends both through its incorporation of time (Thérèse) and narrative (Sarah) – the film suggests the possibility of a different relation not only between hero and landscape but also between artist and subject.

Antonia's Line is, then, a feminist fable which sets its matriarchal fantasy against patriarchal constructions of history, culture, art and heroism. *As* fantasy,

however, its world is not that of Kristeva's *chora* (Silverman, 1988, p. 125), with its separatist vision of women's time and space. Rather, against the ethical and spiritual bankruptcy of patriarchal post-war Europe, whose teleological outcomes are violence (Pitte) or nihilism (Crooked Finger), it sets the fantasised possibility of a different way of inhabiting both time and space. But this is not outside the symbolic, nor does it lead to the construction of a unified subject-identity within it. Rather, to paraphrase Patricia Ticineto Clough's comment on the writing of Toni Morrison, it makes visible film-making itself as 'a desiring production, a fantasy to make the impossible a fictional possibility for living' (1992, p. 13).

Chapter Six

BODIES AND PASSIONS

> I cannot make use of what [the imagination tells] me – about women's bodies for instance – their passions – and so on, because the conventions are still very strong. If I were to overcome the conventions I should need the courage of a hero, and I am not a hero.
>
> (Woolf, 1978/1931, p. xxxix)

> [I]f one recognizes that the textual author ... is a feminist filmmaker, then her function as controller of the discourse (the one who organizes the narrative logic, negotiates the disparate visions) can be seen as one which attempts to originate the representation of her own (female) desire.
>
> (Flitterman-Lewis, 1990, p. 22)

Despite the fact that nearly sixty years separate these two quotations, what I am struck by is the similarity of the problem they describe: the difficulties which the female writer or film-maker encounters in representing female sexual desire. Woolf, as we have seen (Chapter Four), disavows such a project. She is not a hero, and in any case heroes are masculine. The resulting paradox – heroism would mean having the courage to depict the 'dark pool of extraordinary experience' that is women's sexual fantasy (ibid., p. xxxviii), yet this is impossible because heroism is a masculine activity – effectively constructs a double prohibition against the (female-authored) representation of female desire. The 'passions', 'women's bodies' and 'experience', 'our unconscious being' (ibid.) – all, in being unrepresentable, remain split off not only from representation but from the self. Although Woolf herself declared, at the time that she wrote the lecture quoted above, that she had 'conceived an entire new book ... about the sexual life of women',[1] her own writing continued instead to enact the double pull of desire and repression/prohibition.

In contrast, for Flitterman-Lewis such representation is clearly possible: the quotation above comes from her introduction to the study of three French women film-makers. Yet her phrasing is curiously tentative. The feminist film-maker, she says, will '*attempt* ... to *originate* the representation of her own (female) desire' (emphasis added), the italicised words seeming to place once

again a double obstacle – a double element of doubt – between the film-maker and the representation of her/female desire. Part of this doubt comes from the difficulties surrounding the question of *authorship*, discussed in Chapter One; Flitterman-Lewis is acutely aware of the problems in appropriating the masculine notion of the cinematic auteur for feminism. But her description of 'feminist cinema' – as 'foreground[ing] sexual difference in the enunciative relay, focusing on *the status and nature of the representation of the woman* – her desire, her images, her fantasms' (ibid., p. 23, emphasis added) – persistently places intermediary terms between the film-maker and her representation of the female subject and her fantasies and desires. The 'conventions', it seems, remain strong: no longer, as with Woolf, prohibiting *any* representation of female desire, but forcing, it seems, a self-reflexive focus on representation itself ('the status and nature of the representation of the woman') which is not so very far from Woolf's own strategies.

It is, then, 'a formidable task' for female film-makers to 'represent female sexuality positively and affirmatively', as Anneke Smelik observes (1998, p. 159). While '[i]n cinema the mere appearance of a woman signifies sexuality; her body takes on the meaning of sex' (ibid., p. 158), neither the body thus represented nor the representational structures that produce it are those of a desiring subject. Linda Williams has suggested that such structures, and the 'perverse pleasures' that they produce, are bound up with the origins of cinema itself as a 'late nineteenth-century discourse of sexuality, [an] apparatus for aligning socially produced sexual desires with oedipal and familial norms' (1990, p. 46). Unlike earlier theorists, Williams does not view such alignments as immutable – they are, she writes, historically and socially specific, the products – and the (re)producers – of particular regimes of power and pleasure. But they are difficult to dislodge nevertheless, their visual and narrative encoding of fantasy and erotic desire in ways which support specific power structures neither easy to disentangle nor straightforward to rewrite. The fantasies that Virginia Woolf felt unable to retrieve from the 'dark pool' of the unconscious cannot be accessed outside narrative, and such narratives both structure and are structured by a wider culture. If, then, cinema's public narratives and images have both expressed and repressed – have been *constitutive of* – our own desires and pleasures as women, to 'represent female sexuality positively and affirmatively', as Smelik wishes, may be as difficult to define as it is to achieve.

This final chapter is concerned with perhaps the most problematic of the issues I raised at the beginning of this book: with attempts by women film-makers to represent female sexuality – Woolf's 'bodies' and 'passions' – and thus to either negotiate or address directly the difficulties outlined above. First, however, I want to tease out further the difficulties involved. We can, adapting Woolf, identify two questions to be addressed: first, how might we conceptualise and, second, how can the female film-maker depict cinematically, these

bodies and passions? The two questions are, of course, far from distinct. Sexuality, according to whatever theoretical model we choose, is bound up with fantasy and the visual, both of which are crucial to theorisations of cinema, and questions of power trouble both. As Linda Williams has argued: 'questions of pleasure are always, ultimately, questions of power' (1990, p. 279). Analytically, however, they can be distinguished, and I want to deal with them separately here.

THE POLITICS OF SEXUALITY

> I believe it is beside the point to wonder what 'good sex' means for women outside the current patriarchal constraints that circumscribe our sexuality.
> (LeMoncheck, 1997, p. 218)

'[W]e have failed to develop an active feminist theory of sexuality,' commented B. Ruby Rich in 1986 (1998, p. 374). Rich is writing in the context of the 'sexuality debates' or 'sex wars' that characterised feminism of the 1980s. The debates themselves began out of a sense, writes Rich, that feminism's struggle against the sexual oppression of women had created a kind of 'respectable sexuality' for women which ignored or repressed women's actual desires and sexual practices. 'In spite of its publicity,' wrote Ann Snitow, Christine Stansell and Sharon Thompson in one of the key texts of this rebellion, *Powers of Desire*, 'sex remains oddly taboo, particularly for women ... The sexual shame that begins in childhood – and which the entire culture endlessly recreates – keeps the sense of taboo alive even in a blitz of the sexually explicit' (1983, p. 9). The essays in this anthology struggle with the contradiction between feminism's insistence (encapsulated in the slogan 'The personal is political') that *no* sexual acts, fantasies or desires are outside social and ideological power structures, and the powerful counter-claim that in making this argument feminism is in effect policing female desire. Amber Hollibaugh and Cherrie Moraga, for instance, feel that they 'have been forced to give up some of [their] richest potential sexually in the way feminism has defined what is, and what's not "politically correct" in the sexual sphere' (1983, p. 401), and argue instead for a lesbian butch-femme practice that is fully *aware* of the eroticisation of power on which its active/passive play depends.

The problem, Hollibaugh and Moraga argue, is feminism's 'fear of heterosexual control of fantasy' (ibid.). Looming over these fierce arguments about sex, power and erotic fantasy, then, are some familiar spectres. 'In the old days,' writes Rich, 'before behaviour was dictated by political correctness, emotional sadomasochism was a staple of women's sexual life. Heterosexual romance ... was shaped by fantasies of domination, seduction, powerlessness, and force' (1998, p. 357). That the 'old days' remain uncomfortably present, however, is

apparent from Ann Barr Snitow's essay on contemporary romance novels in *Powers of Desire*. For Snitow, these popular texts, in which 'sex is bathed in romance' (1983, p. 257), constitute precisely the kind of fantasy Rich describes. A form of 'pornography for women', they eroticise 'the joys of passivity, of helpless abandon, of response without responsibility', with a heroine who must remain 'passive, undemanding, unthreatening' if she is to win the hero (ibid., pp. 256, 260). But romance fantasies are also contradictory. The heroine's passivity is always rewarded – with emotional nurturance and spiritual adoration. This is a fantasy, in other words, in which women *win*; the problem is that their route to victory is victimisation.

It is this contradiction – the same contradiction that Virginia Woolf described in her repressive and idealised figure of 'the Angel in the House' – that Jessica Benjamin's work of the 1980s and 90s sought to analyse from a psychoanalytic perspective. What prevents women occupying the position of sexual subject – of 'hero' – she writes, is the 'propensity toward ideal' or self-sacrificing 'love' which has 'fostered submission and passivity and hero worship on the part of women' (1986, pp. 79–80). But this is, she writes, a complex and contradictory position to occupy. It is at once 'a *critique* of heroism' – for its masculine insistence on separation and individualism – and an alienated and complicit desire to *identify with* the position of hero (ibid., p. 79, emphasis added). The problem, she writes, is that in an Oedipal trajectory in which their primary figure of identification is the de-sexualised mother, women have no image of *female* sexual agency on which to model their desire. Her solution, in a further echo of Woolf, is the constitution of another *mode* of desire (a 'desire of one's own') which is conceived in spatial terms: an 'intersubjective space' which is both internal – a space in which 'one's own desire can emerge' – and external – the 'space between the I and the you' (ibid., pp. 97, 95). In this space, as Linda Williams writes, 'the woman's interior [will be] experienced as part of her own being, as an extension of the space between her and the other, and not as a passive object or place to be discovered' (1990, p. 260).

Benjamin's 'intersubjective space', then, envisions the possibility of a sexuality freed from binary structures of activity/passivity, hero/victim. Yet its constitution as simply *another* mode of desire seems to leave uncontested male possession of those arenas – cultural, material and psychic – that already exist. In particular, if, as she writes, the domain of 'the symbolic' remains 'occupied and organized by phallic structures' (1986, p. 92), so that 'the fantasy of erotic domination' continues to permeate 'all sexual imagery in our culture' (1983, p. 281), then it is difficult to see how an effective challenge to such imagery can be mounted by the kind of interpersonal sexual ethics she advocates. In what seems to be a ceding of key ground, she argues that 'the power of fantasy' must be destroyed or contained – subordinated to 'real recognition' of the other (1986, p. 93). It is a proposal that seems to constitute an impoverishment of

desire – the kind of 'policing' of female sexual desire to which writers like Hollibaugh and Moraga so vehemently objected. Fantasy, it has been argued,[2] is *constitutive* of sexual desire, but it is also, as Teresa de Lauretis writes, the 'semiosic ground' which 'links the subject to the social through sexuality' (1994, p. 308). Fantasy, that is, constructs sexuality as *narrative*,[3] so that it lies 'at the base of all "stories told in images," in essence, all films and all dreams' (Flitterman-Lewis, 1990, p. 12). Without fantasy, it is difficult to see how Benjamin's 'intersubjective space' can also be an eroticised space, much less a space in which public and private fictions, social and subjective representations, might work together and in conflict to stage and restage desire.

The problem for feminism, as Benjamin recognises, is that the identification of female sexual fantasy with *masochism* is so culturally and historically entrenched. Although feminist psychoanalytic theorists[4] have sought to rethink the Freudian Oedipal scenario in order to argue for women's access both to the symbolic and to the realm of desiring fantasy, 'Masochistic fantasy *instead* of sexuality' – Mary Ann Doane's telling phrase – continues to characterise the cultural representation of female desire.[5] Twenty years on from Snitow's essay in *Powers of Desire*, Deborah Tolman's study of how teenage girls talk about sexuality continues to identify a 'master narrative of romance, which is premised on female passivity and male aggression and dominance', and which continues to provide 'a script not only for how males and females interact but also for expectations about female and male sexuality' (2002, p. 81).

In such a context, it is unsurprising that the *dangerous* aspect of a femininity denied access to the symbolic order – the 'bad', uncontrolled woman who has been the persistent shadow to her passive, compliant sister – has also had its attractions for feminism. From the sexually voracious to the grotsquely fat or aggressive woman, this figure of the 'unruly woman', 'transgressive above all when she lays claim to her own desire' (Rowe, 1995, p. 31), has proved an attractive figure. It has the allure of the transgressive and the powerful, though the unruly woman can also be a complicit and shameful figure,[6] and her power is most often simply the power to disrupt. Conceptualised most famously in Julia Kristeva's notion of abjection,[7] in its most extreme and nightmare version this is a vision of femininity or the female body, in Elizabeth Grosz's powerful formulation, as not just the absence of masculine solidity and subjectivity but as 'a leaking, uncontrollable, seeping liquid; as formless flow; as viscosity, entrapping, secreting; as a formlessness that engulfs all form, a disorder that threatens all order' (1994, p. 203). From philosophy[8] and high art to popular horror and science fiction, such images have offered a representation of female sexuality very different from that of the passive object of desire. For Kristeva, it is an image which hovers between desire and nightmare, and its combination of 'sensation (suffering) and denial (horror)' causes a *shattering* of narrative (1982, pp. 154–5). Perhaps, however, as Anneke Smelik suggests, this also gives

it transformative potential, suggesting a version of female sexuality whose 'play between visibility and invisibility, between repulsion and fascination' (1998, pp. 164–6) can serve feminist ends.

FILMING FEMALE DESIRE

> In order to counter our objectification in the cinema, our collective fantasies must be released: women's cinema must embody the working through of desire: such an objective demands the use of the mainstream entertainment film.
>
> (Johnston, 1973, p. 31)

The question of 'how to represent women's desire *visually*' (Williams, 1990, p. 260, emphasis added) is implicit in all the discussions above, from Benjamin's concern at the 'phallic' structures of representation which dominate the symbolic, and Linda Williams's suggestion that a visual equivalent to Benjamin's 'intersubjective space' might be found in some female-produced pornography,[9] to Smelik's notion of 'the play between visibility and invisibility' which might characterise transgressive images of female desire. As we can see from the quotation from Claire Johnston's work which heads this section, it has been central to conceptualising a women's cinema since the early 1970s. Yet if we also want to argue, as feminist theorists from Mary Wollstonecraft onwards have, that, in Elizabeth Grosz's words, 'we live our sexual bodies ... never, as it were, "in the raw," unmediated by cultural representations', so that our 'pleasures and desires are always lived through models, images, representations' (1994, pp. 196–7), such a cinema becomes not only more *necessary* but also more difficult to achieve. Which fantasies and desires are to be 'released' and 'worked through'? How can the erotic be engaged and represented without becoming both recuperable and recuperated by a dominant conception of the female body as *inherently* saturated with sexuality, and female desire as inherently masochistic? If fantasy is, on the one hand, always already subject to the dominant structures of the symbolic, drawing on the images and narratives of existing cultural texts, and, on the other, slippery, disruptive and resistant to change, how can it be engaged to serve more radical ends? Finally, if, as we see above, more transgressive female fantasies function to shatter the dominant heterosexual narrative, (how) can *heterosexual* desire be represented without succumbing once more to Snitow's fantasies of 'domination, seduction, powerlessness, and force'? It is not surprising, given these difficulties, that feminist discussion of female *desire* has often subtly shifted into discussion of female *agency* or subjectivity, and discussion of female sexuality in film into discussion of transgressive images, textual surfaces or rhythms.[10]

PRIMAL FANTASIES

The two most frequently encountered female perversions are extreme sub-missiveness and womanliness as a masquerade.

(Kaplan, 2000, p. 352)

[F]emale perversity was the subject of the film.

(Borden, in Lucia, 1992, p. 7)

When Teresa de Lauretis, in the mid-1980s, sought a film which would exem-plify a 'radical *rewriting*, as well as ... rereading, of the dominant forms of Western culture' (1987 p. xi, original emphasis), the example she chose was Lizzie Borden's first film, *Born in Flames* (1983). It is a film, she writes, that 'may well answer the call for "a new language of desire"' in women's cinema. Addressing its spectator '*as* a woman', it carries a 'powerful erotic charge', to which its female spectator responds 'with something that is neither pleasure nor *jouissance*, oedipal nor pre-oedipal, ... but with ... a recognition, unmistakeable and unprecedented' (ibid., pp. 143–5). It was a judgment that was widely endorsed; the film, wrote Lynne Jackson in 1987, 'has become a feminist classic ... one of the most important feminist films of the Eighties' (1987, p. 7). Borden's second film, *Working Girls* (1986), which explored prostitution as work, aroused more controversy but was still firmly positioned as an interrogation not only of the economics of prostitution but also of its 'traditional cinematic rep-resentation ... women in short skirts and high heels being attacked by men' (Borden, in Jackson, ibid.). Borden's third feature *Love Crimes* (1991), however, represented a move into the mainstream in terms of both production context – it had a $6 million budget and joint US–European funding – and genre. It also represented a more direct engagement with the issue of female 'sexual repression and fantasy' (Borden, in Lucia, 1992, p. 7). The outcome, as Cynthia Lucia wrote in 1992, was that it 'was received ... with befuddled confusion at best and harsh denunciation at worst' (1992, p. 6). It was Borden's last feature film to date.

The reasons for this reception can in part be traced to the film's production context. Borden found her own ideal audience – 'women over thirty' – replaced with that of the producers – 'nineteen- or twenty-year-old boys'. To appeal to this market the film was released very widely, key scenes were cut and others re-edited, and Borden's ending was rejected and replaced (Borden, in Lucia, ibid., pp. 6–7). But even the re-edited and restored version released on video (the ver-sion I shall discuss here) produces ambivalent responses. The film's narrative engages precisely the 1980s feminist arguments about sexuality described above, and Borden's own position on these issues, as given in interviews, is far from clear. The film, she says, is about 'control, power, and sexuality', and she sees

her female protagonist's sexuality as constructed within the context of a deforming patriarchal culture – but she also adds that, following the film's release, she has 'done a few pieces for The Playboy Channel', because there 'you can deal with sexuality just as sexuality' (ibid., pp. 7, 10). In this self-reflexive narrative of a female district attorney investigating the predatory activities of a photographer who seduces then humiliates his victims through his camera, then, we find played out not only the tension between mainstream visual practices and feminist counter-cinema, but also some of the ambiguities surrounding the question of female fantasy and desire.

In the director's cut of *Love Crimes*[11] we begin with a police interrogation of Detective Maria Johnson about the motives and actions of her best friend, Atlanta assistant district attorney Dana Greenway, in pursuing a man who has posed as fashion photographer David Hanover in order to seduce and exploit a series of women. In the flashback narrative that follows, we see Dana follow 'Hanover' to Savannah in order to entrap him. Tracking him to his cabin in the woods, she is imprisoned, seduced and photographed by 'Hanover' but ends by arresting him at gunpoint. Following his escape, however, a climactic scene in Dana's apartment sees her assaulted by his flashing camera, a scene intercut with her memories of the murder of her mother by her father, and ended when she brings down a heavy glass vase onto his head. The film returns to the present and the interrogation of Maria, who refuses to compromise her friend by revealing the existence of the Polaroid images of Dana taken by Hanover, and ends with Dana's burning of the photographs.

Unlike Borden's earlier films, then, *Love Crimes* is a genre film, an erotic thriller with a female investigator-victim.[12] The timing of its release links it to the 'backlash' films[13] of the late 1980s and early 90s, one strand of which is the erotic thriller featuring a professional woman, often cop or lawyer, whose investigations lead to sexual vulnerability and the threat of her own victimhood (*Jagged Edge* (1985), *Physical Evidence* (1988), *Guilty as Sin* (1993)). It is a link reinforced by the casting of Sean Young, who had appeared in a number of erotic thrillers, as Dana, and Patrick Bergin, who played the abusive husband in *Sleeping with the Enemy* (1991), as Hanover.[14] Like *Blue Steel* (1989, Kathryn Bigelow), *Female Perversions* (1997, Susan Streitfeld) and, more recently, *In the Cut* (2003, Jane Campion), *Love Crimes* uses a generic investigative structure in order to explore the gendered assumptions which underpin it. Like them, this is an investigation conducted from within: Dana's investigation, like that of Campion's Frannie in *In the Cut*,[15] is of the limitations of her agency within the structures that have constituted both her own social (and generic) position and her sexual fantasies.

These erotic thrillers in turn recall the 'paranoid woman's films' of the 1940s described by Mary Ann Doane (1987). In this sub-genre, whose archetype is the Bluebeard story and whose most famous examples are Hitchcock's *Rebecca*

WHAT IF I HAD BEEN THE HERO?

(1940) and Cukor's *Gaslight* (1944), the woman's investigation, like her narrative journey in the romance genre, is a matter of learning to 'read' the hero. The question most often posed is whether he is, or is not, a murderer. In consequence, as Doane writes, the female protagonist's exercise of the investigative function is often 'simultaneous with her own victimization' (ibid., p. 136). These are films, she argues, which enact 'a dialectic between the heroine's active assumption of the position of subject of the gaze and her intense fear of being subjected to the gaze' (ibid., p. 127). Thus, staircases, doorways and mirrors – all devices which are used to frame the image of the woman in film – become key spaces to be investigated. '[D]ramas of seeing', writes Doane, are 'organized around the phenomenon of the closed or locked door and the temptation it offers', but 'what the woman confronts on the other side of the door is an aspect of herself. ... The door in these films opens onto a mirror, and the process is one of doubling or repetition, locking the woman within a narcissistic construct' (ibid., p. 137). Cinema itself is frequently implicated in these confrontations: both *Rebecca* and Ophuls' *Caught* (1949) feature home cinema scenes in which cinema itself, Doane argues, 'attacks the woman, becoming the machine of her torment' (ibid., p. 152).

The psychoanalytic text on which Doane draws for her analysis is Freud's 'A Case of Paranoia Running Counter to the Psychoanalytic Theory of the Disease' (1979/1915), though Freud's more famous example of female masochistic fantasy, 'A Child is Being Beaten' (1979/1919), is also a key reference point. For Freud, female paranoia is characterised by over-identification with the mother – the fantasy of taking the mother's place – which in turn produces delusions of persecution *by* the mother. The problem for him of the 'Case of Paranoia ...' was that in this instance the persecuting figure is not the mother but the woman's male lover. This is Freud's scenario:

> A young woman had asked [her lawyer] to protect her from the molestations
> of a man who had drawn her into a love-affair. She declared that this man
> had abused her confidence by getting unseen witnesses to photograph them
> while they were making love, and that by exhibiting these pictures it was now
> in his power to bring disgrace on her and force her to resign the post she
> occupied. (Freud, 1979/1915, p. 147)

Freud's own rather neat resolution of this problem is to conclude that this 'paranoic delusion' was in fact a displacement, and that the woman's *'original persecutor'* was an older woman – the mother figure. Whatever we think of this sleight of hand, however, his analysis contains a number of points which are suggestive in relation not only to the 'paranoid' films which are Doane's subject but also to Borden's attempt to rewrite their narrative. It is the powerful and universal 'primal fantasy' of 'watching sexual intercourse between [one's] parents'

that, he argues, lies at the root of the young woman's 'delusion'. In her fantasy, her lover has become her father, she herself has 'taken her mother's place', and the clicking noise which betrays the presence of the voyeuristic camera carries a double significance. It is the sound which betrays to the child-observer the sexual activity of the parents, but it is simultaneously the noise which would betray the child's own voyeuristic presence (ibid., p. 154). For the female subject, therefore, the fantasy of the observing camera and its tell-tale sound carries a double sense of guilt and shame. On both sides of the camera – as object and as subject of the gaze – her desire is illicit: she is seeing what she should not see and doing what she should not do. As Doane (1987) points out, this is a plot repeatedly played out in the 'paranoid woman's film', where investigations by a childlike female protagonist, the presence of an older and powerful husband with 'secrets behind the door' and paranoid fantasies which involve a controlling voyeurism are often combined.

Freud's case study is also a remarkable match for the narrative of *Love Crimes*. As with the scenario described by the young woman in Freud's case, 'David Hanover' (we do not learn his real name) photographs his victims, seducing them by making them feel, as they tell Dana, 'special, beautiful'. 'He said the pictures were for *Vogue* magazine,' says one. The promise of public validation is followed by the threat of public humiliation. '[W]hen he stripped me I felt so humiliated,' says another; 'I felt like I had no will, no consent to give.' This is no paranoid delusion, however. If Hanover draws on the women's fantasies of being an idealised object of desire, the sexual aggression behind his promises is immediately clear. As with Mark Lewis in Michael Powell's *Peeping Tom* (1960), when Hanover advances on his victims with his camera, it is clear that this is an action that is both sexual and violent. In contrast to Powell's film, however, it is not the figure of the male photographer who interests Borden. When he advances on his victims, we do not, as in *Peeping Tom*, look through his eyes, share his framing of them. Instead, the editing cuts between the woman's point of view – a close-up shows us Hanover's half visible camera lens and hands against a circle of white light as he moves towards us in the darkness – and shots of her vulnerable and half-concealed body, before moving to a wide shot of his aggressive advance, and her frightened retreat. Her confused protests: 'Can we do it another way please? … Mr Hanover, could you please … You're scaring me,' and his response: 'Don't be such a little girl!', make it clear that by the point of photographic climax – signalled by rapid shutter clicks and his cries, 'Great! Wonderful! That's it!' – she is reduced to the position of child.

Both the subject and the object of the film's investigation is Dana – although as the sequence described above makes clear, her sexual fantasies and vulnerabilities are shared by Hanover's other victims. Indeed, even her investigation echoes that of the first woman we see, who searches Hanover's bag to discover a series of photographs of his other victims, in poses ranging from the conventionally sexual

– head back, mouth open, breasts thrust forward – to the openly sadistic – a naked woman on all fours, a lead or chain around her neck. The continuum, it is clear, is not simply personal, it is social: we have all seen such pictures before. As Dana says, it does not matter whether or not this is 'the real David Hanover'. Both the offer of 'legitimation'[16] through the fantasy of being looked at and admired and its aftermath of exploitation and humiliation echo the performances of gendered power which we see elsewhere in the film, from the man Dana mistakes for Hanover in a bar, who also carries a camera, to the cops who trade sex from the local prostitutes in return for non-prosecution. Most obviously, both Dana's (married) boss, who patronises her and sleeps with her, and the two detectives whose threatening cross-examination of Maria opens the film see Dana, not Hanover, as transgressive threat.

Dana's pursuit of Hanover takes her into the space of fantasy, both public – the cottage in the woods which is the setting of so many fairytale narratives of the girl's sexual awakening – and private: the world of Freud's 'primal fantasy'. The investigation into *why* Hanover's victims, in Maria's words, experience through his predatory actions 'some kind of mutual fantasy' becomes an investigation of Dana's own sexual identity and fantasies. We see from the beginning of the film her uncertain sexual identity. She begins as the repressed, 'mannish' professional, a performance swiftly undercut by her childlike vulnerability in the confrontation – she in the bath, he fully clothed and standing – with her boss. As she alters her appearance to entrap Hanover, her flashbacks to the Freudian 'primal scene' also begin: herself as child climbing a staircase to confront the 'secret behind the door', which is her father's sexual activity with a series of women. The face her mirror shows her as she painfully applies makeup is the cut and bruised face of one of these women – perhaps her mother. Hanover himself looks like her father.

The film's two crucial sequences involve inside spaces 'behind the door': the first the space of Hanover's cabin, with its echoes of Dana's childhood, and the second Hanover's penetration of the space of Dana's own apartment, behind whose door she has sought to hide. In the first of these Dana is stripped, humiliated,[17] thrown into a closet – echoing her father's punishment of her childhood voyeurism – and, finally, after she has sought to attack Hanover with a knife, spanked, bathed, photographed and reduced to total passivity. Its two key points are Dana's speech to Hanover as he cleans fish in the woods, and the erotic fantasy which follows her later submission. The first is a hysterical outburst which reveals the impossibility of a feminine sexuality constructed entirely in relation to male power: 'You tell me what to feel and I'll feel it. ... You want me to act free? ... Do you want me to freak out? ... Are you happy now?' The conclusion of this outburst ('I hate myself. ... I don't like being touched. ... Do I have orgasms? No, never!') provides the female counterpoint to Hanover's (male) story of the fishermen who have sex with a species of fish which 'have

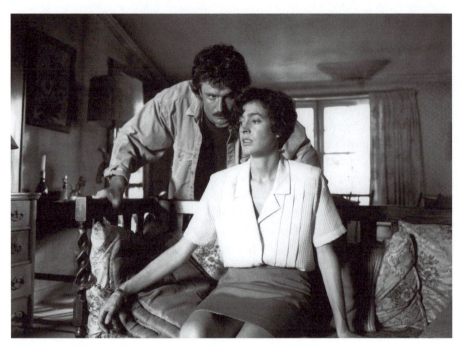

Love Crimes (1991): inside the cabin in the woods

genitals exactly like a woman', recounted calmly as he beheads and eviscerates the fish he has caught. There is, to paraphrase Lacan, no (hetero)sexual relation possible.[18]

The erotic fantasy which accompanies the bathing scene further suggests the difficulty of female sexual fantasy in a culture in which femininity is aligned with masochism – the Freudian fantasy of being loved/beaten by the father. Dana's fantasy itself is tender and mutual: in it she is active and it is her pleasure that is central. But it is immediately followed by a flashback to the scene of her father's sexual domination of one of his lovers, with the child Dana watching. If, as Cynthia Lucia suggests, Hanover's assumption of the role of father, in spanking and then bathing Dana, has made 'the *structure of fantasy* accessible again' to Dana (2005, p. 198, original emphasis), then that fantasy is both socially produced and impossibly compromised, in its shift between lover and father, tenderness and sadism. It is also short-lived. Dana opens her eyes and sees Hanover, and she is immediately returned to an oscillation between passive submission (child/woman) and rebellious activity (tomboy/representative of the law).

The second key sequence, in which Hanover penetrates the locked door of Dana's apartment, re-emphasises the sadistic power of his photography. As he advances on her, out of darkness once again, the camera flash blinds her

WHAT IF I HAD BEEN THE HERO?

repeatedly and the shutter noise is magnified to the sound of gunshots. On the floor and dressed only in a towelling gown, she twists backwards away from him; the analogy with rape is clear. Intercut with the scene the flashback narrative reaches its conclusion. Dana's mother finds her daughter in the closet, we see her with a raised gun, and she is killed in the ensuing struggle with Dana's father. Freud's 'primal fantasy', then, is given a material basis and a final

Love Crimes (1991): photography as rape

twist. Doane writes that, in the Freudian vision, there 'is a sense ... in which paranoia is only a hyperbolization of the "normal" female function of exhibitionism and its attachment to the affect of fear' (1987, p. 126). Borden's Oedipal narrative, unlike Freud's, gives Dana's paranoia a material social cause and a generalised occurrence: in a brief scene half way through the film we see Dana dealing with a case in which another child has witnessed her father's murder of her mother. In the end it is not clear whether Dana's flashbacks are memories or fantasies – some of the camera angles suggest the latter – but neither serve to pathologise her. When Dana finally defeats Hanover, choosing as her weapon the heavy glass bowl rather than the gun that lies beside it, she not only ends his predation and her flashbacks, but also oedipally realigns herself. No longer caught between seduction and rejection of the father, she repositions herself in primary relationship to the mother she has lost. She will not, however, *be* the mother, because that would be to repeat the cycle.

The film's final scene, in which Dana burns the photographs of herself, offers no resolution of her sexual identity or of the problem of heterosexuality for women. Freud's narrative has been rewritten to suggest that women's sense of their own sexuality within a patriarchal (and cinematic) culture is constructed by both the camera and its 'director'. Its pleasures (fantasies of exhibitionism, of being seen as beautiful, of being desired) are inseparable from its humiliations (being manipulated, abused, treated as object/child), and both are aligned with the Oedipal and familial norms of a patriarchal culture. At the film's close, the position of the law is unchanged despite Maria's objections, and Dana remains isolated before her mirror. We might want to read the promise of an alternative relationship between women in Maria's strength and constancy (Borden suggested that she was a maternal figure[19]), but it is a promise that remains unfulfilled.

ROMANCE AND SHAME

> How else can a young girl have access to sex but through the rhetoric of true love?
>
> (Williams, 2008, p. 280)

> I think that masochism is something that women have learned rather than were born with. But they've learned it for 2,000 years, so it's pretty hard to get rid of.
>
> (Breillat, in Sklar and Gluck, 1999)

Catherine Breillat is the female film-maker most identified with the explicit depiction of sexual acts. Breillat published her first erotic novel at seventeen, going on to publish seven novels and a play before, in 1975, adapting her fourth novel as the film *Une vraie jeune fille*, which remained unreleased until 2000. Her fifth film, *Romance* (1999), with its non-simulated sex scenes and disturbance of 'the boundaries between art cinema and pornography' (Wilson, 2001, p. 145), provoked international censorship and a reputation for Breillat as 'the auteur of porn' (Price, 2002), but it has also been the subject of considerable theoretical and critical discussion. It is her seventh film, *À ma soeur/Fat Girl*[20] (2001) that I shall discuss here. The film follows two sisters, twelve-year-old Anaïs, the fat girl of the US title, and fifteen-year-old Eléna, on holiday on the Mediterranean coast with their parents. Eléna flirts with, is seduced by and, finally, in the bedroom shared with her sister, has sex with Italian law student Fernando, who later gives her an 'engagement' ring which he says has been left to him by his grandmother. The ring has, in fact, been stolen from his mother, who demands its return from the girls' mother. The relationship discovered, the mother ends the holiday and drives the girls back to Paris. They stop at a rest station, where a man smashes the car's windscreen and kills first Eléna and then the girls' mother. He then rapes Anaïs in the nearby woods. The film ends at daybreak the following day, as Anaïs is led from the woods supported by two policemen, one of whom says that she claims not to have been raped.

The origins of the film, Breillat has said, lie in two events. The first is her glimpse of a young girl in a swimming pool enacting, as Anaïs does, an imaginary love triangle in which she is a knowing object of desire, and the second a tabloid news story of a rape and murder like that which ends the film. Breillat's films, writes Maria Garcia, depict 'contemporary sexual politics' (2010), and the contemporary relevance of the narrative is underscored by Breillat in interview when she says that, although the original news story is twenty years old, a very similar event occurred in the South of France during the film's shooting (Breillat, in James, 2001, p. 20). Yet the film is also deliberately intertextual, not only in its references to film genres (the coming of age movie, the slasher film),

film-makers (the freeze-frame ending which echoes that of Truffaut's *Les Quatre Cents Coups* (1959)) and performers (the casting of film-maker Romain Goupil as the girls' father and singer and Pasolini actress Laura Betti as Fernando's mother), but also in its references to earlier cultural moments and debates. Thus, Betti not only appears briefly as Fernando's mother but can also be seen immediately before, much younger, in a black-and-white television debate watched by the sisters about the difference between sex and 'the sexual question', in which she urges her male questioner to read Simone de Beauvoir. 'She's great, isn't she,' comments Anaïs, ambiguously. Even more important, arguably, are the film's references to myth and fairytale (the two sisters who are simultaneously opposites and halves of a single identity;[21] the forest around the holiday cottage which Anaïs identifies as a place of 'legend'; the brutal ending, again in the woods, with its punishment of female sexual desire), which fore-shadow the reworkings of fairytale in Breillat's most recent films[22] and form the film's unifying thread.

À ma soeur, then, pitches its intertextual argument against the double target of the contemporary and the archetypal. Unlike *Love Crimes*, it does not attempt to rewrite a Freudian narrative; instead, its family is a social institution embody-ing gendered norms and power. The primary relationship is between the sisters, and Anaïs, analysing the rivalry between them, considers then dismisses the argument for parental guilt for this complex relationship. Its contemporary ref-erence points are the girl-centred coming of age films and teen romances which have become the staples of postfeminist 'chick flicks' (Negra, 2009; Karlyn, 2011), where fat girls are rejected outsiders, beautiful thin girls are recognised as princesses and girls in general 'experience close connections with each other … obsess over boys and experiment with sex' (Karlyn, 2011, p. 79) – while fan-tasising rescue by a heroic Prince Charming. Its ending, however, references a very different genre, the slasher movie, in which the sexually active girl is pun-ished by violent and unmotivated slaughter, and the adolescent outsider – what Carol Clover (1989, 1992) calls the Final Girl – survives. In juxtaposing the two, it invites us to view both the interdependency of these two apparently different constructions of female sexuality, and the power of their double-headed con-struction of female sexual identity. It also presents its own unifying counter-vision.

Behind both contemporary genres lie the narratives of myth and fairytale. Linda Ruth Williams's review of the film refers to it as a 'dark tale of beauty-and-the beast teenage sisters' (2001, p. 40), and Breillat herself talks of its 'magical' quality (James, 2001, p. 20). When Anaïs sings to herself, it is not the songs of contemporary popular culture that we hear but dark folk tales which tell of werewolves and carrion crows. For Breillat, argues Emma Wilson, 'desire and the sex act are never "real", are always conducted with reference to a set of given cultural and personal fantasies' (2001, p. 152). In *À ma soeur*, both Anaïs

and Eléna are engaged in performances of heterosexuality that are at once fully socially and culturally embedded *and* archetypal: enacted within an interior fantasy world, outside social time and space and scripted from a pastiche of romantic fiction[23] and folklore. Apart from the café where the sisters meet Fernando, the film's key places – the bedroom, the two woods, the beach – are archetypal solitary spaces, as much internal as external. Even the motorway's spaces – the inside of the car, the isolated rest station – have this interior quality, at once oppressively close, as the mother bullies and threatens retribution by the absent father and Anaïs seeks to comfort Eléna, and vulnerable, as the final violent shattering of this female space is prefigured by the constant threats from aggressive male drivers of cars and trucks.

Like *Love Crimes*, the film presents heterosexuality as seduction, with the myth of romance concealing a brutality in which women become complicit victims and the bedroom, in Cristina Bacchilega's words, the 'bloody room of collusion' (1997, p. 122). The film's longest scene is that of Fernando's first seduction of Eléna, as Anaïs lies in her bed across the room, pretending to sleep. Its dialogue is foreshadowed by the scene of Anaïs in the swimming pool which immediately precedes it, in which she swims between diving platform and pool steps, constructing them as her two lovers and speaking the language of romance: 'Yes, you are my fiancé … You are jealous? … You're the one I'll give everything to …'. Whereas Anaïs constructs herself as active, however, Eléna is passive, and while Anaïs' rounded child's body and newly developing breasts contrast disturbingly with her imagined scenario, Eléna's slender white body, naked below the waist and stretched out on the bed, is as conventionally feminine and as passive as her words, which seek constant reassurance: 'You love me …? … You'd like to marry me … You'll wait for me?' Eléna, Breillat has commented (2001b), cannot believe that she is simply an object of desire: 'She thinks she's loved when in reality she's just prey.' In this scene it is Fernando who has the power, deploying alternately the banal clichés of romance and a swaggering assertion of the male power to seduce and leave.

The scene is constructed from long takes and ellipses, but despite its length and slow pace, it is neither a realist not a straightforward scene. If Eléna's words are as lacking in agency as her body, their clichéd romantic register contrasts with the beauty of her partially veiled body and face (her lacy nightdress is drawn up to partially cover her face), which belong to the fairytale princess. Fernando, too, with his white shirt, fits the physical part of the prince. But if Breillat creates an uneasy dissonance between words and image, she creates even more with, first, her filming of the physicality of Fernando's body, naked below the waist, with its conspicuous erection, and, second, her constant reminders of Anaïs' watching and uncomfortable presence in the opposite bed. Linda Williams has argued that all 'Fernando's actions, and all Eléna's reactions' are governed by the visible presence of his erect penis in this and the second, much

À ma soeur! (2001): Fernando's seduction of Elena

shorter, seduction scene (2008, p. 280). This emphasis on the physical is a constant reminder of the insistent sexual demand which lies behind his clichéd words, as he presses against Eléna and insists on his need for sexual relief, so that we are constantly aware of the threat implied in his physical dominance. When, finally, Eléna consents to anal intercourse because 'all the girls do it' and 'it doesn't count', we, unlike her, are prepared for the pain this will bring.

This pain is registered, however, not through Eléna, although we hear her cry out, but on the face of Anaïs, who has mimicked involuntarily her sister's actions, veiling her own face with her hands and moving her arm in a rhythmic echo of Fernando's penetration. In this and the second scene, where we see Anaïs weep as Fernando now penetrates Eléna vaginally, it is Anaïs' face which registers her sister's pain and humiliation and Anaïs' body – excessive, out of place, disturbingly caught between childhood and womanhood – on which is written the pain, innocence and perhaps rage which Eléna's own contained passivity cannot express.

This doubling of the sisters is central to the film. We see it as they walk in step down the street, and as they gaze in the mirror, heads turned inwards so that they appear two halves of a single face, however different their physical qualities. We see it also when they visit a dress shop with their mother. Both choose the same dress, but whereas Eléna looks cool and elegant in it, Anaïs' body is lumpy and childlike. As Anaïs commands the shop assistant to pin her dress 'shorter, shorter' against her mother's protests, the camera pans right and we

see Eléna emerge from the fitting room in a red, off-the-shoulder dress. As she descends the stairs towards her mother and sister we see them turn and gaze. Eléna has become the to-be-looked at woman of the filmic gaze, this moment her makeover moment, but the frame, divided by the mother's figure, focuses on the two sisters, equally balanced, exchanging gazes. It is this gaze, not Eléna's transformation, which is central. In *Bluebeard* (2010), which returns to the themes of *À ma soeur*, Breillat creates two pairs of sisters, a 'fairytale' pair in which the younger sister's active heroism contrasts with the elder's more passive beauty, and a 'historical' pair from the 1950s, in which the younger, mutinously active girl causes the death of her more timid and passive older sister. Here, however, Anaïs embodies all forms of 'other' to conventional femininity. She provides the ironic, cynical and knowing voice which constantly undercuts Eléna's romance fantasies, but she is also the unruly and excessive female *body*[24] which is the other side of Eléna's pale ethereality.

It is Anaïs, however, who is the *subject* of the film. Like the younger historical sister in *Bluebeard*, she consciously narrates – in her swimming pool fantasy – the story which Eléna can only helplessly perform. She sings of boredom and death, and is fully aware of Fernando's exploitation. Her own body is as insistently present as that of Fernando in the seduction scenes, but it is always out of place – in the pool, the café, the bedroom, at the family dining table – and, as *both* child *and* woman, out of time. She provides a physical counter to all the myths of innocent brides and postfeminist princesses of which Eléna is the embodiment.

At the end of the film she also becomes the Final Girl. The scene is prefigured – though not prepared for – in the earlier conversations between the sisters, in which Anaïs has countered her sister's romantic visions of 'the first time' with an insistence that 'I want my first time to be with a boy I don't love ... The first time should be with nobody.' In this rape by 'nobody' (the rapist is played by a stunt man not an actor) Anaïs is silent, her fear betrayed only by the urine that trickles down her leg, as the man throws her to the ground and stuffs her knickers in her mouth. It is as if, writes Breillat in her script notes, 'the survival instinct renders her perfectly complicit with her executioner'[25] (2001a, p. 86). If the scene reminds us of Anaïs' earlier words, however, it also reminds us of the seduction scenes between Fernando and Eléna. Her words, 'You're not going to hurt me?' echo Eléna's; as with Eléna, her flimsy slip partially covers her face and, like Eléna, at the moment of penetration, when resistance is futile, she wraps her arms around her rapist. Afterwards, the rape over, there is a moment of muted tenderness as he seems almost to stroke her hair.

It is this scene which has proved most controversial in the film. Ginette Vincendeau writes that it suggests that 'to be raped is a potentially liberating experience' (2001, p. 20), and Breillat herself has said (2001b) that 'the rapist

À ma soeur! (2001): 'Don't believe me if you don't want to'

is the most sympathetic male character in the film'. What the film seems to me to suggest, however, is that this is the reality behind the illusions of romance. It is this elemental confrontation – one also figured in fairytales, as, for instance, in Little Red Riding Hood – that underpins male power, from the lover's seduction to the father's threat to subject his daughter to the humiliation of an internal examination. Anaïs survives, less truly violated than her sister, and it is her final claim, reported by the policeman, that has caused most controversy. The original French, however – 'Elle dit qu'elle a pas été violée' – is more ambiguous than the translation – 'She says he didn't rape her.' How should we read this? In the original ending to the film we see Anaïs, a tiny and powerless figure, being internally examined – the fate with which Eléna was threatened. In the final version, however, Anaïs refuses this fate and the social position of victimised child. As she defiantly says, 'Don't believe me if you don't want to,' she turns to the camera – aggressive, wild and angry – and we end with a freeze-frame of this image, which mirrors that which opens the film.

It is this anger that seems key to the scene. Valerie Walkerdine has written of 'the terrible rage underneath' the pretty, feminine and compliant girl who is 'the

feminised object of the male gaze' (1991, p. 40). In Walkerdine's account of her own childhood, her subjectivity is split between these two figures. In *À ma soeur*, however, they correspond to the two sisters. If, as Breillat has said, the adolescent girl is someone engaged in 'killing what she no longer wants to be' (James, 2001, p. 20), then Eléna's death, the parallels between the rape and Fernando's seduction, and her own refusal to accept violation all release Anaïs into a rage which is also the promise of a clear-sighted subjectivity. It is not the rape but this rage and clarity – the rejection of the romance narrative and its accompanying position of 'submission and passivity and hero worship' (Benjamin, 1986, p. 79) – which are liberating. Anaïs' fat body has never been that of the grotesque – it has simply given her the position of outsider – and throughout the film she has had a voice which has constructed both stories and the self-conscious reflections of an adult sensibility at odds with her child's body. Rage now gives her the power to speak from her body – and defy the camera's gaze.

If, however, *À ma soeur* promotes, as Cristina Bacchilega writes of Angela Carter's 'The Bloody Chamber', 'an unflinching and self-implicating understanding of heterosexual sado-masochism within a socially exploitative society' (1997, p. 123), it also offers us little alternative. The most joyous and physically unconstrained moments in the film are those between the sisters, when they giggle and fight and share a mirror image and a bed. But only one sister can survive, no heterosexual relation seems possible, and female sexuality itself remains undefined and unexperienced beyond the social and cultural norms in which it is enmeshed. If Breillat's film gives us an emergent female subjectivity which – via rage – might unite body and voice, it provides us with no vision of female sexual pleasure.

'A VERY EROTIC MOVIE ABOUT A GIRL WHO THINKS SHE'S A SAINT'[26]

> [R]eligion for certain mystical women had a very physical connotation that inevitably becomes anarchic, because when your emotions are so intimately related to your body you can break away from the institutionally established order.
>
> (Martel, in James, 2005, p. 20)

Like *À ma soeur*, Lucretia Martel's *The Holy Girl* (*La Niña Santa*, 2004) concerns the emergence of adolescent sexual desire. Like Breillat's film, too, it concerns two girls – here friends rather than sisters – whose response to an emergent sexuality is contrasted, but whose immersion in the erotic intensity of adolescence places them outside the specificities of time and place.[27] Like *À ma soeur*, it is profoundly intertextual, playing upon the stories told by Catholicism and medicine, as well as the fairytales on which Breillat also draws.

The Holy Girl (La Niña Santa) (2004)

The film opens with the girls, Amalia and Josefina, attending a religious class whose topic is the need 'always to be alert for God's call'. Amalia lives in a decaying hotel owned by her mother and uncle, both divorced, and the film's events occur during its hosting of a medical conference of ear, nose and throat specialists. As the girls join a crowd watching a street performance of the theremin,[28] we see one of the conference doctors, Dr Jano, stand behind Amalia and press his crotch up against her. Returning to the hotel, she recognises and begins to follow him, confessing to Josefina that she thinks she has 'a mission'. Her pursuit of this 'mission' is counterpointed by both her mother Helena's flirtation with Jano – he remembers her as a teenage high diver – and Josefina's sexual relationship with her cousin Julián. Almost discovered having sex with Julián in their grandmother's bed, Josefina deflects her parents' attention by mentioning Jano's molestation of Amalia. The film ends with Josefina's parents waiting in the hotel for Helena's return from the conference where she is to perform the role of patient in its closing role-play session. We see Jano, who is to play the doctor in the role-play, hesitating in the wings, knowing his exposure to be imminent, before the film returns us to the hotel. In the closing sequence Josefina joins Amalia in the hotel's thermal swimming pool, and we see the two girls swim across the pool and out of frame.

As in *À ma soeur*, then, we are presented here with two responses to the social regulation of adolescent female sexuality, one fantasised and the other – that of Josefina – profoundly pragmatic. Like Eléna and Fernando, Josefina and her cousin seek to evade the prohibition of 'pre-marital relations' through a combination of anal sex (as in *À ma soeur* this doesn't 'count') and an absence of verbal acknowledgment of the body's actions. 'Don't talk to me!' insists Josefina repeatedly during sex. Here, too, we see the family as an institution of social regulation, in this case reinforced not only by the patriarchal power of the medical establishment, with its casual exploitation of the 'lab girls' who service it, but also by the power of the Catholic church. 'You can't confuse ugliness with beauty, or happiness with horror,' insists the girls' teacher, Inés, and it is the role of women to police this separation. Thus Josefina's mother presides over a constant attempt to impose cleanliness and order on a teeming family. And Mirta, the hotel's matriarch, seeks to control not only the sexual waywardness of Helena and the perceived deviance of her own daughter, who would rather be a physiotherapist, with its inappropriate crossing of physical boundaries, than a cook, but also the persistent irruption of unwanted life – children, head lice, bugs – into the hotel's attempted order. Shampoo and deodorant spray, used repeatedly to punctuate the film's narrative, are the ineffectual weapons in this battle to hold in check the unruliness, disorder and potential infection of what Martel has called 'the organic'.[29]

In *The Holy Girl*, the separation – and the policing – on which Inés tries to insist is impossible, and it is both the active presence and the ambiguous meanings of female bodies and passions on which the film insists. If Breillat's film is marked by its detachment and distance, it is closeness that characterises Martel's. From the opening sequence in which we hear Inés's clear soprano singing the words of Teresa of Avila's 'Vuestro Soy' ('I am Yours'), the cinema frame appears over-filled with bodies, as if struggling to contain the jostling physical presence of the group of teenage girls who gaze with puzzled fascination at Inés. As the girls exchange whispered sexual comments about their teacher ('Yesterday she was kissing a man much older than her … He had his tongue down her throat') we are conscious of the texture of their skin and the sensual fullness of their bodies and faces. This, then, is a film in which bodies are everywhere – moving in the background of the most intimate conversations, bursting into the frame – and their desires cannot be contained. When these girls race through the woods, like Breillat's they face danger – here from the random bullets of male hunters – but they fill the woods with an exuberant presence. They explore their sexuality, from Amalia's masturbation to the long kiss with which Josefina ('Jose') 'awakens' her friend from pretend sleep ('You opened your mouth!'; 'No, you stuck your tongue in!'), as desiring agents, for their own pleasure. Thus the sexual encounters between Josefina and Julián are in fact very different from those between Eléna and Fernando. They may take place, like

The Holy Girl (2004): Amalia and Josefina

Perrault's cautionary tale, in grandma's bed, between a granddaughter bearing gifts and a lover who hides beneath the sheets, but it is Josefina who both initiates and controls them, finding a way to by-pass both familial policing and religious prohibition.

In the key symbols and spaces of the film, we see not just an opposition between powerful regulatory forces and female bodies and passions but also their constant slippage and (con)fusion. Thus the photocopied sheets which should attest to the authenticity of the girls' religious sources become instead the basis for other, more fantastic tales, and the need to produce them the pretext for Josefina's assignations. The hotel rooms which should separate and regulate bodies are instead spaces of confusion, occupied apparently at random and by too many bodies. Finally, the swimming pool, which in *À ma soeur* coolly separates bodies, spaces and fantasies, is here too hot, a thermal pool in which, as Frederick Ruf writes, 'all of the characters … swim in languid eroticism. They simmer, they cook' (2006). A place of both infection and cure, it is filled with bodies which are too many and too close.[30]

It is in the film's use of religion that this doubleness is most marked. In *The Holy Girl* Catholicism both acts as a powerful regulatory structure and offers a magical space in which female bodies, passions and desires can be simultaneously expressed and disclaimed. Deborah Martin has noted the film's 'dialogue with conventions of the horror genre', a genre in which the sexuality of the adolescent girl is so often the means of rendering female sexuality monstrous and abject (2011). Amalia, she writes, is an 'uncanny figure *par excellence*' (ibid.), blurring the sensual and the religious in a way that elsewhere would render her demonic. But Amalia is not alone. There are four mother–daughter pairs in the film, each playing out the ambiguities of sameness and difference, regulation and desire. Amalia's story – of a 'much older man' who 'gropes' her – also echoes Josefina's tale about Inés.

The opening sequence sets up these ambiguities. Inés's voice is clear and distinct, and she is framed against a background of light, separated from the adolescent confusions of her students. The words she sings, however, come from St Teresa, the sixteenth-century mystic whose (con)fusion of the erotic and the divine[31] is most famously embodied in Bernini's (1652) representation of her *Ecstasy*. '[Y]ou only have to look at Bernini's statue in Rome to understand immediately that she's coming, there is no doubt about it,' writes Jacques Lacan (1982, p. 147). For Lacan, Bernini's statue embodies women's *jouissance*, an ecstasy 'beyond the phallus' (Grosz, 1990, p. 139) whose 'mystical' quality is literally unspeakable. Beyond the phallus, it is also beyond speech, consciousness, culture and relationship: the woman herself can 'know nothing about it' (Lacan, 1982, p. 147). In Martel's film, however, while the space of the mystical can function as a space of disavowal – as with Inés, whose heightened emotion both expresses and denies the body – in Amalia it is empowering. Martel (2008) has spoken of teenage girls feeling 'tremendous power in themselves' through their blurring of the erotic and the mystical. Jano's sexual transgressions are both furtive and conventionally expressed – in addition to rubbing against Amalia, both he and the other men persistently objectify Helena with their gaze, and when he catches Amalia following him he tries furtively to pay her off. The 'calls' that pursue him through the film – telephone calls from his wife, calls upon him as a doctor – have a regulatory function. The 'call' which Amalia experiences, however, serves to *permit* a heightened sensuality. In this ambiguous state which is both mystical and erotic she can reverse gendered relations of power: she watches Jano as he gazes at Helena; she follows, surprises, judges and forgives him. In Luce Irigaray's riposte to Lacan, she suggests that Teresa's *jouissance* is not unconscious and silent, as Lacan supposes. It is simply that Lacan, in Elizabeth Grosz's words, 'cannot *hear* for he does not know how, or even where to listen' (1990, p. 175, original emphasis). In Amalia's heightened state she *hears* not only her own responses but Jano's inarticulate confusion. Indeed, *The Holy*

Girl, like Martel's other films, insists on our attentiveness to the ambiguities of sound, which unlike vision and language is at once material and immediate and immaterial and evanescent. In *The Holy Girl* its symbol is the theremin, whose strains – both ethereal and cheaply popular (it is most familiar from the soundtrack of horror films) – permeate the film's spaces. Amalia herself is not only attentive to sound; like the film-maker, she also *uses* sound to tease, disorientate and disturb.[32]

Both the medical specialists who populate the conference and the religious teachings cited by Inés offer interpretive structures which discriminate clearly between virtue and sin, health and disease, 'ugliness [and] beauty'. When Jano listens to Helena in his role as doctor he can diagnose the defect in her hearing which causes her to mis-hear the word 'beso' (kiss) as 'rezo' (prayer). That these structures are both oppressive – to women, who are most frequently the objects of their regulation – and absurd is emphasised again and again in the film, however. Both fail to grasp the contingency of embodied experience, its sensuality and elusiveness, its confusion of the material and the immaterial. For Amalia, however, the temporary licence provided by the mystical eroticism of adolescence permits an anarchic collapsing of boundaries and inversion of hierarchies. It is a (con)fusion in which we can see the possibility not only of the emergence of what Benjamin called a 'desire of one's own', but also perhaps of a different and less oppositional relationship between the body and what Elizabeth Grosz, in her own rethinking of the relationship between nature and culture, has called 'the productive excess of the natural': culture, the social and moral order,[33] science, art (Grosz, 2001, p. 101).

At the end of *The Holy Girl* nothing is resolved. We know neither Jano's fate nor the meaning of Amalia's final encounter with him, where she both tells him that he is 'a good man' and tries to kiss him. As he pushes her away he catches her in the eye with his hand and for the third time in the film she deliberately closes and then opens her eyes. Unlike Jose(fina), Jano does not kiss her 'awake' – instead, he resumes the position of concerned doctor – and, though she is smiling, she does not say what she now 'sees'. The final scene, however, returns us from the film's dysfunctional heterosexual relationships to that between Amalia and Josefina. As they glide together across a pool in which they are now the only swimmers, finally moving elusively out of frame, we are reminded that, despite the precision of its details, this is a film that has the structure, and the timelessness, of memory or fantasy.[34] Desire, Martel has said, 'is something that can't be governed ... Desire is always above the law, beyond limitations. Desire is precisely where we see that the world can be anything' (Guest, 2009). As the girls construct their own world from their desires – they decide that what they can smell is 'orange blossom' and they listen to, and hum, a music that we cannot hear – the film ends on these possibilities.

THE TERRIBLE RAGE BENEATH[35]

> The line raced through the girl's fingers. Her imagination had rushed away. It had sought the pools, the depths, the dark places ... And then there was a smash. There was an explosion. There was foam and confusion. ... The girl was roused from her dream.
>
> (Woolf, 1978/1931, p. 61).

> [T]he sea is another story.
>
> (Adrienne Rich, 1973, p. 23)

Kathryn Bigelow's *The Weight of Water* (2000) opens with the texture, movement and modulations of light in water – here the restless movement of the sea rather than the still smoothness of the swimming pool. As the water loses its opacity, we can see a translucent white cloth suspended within it, lifted by the currents so that it looks full and rounded. Moments later, a thin line falls into the water with a light metallic sound, and then we see the cloth again, its shape now altered so that it seems to be a translucent shroud covering an invisible body.

Bigelow's opening recalls two other representations of water as female passion. The first, that of Virginia Woolf, we have already seen, in the thin line which takes the writer's imagination into 'every rock and cranny of the world that lies submerged in our unconscious being' (1978/1931, p. xxxviii). It is an image that will recur at the end of Bigelow's film. The second is much more recent: Jane Campion's image at the close of *The Piano* (1993), of Ada floating above her piano in its 'ocean grave'. Ada has refused the ending of gothic melodrama, rejecting its excess and melancholy silence – what Jayamanne calls her 'mourning for an unspeakable loss' (2001, p. 32) – in favour of a negotiated compromise in which a heterosexual relationship based on the equality of touch might become possible. In what seems to me to be Bigelow's response to both these narratives, however, no compromise is possible after such encounters, and her protagonists end the film alone. Like Ada in Jayamanne's account, Bigelow's protagonist Jean 'reaches the limits of terror ... through a certain curiosity, a certain will to knowledge' (ibid., p. 36), but if these – to follow Woolf – are the explorations of a hero, what they reveal is neither negotiable nor simply erotic. As Virginia Woolf suspected, to explore women's bodies and passions involves an encounter with *rage*. Both Jean and her nineteenth-century counterpart Maren experience what Jean, quoting Maren, calls a rage/anguish 'so swift and so piercing, an attack of all the senses, like a sudden bite on the hand'. In a moment of pause in the film's narrative action which seems to echo that in which Ada *chooses* to place her foot in the coil of rope which will take her into the sea, Jean's choice is that the *other* woman – the image of feminine desirability – will be destroyed.

WHAT IF I HAD BEEN THE HERO?

The Weight of Water (2000): Jean as photographer-investigator

The Weight of Water, based on Anita Shreve's (1997) novel but described by Bigelow as 'a very personal piece for me' (quoted in Jermyn, 2003, p. 143), constructs a double narrative in which photojournalist Jean pursues a magazine assignment to investigate the 1873 double murder of two young women, sisters-in-law Anethe and Karen Christenson, on a remote island off the New Hampshire coast. A third woman, Maren Hontvedt, sister to Karen and sister-in-law to Anethe, survived, her testimony later convicting her former lodger, Louis Wagner, of the crime. Seeking to turn the assignment into a vacation, Jean is accompanied by her husband, Pulitzer prize-winning poet Thomas, now drinking too much and no longer writing, his brother Rich, owner of the yacht which takes them to the island, and Rich's new girlfriend Adaline, who may also be Thomas's lover. As the two narratives unfold in parallel, Jean's growing suspicion that it was Maren not Wagner who murdered her sister and sister-in-law is crystallised on the night of a storm which casts Adaline overboard and sees Thomas drowned trying to save her.

As the opening images suggest, however, the film's narrative action is neither dominant nor straightforward. Reviews expressed unease about what Emanuel

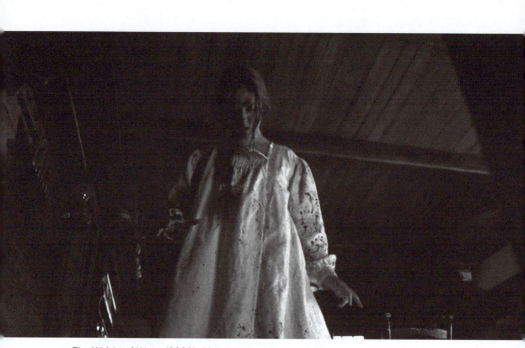

The Weight of Water (2000): Maren as monstrous child-woman

Levy (2000, p. 32) called its 'excessively fractured story', in which time shifts constantly, sound and image blur and overlap, and voice-overs interweave. The film has been called 'an investigative thriller' (Jermyn, 2003, p. 129) and a 'psychological thriller' (Levy, ibid.), but it is also, as Deborah Jermyn has noted, both a melodrama and a horror film, playing with assumptions about the monstrousness of the out-of-control female body to emphasise the relationship between horror and the erotic. In an early sequence, as the camera lingers in close-up on Adaline's body, her body and shoulders caressed by Rich's hands and mouth, we hear Thomas describe the sensuous intimacy of murder ('the vibration of your hand ... the spray of blood warm on your face'). Later a low-angle shot will show us Maren, her white nightdress sprayed with blood, the monstrous child-woman of the horror film in which, as Barbara Creed (1993) writes, female desire, sexuality and the monstrous are equated.

As well as playing with gender and genre, however, the film plays with narrative itself. Laleen Jayamanne has described the way in which in *Blue Steel* the pulsations and oscillations of colour in the cinematic image make 'forms, bodies, spaces, and boundaries unstable, permeable' (2001, p. 211), playing against narrative action and logic. Here, water functions in this way, dissolving the separations of time, place, bodies and voice. There are multiple narratives (Jean's voice-over, the stories she and Thomas tell Adaline, Maren's two different voice-overs and her written testimony, flashbacks within flashbacks, official records,

WHAT IF I HAD BEEN THE HERO?

the two stories we see enacted), but they are unreliable. Women's stories, like the female gaze of photographer Jean, are without authority. Thomas's casual ridicule of Jean's story of his respect for her as his artistic equal ('If I did say that, I was just trying to get into your pants') is a twenty-first-century version of the verdict of prosecutor Plaistow over a century earlier, as he ensures that Maren's confession will not be heard: 'Women are naturally unstable, of course. Not always to be believed.' In the stories *men* tell, women are innocent victims and lost objects of desire (Thomas's poems are about the lost seventeen-year-old 'Magdalene' for whose death he was responsible), or maternal figures (Jean is a mother and Maren a 'mother hen'). Men are romantic heroes and/or villains, and it is the heroic melancholy of loss (real or fantasised) that fuels men's writing. At the film's end, Thomas will prefer the romantic and self-destructive gesture of saving Adaline to the complexities of his life with Jean.

Against all of these narratives, with their cultural and generic expectations, Bigelow sets the fluidity of her images. Until its final sequence, all of this film functions as memory or imagined reconstruction, and sequences echo, respond to, repeat and dissolve into each other through the multiple overlay of flashbacks and re-visionings whose truth-status is always unclear. If Maren's later testimony undermines the court's verdict, both are seen only under water, through Jean's imagination. At the end of the film, indeed, Maren throws both her own statement and Jean's reading of it into doubt. Alone after the murders, sheltering in the sea cave – where Jean mirrored her movements early in the film – she prayed, she tells us, for 'myself, who did not understand the visions God had given me'. Like St Teresa, then, Maren is what Irigaray calls a 'mysteric', at once the hysteric and the self-contained figure of female *jouissance* (Grosz, 1990, pp. 174–5). We do not know whether the rage which she embodies in the film's climactic sequence was ever literally enacted.

The 'impulse to violence' enacted in this climactic scene is Jean's as well as Maren's, and in both cases it is enacted not against men but against the other woman. If men's sexuality in the film is voyeuristic and conventional, that of women is once again split and doubled. In the uncanny, Freud writes, 'there is a doubling, dividing and interchanging of the self' in which 'something which ought to have remained hidden' frighteningly 'recurs' (2001/1919, pp. 234, 241). The camera's voyeuristic treatment of Adaline's/Liz Hurley's body was much remarked upon in reviews of the film (Jermyn 2003, p. 137) and while these sequences seem self-reflexively structured to emphasise Thomas's gaze, they also emphasise Adaline's seductive awareness of that gaze. Her double in the nineteenth-century story, Anethe, is also both seductive – though coyly so – and 'pleasant to look upon', as Maren notes. Like Adaline, she is manipulative in her playing to male expectations. The eroticism of the woman who *sees*, however, is more complex. Both Jean and Maren are highly controlled, masking their pain through work and silence. 'It is wiser, I think, to keep silent and preserve the

bond,' says Maren, who seems to speak for both of them, and later: 'I vowed to keep as still and as silent as possible so that the stormy motions that threatened to consume me might come under my control.' Juliana Schiesari's account of 'the gendering of melancholia' contrasts the functioning of melancholy in men, where it serves to legitimate the male writer 'in terms of a loss that he can represent' through language, with 'female melancholia, or depression', in which the woman is reduced to silence or the 'inarticulate babble' of the hysteric (1992, pp. 74, 17). 'The best cure for melancholy is industry,' says Maren, over a sequence of shots which show both the hardships of her life and marriage and her resolute silence.

For both women, repression or containment is broken through touch. The reawakening of Thomas's desire for Jean – an 'illegitimate' desire in the context of the archival vaults where it takes place – produces first a response, then resistance and guilt in Jean. In Maren, the return of desire comes with the visit of her brother Evan, with whom she shared a childhood incestuous relationship, and his new wife Anethe. While Evan now rejects her embrace, Anethe's seductive body and touch reawaken desire. As Maren strokes Anethe's face and breast, and then later kisses her, we see both how malleable and transgressive desire is and – in Maren's fascination with the woman who is now her brother's lover – how far Anethe also functions as her double. As the two women embrace, Maren's voice-over speaks of the way in which 'pleasure and death and rage and tenderness [are] all intermingled, so that one can barely distinguish one from the other'. Her words, of course, apply equally to Jean, whose conversation with Adaline ('I wanted to meet you Jean. That's why I came. Thomas has told me a lot about you') seems to reveal that she and Thomas are lovers, and whose gestures towards Adaline at the height of the storm also combine tenderness and rage.[36]

In the cross-cutting sequences of the film's climax, Maren, as monstrous child-woman of the horror genre,[37] acts out Jean's ambiguous desires. Thomas's straightforward heroism is not available to Jean. Instead, dragged underwater by the sea, she comes face to face first with Anethe and then with Maren, their white nightdresses billowing around them as they gently float in its depths. We are returned to the white cloth of the film's opening sequence, but now doubly filled; as the two women gaze at Jean, she backs away in panic. If Jean, like Campion's Ada, seems to 'choose life' at this point, she is impelled not by the will to life but by horror: the two women are doubles not only of each other but of herself. The gaze of both compels recognition.

In her essay on abjection, Julia Kristeva (1982) writes of its identification with the female body – that 'leaking, uncontrollable, seeping liquid … formlessness that engulfs all form, … disorder that threatens all order' of which Grosz writes – and of its relationship to both *jouissance* and violence. Horror, she writes, is founded on its mixture of fascination and repulsion. Traditionally, of course, order is restored, and the crisis of subjectivity induced in the male viewing subject by horror's abject images is assuaged. For the female viewer, however, as

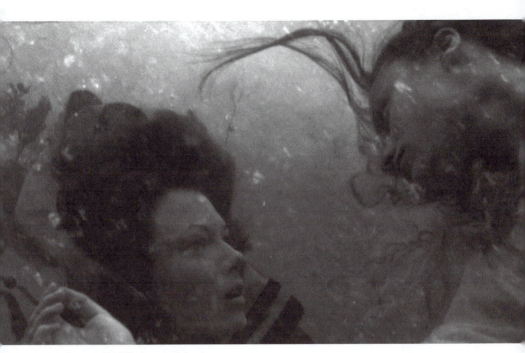

The Weight of Water (2000): Jean and Anethe

Linda Williams argues, the monster functions as a mirror, in which she can read 'the threatening nature of her own sexuality' (1984, p. 96). In *The Weight of Water*'s narrative, the unruly woman's monstrous guilt and rage are revealed to its female investigator who, recognising her own complicity with these illegitimate passions, pays with the loss of her lover, while her opposites and doubles, the narrative's desirable, feminine women, are inexorably drawn to victimhood.[38] Against this narrative, however, Bigelow's constantly dissolving and shifting images pull in another direction, disturbing and questioning narrative logic and temporality. In *The Weight of Water*, female desire is at its most unruly because it is outside narrative, history, official record, poetry. Yet in this visual exploration of 'the pools, the dark places, the depths' of which Woolf wrote, the passion that is ultimately confronted is rage. Of the films I have discussed here, it is this one that comes closest to Kristeva's notion of images which, caught between desire and nightmare, 'sensation (suffering) and denial (horror)' (1982, p. 154), function to undermine or shatter narrative. Yet, although one can argue, as for instance Valerie Walkerdine (1991) does, that recognition of the rage beneath the mask of compliant femininity is necessary if new narratives are to be constructed, and though Jean, as creator of images and stories, must to some extent stand in for the film-maker herself, the film closes without possibility of an erotic relationship for either of its protagonists.

Conclusion

UNFINISHED BUSINESS

I am indebted for the title of this Conclusion, and indeed for the conclusion itself, to the anonymous reviewer who insisted that this book needed more than the postscript I had given it. She – or perhaps he – also perceptively pointed to the cause of my omission, highlighting the tension at the book's core between 'on the one hand, the generational narrative that is implied by references to a succession of female voices' and, on the other, an 'apparent resistance to a structure that prioritises succession, or … any suggestion that those who come after necessarily build upon what went before'. There is indeed a tension here. On the one hand, there is the pull of affirmation – what my reviewer calls the 'sense of heritage, rich history and potentiality' in women's film-making. And there is also a tracing of repeated themes and figures within this history: of the position of *vagabondage*, the subject position of the woman who seeks to write female desire; of the landscapes created by film-makers who seek to stage 'another logic of plot'; and, above all, of the figure of the female investigator hero, whose investigations are always a *re-vision*. On the other, there is a powerful fear of loss: the debates which are charted in the early chapters of this book, and which then frame its structure, risk being lost today in celebrations of the individual film-maker (woman as auteur, taking her place among the men) or worse, of the liberatory potential of the female action hero(ine), no matter who is telling her story.

What I have attempted in this book, therefore, is both critical interrogation – of the issues inherent in the question of what happens when women tell their own stories in film, and of some of the films through which these questions can be traced – and an act of retrieval – an insistence on the continued import-ance of these issues and questions. In one sense, then, the later chapters in this book do indeed suggest the ways that later film-makers have built on what has gone before. Yet in a neo-liberal and post-feminist climate which has seen the return of the narratives of femininity against which feminist (re)writings have been constructed, but now given new power by their claim to be speak-ing to and for the liberated woman, this is not a straightforward process. Rather, the issues confronted by the feminist film-makers and film theorists of the 1970s and 80s have to be confronted anew, and differently, by today's

film-makers as they work through their own relationship to women as authors and heroes.

In 1988 Carolyn Heilbrun wrote, 'If I had to emphasize the lack either of narrative or of language to the formation of new women's lives, I would unquestionably emphasise narrative.' Women, she added, 'must share the stories of their lives and their hopes and their unacceptable fantasies' (1988, pp. 43–4). Twenty years later, however, Liedeke Plate notes the limitations of such 'rewriting'. The 'affirmation of gender difference' which was so challenging in the 1970s has, she argues, been 'given new meaning in the context of neo-liberal capitalism', so that 'if it is possible to speak of women's rewriting as transforming cultural memory, this is only in the sense that women are encouraged to develop another body of cultural references by reading and buying another set of books than men' (2011, pp. 135–6). Feminist insistence on difference, that is, has been co-opted for a notion of identity as individual project and 'women's stories' have become an area of niche marketing, though always with the proviso that the stories of women are never 'marked as memorable for posterity in the same way as men's' (ibid., p. 137). An Amazon search for Jane Campion's *Bright Star* thus throws up a raft of other 'recommendations', including *Young Victoria* (2009) and *Brideshead Revisited* (2008), together with a helpful list of the best period dramas; my status as viewer of women's films, my identity as woman, is reaffirmed.

That isn't, of course, the whole story. My own positioning of Campion's film has been within a very different set of narratives and in response to a set of theoretical questions which are irrecuperably feminist. Nancy Fraser, on whose essay 'Feminism, Capitalism and the Cunning of History' Liedeke Plate draws in the analysis quoted above, concludes that despite the appropriations she has described, and '[h]aving watched the neoliberal onslaught instrumentalize our best ideas, we have an opening now in which to reclaim them' (2009, p. 117). Countering such co-options and recuperations, I argue, involves continuing to ask the questions which are sidestepped when difficult feminist theory is replaced by post-feminist celebration. It *matters* what happens when a female film-maker confronts questions of narrative, subjectivity, authorship, fantasy and desire. If identity, as I have suggested, is itself a process of appropriation, interpretation and retelling, in which we appropriate the public narratives available to us and rework them through fantasy, returning them to the public world as narratives of ourselves, then these stories bearing 'the signature of women' are crucial in that process. Transforming the sedimented narratives of history and culture and reconnecting to embodied experience, memory and desire, these stories which are '*always* another story' (Miller, 1988, p. 72, original emphasis) provide material for more complex understandings of identity, subjectivity and desire than those presented to us in the seductive reworkings of neo-liberalism.

FEMINISM AND NOSTALGIA

In an essay on Virginia Woolf's *To the Lighthouse*, Mary Jacobus asks how as feminists we can 'answer Woolf's call to "think back through our mothers"' when 'the mother is always lost', the subject always in motion, so that the attempt to revision an 'unalienated' relationship between mother and daughter is always an exercise in nostalgia (defined as 'melancholy regret, or unsatisfied desire') and 'psychic utopianism' (1988, pp. 103–5). In *To the Lighthouse*, she argues, the 'daughter' Lily Briscoe becomes an artist not through her nostalgic memory of the mother figure, Mrs Ramsay, but through an acceptance of loss and separation which is also an identification and a 'thinking through'. Like Lily's – and Woolf's – art, the feminist cinema of the 1970s was, to borrow B. Ruby Rich's terminology,[1] a cinema of 'the Daughters'. In this, perhaps the paradigmatic text is a film I haven't discussed in detail in this book, Chantal Akerman's *Jeanne Dielman, 23 Quai du Commerce, 1080 Bruxelles* (1975). For Janet Bergstrom in 1977, in the absence of the 'unalienated feminine language' (1977, p. 118) for which she too expresses a nostalgic longing, what makes the film feminist is the framing of the mother through a gaze which is unequivocally that of the daughter: distanced, controlling but also obsessed and fascinated – a look, Akerman has said, 'of love and respect' (1977, p. 119). Teresa de Lauretis, writing ten years later, echoes this view. There are, she writes, 'two logics' at work in the film: 'character and director, image and camera, [which] remain distinct yet interacting and mutually interdependent positions. Call them femininity and feminism; the one is made representable by the critical work of the other' (1987, p. 132). Yet as Kaja Silverman has observed (1988, p. 210), this split isn't quite as neat as Bergstrom and de Lauretis suggest. The obsessive self-control which is ruptured by Jeanne's unwitting experience of orgasm and ensuing murder of her client is also a rupture of the formalist control of Akerman, the director, by narrative elements that disturb the film's formal 'purity'.[2] The feminist author, as Silverman observes, is not so easily separated from her female protagonist, from the eruption of desire and from the contradictions of narrative cinema.

Feminist celebrations of the authorial voice in Akerman's film, argues Silverman, are in part at least evidence of a 'certain nostalgia for an unproblematic agency' on the part of feminist critics (ibid., p. 209). Here, nostalgia for an unalienated relationship between mother and daughter is replaced by that for an equally impossible *separation*, in which the agency of the daughter-as-author can be affirmed by her distance from mother as object. Yet desire and rage, the impossibility of separating order from disorder, mother from daughter, myself as speaking subject from the other woman who is the object of my contemplation – all of these make such separation finally untenable.

If film feminists of the 1970s found what Silverman calls 'nostalgic' pleasure in identifying with such imaginary separations, seeing them as evidence of a new

active, critical and creative female subjectivity made possible by feminism, we can identify another kind of nostalgia today in the face of another generational shift, another set of mothers and daughters. Here, feminist film theory is itself historically 'placed',[3] its debates worked through in relation to a set of films that are themselves of primarily historical interest, to one side of the more mainstream fiction films whose postfeminist narratives are the focus of critical interest. Angela McRobbie (2009) has called this periodisation a 'repudiation' of feminism, but like the desire for an unalienated feminine language or an unproblematic agency, it is tinged with the 'melancholy regret, or unsatisfied desire' which signifies nostalgia. Just as it is important, however, to insist that the rich heritage of women's film-making does indeed build on what has gone before – Lynne Ramsay's 2011 film *We Need to Talk about Kevin* could perhaps not have been made without *Jeanne Dielman* and Andrea Arnold's 2011 *Wuthering Heights* without *The Piano*, which in turn owes its own debts to Emily Brontë's novel – it is equally important to continue to develop the theoretical debates within which these films can be explored. For if we must, like Jacobus, conclude that the mother is always lost and the subject always in motion, and that agency can never be unproblematic, it is precisely such awareness that grounds both our theory and our agency. Rather than deploying nostalgia for a lost femininity or a lost feminism – mothers, both – we need to continue to explore the complexities of their relationship, pursuing, in theory and criticism as well as film-making, those other stories for and by women in which the impossibilities of fantasy are enacted to become fictional possibilities.

Postscript

My grand-daughter, who is two years old, frequently fantasises inhabiting other identities. 'Today I'm a cat,' she will say, or 'I'm a penguin and my name is Henry.' The identities are taken, inevitably, from her favourite books and films. Sometimes, preparing to launch her next assault on the playground's climbing frame, she says, 'Now I'm a boy.' I hope that as she becomes an adult such stratagems will no longer feel necessary, and that the question posed by Mimi/Potter will seem quaintly irrelevant. But I doubt it.

Notes

INTRODUCTION

1. See Miller, *Subject to Change* (1988), pp. 68–76.
2. Examples are: Austin-Smith and Melnyk (eds), *The Gendered Screen: Canadian Women Filmmakers* (2010); Lane, *Feminist Hollywood* (2000); Hillauer, *Encyclopedia of Arab Women Filmmakers* (2006); Rashkin, *Women Filmmakers in Mexico* (2001); Robin and Jaffe (eds), *Redirecting the Gaze: Gender, Theory and Cinema in the Third World* (1999); Foster, *Women Filmmakers of the African and Asian Diaspora* (1997); and Levitin, Plessis and Raoul (eds), *Women Filmmakers: Refocusing* (2003), which has sections on Europe and Canada, and on 'Postcolonial' and 'Minority' women filmmakers.
3. See, for example, Faludi, *Backlash* (1991), Rosenfelt and Stacey, 'Second Thoughts on the Second Wave' (1990), Tasker and Negra, *Interrogating Postfeminism* (2007) and Negra, *What a Girl Wants* (2009).
4. Dust jacket of Phoca and Wright, *Introducing Postfeminism* (1999).
5. See particularly Angela McRobbie, *The Aftermath of Feminism* (2009).
6. 'Time and Punishment', series 4, episode 7.
7. The term 'female action heroine' rather than 'female hero' is taken from Yvonne Tasker's *Spectacular Bodies* (1993), though Tasker is far more ambivalent about this figure. For further definitions, see Chapter One.
8. Barbara Creed, for example, has argued in a 2007 essay that cinema, as a contemporary form of myth-making, has popularised a 'neomyth' of the journey of the female hero, a journey in which this hero contests the 'paternal symbolic order' and achieves a new identity through self-discovery – an identity which positions her as 'other' to the patriarchal order and often leads to her death. While this structure does indeed characterise many of the films which I discuss in this book, I find myself uncomfortable with the range of films she includes in her account, and with the flattening out of differences between them. See Creed, 'The Neomyth in Film' (2007).

1 'WHAT IF I HAD BEEN THE HERO?'

1. For an elaboration of these terms, see Cohan and Shires, *Telling Stories* (1988).
2. We might also think of *Copycat* (Jon Amiel, 1995), where Holly Hunter plays the tomboy role. The film's action narrative ends with an embrace between its two female protagonists, but it is shot from a distance, in long shot, and the film returns us to the figure of the serial killer who speaks direct to camera, confirming women's vulnerability.
3. The most famous expression of this is, of course, Laura Mulvey's. See Mulvey, 'Visual Pleasure and Narrative Cinema' (1989a), pp. 14–26.
4. Miller, *Subject to Change* (1988), p. 87, quotes Gilbert and Gubar, who argue that 'the story of female authorship, its mode of self-division, may often be read as a "palimpsest" through the script of the dominant narrative'.
5. Campion's statement in fact conflates two spaces: the New Zealand bush and the underwater space which ends the film. The bush, she writes, has 'an underwater look that's always charmed me' (1993, p. 139).
6. Cohan and Shires present a detailed analysis of the multiple voices and subjectivities in Brontë's *Jane Eyre* in support of this conclusion. See *Telling Stories*, pp. 142–8.
7. Gledhill's essay was first published in the *Quarterly Review of Film Studies* in 1978, and reprinted in Doane, Mellencamp and Williams (eds), *Re-Vision* (1984).
8. Johnston is quoting here from Christian Metz. See Metz, 'Histoire/Discours' (1982), pp. 91–8.
9. For an analysis of Johnston's work and its importance, see Meaghan Morris, '"Too Soon Too Late"' (1998), pp. xiii–xxiii.
10. This title comes from a 1978 essay by Laura Mulvey. See Mulvey, 'Feminism, Film and the *Avant-Garde*', in M. Jacobs (ed.), *Women Writing and Writing About Women* (1979), pp. 177–95.
11. Flitterman and Cook are the only female contributors to Caughie's 1981 collection on film authorship. Both argue for an 'artisanal', avant-garde and 'deconstructive' cinema as the way forward for feminist film-making. See Caughie, *Theories of Authorship* (1981).
12. Patricia Mellencamp, *A Fine Romance* (1995), p. 173, argues that feminism is always 'initially an undoing'.
13. The analogy was also used earlier, in 1978, by Chantal Akerman, to describe her own film practice. See Bergstrom, 'Chantal Akerman: Splitting' (1999), p. 277.

2 WOMEN'S LIBERATION CINEMA?

1. Also published in that year were Germaine Greer's *The Female Eunuch*, Eva Figes's *Patriarchal Attitudes* and Cellestine Ware's *Woman Power.*
2. The festival's full programme can be found in *Women and Film: A Resource Handbook* (1972). It can be accessed at: <www.eric.ed.gov/ERICWebPortal/recordDetail?accno=ED085034>
3. Patricia Erens comments in 1981 that before the 1970s women's involvement in documentary film-making was 'appallingly limited'. In the USA, she cites only Helen Levitt and Janice Loeb, Joyce Chopra, Shirley Clarke and Charlotte Zwerin. Of these only Shirley Clarke received sole credit (Erens, 'Women's Documentary Filmmaking', 1988/1981, p. 554).
4. The oddest example of this urge to produce taxonomies appears in a slighter later book, Louise Heck-Rabi's *Women Filmmakers: A Critical Reception* (1984). Heck-Rabi's list of the characteristics shared by women film-makers reads as follows:

 1. Most are married or work in collaboration with men. The fact that men open doors into the film industry for women is well known. ...
 2. Most are of short stature, are considered attractive, restless, dynamic, energetic.
 3. Most have had previous training in the arts, especially dance.
 4. Most have made, or want to make, films about women, or from a woman's point-of-view. (1984, p. xiii)

5. In a later version of the article, Rich adds a further two categories to her taxonomy of feminist films. 'Reconstructive' films include Potter's *Thriller* and Citron's *Daughter Rite*; they seek to reconstruct existing forms to fulfil feminist aims. A final category, that of 'corrective realism', reworks fictional realism for feminist ends ('In the Name of Feminist Film Criticism', 1985, pp. 353–4). This recategorisation of the films by Potter and Citron and willingness to include fictional realism within feminist film-making strategies signals an important shift in thinking about feminist film-making.
6. Compare *Women & Film*'s 'The women in this magazine, as part of the women's movement, are aware of the political, psychological, social and economic oppression of women.' ('Overview', 1972, p. 5). The *Camera Obscura* collective comprised Janet Bergstrom, Sandy Flitterman, Elizabeth Hart Lyon and Constance Penley.
7. In the 'Chronology' of 1981, the editors recognise that in these early issues of the journal they had sometimes been guilty of 'conflating Modernism and Brechtian practice', seeing a radical message in an experimental form (1981, p. 11).

8. The only exceptions cited are Joan Micklin Silver's *Hester Street* (1974) and Claudia Weill's *Girlfriends* (1978), both of which, Rosenberg feels, fulfil her criteria.

9. Rosenberg's account, however, deals only with feminist film in the USA, although this limitation is never made explicit, and a number of the films discussed by *Camera Obscura* are European.

10. See the discussion in Chapter 1, p. 17.

11. The term is, of course, drawn from the Freudian account of the workings of dreams.

12. The review appeared in *Second Wave* (1971–80), published in Boston.

13. See Chapter 1, pp. 20–1.

14. Unlike in *Union Maids*, we see photographs of all the interviewees as young women, in conventionally glamorous feminine poses.

15. One of the film's most striking moments is when Dr Marynia Farnham, co-author of *Modern Woman: The Lost Sex*, is pictured, in full professional garb and context, dictating to her female secretary her condemnation of the working woman.

16. Interestingly, in an early contribution to the 'realist debate' about feminist documentaries, Eileen McGarry makes a similar argument. Her article, drawing on Johnston's arguments about the ideological implications of notions of transparency, argues that realism is in fact always coded in complex ways. However, she also argues that films which, like *Union Maids*, are constructed from interviews, historical material and song, despite their realist aesthetic also go beyond realism 'in the almost *heroic* coding and use of women who would perhaps not appear in a favourable light in more traditional film … elevat[ing] *real* women beyond traditional *natural* and *filmic* sexual stereotypes' ('Documentary, Realism & Women's Cinema', 1975, p. 57, original emphasis).

17. Rainer's later films are much more explicitly concerned with political issues.

18. Jackson was a member of the Black Panther Party whose *Soledad Brother: The Prison Letters of George Jackson* was published in 1970. He was killed in 1971. Davis was tried in 1972 on charges of involvement in a plot to free Jackson.

19. In one dream sequence, the narrator recounts a dream in which her mother tries kill her with 'an injection': 'It is Mom who has the needle. … A big glass cylindrical thing … with a long stainless needle.' The accompanying images are of a small child struggling with her mother, who tries to put curlers in her hair. The account is followed by the vérité sequence in which the younger daughter recounts her rape.

20. See Luce Irigaray, who suggests that in the current symbolic order 'love of the mother among women can and may be practiced only through *substitution* … By a taking the place of … Which is unconsciously colored by hate' ('Love of Same, Love of Other', 1993/1984, p. 87, original emphasis).

21. For a much fuller account of the film, see Kaplan, *Women and Film*, 1983.
22. See Citron, 'Women's Film Production', 1988. Potter has commented that she 'fell in love with narrative'. See Florence, 'A Conversation with Sally Potter', 1993, pp. 277–8.

3 UNEXPLORED TERRITORIES

1. A brief reference to *Girlfriends* in the book's conclusion suggests that Rosenberg felt that it, too, had sacrificed politics to a focus on 'private life and interpersonal relationships' (*Women's Reflections*, 1979, p. 114).
2. Rosen's *Popcorn Venus* (1974/1973) and Haskell's *From Reverence to Rape* (1987/1974) are both histories of Hollywood representations of women. Both add a very few pages on the virtual absence of contemporary female directors of fiction films. Although Joan Mellen's *Women and their Sexuality in the New Film* (1974) includes a short sub-section on 'Women Writers, Women Directors', her search for *positive images* of women leads her to prefer Hollywood films of the 1940s. In a 1975 review of the books, Claire Johnston comments on what she sees as their flaws: 'With no sense of film theory, none of the writers are able to give an adequate account of how a feminist cinema can develop and what, if any, contributions have been made by women in the past' ('Feminist Politics and Film History', 1975, p. 121).
3. 'Are Women Directors Different?', *Village Voice*, 3 February 1975, p. 72.
4. In a 1974 interview conducted by E. Ann Kaplan with Claire Johnston, Pam Cook and Laura Mulvey, Kaplan concludes that according to the 'thesis' of these 'British cine-feminists', 'If women continue to use male cinematic conventions, ... there won't be a feminist cinema at all' (Kaplan, 'Interview with British Cine-Feminists', 1977, p. 406).
5. Haskell herself, however, despite her earlier desire for 'positive, women-centred stories', reviews both films favourably.
6. Loden herself, in fact, left the festival before the screening, feeling that the atmosphere there was too aggressive – 'not really a collective, sisterhood type feeling' – and unwilling to recognise the validity of women like her protagonist (Loden, 'Barbara Loden Revisited', 1974, p. 68).
7. Roger Greenspun ('Movie Review', 1 March 1971) writes, 'It would be hard to imagine better or more tactful or more decently difficult work for a first film. I suppose it is significantly a woman's film in that it never sensationalizes or patronizes its heroine, and yet finds her interesting and not (as it might have) just interestingly dull. ... *Wanda* is a small movie, fully aware of its limits, and within those limits lovely.' Marion Meade ('Lights! Camera! Women!', 25 April 1971) finds *Wanda* 'a bit troubling. ... Perhaps expecting [Loden] to have come up with a bold new breed of screen woman is asking too much, but one wishes [her] timid, little-girl wom[a]n could have

shown a touch more spunk'. For other reviews, see Reynaud, 'For *Wanda*', 2004/2002.

8. This is true also of Reynaud's own article 'For *Wanda*' (2004/2002), despite its detailed analysis of the film. Here Reynaud is quoting from a 1971 interview with Loden.

9. An exception was the review by Andrew Sarris in *Village Voice* of 17 October ('The Nasty Nazis', 1974). Haskell's positive response was published four months later ('Are Women Directors Different?').

10. Canby's review ('"The Night Porter" is Romantic Pornography') and Lichtenstein's interview with Cavani ('In Liliana Cavani's Love Story') appeared in the *New York Times* of 13 October 1974, and Kael's review ('The Current Cinema') in the *New Yorker* of 7 October. For further reviews see Marrone, *The Gaze and the Labyrinth*, 2000, pp. 101–3 and 224–5.

11. Vincent Canby's review in particular repeatedly emphasises that it is *Miss* Cavani who is responsible for what he sees as the trivialisation and romanticisation of issues dealt with more profoundly by Bergman, Sade or Genet ('"The Night Porter" is Romantic Pornography').

12. 'Certainly the first female masterpiece in the history of cinema', *Le Monde*, 22 January, 1976. Quoted by Jacqueline Suter ('Feminine Discourse in *Christopher Strong*', 1988, p. 103).

13. Janet Maslin review, 'Film: "Les Rendez-vous"', 27 April 1979. Maslin writes that 'the film's attention to detail, like Anna's, is at times peculiarly excessive', and follows with an example of *Anna*'s preoccupation with detail.

14. Janet Maslin review, 'Film: Australian "Brilliant Career" by Gillian Armstrong', 6 October, 1979. Geoffrey Barker's review in May 1979, for both *The Sydney Morning Herald* and *The Age*, similarly reports that the film has 'both the virtues and vices that might be expected in a feminist love story written, produced and directed by women', being guilty of making 'some of its feminists points a touch too obtrusively'. It is also worth noting that feminist critics were much less complimentary, with Barbara Creed, for example, arguing that 'the female narrator's voice is lost soon after the film begins, the visual narrative takes over and focuses not on the career but on the love story of an unconventional girl' (quoted in Wright, *Brilliant Careers*, 1986, pp. 95–6).

15. References are to Hans Anderson's story ('The Little Mermaid', 1995, pp. 149–70).

16. Reynaud is criticising Raymond Carney's reading of the film in these terms. See Carney, *American Dreaming*, 1985, p. 152.

17. Vincent Canby (*New York Times*, 21 March, 1971) commented that Mr Dennis 'tried to transform [Wanda] into a Bonnie for his Clyde' (quoted in Reynaud 2004/2002, p. 224). Critics also suggested links to the male-centred

WHAT IF I HAD BEEN THE HERO?

road movies of the late 1960s, Barbara Meade ('Lights! Camera! Women!') commenting that 'this easy rider owns no bike'.

18. Loden herself described in an interview her rejection of the 'Pygmalion theme' suggested by the film's narrative (Melton, 'An Environment that is Overwhelmingly Ugly and Destructive', 1971, p. 11).

19. The American dream, as Richard Dyer has observed, is founded on heroes and organised around themes of consumption and success (*Stars*, 1979, pp. 27, 39). The interview with Loden by McCandlish Phillips, which persistently undermines Loden's statements through reference to her status as Kazan's wife, comments: 'The film was made in express rejection of Hollywood techniques. It was also made in express rejection of national values as Miss Loden sees them. ... "I really hate slick pictures," she said, coiled in a green chair in the sitting room in which she presides as Mrs Elia Kazan' (*New York Times*, 11 March 1971).

20. Cavani's screenplay indicates that Lucia was fifteen at this point. See Marrone, *The Gaze and the Labyrinth*, p. 97.

21. Max refers to the now adult Lucia as 'my little girl' and insists that 'She's exactly the same ... as she was then.'

22. See, for example, Waller, 'Signifying the Holocaust', 1995, p. 214.

23. See Radway, *Reading the Romance*, 1984, p. 127. Initially 'a man incapable of expressing emotions or of admitting dependence' but powerful in the public sphere, the typical romance hero, she writes, is transformed in the course of the story into a figure possessing both 'masculine power and prestige' and a quasi-maternal sensitivity to the heroine's needs. It is a decisive act of tenderness on the hero's part which enables the heroine to see that what she had seen as his arrogance and coldness was in fact the result of previous hurt (by a woman).

24. Kaja Silverman's psychoanalytic reading of the film ('Masochism and Subjectivity', 1980) identifies this cut with both the 'bleeding wound' which for Laura Mulvey signifies the female genitalia in the male imagination and with the cinematic 'cut' which constantly disturbs the pleasure of the image for the viewing subject.

25. For a feminist analysis of the opera, see Clément, *Opera, or the Undoing of Women*, 1989.

26. See, for example, Scherr ('The Uses of Memory and the Abuses of Fiction', 2000), who argues that Cavani 'misreads' the Holocaust by 'representing perverse and paranoid sex as symbolic of Holocaust memory'.

27. In the flashback scenes, the lighting constantly picks out the swastika on Max's arm, his hotel uniform mimics that of the concentration camp scenes, and at the start of the concluding scenes in his apartment the light once again picks up the swastika on his uniform, now hanging in the wardrobe whose door Lucia opens.

28. That rape underlies the 'devouring' or 'awakening' of the princess is a point made by a number of writers. See, for example, Zipes, *Don't Bet on the Prince*, 1986. In the seventeenth-century version of *Sleeping Beauty* by Giambattista Basile this is explicitly the case.

29. See Freud, 'A Child is being Beaten', 1979/1919, pp. 159–93.

30. While the romance fantasy is a powerful weapon with which to control women, it is also a threat for the masculine hero, since if he succumbs to it he too becomes 'feminised'.

31. As Max returns to the apartment and a chained Lucia, he first hits her, twice, and then confesses 'I – love you'. From this point, she has greater sexual power within the relationship, though she retains the position of child.

32. For Cavani, Max 'is literally the porter – or gate-keeper – of the night' (quoted in Marrone, *The Gaze and the Labyrinth*, p. 221 n. 24) Marrone adds that the night is also 'a metaphor for the unconscious' (ibid., p. 90).

33. Silverman argues that in Cavani's films the female author has a presence 'inside' the text via the figure of the 'lacking' or 'castrated' male subject – for example, in the case of *The Night Porter* via Max himself. See *The Acoustic Mirror*, 1988, pp. 224–5.

34. See Chapter Two, p. 41.

35. 'You're the directress [i.e., female director] – that's the word, isn't it?'

36. See Margulies, 'Echo and Voice in *Meetings with Anna*', 2003, p. 75 n. 23. Aurore Clément, who plays Anna, in an interview with Akerman for the 2007 DVD of the film, also describes Akerman's preoccupation with constructing a 'Hitchcockian' woman.

37. See also the comments by Jodi Ramer, 'Postmodernism and Post(Feminist) Boredom', 2004.

38. See Baudry, 'The Apparatus', 1976.

39. In an unremarked reversal of roles, Anna recalls dressing her mother for an evening out, and her mother recalls Anna telling her to 'Have a good time' and lying awake waiting for her return.

40. See Chapter One, p. 16.

41. On hearing her lover's voice we see just the slightest of smiles on Anna's face, but the next message returns us to someone else's demands.

42. At Heinrich's house, on Cologne station with Ida, with her mother and with Daniel, Anna is offered food or says she is hungry but then cannot eat. The only time we see her eat is when, walking down the hotel corridor, she sees the remains of a meal left out for collection by another guest and picks up and eats some of the peas left there, one by one. For Lynn Higgins, this act, like the trains and showers which also feature in the film, recalls the privations and abuses of the concentration camp, but it also speaks of the attenuated nature of her desire. See Higgins, 'Two Women Filmmakers Remember the Dark Years', 1999, pp. 65–6.

43. For Australian audiences, the book had been continuously in print since its re-publication in 1965. The information was also made widely available through press packs and reviews.

44. Early publicity persistently identified the two, an identification confirmed by Armstrong's own statement that 'I took *My Brilliant Career* and turned it a little into my own story' (Wright, *Brilliant Careers*, p. 95).

45. Compare *My Brilliant Career*'s screenplay:

> HARRY
> I thought … I thought we might get married.
> SYBYLLA is taken by surprise and hesitates a moment. Then she flares back at him.
> SYBYLLA
> (Mocking him)
> Well, what a handsome proposal! How could anyone say no?
> At the end of his tether, HARRY grabs her.
> HARRY
> (Grating it out!)
> How dare you!
> HARRY suddenly pulls her to him as though he is going to kiss her roughly.
> SYBYLLA raises the riding crop and slashes HARRY across the face.

See <www.scriptcrawler.com/view.php?id=985>. Accessed via: <www.archive.org/web/web.php>

46. In an article of 1980–1, Christine Geraghty groups together *Girlfriends*, Paul Mazursky's *An Unmarried Woman* (1977) and Michael Crichton's *Coma* (1977) as examples of the 'revival of the "woman's film", suitably revised for the seventies' (see Geraghty, 'Three Women's Films', 1986, p. 138), and Annette Kuhn similarly describes the narratives of these male-directed films of the 1970s as organised around 'women who are not attractive or glamorous in a conventional sense' and their journey to 'self-discovery and growing independence' (1982, *Women's Pictures*, p. 135).

47. Within 'the film's diegetic world of rural New South Wales in 1897 the Australian woman writer exists somewhere in the future' (Collins, *The Films of Gillian Armstrong*, 1999, p. 23).

4 HEROES AND WRITERS

1. In the following quotations I am drawing on the various versions of the text preserved in Woolf, 'Speech', 1978/1931.

2. The 'bright work' of these women did take the form of tablecloths (Byatt, 'Arachne', 2001, p. 139). Byatt echoes here Woolf's comment in 'A Room of One's Own' that 'we think back through our mothers if we are women' (1993/1929, p. 69).

3. See, for example, Jean-Louis Baudry, 'Ideological Effects of the Basic Cinematic Apparatus', 2004/1970.

4. In cinema, writes Baudry, 'the spectator identifies less with what is represented, the spectacle itself, than with what stages the spectacle, makes it seen, obliging him to see what it sees. ... Just as the mirror assembles the fragmented body in a sort of integration of the self, the transcendental self unites the discontinuous fragments of phenomena, of lived experience into unifying meaning' ('Ideological Effects of the Basic Cinematic Approach', 2004, p. 364). In thus constructing meaning, therefore, the cinema screen also constructs the 'unified' self that grasps that meaning.

5. The most famous instance of this is in 'A Room of One's Own', where Woolf criticises Charlotte Brontë's writing in *Jane Eyre* for just such a disturbance of the fabric of her text: 'That is an awkward break, I thought. ... One sees that [Brontë] will never get her genius expressed whole and entire. Her books will be deformed and twisted. She will write in a rage where she should write calmly' (1993/1929, pp. 63–4). Clearly this is at least in part an internal argument.

6. In giving the narrating voice to the child actor (Abigail Breslin) who plays Kit, however, the film invites the adult viewer to insert her own gap between the film's narrative and realism.

7. The analogy is repeated elsewhere in his analysis. Thus, 'we first learn that the Minister ... has turned the letter over ... as one turns a garment inside out. So he must procede [sic], according to the methods of the day for folding and sealing a letter, in order to free the virgin space on which to inscribe a new address' (Laccan, 'Seminar on "The Purloined Letter"', 1972, p. 65).

8. The chief implausibility, referred to by both Philip French in the *Observer* and Peter Bradshaw in the *Guardian*, is that Ramsay substitutes for the payment of £1,875 which Morvern is offered by the publishers the unlikely sum of £100,000. Bradshaw also refers to the implausibility of Morvern's being able to cut up the body with kitchen implements and bury it using only a trowel. Both critics, however, do acknowledge the 'magical' quality of the film. See French, 'The Amoral High Ground, 2002, and Bradshaw, '*Morvern Callar*', 2002.

9. Samantha Morton, who plays Morvern, said that the character 'was a hero to me' (Leigh, 'About a Girl', 2002).

10. In interviews Ramsay frequently described her own sense of 'fraudulence': ' "It's funny," she says, "I'm always thinking I'm never going to get to make

another film. Still fully expect to be back down the jobcentre"' (ibid.). In fact, she didn't release another film until 2011. Scheduled to adapt Alice Sebold's *The Lovely Bones*, she found the rights instead bought by *Lord of the Rings* director Peter Jackson.

11. See Collins, *The Films of Gillian Armstrong*, 1999, for an account of these two figures in Armstrong's earlier films.

12. In *High Tide* the scene occurs twice, the first time when Ally watches the fascinating figure of Lilli, as she sits with her fellow travelling performers, and the second when Ally, now knowing that Lilli is her mother, watches her perform a strip show.

13. Mica Nava reports that 'spectacular oriental extravaganzas', with 'live performers, dance, music and … oriental products' were also frequent events in department stores and exhibition spaces of early twentieth-century western cities ('Modernity's Disavowal', 1997: 67).

14. In Frame's *To the is-land*, she specifically describes disliking Keats, 'a poet who could go into such boring details about his feelings' (1984, p. 120). Poems by Keats are among those from the New York subway Poetry in Transit programme quoted aloud by Frannie.

15. In the 'rhyming' sequence, where Fanny lies in a field of bluebells, it is Keats's words that we hear in voice-over, not her own.

16. Stella's unfulfilled desire is registered in a more and more excessive performance of femininity, registered through clothes and hairstyle.

17. All women 'confuse' him, he says: 'I yearn to be ruined by shrews and saved by angels and in reality, I have only ever loved my sister.'

18. Keats fails to suspect that Brown might be the father of Abigail's child because he had 'no notion of a love affair' between them.

19. Schiesari points particularly to Freud's Studies on Hysteria as an example. See Schiesari, *The Gendering of Melancholia*, 1992, pp. 61–2, and Freud and Breuer, *Studies on Hysteria*, 1974/1893–5.

20. In Campion's original screenplay the pillowslip, like Arachne's tapestry, is bordered by 'a simple pattern of wild flowers'.

21. See, for example, Peterson, 'Jane Campion Directs Romance About Poet John Keats and Fanny Brawne', 2009: 'These poetic images, often filmed in natural light and saturated color, don't merely symbolize the lovers. They celebrate the beauty in the images themselves.'

5 LANDSCAPES AND STORIES

1. See Somers and Gibson, 'Reclaiming the Epistemological "Other"', 1994, for a fuller account of such structuring 'meta-narratives'.

2. Sharon Willis makes a similar point, though her conclusion is more positive. Through the sepia news photograph into which the film's final freeze-frame

transforms, Butch Cassidy and the Sundance Kid, she writes, 'are frozen as the figure of a failed masculinity outstripped by the history whose image they become. Thelma and Louise, on the other hand, are suspended as the image of the unfinished' ('Hardware and Hardbodies', 1993, p. 277 n.4).

3. Compare Seymour Chapman's account of the function of description in narrative: 'what happens in description is that the time line of the story is interrupted and frozen. Events are stopped, though our reading – or discourse-time continues, and we look at the characters and the setting elements as a *tableau vivant*' ('What Novels Can Do That, Films Can't (and Vice Versa)', 1981, p. 119).

4. Moers is quoting Willa Cather here.

5. Benjamin, writes Butler, 'remarks that melancholia *spatializes*, and that its effort to reverse or suspend time produces "landscapes" as its signature effect' (*The Psychic Life of Power*, 1997, p. 174).

6. Mieke Bal, in her account of 'Description as Narration', suggests that 'the referential, encyclopaedic description' might exclude metaphor, but this is rare (*On Story-Telling*, 1991, pp. 126–32).

7. Polley was nominated in 2008 for Best Screenplay Based on Material Previously Produced or Published and Julie Christie for Best Actress. The film also received numerous other nominations and awards, including the 2008 Golden Globe award for Christie.

8. *Letters from Iceland* is by W. H. Auden and Louis MacNeice (1967/1937). It is referred to in the film as Auden's *Letters from Iceland*, however (Auden is the major contributor), and it is Auden's contributions that are quoted.

9. Copyright © 1937 by W. H. Auden & Louis MacNeice. Reprinted by permission of Curtis Brown Ltd.

10. Whereas in the story it is clear that, though the female students Grant slept with might have threatened it when he abandoned them, no suicide had in fact occurred, in the film it is implied that Veronica did kill herself.

11. Aubrey does not speak, but he produces drawings of Fiona which depict her as a young woman.

12. See Chapter Three.

13. For discussion of these images, and the connection they make between imperialism, whiteness, purity and domesticity, see McClintock, *Imperial Leather*, 1995, pp. 207–31.

14. Krishna is often depicted as an infant or young boy playing a flute, as he is in Kalyani's statue. Narayana is sometimes used as another name for Krishna.

15. Camille Claudel's (1888) statue of Shakuntala, for example, has the alternative title of *Abandonment*.

16. Kamala Visweswaran has noted the conservatism of the nationalist movement in relation to women, arguing that although 'Gandhi … argu[ed] that the terms of the marriage contract be changed and women allowed to choose

their own husbands,' this was still 'a strategy of containment, an attempt to keep women within defined roles' ('Betrayal', 1994, p. 104).

17. The film's Dutch title is simply *Antonia*.

18. Ramanathan uses the term 'myth', though her example is Homer's *Odyssey*. Anneke Smelik (*And the Mirror Cracked*, 1998, p. 93) calls the film 'a feminist rewriting of the epic genre'. Gorris herself commented that the film is 'whatever you want to call it – a fable, or a bit of a myth, or fairy tale' (Sklar, 'The Lighter Side of Feminism', 1996, p. 27).

19. A similar structure is used by Julie Dash in *Daughters of the Dust* (1991). Here, too, historical time is removed to the periphery of the narrative, and the composite narrative voice centres principally on a child (here an unborn child) and grandmother.

20. In a 1996 interview, Gorris commented on the film that, 'I loved playing around with people's perceptions of things – like when Danielle wants a child, she's not going to look for a husband, she's going to look for somebody who can make her pregnant. That happens to be the knight on the white charger, and then they go to a castle, but the castle is a hotel' (Sklar, 'The Lighter Side of Feminism', 1996, p. 27).

6 BODIES AND PASSIONS

1. Woolf's diary of 20 January 1931 (the day before she gave the speech quoted above), notes: 'I have this moment, while having my bath, conceived an entire new book – a sequel to A Room of One's Own – about the sexual life of women' (quoted in Barrett, 'Introduction', 1993, p. xxv). The 'book' eventually became *The Years* (1937) and *Three Guineas* (1938), neither of which fulfils the original brief.

2. See Chapter One, p. 31.

3. Slavoj Žižek argues that '*narrative as such*' emerges as an attempt to resolve the irreconcilable psychic tensions of fantasy, by rearranging their contradictions 'into a temporal succession' (*The Plague of Fantasies*, 1997, pp. 10–11, original emphasis).

4. Kaja Silverman (*The Acoustic Mirror*, 1988) and Teresa de Lauretis (The *Practice of Love*, 1994), for example, have argued that the sense of loss or lack which propels the child into the realm of language and the symbolic originates not in the threat of castration, as Freud supposes, but in an earlier loss – that of the mother's body. Since such loss is experienced alike by girl or boy, access to the symbolic is equally available to both. The repressions which accompany such access are in turn generative of fantasies – fantasies of the *other* woman's body, of a sexually empowered and empowering mother, of a mobile and non-phallic fetish object which can provide 'fantasmatic access' to this 'originally lost body' (de Lauretis, *The Practice of*

Love, 1994, p. 251, original emphasis) – which are constitutive of a *female* desiring subject.

5. See Doane, *The Desire to Desire*, 1987, p. 19, original emphasis.

6. Jane Arthurs writes of the ways in which the abject and transgressive body performances of female comedians and actors are often recuperated in ways which 'diminish the transgress potential of the original "risky" performance' ('Revolting Women', 1999, p. 161).

7. See Russo, *The Female Grotesque*, 1994.

8. See le Doeuff, *The Philosophical Imaginary*, 2002.

9. See Williams, *Hard Core*, 1990, pp. 258–60.

10. See, for instance, the work of Steven Shaviro (*The Cinematic Body*, 1993) and Jennifer Barker (*The Tactile Eye*, 2009).

11. This framing scene was omitted from the theatrical release, which begins with Hanover's exploitation of one of his victims, thus shifting the focus away from the issue of Dana's sexuality and motivation and suggesting a more straightforward investigative structure.

12. Janet Maslin's *New York Times* review ('Trying to Set a Trap For a Serial Rapist', 1992) called the film an 'exploitation thriller', and Christina Lane (*Feminist Hollywood*, 2000, p. 54) calls the genre the 'psychothriller'. Lane also notes Borden's statement that initially she 'had no intention at all of making a genre film', but was pressured into this by the production company (ibid., p. 138).

13. See Susan Faludi's *Backlash* (1991) for the most forceful – if un-nuanced – statement of the argument that film-makers of the 1980s 'became preoccupied with toning down independent women and drowning out their voices' (p. 144). See also Williams (*The Erotic Thriller in Contemporary Cinema*, 2005) for a discussion of these films.

14. The 'unrated' video cover reads: 'More menacing than your worst nightmare, *Sleeping with the Enemy*'s Patrick Bergin is back on the streets, posing as photographer David Hanover. He uses his camera to seduce women: undressing, possessing and abusing them – but leaves his victims so humiliated that they're ashamed to face him in court.'

15. *Love Crimes* seems to be one of the texts on which Campion draws for her own very self-reflexive film. Mark Ruffalo's appearance recalls that of Bergin in the earlier film, and Frannie's investigation, too, is punctuated by childhood memories/fantasies.

16. Borden stated that 'The idea throughout was of women willingly submitting themselves to be looked at in order to be monumentalized, put into a magazine, legitimized' (in Lucia, 'Redefining Female Sexuality in the Cinema', 1992, p. 9).

17. The R-rated version includes a sequence where Dana's fear causes her to urinate on the floor.

18. See Lacan, 'God and the *Jouissance* of/The/Woman', 1982, pp. 138–48.
19. See Borden in Lucia, 'Redefining Female Sexuality in the Cinema', 1992, p. 9.
20. *Fat Girl* was the title of the American release. In a number of interviews, however, Breillat has said that this was in fact her original title for the film.
21. Breillat has called them 'one soul with two bodies', and 'my sister divided in two' (Interview, 2001b).
22. *Bluebeard* (2010), *Sleeping Beauty* (2011) and the projected *Beauty and the Beast*.
23. In Deborah Tolman's study of teenage girls talking about their first sexual experiences, we see this language constantly re-echoed, as, for example, when Jenny contrasts her first experience of sex with her expectations: 'I was always like, well, I wanted to wait, and I want to be in a relationship with someone who I really like, and I want it to be a special moment' (*Dilemmas of Desire*, 2002, p. 62).
24. Breillat (Interview, 2001b) described it as the 'forbidden body, a blend of a little girl's body and an incredible sexual opulence'.
25. 'comme si l'instinct de survie la rendait parfaitement complice de son bourreau'. Breillat's script notes add of the rapist, 'Il ne ressemble pas à Fernando mais si on le regarde strictement comme elle le regarde, c'est aussi un homme et il y a quelque chose qui ressemble' (*À ma Soeur scénario*, 2001a, p. 87).
26. Martel's description of the project which was to become *The Holy Girl* in a 2001 interview. See www.telegraph.co.uk/culture/4725891/Great-pool-of-talent.html
27. As Dominique Russell has noted, 'The mise en scène emphasizes this "timelessness" with a mix of periods in the furniture and décor.' See 'Lucretia Martel', 2008.
28. An electronic musical instrument controlled without physical contact from the player. It has two metal antennae which respond to the position of the player's hands, so it can be played without being touched. The electric signals are transmitted via a loudspeaker.
29. Mantel, *La Niña Santa* DVD, 2008.
30. Martel has commented that 'I don't like swimming pools, because I have the feeling that they are always dirty, like an infection. … I like to shoot in swimming pools, though, because it's like a room, below the level of the ground, full of water. … I think there are a lot of similarities in perception – between being in a pool and being in the world. … You know, family is like a swimming pool too. If you want to understand things that you see in the spread of social life, if you focus on the family, you can see it immediately' (Martel, in Wisniewski, 'When Worlds Collide', 2008). Pools also feature in Martel's *The Swamp* (*La Ciénaga*, 2001) and *The Headless Woman* (*La mujer sin cabeza*, 2008).

31. 'He appeared to me to be thrusting [his spear] at times into my heart, and to pierce my very entrails; when he drew it out, he seemed to draw them out also, and to leave me all on fire with a great love of God. The pain was so great, that it made me moan; and yet so surpassing was the sweetness of this excessive pain, that I could not wish to be rid of it.' See Teresa de Avila, *The Life of Teresa de Avila*, 1562, 29:17. St Teresa was also used by George Eliot in the Prelude to *Middlemarch* (1874), as a figure whose desire for a 'life beyond self' prefigures the confusion of the sexual, the romantic and the religious in Dorothea, *Middlemarch*'s protagonist. See www.gutenberg.org/files/145/145-h/145-h.htm

32. Martel, notes Dominique Russell ('Lucretia Mantel', 2008), often delays the revelation of the source of the sounds we hear. Jano is alerted to the watching presence of Amalia at the swimming pool by the sound of her fingernails scraping along fabric followed by the tapping of her nail on a metal eyelet; he must then search for the sounds' source.

33. Martel has said that her own vision is of 'the possibility of a social order which is in keeping with the body' (*La Niña Santa* DVD, 2008).

34. Martel has repeatedly emphasised the film's basis in her own memories and its blurring of fantasy and reality. While the film was not conceived as 'a period film', she says, 'what we show clearly ends up being a strange period of around [the 1970s or the 80s]' (*La Niña Santa* DVD, 2008).

35. See Walkerdine, 'Behind the Painted Smile', 1991.

36. Jean both leaves the tiller in order to attend to Adaline, and omits the warning that might save her from being knocked overboard.

37. Jermyn sees Maren as 'a potent example of an "unnatural" woman; barren, incestuous, "bisexual" and finally murderous', who typifies 'archaic and ultimately reactionary fears of woman as duplicitous and monstrous' ('Cherchez la Femme', 2003, p. 137).

38. Anethe ceases to run when Maren calls her and seems to offer herself to the axe. Adaline goes on deck in the storm without the life jacket that Rich has insisted she wear.

CONCLUSION

1. Rich (*Chick Flicks*, 1998, p. 63) writes of a 'Cinema of the Fathers' ('dominant' cinema) and a 'Cinema of the Sons' (avant-garde experimental cinema). By implication, the feminist cinema she describes is a cinema of 'the Daughters'.

2. Akerman defends the film against 'certain people' who 'hate this murder and say, "You have to be more pure"' ('Chantal Ackerman on *Jeanne Dielman*', 1977, p. 120).

3. We can note here too a similar 'placing' of 1970s film feminism by scholars who were themselves part of this 'exciting movement'. Linda Williams, for

example, describes herself as feeling 'weighed down by what feels like orthodox feminist position taking' ('Why I Did Not Want to Write This Essay', 2004, p. 1264). In the same issue of *Signs*, Patrice Petro writes of feminist film theory having been 'relegated to the past' ('Reflections on Feminist Film Studies, Early and Late', 2004, p. 1272).

Bibliography

Akerman, C., 'Chantal Akerman on *Jeanne Dielman*', *Camera Obscura* no. 2, 1977, pp. 118–21.

Anderson, H., 'The Little Mermaid', in *Hans Anderson: His Classic Fairy Tales* trans. E. Haugaard (London: Gollancz, 1995), pp. 149–70.

Anderson, J. M., 'Interview: Jane Campion "Star" Maker', *Combustible Celluloid*, 30 July 2009, accessed at: www.combustiblecelluloid.com/interviews/campion.shtml

Andrew, G., Interview with Lynne Ramsay, *Guardian*, Monday, 28 October 2002, accessed at: www.guardian.co.uk/film/2002/oct/28/features

Arthurs, J., 'Revolting Women: The Body in Comic Performance', in J. Arthurs and J. Grimshaw (eds), *Women's Bodies: Discipline and Transgression* (London: Cassell, 1999), pp. 137–64.

Atwood, M., 'Alien Territory', in M. Atwood, *Good Bones* (London: Virago, 1993), pp. 75–88.

Auden, W. H., 'The Guilty Vicarage', in W. H. Auden, *The Dyer's Hand and Other Essays* (London: Faber and Faber, 1963/1938), pp. 146–58.

Auden, W. H. and MacNeice, L., *Letters from Iceland* (London: Faber and Faber, 1967/1937).

Austin-Smith, B. and Melnyk, G. (eds), *The Gendered Screen: Canadian Women Filmmakers* (Waterloo: Wilfred Laurier University Press, 2010).

Avila, T. de, *The Life of Teresa de Avila* (1562), accessed at: www.ccel.org/ccel/teresa/life.viii.xxx.html

Bacchilega, C., *Postmodern Fairy Tales: Gender and Narrative Strategies* (Philadelphia: University of Pennsylvania Press, 1997).

Bal, M., *On Story-Telling: Essays in Narratology*, ed. D. Jobling (Sonoma, CA: Polebridge Press, 1991).

Barker, J. M., *The Tactile Eye* (Berkeley and London: University of California Press, 2009).

Barrett, M., 'Introduction', to Virginia Woolf's *A Room of One's Own and Three Guineas* (London: Penguin, 1993/1931), pp. ix–liii.

Barthes, R., *Mythologies* (London: Granada, 1973).

Barthes, R., 'The Death of the Author', in R. Barthes, *Image/Music/Text*, trans. S. Heath (London: Fontana, 1977), pp. 142–8.

Baudry, J.-L., 'Ideological Effects of the Basic Cinematic Apparatus', in
L. Braudy, and M. Cohen (eds), *Film Theory and Criticism*, 6th edn (New York
and Oxford: Oxford University Press, 2004/1970), pp. 355–65.

Baudry, J.-L., 'The Apparatus', *Camera Obscura* no. 1, 1976, pp. 104–26.

Benjamin, J., 'Master and Slave: The Fantasy of Erotic Domination', in A. Snitow,
C. Stansell and S. Thompson (eds), *Powers of Desire: The Politics of Sexuality*
(New York: Monthly Review Press, 1983), pp. 280–99.

Benjamin, J., 'A Desire of One's Own: Psychoanalytic Feminism and
Intersubjective Space', in T. De Lauretis (ed.), *Feminist Studies/Critical Studies*
(Basingstoke and London: Macmillan Press, 1986), pp. 78–101.

Bergstrom, J., '*Jeanne Dielman, 23 Quai du Commerce, 1080 Bruxelles* by Chantal
Akerman', *Camera Obscura* no. 2, 1977, pp. 114–18.

Bergstrom, J., 'Chantal Akerman: Splitting', in J. Bergstrom (ed.), *Endless Night:
Cinema and Psychoanalysis, Parallel Histories* (London: University of California
Press, 1999), pp. 273–90.

Betancourt, J., *Women in Focus* (Dayton, OH: Pflaum, 1974).

Blixen, K. (Isak Dinesen), *Out of Africa* (London: Penguin, 1954).

Blunt, A., 'Mapping Authorship and Authority: Reading Mary Kingsley's
Landscape Descriptions', in A. Blunt and G. Rose (eds), *Writing Women and
Space: Colonial and Postcolonial Geographies* (New York and London: Guilford
Press, 1994), pp. 51–72.

Bradshaw, P., '*Morvern Callar*' Review, *Guardian*, 1 November 2002, accessed at:
www.guardian.co.uk/culture/2002/nov/01/artsfeatures3

Breillat, C., '*À ma Soeur* scénario' (Paris: Cahiers du cinéma, 2001a).

Breillat, C., Interview, *Fat Girl* DVD (Criterion Collection 2001b).

Butler, A., *Women's Cinema: The Contested Screen* (London: Wallflower, 2002).

Butler, J., *The Psychic Life of Power* (Stanford, CA: Stanford University Press,
1997).

Butler, J., *Antigone's Claim* (New York: Columbia University Press, 2000).

Butler, J., *Undoing Gender* (New York: Routledge, 2004).

Byatt, A. S., 'Arachne', in P. Terry (ed.), *Ovid Metamorphosed* (London: Vintage,
2001), pp. 131–57.

Cahiers du cinéma editors, 'John Ford's *Young Mr Lincoln*', in B. Nichols (ed.),
Movies and Methods (Berkeley and Los Angeles: University of California Press,
1976), pp. 493–529.

Callahan, A., *Writing the Voice of Pleasure* (New York and Basingstoke: Palgrave,
2001).

Camera Obscura collective, 'Feminism and Film: Critical Approaches', *Camera
Obscura* no. 1, 1976a, pp. 1–10.

Camera Obscura collective, 'Yvonne Rainer: An Introduction', *Camera Obscura*
no. 1, 1976b, pp. 53–70.

Camera Obscura collective, 'Chronology', *Camera Obscura* no. 7, 1981, pp. 5–13.

WHAT IF I HAD BEEN THE HERO?

Campion, J., *The Piano* (London: Bloomsbury, 1993).

Canby, V., '"The Night Porter" is Romantic Pornography', *New York Times*, 13 October 1974, pp. D1, 19.

Carney, R., *American Dreaming: The Films of John Cassavetes and the American Experience* (Berkeley: University of California Press, 1985).

Caughie, J. (ed.), *Theories of Authorship* (London: Routledge, 1981).

Cavarero, A., *Relating Narratives: Storytelling and Selfhood* (London and New York: Routledge, 2000).

Changas, E., Review of *Wanda*, *Film Quarterly*, vol. 25 vo. 1, 1971, pp. 49–51.

Chapman, J., 'Some Significant Women in Australian Film: A Celebration and a Cautionary Tale', ScreenSound Australia Longford Lyell Lecture, *Metro Magazine* no. 136, 2002, pp. 98–107.

Chapman, S., 'What Novels Can Do That Films Can't (and Vice Versa)', in W. J. T. Mitchell (ed.), *On Narrative* (London: University of Chicago Press, 1981), pp, 117–36.

Chaudhuri, S., 'Snake Charmers and Child Brides: Deepa Mehta's *Water*, "Exotic" Representation, and the Cross-cultural Spectatorship of South Asian Migrant Cinema', *South Asian Popular Culture* vol. 7 no. 1, April 2009, pp. 7–20.

Citron, M., 'Women's Film Production: Going Mainstream', in E. D. Pribram (ed.), *Female Spectators* (London: Verso, 1988), pp. 45–63.

Citron, M., Lesage, J., Mayne, J., Rich, B. R., Taylor, A. M. and the editors of *New German Critique*, 'Women and Film: A Discussion of Feminist Aesthetics', *New German Critique* no. 13, 1978, pp. 83–107.

Clément, C., *Opera, or the Undoing of Women* (London: Virago, 1989).

Clough, P. T., *The End(s) of Ethnography: From Realism to Social Criticism*, New York: Peter Lang, 1998).

Clover, C. J., 'Her Body, Himself: Gender in the Slasher Film', in J. Donald (ed.), *Fantasy and the Cinema* (London: BFI, 1989), pp. 91–133.

Clover, C. J., *Men, Women and Chainsaws: Gender in the Modern Horror Film* (London: BFI, 1992).

Cohan, S. and Shires, L. M., *Telling Stories: A Theoretical Analysis of Narrative Fiction* (London: Routledge, 1988).

Collins, F., *The Films of Gillian Armstrong*, The Moving Image No. 6 (St Kilda: Australian Teachers of Media (ATOM), 1999).

Comolli, J.-L., 'Machines of the Visible', in T. de Lauretis and S. Heath (eds), *The Cinematic Apparatus* (Basingstoke: Macmillan, 1980), pp. 121–42.

Constable, C., *Thinking in Images* (London: BFI, 2005).

Cook, P., 'The Point of Self-expression in Avant-garde Film', in J. Caughie (ed.), *Theories of Authorship* (London: Routledge, 1981/1977), pp. 271–81.

Cook, P., 'Melodrama and the Women's Picture', in S. Aspinall and R. Murphy (eds), BFI Dossier 18: Gainsborough Melodrama (London: BFI, 1983), pp. 14–28.

Coulthard, L., 'Killing Bill: Rethinking Feminism and Film Violence', in Y. Tasker and D. Negra (eds), *Interrogating Postfeminism* (Durham and London: Duke University Press, 2007), pp. 153–75.

Cowie, E., *Representing the Woman: Cinema and Psychoanalysis* (Basingstoke: Macmillan, 1997).

Creed, B., *The Monstrous Feminine: Film, Feminism, Psychoanalysis* (London and New York: Routledge, 1993).

Creed, B., 'The Neomyth in Film: The Woman Warrior from Joan of Arc to Ellen Ripley', in S. Andris and U. Frederick (eds), *Women Willing to Fight: The Fighting Woman in Film* (Newcastle: Cambridge Scholars, 2007), pp. 15–37.

Dargis, M., ' "Thelma & Louise" and the Tradition of the Male Road Movie', in P. Cook and P. Dodd (eds), *Women and Film: A Sight and Sound Reader* (London: Scarlet Press, 1995), pp. 86–92.

Dawson, B., *Women's Films in Print* (San Francisco: Booklegger Press, 1975).

De Lauretis, T., 'Cavani's *Night Porter*: A Woman's Film?', *Film Quarterly* vol. 30 no. 2, 1976–7, pp. 35–8.

De Lauretis, T., *Alice Doesn't: Feminism, Semiotics, Cinema* (Basingstoke and London: Macmillan, 1984).

De Lauretis, T., *Technologies of Gender: Essays on Theory, Film, and Fiction* (Basingstoke and London: Macmillan, 1987).

De Lauretis, T., 'Aesthetic and Feminist Theory', in E. D. Pribram (ed.), *Female Spectators* (London: Verso, 1988), pp. 174–95.

De Lauretis, T., *The Practice of Love: Lesbian Sexuality and Perverse Desire* (Bloomington and Indianapolis: Indiana University Press, 1994).

Doane, M. A., 'The "Woman's Film": Possession and Address', in M. A. Doane, P. Mellencamp and L. Williams (eds), *Re-Vision: Essays in Film Criticism* (Los Angeles: AFI, 1984), pp. 67–82.

Doane, M. A., *The Desire to Desire: The Woman's Film of the 1940s* (Basingstoke and London: Macmillan, 1987).

Doane, M. A., Mellencamp, P. and Williams, L. (eds), *Re-Vision: Essays in Film Criticism* (Los Angeles: AFI, 1984).

Doland, A., 'Campion Laments Lack of Female Filmmakers', *The Age*, 22 May, 2007. Accessed at, www.theage.com.au/news/film/campion-laments-lack-of-female-filmmakers/2007/05/21/1179601326829.html

Dyer, R., *Stars* (London: BFI, 1979).

Eliot, G. (Mary Ann Evans), *Middlemarch* (1874), accessed at: www.gutenberg.org/files/145/145-h/145-h.htm

Erens, P., 'Women's Documentary Filmmaking: The Personal Is Political', in A. Rosenthal (ed.), *New Challenges for Documentary* (Berkeley: University of California Press, 1988/1981), pp. 554–65.

Faludi, S., *Backlash: The Undeclared War Against Women* (London: Chatto & Windus, 1991).

Feuer, J., '*Daughter Rite*: Living with our Pain, and Love', *Jump Cut* no. 23, 1980, pp. 12–13.

Flitterman, S., 'Woman, Desire and the Look: Feminism and the Enunciative Apparatus in Film', in J. Caughie (ed.), *Theories of Authorship* (London: Routledge, 1981), pp. 242–50.

Flitterman-Lewis, S., *To Desire Differently: Feminism and the French Cinema* (Urbana and Chicago: University of Illinois Press, 1990).

Florence, P., 'A Conversation with Sally Potter', *Screen* vol. 34 no. 3, 1993, pp. 277–8.

Foreman, P. G., 'Past-On Stories: History and the Magically Real, Morrison and Allende on Call', in L. P. Zamora and W. B. Faris (eds), *Magical Realism: Theory, History, Community* (Durham and London: Duke University Press, 1995), pp. 285–303.

Foster, G. A., *Women Filmmakers of the African and Asian Diaspora* (Carbondale: Southern Illinois University Press, 1997).

Foster, G. A., 'Introduction', in G. A. Foster (ed.), *Identity and Memory: The Films of Chantal Akerman* (Carbondale and Edwardsville: Southern Illinois University Press, 2003), pp. 1–8.

Foucault, M., 'What Is an Author?', in P. Rabinow (ed.), *The Foucault Reader* (London: Penguin, 1984), pp. 101–20.

Frame, J., *To the is-land* (London: Women's Press, 1984).

Fraser, N., "Feminism, Capitalism and the Cunning of History', *New Left Review* no. 56, March–April 2009, pp. 9–117.

French, P., 'The Amoral High Ground', *Observer*, 3 November, 2002, accessed at: www.guardian.co.uk/film/2002/nov/03/philipfrench

Freud, S., 'Symbolism in Dreams', Lecture 10, *New Introductory Lectures on Psychoanalysis*, trans. J. Strachey, Pelican Freud Library Vol. 1 (London: Penguin, 1973/1915), pp. 182–203.

Freud, S., *The Interpretation of Dreams*, trans. J. Strachey, Pelican Freud Library Vol. 4 (London: Penguin, 1976/1900).

Freud, S., 'Female Sexuality', in S. Freud, *On Sexuality*, trans. A. Richards, Pelican Freud Library Vol. 7 (London: Penguin, 1977/1925), pp. 367–92.

Freud, S., 'A Case of Paranoia Running Counter to the Psychoanalytic Theory of the Disease', in S. Freud, *On Psychopathology*, trans. A. Richards. Pelican Freud Library Vol. 10 (London: Penguin, 1979/1915), pp. 145–58.

Freud, S., 'A Child is Being Beaten', in S. Freud, *On Psychopathology*, trans. A. Richards, Pelican Freud Library Vol. 10 (London: Penguin, 1979/1919), pp. 159–93.

Freud, S., 'The Ego and the Id', trans. J. Strachey, Penguin Freud Library Vol. 11 (London: Penguin, 1984/1923), pp. 339–403.

Freud, S., 'The Uncanny', in S. Freud, *An Infantile Neurosis and Other Works*, The Standard Edition of the Complete Psychological Works, trans. J. Strachey, Vol. XVII (London: Vintage, 2001/1919), pp. 217–56.

Freud, S., 'Mourning and Melancholia', in S. Freud, *On Murder, Mourning and Melancholia*, trans. S. Whiteside (London: Penguin, 2005/1917), pp. 201–18.

Freud, S. and Breuer, J., *Studies on Hysteria*, trans. J. and A. Strachey, Penguin Freud Library Vol. 3 (London: Penguin, 1974/1893-5).

Gaines, J. M., 'Political Mimesis', in J. M. Gaines and M. Renov (eds), *Collecting Visible Evidence* (Minneapolis and London: University of Minnesota Press, 1999), pp. 84–102.

Gallop, J., *Feminism and Psychoanalysis: The Daughter's Seduction* (London: Macmillan, 1982).

Gallop, J., *Thinking Through the Body* (New York: Columbia University Press, 1988).

Garcia, M., 'A Sweet Unrest: Jane Campion Recreates Love Affair between Poet John Keats and Fanny Brawne', *Film Journal International*, 21 August, 2009, accessed at: www.filmjournal.com/filmjournal/content_display/news-and-features/features/movies/e3ib9d44f33bad88c089200b320dd99e108?pn=1

Garcia, M., '*Bluebeard*', *Cineaste* vol. 35 no. 2, p. 61(3), 2010, accessed at: *Shakespeare Collection*, Thomson Gale, University of Sussex, 1 July 2011, http://find.galegroup.com.ezproxy.sussex.ac.uk/shax/infomark.do?&contentSet=IAC

Geraghty, C., 'Three Women's Films', in C. Brunsdon (ed.), *Films for Women* (London: BFI, 1986), pp. 138–45.

Gilbert, S. M. and Gubar, S., *The Madwoman in the Attic: The Woman Writer and the Nineteenth-Century Imagination* (New Haven and London: Yale University Press, 2000/1979).

Gledhill, C., 'Developments in Feminist Film Criticism', in M. A. Doane, P. Mellencamp and L. Williams (eds), *Re-Vision: Essays in Film Criticism* (Los Angeles: AFI, 1984), pp. 18–48.

Gordon, L., '*Union Maids*: Working Class Heroines', *Jump Cut* no. 14, 1977, pp. 34–5.

Greenspun, R., 'Movie Review: *Wanda* (1970)', *New York Times*, 1 March 1971, p. 22.

Grosz, E., *Jacques Lacan: A Feminist Introduction* (London and New York: Routledge, 1990).

Grosz, E., *Volatile Bodies: Toward a Corporeal Feminism* (Bloomington and Indianapolis: Indiana University Press, 1994).

Grosz, E., *Architecture from the Outside* (Cambridge and London: MIT Press, 2001).

Guest, H., 'Lucrecia Martel', BOMB 106/Winter 2009, accessed at: bombsite.com/issues/106

Gunning, T., 'Narrative Discourse and the Narrator System', in L. Braudy and M. Cohen (eds), *Film Theory and Criticism*, 6th edn (Oxford: Oxford University Press, 2004), pp. 470–81.

Haskell, M., 'Are Women Directors Different?', *Village Voice*, 3 February 1975), p. 72.

Haskell, M., *From Reverence to Rape: The Treatment of Women in the Movies*, 2nd edn (Chicago and London: University of Chicago Press, 1987/1974).

Heath, Stephen, 'Comment on "The Idea of Authorship"', in J. Caughie (ed.), *Theories of Authorship* (London: Routledge, 1981/1973), pp. 214–20.

Heck-Rabi, L., *Women Filmmakers: A Critical Reception* (Metuchen, NJ, and London: Scarecrow Press, 1984).

Heilbrun, C., *Writing a Woman's Life* (New York: Ballantine, 1988).

Higgins, L., 'Two Women Filmmakers Remember the Dark Years', *Modern & Contemporary France* vol. 7 no. 1, 1999, pp. 59–69.

Hillauer, R. (ed.), *Encyclopedia of Arab Women Filmmakers* (Cairo: American University in Cairo Press, 2006).

Hollibaugh, A. and Moraga, C., 'What We're Rollin Around in Bed With: Sexual Silences in Feminism', in A. Snitow, C. Stansell and S. Thompson (eds), *Powers of Desire: The Politics of Sexuality* (New York: Monthly Review Press, 1983), pp. 394–405.

Hunt, C., 'Lawless Hearts', *Sight & Sound* vol. 19 no. 8, August, 2009a, p. 49.

Hunt, C., DVD Interview (Axiom Films, 2009b).

Inness, S., 'Introduction: "Boxing Gloves and Bustiers": New Images of Tough Women', in S. Inness (ed.), *Action Chicks: New Images of Tough Women in Popular Culture* (Basingstoke and New York: Palgrave Macmillan, 2004), pp. 1–17.

Irigaray, L., 'Love of Same, Love of Other', in L. Irigaray, *An Ethics of Sexual Difference*, trans. C. Burke and G. C. Gill (London and New York: Continuum, 1993/1984), pp. 83–98.

Jackson, L., 'Labor Relations: An Interview with Lizzie Borden', *Cineaste* vol. 40 no. 3, 1987, pp. 4–9.

Jacobus, M., 'The Difference of View', in M. Jacobus. (ed.), *Women Writing and Writing about Women* (London: Croom Helm, 1979), pp. 10–21.

Jacobus, M., *Reading Woman: Essays in Feminist Criticism* (London: Methuen, 1986).

Jacobus, M., '"The Third Stroke": Reading Woolf with Freud', in S. Sheridan (ed.), *Grafts: Feminist Cultural Criticism* (London: Verso, 1988), pp. 93–110.

Jaehne, K., 'Antonia's Line', *Film Quarterly* vol. 50 no. 1, Autumn, 1996, pp. 27–30.

James, N., 'Looks that Paralyse', *Sight & Sound* vol. 11 no. 12, 2001, p.18.

James, N., 'Divine Innocence', in *Sight & Sound* vol. 15 no. 2, 2005, pp. 18–20.

Jameson, F., 'On Magic Realism in Film', in F. Jameson, *Signatures of the Visible* (New York and London: Routledge, 1992), pp. 128–52.

Jayamanne, L., *Toward Cinema and its Double* (Bloomington and Indianapolis: Indiana University Press, 2001).

Jermyn, D., 'Cherchez la Femme: *The Weight of Water* and the Search for Bigelow in "A Bigelow Film"', in D. Jermyn and S. Redmond (eds), *The Cinema of Kathryn Bigelow: Hollywood Transgressor* (London: Wallflower, 2003), pp. 125–43.

Johnston, C. (ed.), *Notes on Women's Cinema*, Screen Pamphlet 2 (London: Society for Education in Film and Television, 1973).

Johnston, C., 'Feminist Politics and Film History', *Screen* vol. 16 no. 3, 1975, pp. 115–25

Johnston, C., 'Towards a Feminist Film Practice: Some Theses', in P. Hardy, C. Johnston and P. Willeman (eds), *Edinburgh '76 Magazine* no. 1 (London: BFI, 1976), pp. 50–9.

Johnston, C., 'The Subject of Feminist Film Theory/Practice', *Screen* vol. 21 no. 2, 1980, pp. 27–34.

Johnston, C., 'Dorothy Arzner: Critical Strategies', in C. Penley (ed.), *Feminism and Film Theory* (London: Routledge, 1988), pp. 36–45.

Juhasz, A., 'They Said We Were Trying to Show Reality – All I Want to Show Is My Video: The Politics of the Realist Feminist Documentary', in J. M. Gaines and M. Renov (eds), *Collecting Visible Evidence* (Minneapolis and London: University of Minnesota Press, 1999), pp. 190–215.

Kael, P., 'The Current Cinema: Stuck in the Fun', *New Yorker*, 7 October 1974, pp. 151–2.

Kaplan, C., *Sea Changes: Essays on Culture and Feminism* (London: Verso, 1986).

Kaplan, E. A., 'Interview with British Cine-Feminists', in K. Kay and G. Peary (eds), *Women and the Cinema* (New York: E. P. Dutton, 1977), pp. 393–406.

Kaplan, E. A., *Women and Film: Both Sides of the Camera* (New York and London: Methuen, 1983).

Kaplan, E. A., 'The Case of the Missing Mother: Maternal Issues in Vidor's *Stella Dallas*', in E. A. Kaplan (ed.), *Feminism & Film* (Oxford: Oxford University Press, 2000/1983), pp. 466–78.

Kaplan, L. J., 'Further Thoughts on Female Perversions', *Studies in Gender and Sexuality* vol. 1 no. 4, 2000, pp. 349–70.

Karlyn, K. R., *Unruly Girls, Unrepentant Mothers* (Austin: University of Texas Press, 2011).

Kazan, E., *A Life* (New York: Alfred Knopf, 1988).

King, N., 'Recent "Political" Documentary: Notes on "Union Maids" and "Harlan County USA"', *Screen* vol. 22 no. 2, 1981, pp. 7–20.

Kipling, R., Kim, Project Gutenberg Etext (kimrk12.txt), (2000/1901), accessed at: www.getfreebooks.co/The-Project-Gutenberg-Etext-of-Kim-by-Rudyard-Kipling—DOC.html

Kristeva, J., *Powers of Horror: Essays on Abjection* (New York: Columbia University Press, 1982).

Kristeva, J., 'Women's Time', in T. Moi (ed.), *The Kristeva Reader* (Oxford: Blackwell, 1986), pp. 187–213.

Kuhn, A., 'Film Culture: Women's Cinema and Feminist Film Criticism', *Screen* vol. 16 no. 3, 1975, pp. 107–12.

Kuhn, A., 'Film Culture: Camera Obscura', *Screen* vol. 18 no. 2, 1977, pp. 123–8.

Kuhn, A., *Women's Pictures* (London: Routledge & Kegan Paul, 1982).

Kuhn, A., 'A Journey Through Memory', in S. Radstone (ed.), *Memory and Methodology* (Oxford and New York: Berg, 2000), pp. 179–96.

Lacan, J., 'Seminar on "The Purloined Letter"', trans. J. Mehlman, *Yale French Studies* no. 48, 1972, pp. 39–72.

Lacan, J., 'God and the *Jouissance* of /The/ Woman', in J. Mitchell and J. Rose (eds), *Feminine Sexuality: Jacques Lacan and the École Freudienne* (New York and London: Norton, 1982), pp. 137–48.

Lane, C., *Feminist Hollywood* (Detroit: Wayne State University Press, 2000).

Laplanche, J. and Pontalis, J.-B., 'Fantasy and the Origins of Sexuality', in V. Burgin, J. Donald and C. Kaplan (eds), *Formations of Fantasy* (London and New York: Routledge, 1986), pp. 5–34.

Lapsley, R. and Westlake, M., *Film Theory: An Introduction* (Manchester: Manchester University Press, 1988).

Lauzen, M., *The Celluloid Ceiling: Behind-the-Scenes Employment of Women on the Top 250 Films of 2010*. Report (2011), accessed at: http://agnesfilms.com/wp-content/uploads/2011/02/2010-Celluloid-Ceiling.pdf

Le Doeuff, M., *Hipparchia's Choice*, trans. T. Selous (Oxford: Blackwell, 1991).

Le Doeuff, M., *The Philosophical Imaginary*, trans. C. Gordon (London and New York: Continuum, 2002).

Leigh, D., 'About a Girl', *Guardian*, 5 October 2002, accessed at: www.guardian.co.uk/film/2002/oct/05/features.weekend

LeMoncheck, L., *Loose Women, Lecherous Men: A Feminist Philosophy of Sex* (Oxford: Oxford University Press, 1997).

Lesage, J., 'The Political Aesthetics of the Feminist Documentary Film', in P. Erens (ed.), *Issues in Feminist Film Criticism* (Bloomington and Indianapolis: Indiana University Press, 1990/1978), pp. 222–37.

Lesage, J., Martineau, B. H. and Kleinhans, C., 'New Day's Way: Interview with Julia Reichert and Jim Klein', *Jump Cut* no. 9, 1975, pp. 21–2.

Levertov, D., *Relearning the Alphabet* (New York: New Directions, 1970).

Levitin, J., Plessis, J. and Raoul, V. (eds), *Women Filmmakers: Refocusing* (New York and London: Routledge, 2003).

Levy, E., '*The Weight of Water*' Review, *Variety*, 18–24 September 2000, p. 32.

Lichtenstein, G., 'In Liliana Cavani's Love Story, Love Means Always Having to Say Ouch', *New York Times*, 13 October 1974, p. D19.

Loden, B., 'Barbara Loden Revisited', Interview by the Madison Women's Media Collective, *Women & Film* vol. 5–6, 1974, pp. 67–70.

Lucia, C., 'Redefining Female Sexuality in the Cinema: An Interview with Lizzie Borden', *Cineaste* vol. 19 no. 2–3, 1992, pp. 6–10.

Lucia, C., *Framing Female Lawyers: Women on Trial in Film* (Austin: University of Texas Press, 2005).

Lynd, A. and Lynd, S., *Rank and File* (Boston: Beacon Press, 1973).

Margulies, I., 'Echo and Voice in *Meetings with Anna*', in G. A. Foster (ed.), *Identity and Memory: The Films of Chantal Akerman* (Carbondale and Edwardsville: Southern Illinois University Press, 2003), pp. 59–76.

Marrone, G., *The Gaze and the Labyrinth: The Cinema of Liliana Cavani* (Princeton: Princeton University Press, 2000).

Martel, L., *La Niña Santa* DVD Interview (Artificial Eye, 2008).

Martin, D., 'Wholly Ambivalent Demon-girl: Horror, the Uncanny and the Representation of Feminine Adolescence in Lucrecia Martel's *La Niña Santa*', *Journal of Iberian and Latin American Studies* vol. 17 no. 1, 2011, pp. 59–76.

Maslin, J., 'Film: "Les Rendez-vous"; Enigmatic Character', *New York Times*, 27 April 1979, p. C14.

Maslin, J., 'Film: Australian "Brilliant Career" by Gillian Armstrong', *New York Times*, 6 October 1979, accessed at: movies.nytimes.com/movie/review?_r= 1&res=9405E0DC1438E432A25755C0A9669D946890D6CF&scp=1&sq= film:%20australian%20brilliant%20career&st=cse

Maslin, J., 'Trying to Set a Trap For a Serial Rapist', Review of *Love Crimes*, *New York Times*, 26 January 1992, accessed at: www.nytimes.com/1992/01/26/ movies/review-film-trying-to-set-a-trap-for-a-serial-rapist.html

Mayne, J., 'Feminist Film Theory and Criticism', *Signs* vol. 11 no. 1, 1985, pp. 88–100.

Mayne, J., *The Woman at the Keyhole: Feminism and Women's Cinema* (Bloomington and Indianapolis: Indiana University Press, 1990).

McClintock, A., *Imperial Leather: Race, Gender and Sexuality in the Colonial Contest* (New York and London: Routledge, 1995).

McGarry, E., 'Documentary, Realism & Women's Cinema', *Women & Film* vol. 2 no. 7, 1975, pp. 50–9.

McRobbie, A., *The Aftermath of Feminism: Gender, Culture and Social Change* (London: Sage, 2009).

Meade, M., 'Lights! Camera! Women!', *New York Times*, 25 April 1971, Section II, p. 11.

Mellen, J., *Women and their Sexuality in the New Film* (London: Davis-Poynter, 1974).

Mellencamp, P., *A Fine Romance: Five Ages of Film Feminism* (Philadelphia: Temple University Press, 1995).

Melton, R., 'An Environment that is Overwhelmingly Ugly and Destructive: An Interview with Barbara Loden', *Film Journal* vol. I no. 2, 1971, pp. 10–15.

Merin, J., 'Patricia Rozema talks "Kit Kittredge" with Jennifer Merin', Alliance of Women Film Journalists (2008), accessed at: awfj.org/2008/06/19/patricia-rozema-talks-kit-kittredge-with-jennifer-merin/

WHAT IF I HAD BEEN THE HERO?

Metz, C., 'The Imaginary Signifier', in C. Metz, *The Imaginary Signifier: Psychoanalysis and the Cinema*, trans. C. Britton and A. Williams (Bloomington and Indianapolis: Indiana University Press, 1982/1975), pp. 1–87.

Metz, C., 'Histoire/Discours', in C. Metz, *The Imaginary Signifier: Psychoanalysis and the Cinema*, trans. C. Britton and A. Williams (Bloomington and Indianapolis: Indiana University Press, 1982), pp. 89–98.

Michel, S., 'Feminism, Film and Public History', in P. Erens (ed.), *Issues in Feminist Film Criticism* (Bloomington and Indianapolis: Indiana University Press, 1990/1981), pp. 238–49.

Miller, N., *Subject to Change: Reading Feminist Writing* (New York: Columbia University Press, 1988).

Mizejewski, L., 'Dressed to Kill: Postfeminist Noir', *Cinema Journal* vol. 44 no. 2, 2005, pp. 121–7.

Modleski, T., *Old Wives' Tales: Feminist Re-Visions of Film and Other Fictions* (London: I.B. Tauris, 1999).

Moers, E., *Literary Women* (London: Women's Press, 1986).

Morley, M., '*Les Rendez-Vous d'Anna* (Chantal Akerman)', *Camera Obscura* vol. 3 no. 1, 1979, pp. 211–15.

Morris, M., '"Too Soon Too Late": In Memory of Claire Johnston, 1940–87', in M. Morris, *Too Soon Too Late* (Bloomington and Indianapolis: Indiana University Press, 1998), pp. xiii–xxiii.

Mulvey, L., 'Feminism, Film and the *Avant-Garde*', in M. Jacobus (ed.), *Women Writing and Writing About Women* (Beckenham: Croom Helm, 1979), pp. 177–95.

Mulvey, L., 'Visual Pleasure and Narrative Cinema', in L. Mulvey, *Visual and Other Pleasures* (Basingstoke and London: Macmillan, 1989a), pp. 14–26.

Mulvey, L., 'Afterthoughts on "Visual Pleasure and Narrative Cinema" inspired by King Vidor's *Duel in the Sun* (1946)', in L. Mulvey, *Visual and Other Pleasures* (Basingstoke and London: Macmillan, 1989b), pp. 29–38.

Mulvey, L., 'British Feminist Film Theory's Female Spectators: Presence and Absence', *Camera Obscura* no. 20/21, 1989c, pp. 68–81.

Munro, A., 'The Bear Came Over the Mountain', in A. Munro, *Hateship, Friendship, Courtship, Loveship, Marriage* (London: Vintage, 2002), pp. 275–323.

Nava, M., 'Modernity's Disavowal: Women, the City and the Department Store', in P. Falk and C. Campbell (eds), *The Shopping Experience* (London: Sage, 1997), pp. 56–91.

Negra, D., *What a Girl Wants: Fantasizing the Reclamation of Self in Postfeminism* (London and New York: Routledge, 2009).

Nichols, B., *Representing Reality* (Bloomington and Indianapolis: Indiana University Press, 1991).

Olkowski, D., *Gilles Deleuze and the Ruin of Representation* (Berkeley, Los Angeles, London: University of California Press, 1999).

Penley, C., 'The Avant-Garde and its Imaginary', *Camera Obscura* no. 2, 1977, pp. 3–33.

Pera, B., 'Off-ing for Pleasure: A conversation between Brian Pera and Masha Tupitsyn', *Semiotext(e)*, 2008, accessed at: www.semiotexte.com/documentPage/PeraMasha.html

Peterson, D., 'Jane Campion Directs Romance About Poet John Keats and Fanny Brawne', *suite101.com*, 6 October 2009, accessed at: www.suite101.com/content/bright-star-film-review-a156350

Petro, P., 'Feminism and Film History', in D., Carson, L. Dittmar and J. R. Welsch (eds), *Multiple Voices in Feminist Film Criticism* (Minneapolis and London: University of Minnesota Press, 1994), pp. 65–81.

Petro, P., 'Reflections on Feminist Film Studies, Early and Late', *Signs* vol. 30 no. 1, 2004, pp. 1272–78.

Phillips, M., 'Barbara Loden Speaks of the World of "Wanda" ', *New York Times*, 11 March 1971,accessed at: select.nytimes.com/gst/abstract.html?res= F20F11F93A55127B93C3A81788D85F458785F9

Phoca, S. and Wright, R., *Introducing Postfeminism* (Duxford: Icon, 1999).

Plate, L., *Transforming Memories in Contemporary Women's Rewriting* (Basingstoke: Palgrave Macmillan, 2011).

Poe, E. A, 'The Purloined Letter' (2010/1845), accessed at: xroads.virginia.edu/~hyper/poe/purloine.html

Price, B., 'Catherine Breillat', *Senses of Cinema* no. 23, 2002, accessed at: www.sensesofcinema.com/2002/great-directors/breillat

Radner, H., *Shopping Around* (New York and London: Routledge, 1995).

Radway, J., *Reading the Romance* (Chapel Hill and London: University of North Carolina Press, 1984).

Rainer, Y., 'Interview', *Camera Obscura* no. 1, 1976, pp. 76–96.

Ramanathan, G., *Feminist Auteurs: Reading Women's Films* (London and New York: Wallflower, 2006).

Ramer, J., 'Postmodernism and (Post)Feminist Boredom', *Synoptique*, 2004, accessed at: www.synoptique.ca/core/en/print/feminist_boredom/

Ramsay, L., 'Morvern Callar', Interview in *Empire*, 2002, accessed at: www.empireonline.com/interviews/interview.asp?IID=54

Rashkin, E. J., *Women Filmmakers in Mexico* (Austin: University of Texas Press, 2001).

Reynaud, B., 'For *Wanda*', in T. Elsaesser, A. Horwath and N. King (eds), *The Last Great American Picture Show* (Amsterdam: Amsterdam University Press, 2004/2002), pp. 223–47.

Rich, A., *Diving into the Wreck: Poems 1971–1972* (New York: W. W. Norton & Co., 1973).

Rich, A., 'When We Dead Awaken: Writing as Re-Vision', in A. Rich, *On Lies, Secrets, and Silence: Selected Prose 1966–1978* (New York and London: W. W. Norton, 1979), pp. 33–49.

Rich, B. R., 'The Crisis of Naming in Feminist Film Criticism', *Jump Cut* no. 19, 1978, pp. 9–12.

Rich, B. R., 'In the Name of Feminist Film Criticism', in B. Nichols (ed.), *Movies and Methods* Vol. II (Berkeley: University of California Press, 1985), pp. 340–58.

Rich, B. R., *Chick Flicks* (Durham and London: Duke University Press, 1998).

Rich, B. R. and Williams, L., 'The Right of Re-Vision: Michelle Citron's *Daughter Rite*', in B. R. Rich, *Chick Flicks* (Durham and London: Duke University Press, 1998/1979), pp. 212–19.

Ricoeur, P., 'Life: A Story in Search of a Narrator', in M. J. Valdés (ed.), *A Ricoeur Reader: Reflection and Imagination* (New York: Harvester Wheatsheaf, 1991), pp. 425–37.

Robin, D. and Jaffe, I. (eds), *Redirecting the Gaze: Gender, Theory and Cinema in the Third World* (Albany: State University of New York Press, 1999).

Robson, J. and Zalcock, B., *Girls Own Stories: Australian and New Zealand Women's Films* (London: Scarlet Press, 1997).

Rose, G., *Feminism & Geography: The Limits of Geographical Knowledge* (Cambridge: Polity, 1993).

Rosen, M., *Popcorn Venus* (New York: Avon, 1974/1973).

Rosenberg, J., *Women's Reflections: The Feminist Film Movement* (Ann Arbor/London: UMI Research Press, 1979).

Rosenfelt, D. and Stacey, J., 'Second Thoughts on the Second Wave', in K. V. Hansen and I. J. Philipson (eds), *Women, Class and the Feminist Imagination* (Philadelphia: Temple University Press, 1990), pp. 549–67.

Rowe, K., *The Unruly Woman* (Austin: University of Texas Press, 1995).

Ruf, F., '*The Holy Girl* (*La Niña Santa*)', *Journal of Religion and Film* vol. 10 no. 1, 2006, accessed at: www.unomaha.edu/jrf/vol10no1/Reviews/HolyGirl.htm

Russell, D., 'Lucrecia Martel – "A Decidedly Polyphonic Cinema"', *Jump Cut* no. 50, 2008, accessed at: www.ejumpcut.org/archive/jc50.2008/LMartelAudio/text.html

Russo, M., *The Female Grotesque* (New York and London: Routledge, 1994).

Saltzman, D., *Shooting Water* (New York: Newmarket Press, 2005).

Sarris, A., 'The Nasty Nazis: History or Mythology?', *Village Voice*, 17 October 1974, pp. 77–8.

Scherr, R., 'The Uses of Memory and the Abuses of Fiction: Sexuality in Holocaust Fiction and Memoir', *Other Voices* vol. 2 no. 1, 2000, accessed at www.othervoices.org/2.1/scherr/sexuality.html

Schiesari, J., *The Gendering of Melancholia* (Ithaca and London: Cornell University Press, 1992).

Sellery, J. M., 'Women's Communities and the Magical Realist Gaze of *Antonia's Line*', *West Virginia University Philological Papers*, 48, Autumn 2001, pp. 115–24.

Shaviro, S., *The Cinematic Body* (Minneapolis and London: University of Minnesota Press, 1993).

Shohat, E. and Stam, R., *Unthinking Eurocentrism: Multiculturalism and the Media* (London and New York: Routledge, 1994).

Silverman, K., 'Masochism and Subjectivity', *Framework* no. 12, 1980, pp. 2–9.

Silverman, K., *The Acoustic Mirror: The Female Voice in Psychoanalysis and Cinema* (Bloomington and Indianapolis: Indiana University Press, 1988).

Sklar, R., 'The Lighter Side of Feminism: An Interview with Marleen Gorris', *Cineaste* vol. 22 no. 1, 1996, pp. 26–8.

Sklar, R. and Gluck, S., 'A Woman's Vision of Shame and Desire: An Interview with Catherine Breillat', *Cineaste* vol. 25 no. 1, 1999, pp. 24–38.

Slane, A., *A Not so Foreign Affair: Fascism, Sexuality and the Cultural Rhetoric of American Democracy* (Durham and London: Duke University Press, 2001).

Smelik, A., *And the Mirror Cracked: Feminist Cinema and Film Theory* (Basingstoke: Palgrave, 1998).

Smith, S., *Women Who Make Movies* (New York: Hopkinson and Blake, 1975).

Snitow, A. B., 'Mass Market Romance: Pornography for Women is Different', in A. Snitow, C. Stansell and S. Thompson (eds), *Powers of Desire: The Politics of Sexuality* (New York: Monthly Review Press, 1983), pp. 245–63.

Snitow, A., Stansell, C. and Thompson, S., 'Introduction', in A. Snitow, C. Stansell and S. Thompson (eds), *Powers of Desire: The Politics of Sexuality* (New York: Monthly Review Press, 1983), pp. 9–47.

Sobchack, V., 'Toward a Phenomenology of Nonfictional Film Experience', in J. M. Gaines and M. Renov (eds), *Collecting Visible Evidence* (Minneapolis and London: University of Minnesota Press, 1999), pp. 241–54.

Solway, D., 'Jane Campion', *W* magazine, February 2010, accessed at: www.wmagazine.com/celebrities/2010/02/jane_campion?currentPage=1

Somers, M. R. and Gibson, G. D., 'Reclaiming the Epistemological "Other": Narrative and the Social Constitution of Identity', in C. Calhoun (ed.), *Social Theory and the Politics of Identity* (Oxford: Blackwell, 1994), pp. 37–99.

Stables, K., *Bright Star* review, *Sight & Sound* vol. 19 no. 12, 2009, p. 46.

Steedman, C., *Landscape for a Good Woman* (London: Virago, 1986).

Suter, J. 'Feminine Discourse in *Christopher Strong*' (1979), in C. Penley (ed.), *Feminism and Film Theory* (London: BFI, 1988), pp. 89–103.

Tasker, Y., *Spectacular Bodies: Gender, Genre and Action Cinema* (London: Routledge, 1993).

Tasker, Y. and Negra, D. (eds), *Interrogating Postfeminism* (Durham and London: Duke University Press, 2007).

Thornham, S., *Passionate Detachments: An Introduction to Feminist Film Theory* (London: Bloomsbury, 1997).

Tolman, D. L., *Dilemmas of Desire: Teenage Girls Talk about Sexuality* (Cambridge and London: Harvard University Press, 2002).

Vincendeau, G., 'Sisters, Sex and Sitcom', *Sight & Sound* vol. 11 no. 12, 2001, pp. 18–20.

Visweswaran, K., 'Betrayal: An Analysis in Three Acts', in I. Grewal and C. Kaplan (eds), *Scattered Hegemonies: Postmodernity and Transnational Feminist Practices* (Minneapolis and London: University of Minnesota Press, 1994), pp. 90–109.

Walker, J. and Waldman, D., 'Introduction', in D. Waldman, and J. Walker (eds), *Feminism and Documentary* (Minneapolis and London: University of Minnesota Press, 1999), pp. 1–35.

Walkerdine, V., 'Behind the Painted Smile', in J. Spence and P. Holland (eds), *Family Snaps: The Meanings of Domestic Photography* (London: Virago, 1991), pp. 35–45.

Walkerdine, V., *Daddy's Girl: Young Girls and Popular Culture* (Basingstoke: Macmillan, 1997).

Waller, M., 'Signifying the Holocaust: Liliana Cavani's *Portiere di Notte*', in L. Pietropaolo and A. Testaferri (eds), *Feminisms in the Cinema* (Bloomington and Indianapolis: Indiana University Press, 1995), pp. 206–19.

Warner, A., *Morvern Callar* (London: Vintage, 1996).

Williams, L., 'When the Woman Looks', in M. A. Doane, P. Mellencamp and L. Williams (eds), *Re-Vision: Essays in Film Criticism* (Los Angeles: AFI, 1984), pp. 83–99.

Williams, L., *Hard Core: Power, Pleasure and the 'Frenzy of the Visible'* (London: Pandora, 1990).

Williams, L., '"Something Else Besides a Mother": *Stella Dallas* and the Maternal Melodrama', in E. A. Kaplan (ed.), *Feminism & Film* (Oxford: Oxford University Press, 2000/1985), pp. 479–504.

Williams, L., 'Why I Did Not Want to Write this Essay', *Signs* vol. 30 no. 1, 2004, pp. 1264–72.

Williams, L., *Screening Sex* (Durham and London: Duke University Press, 2008).

Williams, L. R., '*À Ma Soeur*', *Sight & Sound* vol 11 no. 12, 2001, p. 40.

Williams, L. R., 'Escape Artist', *Sight & Sound* vol. 12 no. 10, 2002, pp. 22–5.

Williams, L. R., *The Erotic Thriller in Contemporary Cinema* (Edinburgh: Edinburgh University Press, 2005).

Willis, S., 'Hardware and Hardbodies: What do Women Want?: A Reading of *Thelma and Louise*', in J. Collins, H. Radner and A. P. Collins (eds), *Film Theory Goes to the Movies* (New York and London: Routledge, 1993), pp. 120–8.

Wilson, E., 'The Invisible *Flaneur*', *New Left Review* no. 191, 1992, pp. 90–110.

Wilson, E., 'Deforming Femininity: Catherine Breillat's *Romance*', in L. Mazdon (ed.), *France on Film* (London: Wallflower, 2001), pp. 145–57.

Wilson, F., 'Keats and the Minx', *The Times Literary Supplement*, 2 December, 2009, accessed at: entertainment.timesonline.co.uk/tol/arts_and_entertainment/the_tls/article6940504.ece

Wilson, R., 'The Metamorphoses of Fictional Space: Magical Realism', in L. P. Zamora and W. B. Faris (eds), *Magical Realism: Theory, History, Community* (Durham and London: Duke University Press, 1995), pp. 209–33.

Winship, J., 'A Woman's World: *Woman* – An Ideology of Femininity', Women's Studies Group, CCCS, *Women Take Issue: Aspects of Women's Subordination* (London: Hutchinson, 1978), pp. 133–54.

Wisniewski, C., 'When Worlds Collide: An Interview with Lucrecia Martel', *Reverse Shot* no. 25, 2008, accessed at: reverseshot.com/article/interview_lucrecia_martel

Wollen, P., *Signs and Meaning in the Cinema* (London: Secker and Warburg, 1972).

Women and Film: A Resource Handbook (1972), accessed at: www.eric.ed.gov/ERICWebPortal/recordDetail?accno=ED085034

Women & Film collective, 'Overview', *Women & Film* no. 1, 1972, pp. 3–6.

Woolf, V., 'Speech', in M. A. Leaska (ed.), *The Pargiters* (London: Hogarth Press, 1978/1931), pp. xxvii–xliv, 163–7.

Woolf, V., 'A Room of One's Own', in M. Barrett (ed.), *A Room of One's Own and Three Guineas* (Harmondsworth: Penguin, 1993/1929), pp. 1–114.

Woolf, V., 'Professions for Women', in M. Barrett (ed.), *A Room of One's Own and Three Guineas* (Harmondsworth: Penguin, 1993/1931), pp. 356–61.

Wright, A., *Brilliant Careers: Women in Australian Cinema* (Sydney: Pan Australia, 1986).

Zamora, L. P. and Faris, W. B., 'Introduction: Daiquiri Birds and Flaubertian Parrot(ie)s', in L. P. Zamora and W. B. Faris (eds), *Magical Realism: Theory, History, Community* (Durham and London: Duke University Press, 1995), pp. 1–11.

Zimmerman, D., 'About Women Make Movies', *Women Make Movies* catalogue (New York: Women Make Movies, 2011).

Zipes, J., *Don't Bet on the Prince* (Aldershot: Gower, 1986).

Žižek, S., *The Plague of Fantasies* (London: Verso, 1997).

FILMS

À ma soeur/Fat Girl (Catherine Breillat, 2001)

An Angel at My Table (Jane Campion, 1990)

Antonia's Line (Marleen Gorris, 1995)

Away From Her (Sarah Polley, 2006)

Betty Tells Her Story (Liane Brandon, 1972)

Blue Steel (Kathryn Bigelow, 1989)

Bluebeard (Catherine Breillat, 2010)

Bonnie and Clyde (Arthur Penn, 1967)

Born in Flames (Lizzie Borden, 1983)

Brief Encounter (David Lean, 1945)

Bright Star (Jane Campion, 2009)

Butch Cassidy and the Sundance Kid (George Roy Hill, 1969)

Caught (Max Ophuls, 1949)

Coma (Michael Crichton, 1977)

Copycat (Jon Amiel, 1995)

Dance, Girl, Dance (Dorothy Arzner, 1940)

Daughter Rite (Michelle Citron, 1978)

Daughters of the Dust (Julie Dash, 1991)

Death Defying Acts (Gillian Armstrong, 2007)

The Devil Wears Prada (David Frankel, 2006)

Female Perversions (Susan Streitfield, 1997)

La Fiancée du Pirate (Nelly Kaplan, 1969)

Film about a woman who … (Yvonne Rainer, 1974)

Frozen River (Courtney Hunt, 2008)

Gaslight (George Cukor, 1944)

Girlfriends (Claudia Weill, 1978)

The Gold Diggers (Sally Potter, 1983)

Guilty as Sin (Sidney Lumet, 1993)

The Headless Woman/La mujer sin cabeza (Lucrecia Martel, 2008)

Hester Street (Joan Micklin Silver, 1974)

High Tide (Gillian Armstrong, 1987)

The Holy Girl/La Niña Santa (Lucretia Martel, 2004)

In the Cut (Jane Campion, 2003)

Jagged Edge (Richard Marquand, 1985)

Jeanne Dielman, 23 Quai du Commerce, 1080 Bruxelles (Chantal Akerman, 1975)

Joyce at 34 (Joyce Chopra and Claudia Weill, 1972)

Kit Kittredge: An American Girl (Patricia Rozema, 2008)

The Last Days of Chez Nous (Gillian Armstrong, 1992)

Legally Blonde (Robert Luketic, 2001)

Life and Times of Rosie the Riveter (Connie Fields, 1980)

Little Women (Gillian Armstrong, 1994)

Love Crimes (Lizzie Borden, 1991)

Marnie (Alfred Hitchcock, 1964)

Miss Congeniality (Donald Petrie, 2000)

Morvern Callar (Lynne Ramsay, 2002)

My Brilliant Career (Gillian Armstrong, 1979)

The Night Porter (Liliana Cavani, 1974)

Now, Voyager (Irving Rapper, 1942)

Orlando (Sally Potter, 1992)

Peeping Tom (Michael Powell, 1960)

Penthesilea (Laura Mulvey and Peter Wollen, 1974)

Physical Evidence (Michael Crichton, 1988)

The Piano (Jane Campion, 1993)
Psycho (Alfred Hitchcock, 1960)
Les Quatre Cents Coups (François Truffaut, 1959)
Rebecca (Alfred Hitchcock, 1940)
Les Rendez-Vous d'Anna (Chantal Akerman, 1978)
Riddles of the Sphinx (Laura Mulvey and Peter Wollen, 1976)
Romance (Catherine Breillat, 1999)
The Seduction of Mimi (Lina Wertmüller, 1972)
Silence of the Lambs (Jonathan Demme, 1991)
Sleeping Beauty (Catherine Breillat, 2011)
Sleeping with the Enemy (Joseph Ruben, 1991)
Stella Dallas (King Vidor, 1937)
The Swamp/La Ciénaga (Lucrecia Martel, 2001)
Thelma and Louise (Ridley Scott, 1991)
Thriller (Sally Potter, 1979)
Unfolding Florence (Gillian Armstrong, 2006)
Union Maids (Julia Reichert, Jim Klein and Miles Mogulescu, 1976)
An Unmarried Woman (Paul Mazursky, 1977)
Une vraie jeune fille (Catherine Breillat, 2000)
Wanda (Barbara Loden, 1970)
Water (Deepa Mehta, 2005)
We Need to Talk About Kevin (Lynne Ramsay, 2011)
The Weight of Water (Kathryn Bigelow, 2000)
Working Girls (Lizzie Borden, 1986)
Wuthering Heights (Andrea Arnold, 2011)

Index

Page number in **bold** denote detailed analysis; those in *italics* denote illustrations;
n = endnote

WHAT IF I HAD BEEN THE HERO?

LIST OF ILLUSTRATIONS

Whilst considerable effort has been made to correctly identify the copyright holders, this has not been possible in all cases. We apologise for any apparent negligence and any omissions or corrections brought to our attention will be remedied in any future editions.